PUNK 365

HOLLY GEORGE-WARREN

FOREWORD BY RICHARD HELL

ABRAMS, NEW YORK

Punk is pretty funny. It's like reality itself, as exemplified by the statement, "This sentence is a lie." It's hard to be authentic.

The first thing I noticed about this picture book is that it's one in a series the main purpose of which is to have the widest possible public appeal. The twenty or so prior volumes have subjects like baseball, Star Wars, golf courses, the Civil War, and gardens. So far there are three pop music collections in the series: The Beatles, The Rolling Stones, and now Punk. It's weird that "punk" could be classified with the Beatles and the Rolling Stones (not to mention golf and gardens). The original punks did intend to conquer the world, but right away everybody failed and self-destructed, and soon it was accepted as logical and inevitable that all those musical propagators of subversion, chaos, poetry, and destruction (frequently of the "self" variety) were doomed to be appreciated strictly by connoisseurs. Thirty years later, punk is everybody's aspiration.

Unlike the subjects of those two previous band picture books, though, "punk" may have gotten big, but it's as an idea, an ideal, that no one band, or even ten bands, can fully embody. Or at least that no one band was successful and long-lived enough in pursuing to provide 365 good pictures. The English Invasion and '60s rock really did spring from the Beatles and the Rolling Stones. Rockabilly came from Elvis. Funk came from James Brown. But "punk" has a much muddier, grungier, more various pool of sources and archetypal exemplars. (Though a real good case could be made that it all sprang from the Stooges and the Velvet Underground, bands that I'd argue made the best records of any of the groups in this book. But the word *punk* was adopted to describe a music genre that arose after those groups . . .)

The Sex Pistols came closest to living the ideal, but even they fell short of dream-punk perfection in a few major ways: for instance, much of their style was manufactured by their boutique-owning image-making manager (so much for "do it yourself"), and their famous tunes were written mainly by a guy—Glen Matlock, their original bass player—who was soon fired because the group decided he was too straight and unthreatening to be a Sex Pistol (so much for community and disdain for "public image"). His replacement, Sid Vicious, was suitably "anarchic," but pretty soon the band ran out of material, and, as everybody knows, they broke up after one album. But ultimately such failings themselves are "punk" virtues too.

Yeah, in a way, punk is about failure. "There's no success like failure," as one wiseass prepunk put it. Take the Ramones. They failed miserably year after year. They weren't especially highly respected or popular even at CBGB, in the days of the original five or six core bands. They were a self-conscious cartoon concept of rock & roll, like the Stooges mixed with surf music. Talk about "managed style"—they conceived of themselves as a boy band and a brand, like the Bay City Rollers, more than anything else. They wanted to create as reliable an experience as McDonald's and as funny a one as Huey, Dewey, and Louie Duck, in the personae of bored kids from the projects on glue. And they did, but still they never had a hit song or album, and it took them over twenty years of failed bidding for mass attention via brutal touring, culminating in the ultimate failure—of Joey Ramone's pulse—before they finally broke through to the general public. How punk is that? I mean exactly how punk? If all that's punk, what is punk?

Punk is an idea, not a band. It's a real good idea. It's about subversion, but in the service of youthful pleasure. It's opposed to everything adult. It's against not just success, but good manners, good grooming, and any education or skill. But no definition of "punk" is true. It's poetic that way ("This sentence is a lie."). Maybe it's about failure because it's the ultimate kids' music and nobody can remain a kid, except maybe by deciding to die early enough, which was the route taken by more than one (Sid Vicious, Ian Curtis, Darby Crash). It's about honesty, anger, frustration, obnoxiousness, and chaos, but it's also about funniness, shared values, artistic control, personal appearance, and, in a surprisingly secret way for "rock & roll," sex. Maybe sadistic sex, drug sex, infantile cuddly sex, stripper sex. Not much "love," anyway. But there's always a punk band to which some, or even most, of these definitions don't apply. Because a good band wants to be quick enough not to get pinned down. Taking a picture just takes a split second, though, so here are some pictures of it.

Introduction by Holly George-Warren

Thirty-plus years ago a dark rumble of noise gurgled up from the Lower East Side of New York City, made its way across the Atlantic to Great Britain, zigzagged back over the pond to the West Coast, and soon spread throughout the land. Its name: punk. Our lives changed, and our culture will never be the same.

A rush of images and sounds from that time stays with me: Patti Smith whirling like a dervish onstage at Memorial Hall, on the campus of the University of North Carolina, Chapel Hill, January 21, 1977 (I still have the poster from the show—that's why I know the date!). Godfather of punk Iggy Pop making a "comeback" tour with David Bowie on piano, a riveting performance I caught on September 30, 1977, at the Rainbow Theatre (with the Adverts opening) in London. There I also witnessed street punks decked out in safety pins and Mohawks. And, back in North Carolina, the emergence of homegrown punk bands the H-Bombs and Th' Cigaretz (the latter of whom opened for the Ramones in '78 when they played the Pier, located in a shopping center).

In those days, we drove the ten hours to New York City to buy punk 45s and zines at Bleecker Bob's; then we started making our own fanzines. Finally, wanting to see more than just the occasional gig by the Ramones, the Dictators, Elvis Costello, and Devo—all of whom came through my neck of the woods that year—I packed my bags for Manhattan, landing there in time to experience endless nights at TR3, CBGB, Max's Kansas City, the Mudd Club, Hurrah, and the Palladium.

The message coming from the stage was DIY: pick up a guitar and play in a band, or go home and write about the show for an underground zine (heeding the call, I did both). Perhaps "do it yourself" is punk's most enduring message—and the one that most changed our culture. In addition to plugging in and grabbing the mic, we gals increasingly began writing about music and documenting the scene with cameras. PUNK 365 illustrates how women were out there in the trenches—and later the mosh pits—alongside their male counterparts. Thanks to the powerful images by Roberta Bayley, Janette Beckman, Sumishta Brahm, Nancy Breslow, Stephanie Chernikowski, Maria Del Greco, Jill Furmanovsky, Theresa Kereakes, Jenny Lens, Mellon Tytell, April Palmieri, Marcia Resnick, Raeanne Rubenstein, Ebet Roberts, Dawn Wirth, and Charlyn Zlotnik, as well as David Arnoff, Danny Fields, Godlis, Gary Green, Bobby Grossman, Bob Gruen, Chuck Krall, Bob Leafe, Gary Leonard, Robert Matheu, Dennis

Morris, and Frank White, PUNK 365 captures the scenes in New York, Detroit, Cleveland, the West Coast, Great Britain, and beyond, from the 1970s through the 1980s.

Also represented are the prepunk pioneers who paved the way: the Velvet Underground, the Stooges, the New York Dolls, and the MC5, among them. These artists' acolytes—the Ramones, Television, Richard Hell and the Voidoids, the Sex Pistols, the Clash, the Damned, the Slits, X, the Germs, the Weirdos, the Dils, the Nuns, and the Zeros, to name a baker's dozen—validated them, although mainstream America never did. That happened again with a new generation of artists; by the mid-1980s, from Minneapolis' Replacements to Washington, DC's Bad Brains, the sound had transmogrified into everything from garage bands to hardcore, from power pop to Paisley Underground, from cowpunk to punk funk, from New Romantic to Goth. Except for the hardcore scene, the fury of punk had dissipated, but with the proliferation of new kinds of hybrid sounds (including influences ranging from ska to disco to hip-hop), the impact of punk was unmistakable. Rockabilly throwbacks the Stray Cats, dance-music diva Madonna, funky thrashers the Red Hot Chili Peppers, and stadium superstars U2: they all cut their

teeth during the punk era. And bands that came to rule the charts in the 1990s and the twenty-first century have cited punk as their inspiration and impetus.

Poring over the evocative images in this book takes me back to seeing Richard Hell and the Voidoids at Hurrah, to Lou Reed at the Bottom Line, the Heartbreakers at Max's Kansas City, the Raincoats at TR3, the Only Ones at CBGB, the Clash at the Palladium, the Bad Brains at A7, the Gun Club at the Pyramid, the Replacements at CB's. But the true meaning of punk has nothing to do with nostalgia. Today, every time someone downloads a Cramps video from YouTube or e-mails Saints guitarist Ed Keupper at his MySpace site, or creates a punk track using GarageBand—or when my son Jack's elementary school chorus sings a Green Day song during their winter concert—it proves that punk is very much alive.

PUNK LIVES—365 days a year.

IN THE BEGINNING

The Stooges, 1970 photograph by Robert Matheu

Live, the Stooges never failed to shock—even in broad daylight, as at this Goose Lake outdoor festival (on August 8) near their Ann Arbor, Michigan, stomping grounds. Lead singer/provocateur Iggy Pop (b. James Osterberg) astounded audiences with the raw power of his stage presence and vocal chops. Guitarist Ron Asheton (seen here) and his drummer brother Scott, along with bassist Dave Alexander, made two albums that predated the fury of punk by more than half a decade: *The Stooges* (in 1969) and *Funhouse* (in 1970). Then, in true punk style, the group imploded—only to re-form two years later.

001

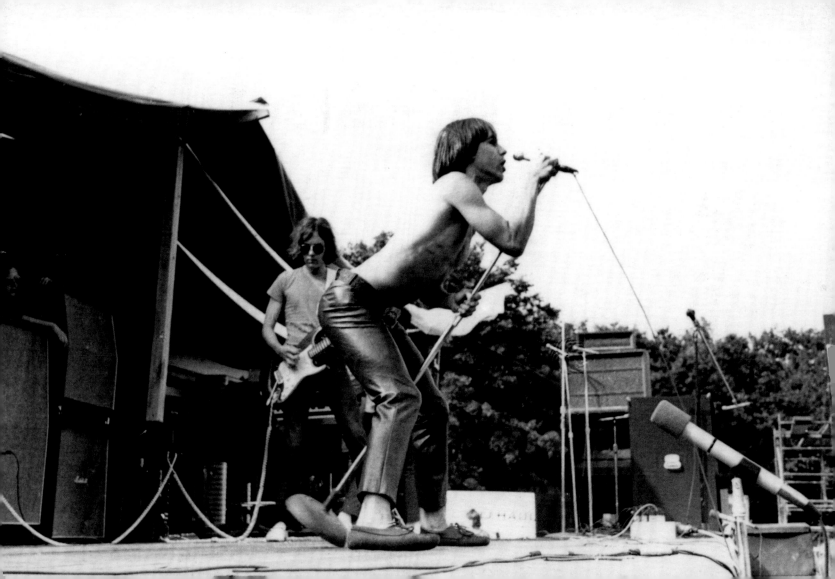

The 13th Floor Elevators, 1966 photograph by Bob Simmons

Merging psychedelia with basic three-chord rock and fueled by the shredding vocals of lead singer Roky Erickson, the 13th Floor Elevators played the kind of stripped-down rock & roll favored ten years later by punk. Hailing from Austin, Texas, the band hit the Hot 100 in 1966 with "You're Gonna Miss Me," later included on Lenny Kaye's influential *Nuggets* collection of '60s rock. Erickson wrote it as a high school student for his original garage band, the Spades. The Elevators split following Erickson's 1969 drug bust; after being committed for three years to a mental institution and enduring electroshock therapy, Roky recorded such protopunk originals as "I Walked with a Zombie" and "(I've Been Working in the Kremlin with a) Two-Headed Dog."

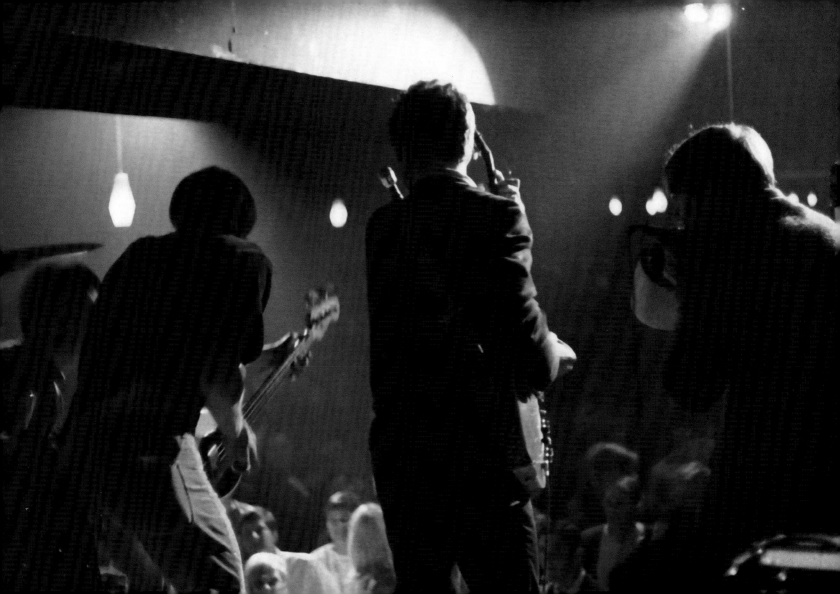

Velvet Underground, 1966 photograph by Nat Finkelstein

Along with the Stooges, no other band of the 1960s had such an impact on punk as the Velvet Underground did. Formed in New York City by John Cale, Sterling Morrison, and Lou Reed (from left), the group originally included Angus MacLise, who dropped out in 1965. They were soon joined by minimalist drummer Maureen Tucker, like Reed a native of Long Island. After Andy Warhol caught them at the Café Bizarre, he became the group's manager, buying them new amplifiers and allowing them to rehearse at the Factory. Here, the band is about to crank up the feedback at Paraphernalia.

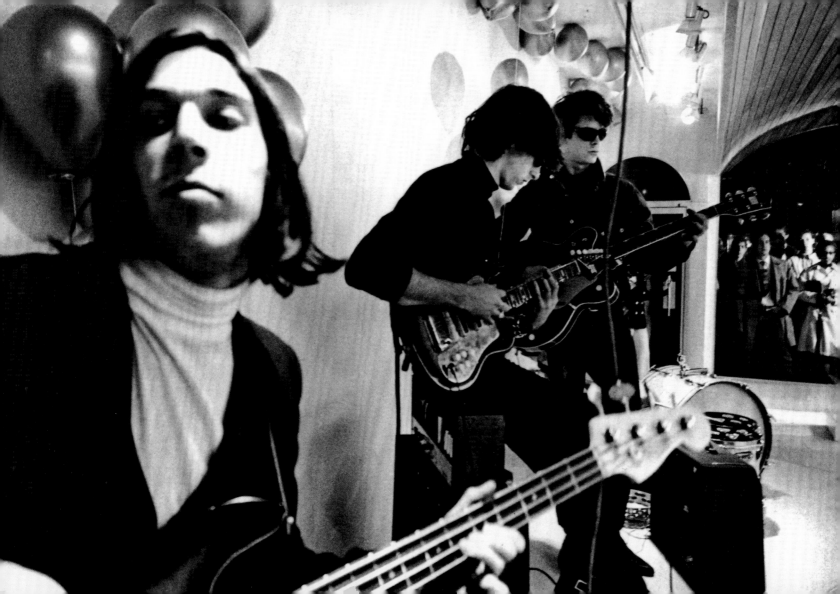

Nico, 1966 photograph by Nat Finkelstein

Andy Warhol introduced German chanteuse Nico to the Velvet Underground in 1966, when she came to New York after recording a single—produced by Andrew Loog Oldham—with Brian Jones and Jimmy Page. The statuesque "Moon Goddess," who had modeled and acted, notably in Fellini's *La Dolce Vita* (1961), became Lou Reed's muse. Her deep, monotonic vocals added a haunting beauty to his "Femme Fatale" and "I'll Be Your Mirror," released on the Velvets' debut album in 1966.

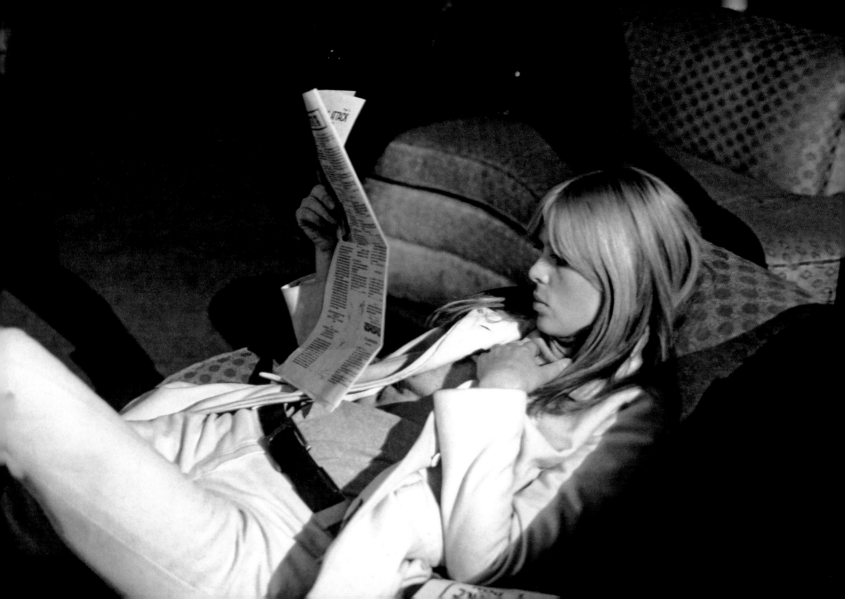

Filmmaker Paul Morrissey, Andy Warhol, and Lou Reed, 1966

photograph by Nat Finkelstein

"Andy told me that what we were doing with music was the same thing he was doing with painting and movies and writing, i.e., not kidding around. To my mind, nobody in music was doing anything that even approximated the real thing, with the exception of us. We were doing a specific thing that was very, very real. It wasn't slick or a lie in any conceivable way, which was the only way we could work with him. Because the first thing I liked about Andy was that he was very real."

—Lou Reed

005

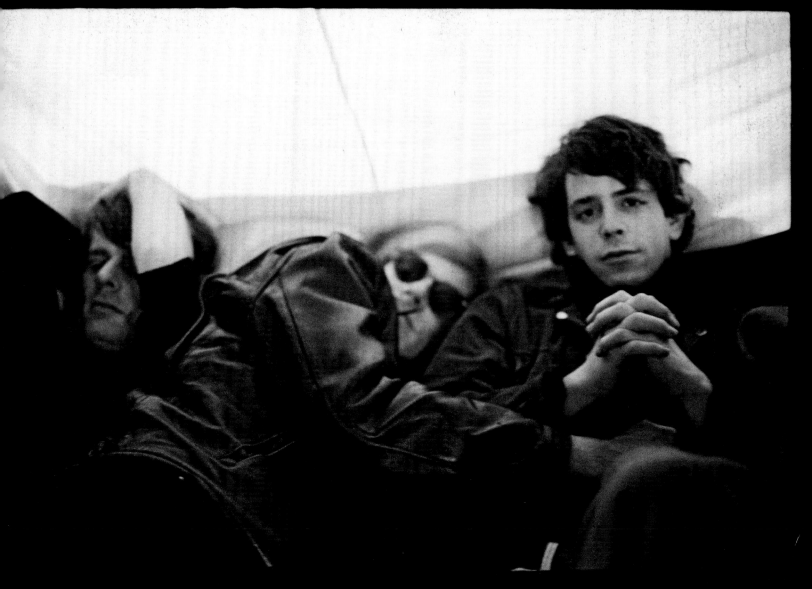

MC5, 1969

Formed in Detroit, the Motor City 5 put their working-class roots and political radicalism into a fiery brand of hard-edged rock & roll. Bassist Michael Davis, drummer Dennis Thompson, guitarist Wayne Kramer, vocalist Rob Tyner, and guitarist Fred "Sonic" Smith (from left) came from the wrong side of the tracks—and were proud of it. Their incendiary performances and lyrics, often espousing views of the White Panther Party, were protopunk fury incarnate. A controversy over the title track from their debut album, *Kick Out the Jams,* jangled record executives' nerves, foreshadowing profane days ahead.

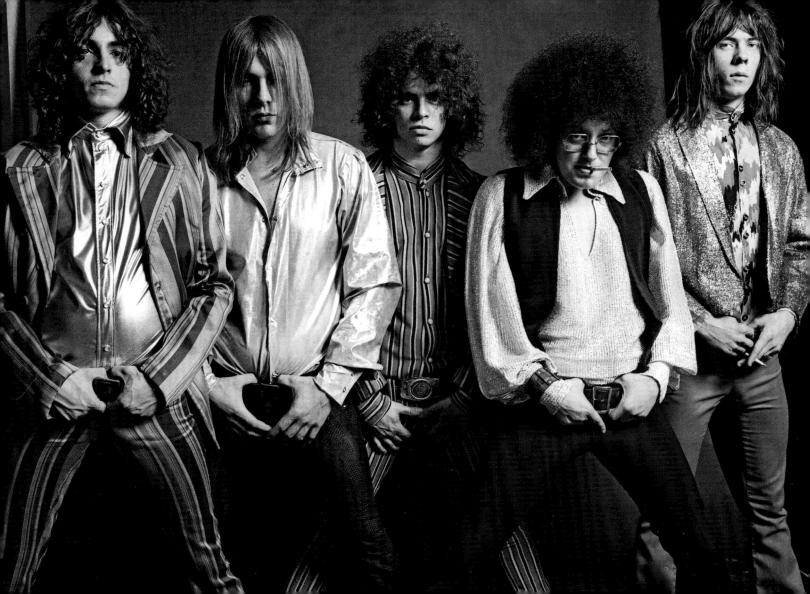

MC5 live, 1969 photograph by Robert Matheu

The all-day Detroit Pop Festival at the massive Olympia Arena (on April 7) featured, in addition to the Five, such hometown heroes as Ted Nugent and Bob Seger. Not the most unlikely bill, considering the MC5 once played a show in Boston with the Velvet Underground—equally as influential but the polar opposite stylistically. As guitaris Wayne Kramer pointed out about the Boston Tea Party bill (in December 1968 "There seemed to be two different kinds of energy, because everything the Velvets did was more sinister and blue green, whereas our thing was just blast, blast, blast, real loud."

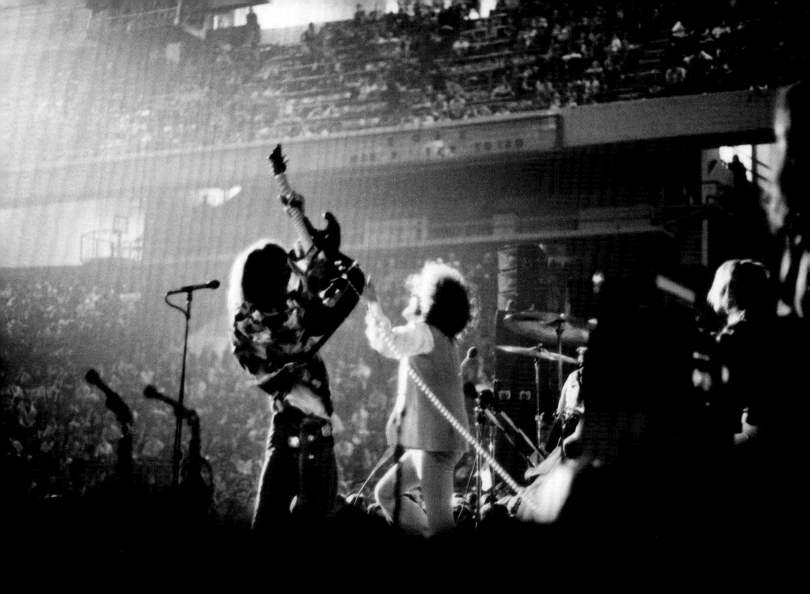

MC5 guitarist Wayne Kramer, 1969 photograph by Chuck Krall

A week after Woodstock, the MC5 played a different kind of "festival"—a decibel festival—at the site of the 1964 World's Fair in Flushing Meadows, Queens, when the band opened for the Stooges. The noise fest was the best rock show that veteran photographer Chuck Krall says he has ever experienced. MC5's Wayne Kramer, seen here onstage, once proffered ten tips for electric guitar players, as follows:

1 Plug the thing in. I'm no technical wiz, but I've noticed that electric things always work better plugged in.
2 Wash your hands. You play better with clean hands.
3 If you have to sing and play guitar, practice by yourself before you do it at band practice; you don't want to bring down the rest of the band by making them watch you learn how to walk and chew gum at the same time.
4 Always wear your coolest clothes onstage. It's better to look good than feel good.
5 Work on developing your own sound.
6 Learn music—not guitar.
7 Write songs (with words!).
8 Watch other guitarists' hands—and feet.
9 Breathe—don't hold your breath.
10 When smashing the guitar, keep a smile on your lips and a song in your heart.

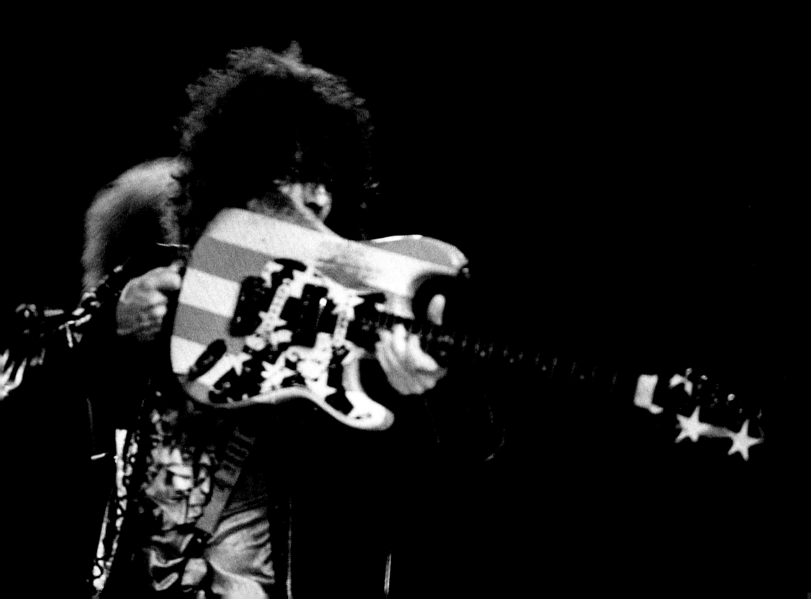

Captain Beefheart, 1975 photograph by Chuck Krall

Auteur Don Van Vliet, better known as Captain Beefheart, began recording his twisted mix of Delta blues, jazz, and avant-garde in the mid-1960s. Though label executives didn't know what to do with his irregular rhythms, grating harmonies, and surreal lyrics, Beefheart found a champion in Frank Zappa, who invited him to play on his recordings and also released Van Vliet's Magic Band on his Straight label. Beefheart's 1969 opus, *Trout Mask Replica,* became a signpost of a new aggressive sound that would develop in London, New York, and Los Angeles. Here, Captain Beefheart plays a soprano sax onstage at San Francisco's Winterland two days after Christmas.

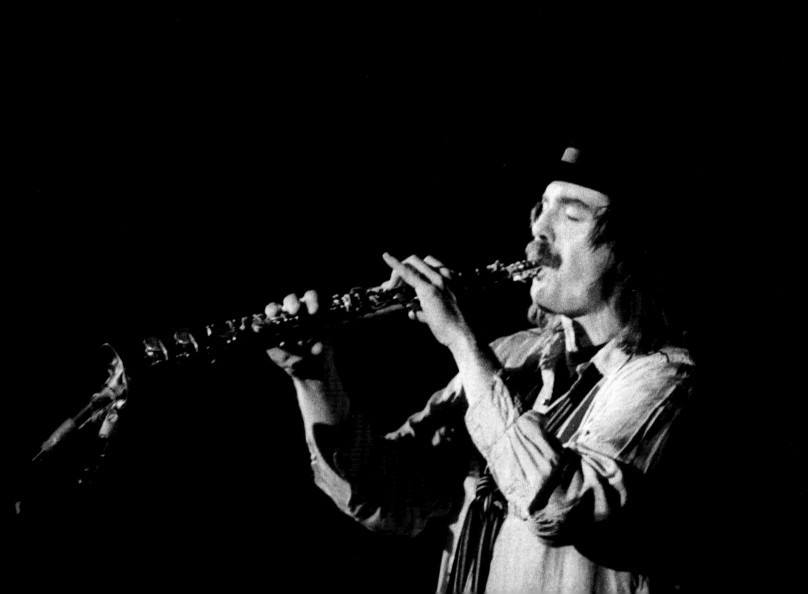

Captain Beefheart, 1977 photograph by Jill Furmanovsky

Captain Beefheart found a new audience among punk fans, who fully appreciated his abrasive sound and enigmatic personality. He had just appeared before a throng of Brits when Jill Furmanovsky photographed him at the Hotel London in November 1977. Beefheart began the next decade with his seventh or eighth—and final—incarnation of the Magic Band. After the release of the acclaimed 1980 LP *Doc at the Radar Station,* he toured America and Europe. Two years later, in 1982, he followed up with *Ice Cream for Crow,* then retreated to a trailer in the Mojave Desert, where he has remained for the past twenty-five years.

OIO

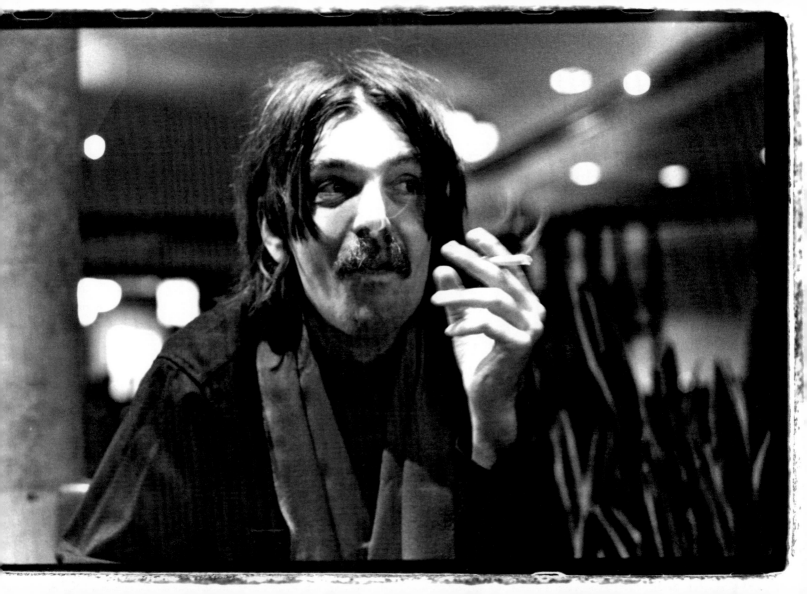

New York Dolls, 1973 photograph by Bob Gruen

Bassist Arthur "Killer" Kane, guitarist Sylvain Sylvain, vocalist David Johansen, drummer Jerry Nolan, and guitarist Johnny Thunders (from left) constituted the most notorious Big Apple combo since ... the Velvets—or maybe forever. Naming themselves the New York Dolls, the band formed in late 1971, playing amped-up '60s R&B and girl-group rock & roll with street-style lyrics and a dress code that made Mick Jagger look like a wallflower.

They lost their original drummer, Billy Murcia, to a drug overdose during their first "junket" to London, but managed to bounce back with Nolan on sticks. After the band's debut gig in March 1972 at the seedy Diplomat Hotel, they became fixtures downtown at the Mercer Arts Center, then Max's Kansas City. Here, dressed down, they took the stage at Manhattan nightspot Kenny's Castaways.

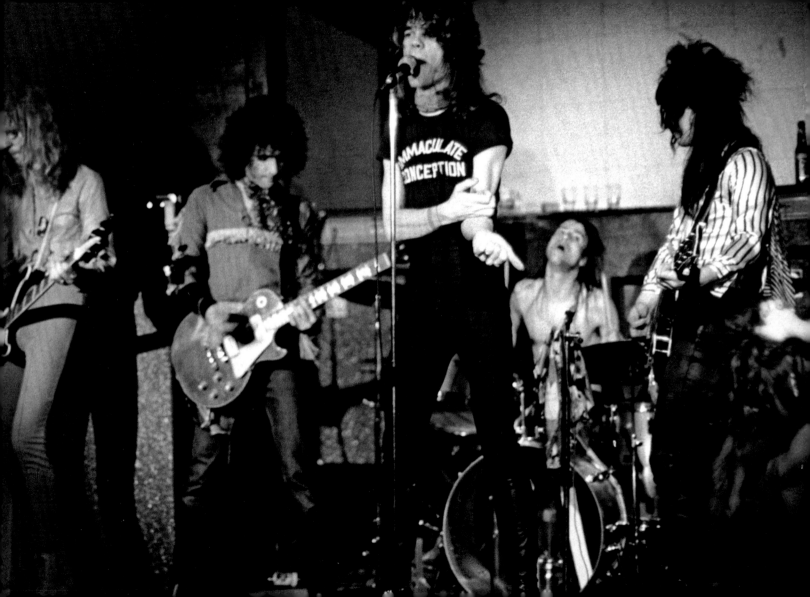

David Johansen and Johnny Thunders, 1973 photograph by Bob Gruen

The Mick Jagger and Keith Richards of the Lower East Side, Staten Island–born David Johansen and Brooklyn-born John Anthony Genzale were more gutter than Glimmer Twins, more "Trash" than "Satisfaction." With frequent gigs at Max's Kansas City (as seen here), the Dolls soon built up a rabid local following, as described by Johansen:

"You'll see younger kids at the Dolls gigs in New York than at any other. Of course, they're sophisticated, hip little New York kids—not the kids who come in from Long Island to see the Osmonds. [They're] the kind who try and sneak out at night to hang out in Max's back room, wear what their parents feel is obscene clothing, and have nasty thoughts."

012

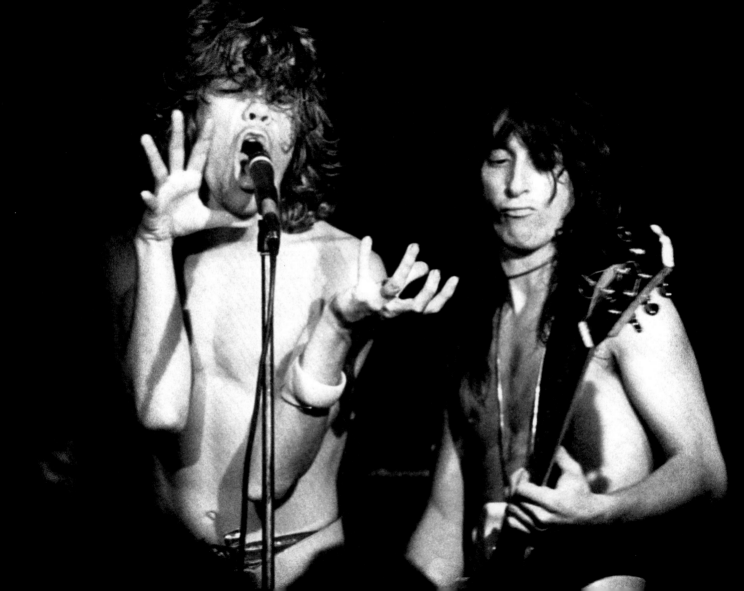

Jayne/Wayne County, 1974 photograph by Bob Gruen

Georgia-born Wayne Rogers became punk's first transsexual star. In the early '70s, Wayne County—who eventually became Jayne—spun discs at Max's. He/she then formed Wayne County and the Electric Chairs, later changing the band's name to the Back Street Boys, which featured future Tuff Darts guitarist Jeff Salen and drummer Marc Bell, who would later play in the Voidoids and the Ramones. Here, County performs at Club 82, a basement nightery on East Fourth Street and Second Avenue, which frequently hosted the New York Dolls. In the late '70s, County moved to London and took on a new persona—Queen Elizabeth. "I am what I am / I don't give a damn / Are you man enough to be a woman?" the performer later sang in the number "Transgender Rock 'n' Roll."

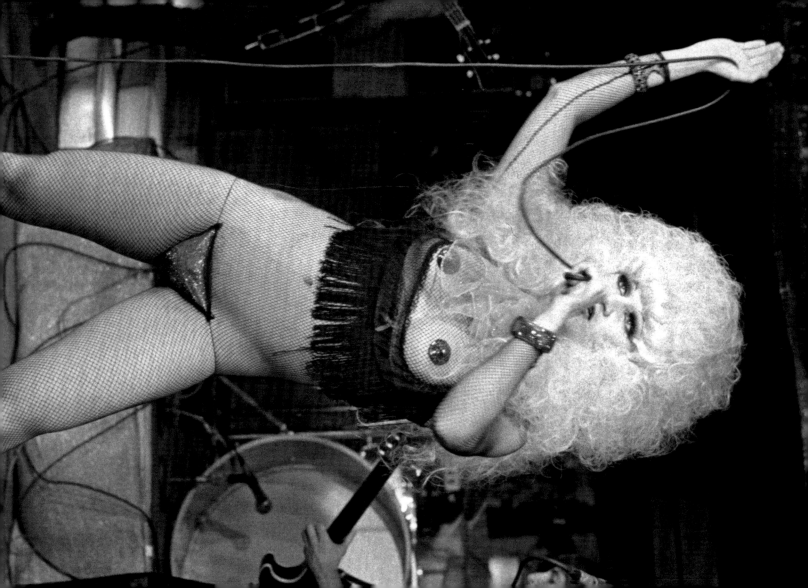

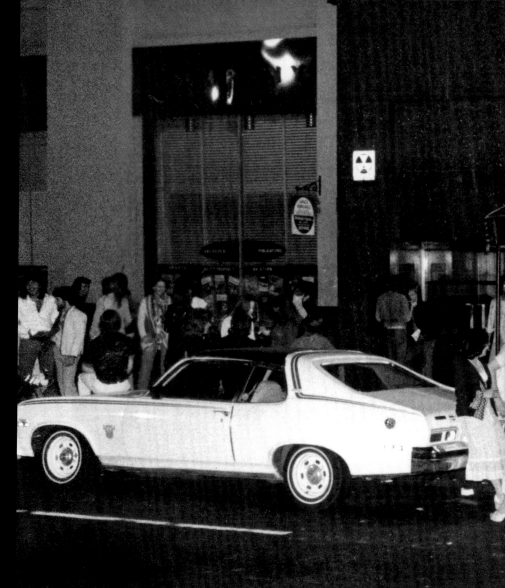

Max's Kansas City, 1977 photograph by Bob Gruen

In the 1960s, Andy Warhol and Bob Dylan rubbed shoulders in the back room at Max's Kansas City, located on Park Avenue South at Seventeenth Street. A friend of the arts, owner Mickey Ruskin bartered steak dinners for artwork. In the early '70s, the Dolls and others took over the second-floor stage, where the Velvets had played one of their last gigs. In 1975 Ruskin relinquished the club to Tommy Dean, and soon it became a spot where glam met punk and new bands flocked to perform.

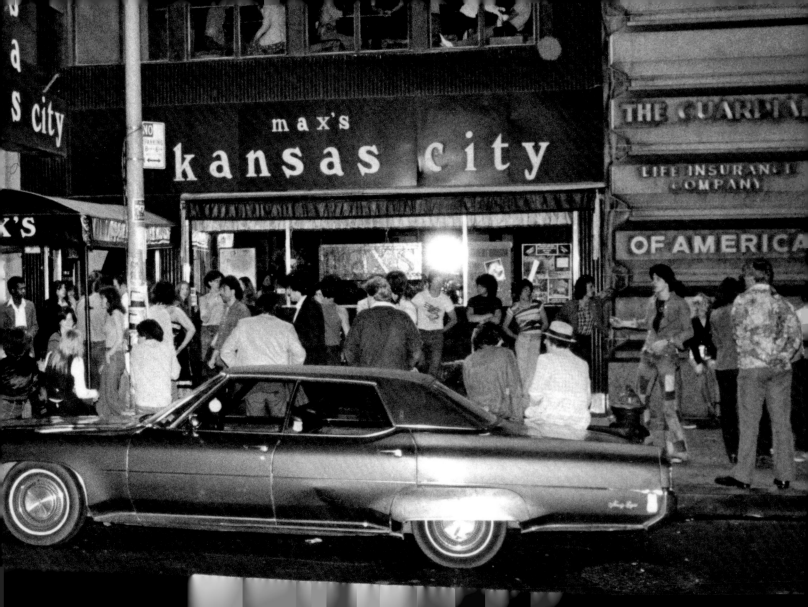

Lou Reed and friend, 1974 photograph by Bob Gruen

After Lou Reed quit the Velvet Underground in 1970, he dropped out of sight for a while before resurfacing in London, where the glam scene had taken hold. Led by the melodic rock and space-age lyrics of Ziggy Stardust (aka David Bowie) and the Spiders from Mars (featuring guitarist Mick Ronson), the glitterati embraced Reed. Albeit with his New York decadence intact, he reinvented himself and hit the Top Ten with the Bowie-produced "Walk on the Wild Side," a coy chronicle of the Factory crowd's exploits. He returned to New York a pop star, with a new hairstyle and black polished fingernails—the first of many guises he'd adopt over the next few years. On this evening, Reed soaked in the sounds on the opening night of New York cabaret the Bottom Line, where Dr. John "the Night Tripper" dazzled the audience.

Back room at Max's, 1973 photographs by Danny Fields

The crème de la crème turned out to catch the Stooges at Max's. Iggy's 1971 performance at the Electric Circus had found the front man painted with silver glitter and barfing on the audience—what would he do next? Contained in these contact sheets is an effective who's who of hip, circa 1973. Among those watching Iggy work the room (and pose for pictures with bandmates Scott Asheton and James Williamson) are Larissa, Johnny Thunders, Cherry Vanilla, Lenny Kaye, Lou Reed, Lillian Roxon, and Jackie Curtis. Danny Fields later quipped, "The stars mixed and mingled with the back room crowd as graciously as if they were hanging out with ordinary people."

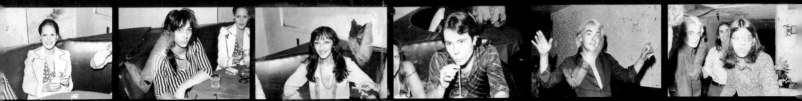
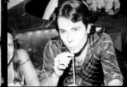
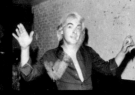
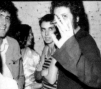

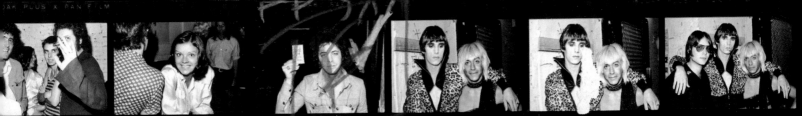

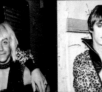
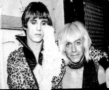
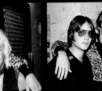
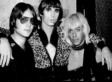
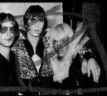

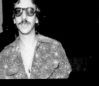
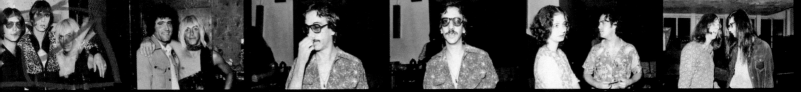

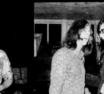

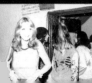
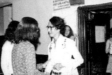
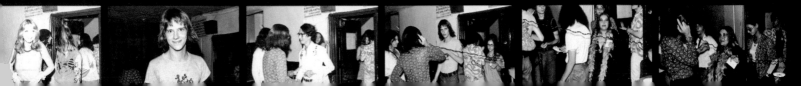
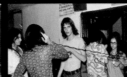

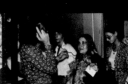

Iggy Pop and Lou Reed, 1973 photograph by Danny Fields

Though the Stooges broke up after their second album, the recently platinum-tressed Iggy had joined forces with ace guitarist James Williamson, and the twosome made their own trek to glam-struck London. There, as Iggy and the Stooges, they recorded the incendiary *Raw Power* and played one UK gig of which was written, "The total effect was more frightening than all the Alice Coopers and *Clockwork Orange*s put together, simply because these guys weren't joking." The album's tour de force, "Search and Destroy," said it all: "I'm the world's forgotten boy / the one who searches and destroys." The Stooges Mach 2 barreled into New York in time for the LP's May 1973 release date. Here, Lou gives his blessing to the Igster over champagne, chickpeas, and coffee, pre-showtime.

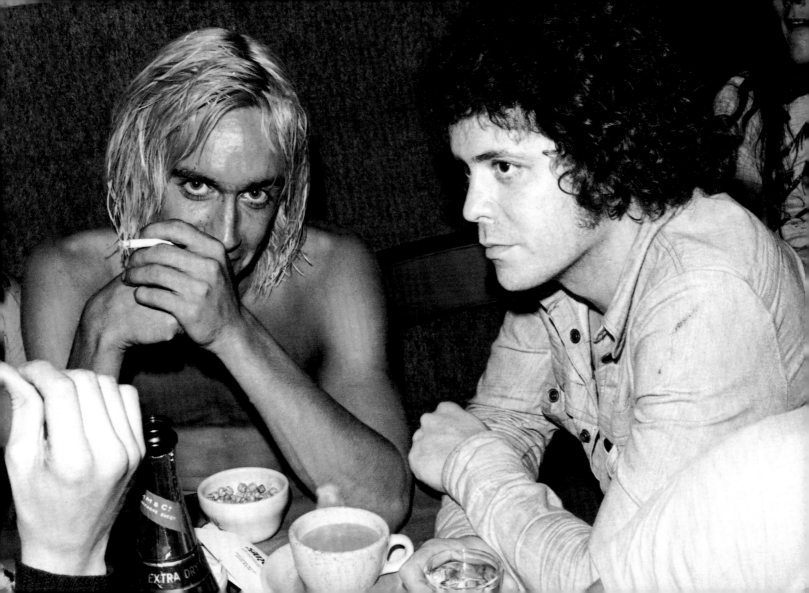

Iggy and the Stooges at Max's, 1973 photograph by Danny Fields

Tastemaker and Elektra Records' "company freak" Danny Fields, who had secured deals for the Stooges and MC5—from which both bands were eventually dropped—had courageously taken on managerial duties for the Stooges in 1973. The avid shutterbug documented their set at Max's; seen here are the hand of Ron Asheton (former Stooges guitarist, now on bass), drummer Scott Asheton, Iggy, and guitarist James Williamson (from left). Touring to support *Raw Power,* Iggy and company left devastated audiences in their wake. As Stooges historian Jim Marshall puts it, "The trek, which Iggy called 'my blows against the empire tour,' wowed 'em at Max's Kansas City (where Iggy belly-flopped onto a broken bottle) . . . The tour's sets found the *Raw Power* material augmented by newer numbers like 'Open Up and Bleed,' 'Head on the Curb,' 'Cock in My Pocket,' and 'Wet My Bed.' In retrospect, Iggy must have been delusional to think that the teens of 1973 would want to hear such ditties." Miraculously, the Stooges would reunite in the twenty-first century and release a new album in 2007.

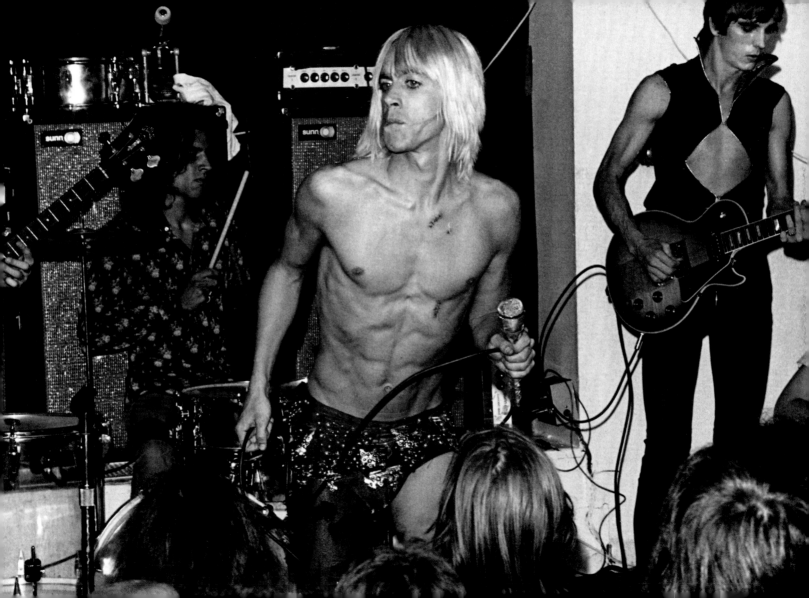

Modern Lovers, 1972 photograph by Danny Fields

Characterized by the astute yet childlike observations of baritone Jonathan Richman (center), the Modern Lovers formed in Boston in 1972. Richman, a fierce Velvet Underground fan who attended the band's Boston gigs, wrote quirky little rock songs with lyrics like "nobody ever called Pablo Picasso an asshole." The original band included keyboardist Jerry Harrison, who would join the Talking Heads, bassist Ernie Brooks, and drummer Dave Robinson, a future member of the Cars. Championed by Danny Fields, the band cut some demos for Warner Bros., but no album was released. In the meantime, Richman began to tire of loud music and had his musicians turn way down, eventually requesting that Robinson play a sole snare covered with a towel. Robinson decided to move on. Just in time for punk, the original '72 sessions were finally released on *Modern Lovers* in '76 by indie label Beserkley. Talking Head David Byrne later said of the Modern Lovers, "Obviously, they were an influence. We hired one of them. They were doing really spare, barebones stuff that spoke in a rock vocabulary but was very honest."

Patti Smith, David Johansen, Cyrinda Foxe, Lenny Kaye, 1975

photograph by Danny Fields

The event: a free concert celebrating the end of the Vietnam War, in Central Park, May 1975. Among the performers: Patti Smith, who began doing her spoken-word poetry backed by guitarist Lenny Kaye at St. Mark's Church on February 10, 1971. The Patti Smith Group, composed of Kaye, pianist Richard Sohl, guitarist Ivan Kral, and drummer Jay Dee Daugherty, would evolve over the next few years, playing to increasing downtown crowds at Max's, then CBGB. Of this uptown performance, Danny Fields reported in his *Soho Weekly News* column, "Most of the audience in Central Park on Sunday had never heard—nor heard of—Patti Smith before, but when she finished two songs, she got a rousing ovation from the vast crowd. It was a revelation, too, for those of us who have only heard Patti perform in relatively tiny rooms. All great rock acts, for some reason, ultimately sound their best out of doors in broad daylight." Bearing witness, former New York Doll David Johansen and his paramour Cyrinda Foxe. In the fall, Smith would record her debut album, the seminal *Horses,* with John Cale as producer.

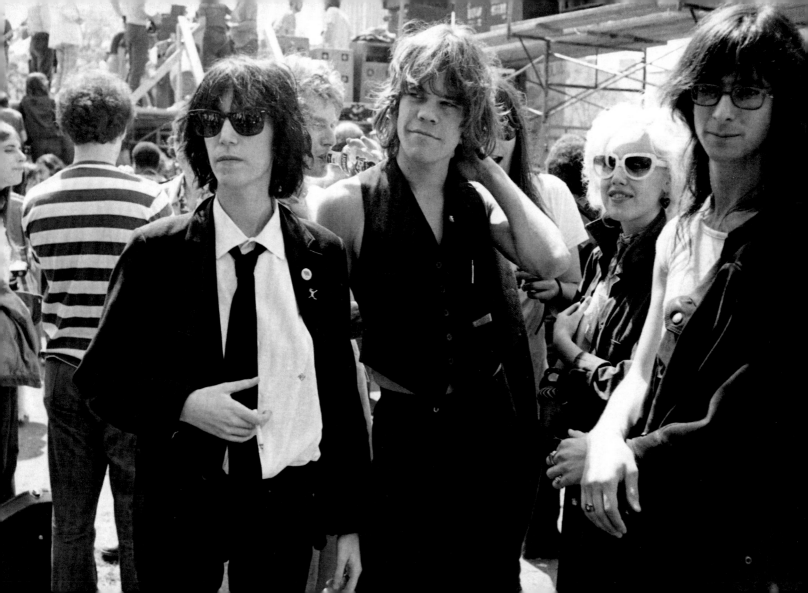

Patti Smith and Bob Dylan, 1975 photograph by Danny Fields

Another high-profile outing for Patti Smith came in July at the revered folk club the Other End. After her riveting performance, her idol, Bob Dylan, came backstage, and the two met for the first time. Painter and musician Bobby Neuwirth, a longtime pal of Dylan's, first encouraged Smith to perform her poetry to an audience: "You walk like a poet," he told her in 1971, when the two met at the Chelsea Hotel (where she was living with Robert Mapplethorpe). Her spoken word gradually transitioned into singing, but her "linguistics," as she called them, were always primary. "She can generate more intensity with a single movement of one hand than most rock performers can produce in an entire set," wrote UK critic Charles Shaar Murray after one incendiar show. "She stands there machine gunning out her lines, singing a bit and talking a bit, in total control, riding it and steering it with a twist of the shoulder here, a flick of the wrist there—scaled-down birdlike movements that carry an almost unbelievable degree of power."

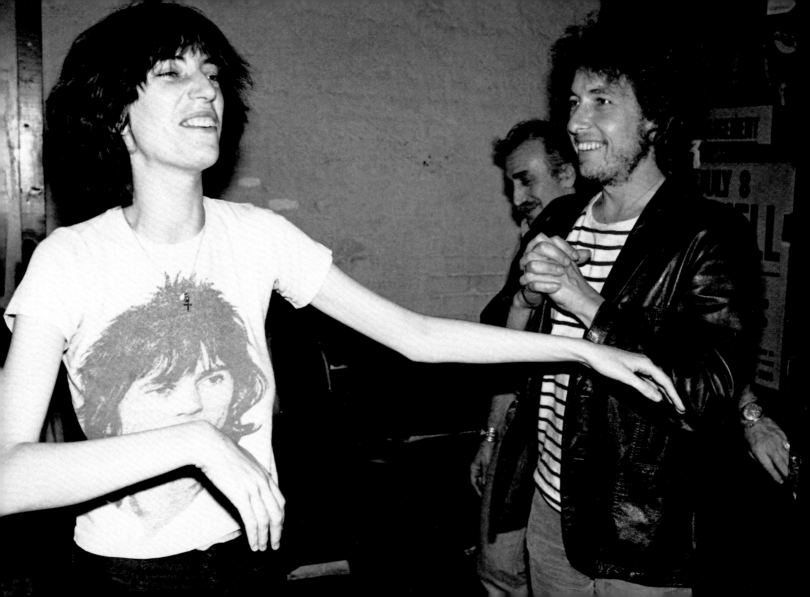

Jonathan Richman, 1972 photograph by Danny Fields

"The main thing you get from Jonathan Richman is to be loose, be yourself. It's really enjoyable to watch someone who doesn't have any problem with being onstage. The honesty and sincerity of what he is doing is undeniable. He's really a genius."

—Jeff Tweedy, Wilco

The Stillettos, 1974 photograph by Bob Gruen

Elda Stilletto (b. Gentile) recruited Debbie Harry and Rosie Ross to form the campy singing-dancing Stillettos in 1973. The following year they drafted School of Visual Arts student Chris Stein on guitar and bassist Fred Smith. "It was more fun than music," Smith later remembered. "The Stillettos ... were probably more into presentation than music, but the girls wrote a few good songs." By the summer's end, though, the band—minus former leader Elda and Amanda Jones, the gal who'd replaced Rosie—had segued into a new outfit. Led by Harry and Stein, they were originally known as Angel and the Snakes—before settling on Blondie. Here, the Stillettos open for the New York Dolls at the midtown Manhattan club Blue Angel: Chris Stein, Debbie Harry, Elda Stilletto, Amanda Jones, Fred Smith (from left). Elda re-formed the Stillettos in the late '70s, employing punk musicians like Cheetah Chrome of the Dead Boys and Heartbreakers Walter Lure and Billy Rath

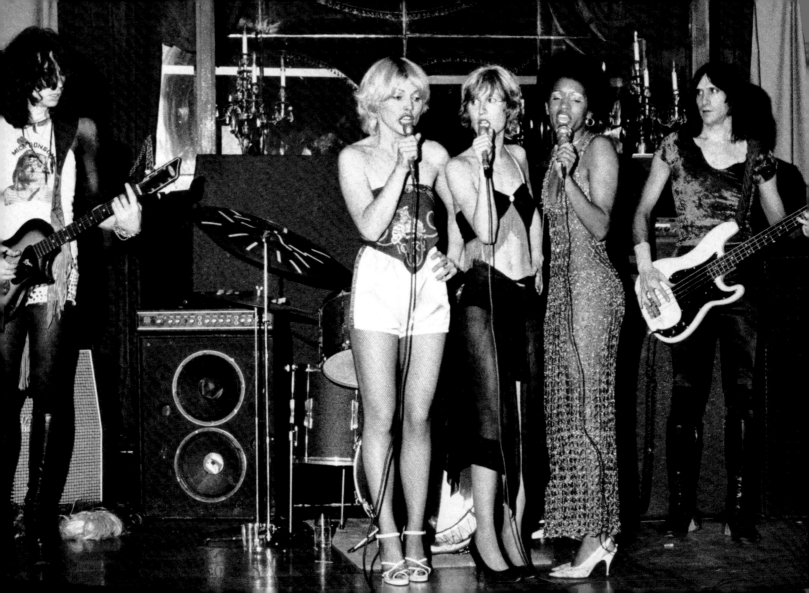

Max's Kansas City Christmas party, 1975 photograph by Bob Gruen

New Max's owners Tommy and Laura Dean, and Peter Crowley, who booked the acts, invited the regular coterie of performers and scenesters for a festive Yuletide soiree, "Maxmas," if you will. The gathering was photographed by "resident" photographer Bob Gruen, who, in addition to shooting the proliferating punk shows at the club, had recorded video footage of performances there by the Dolls and Patti Smith. Among the artists seen here are Jayne County, the Ramones, Richard Hell, party gal Sable Starr, Sylvain Sylvain, and members of Mink Deville, the Fast, the Miamis, the Planets, and Tuff Darts. "There was an open bar and awful finger food, and a surprising amount of band guys turned up recalls Planets guitarist Binky Philips. "My most vivid memory of the night, though, is looking around while the party was in fu swing and thinking, 'Maybe those *Village Voice* rock critics are right—maybe this Max's / CBGB thing really is becoming a scene, a movement'—then smugly thinking, 'God, we're all gonna make it!'"

024

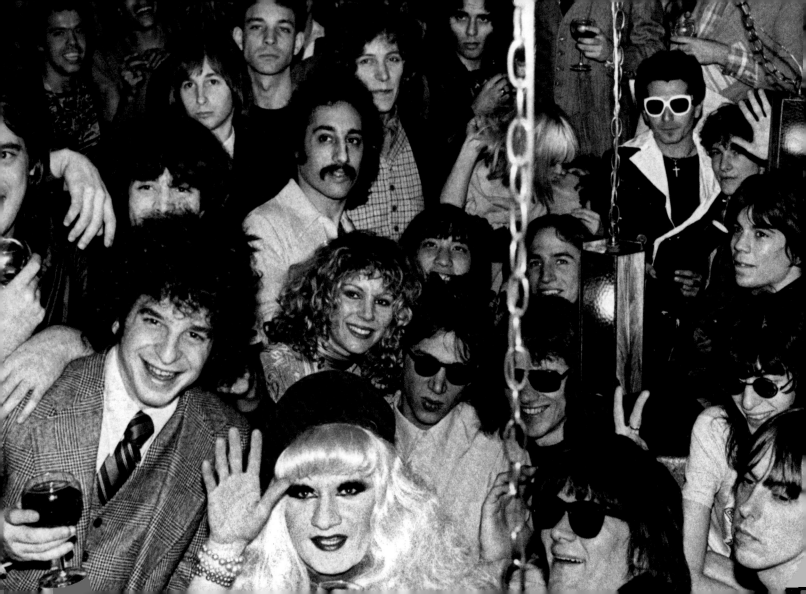

Television, 1974 photograph by Bob Gruen

Richard Hell, Billy Ficca, Richard Lloyd, and Tom Verlaine (from left), as Television, turned a run-of-the-mill Bowery dive into ground zero for what CBGB owner Hilly Kristal called "street music." Beginning with successive Sunday nights in 1974—Television's original residency—CBGB began its crawl toward immortality. Evolving from an earlier outfit called the Neon Boys, Hell, Ficca, and Verlaine enlisted pretty boy Lloyd as second guitarist (after future Blondie cofounder Chris Stein and Ramone-to-be Dee Dee flunked their auditions). Hell humbly recalled, "We were these notch-thin, homeless hoodlums, playing really powerful, passionate, aggressive music that was also lyrical. I think we were the best band in the world that year—well, for the first four or five months."

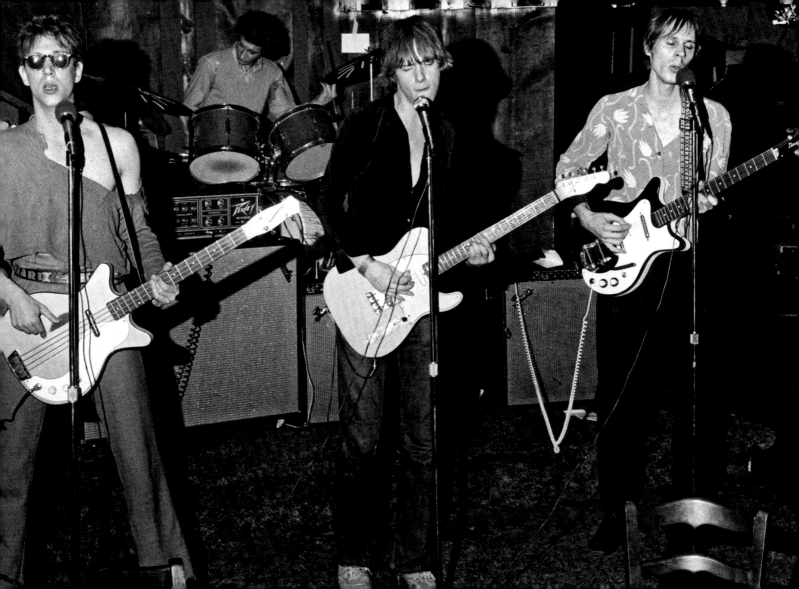

EAST COAST USA

The Ramones, 1975 photograph by Bob Gruen

Enter the Ramones: Debuting in March 1974, bassist Dee Dee (b. Douglas Colvin), drummer Tommy (b. Tom Erdelyi), vocalist Joey (b. Jeffrey Hyman), and guitarist Johnny (b. John Cummings) (from left) revolutionized three-chord rock. By the time of this CBGB show, the Ramones had honed their loud, fast chops at the club since it opened in 1974. Danny Fields, who would become their manager, began touting them in his *Soho Weekly News* column—"five songs in thirteen power-packed minutes, a record even for them!"—and Lou Reed showed up at one gig with a portable Sony tape recorder to document the event. All from the same Forest Hills, Queens, neighborhood, the band started as a trio with Joey on drums and Dee Dee singing lead. After their first gig at Erdelyi's Performance Studio on East Twentieth Street, not far from Max's, Tommy joined on drums, freeing Joey up for the front man spot.

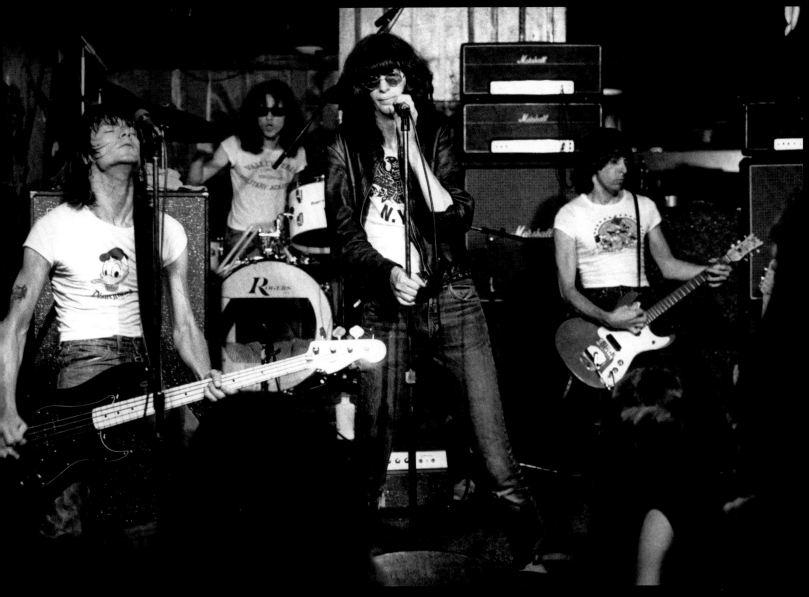

Television, 1974 photograph by Jay Craven

For his post–Neon Boys combo, Richard Hell devised the name Television—with the Big Picture in mind as well. "One thing I wanted to bring back to rock & roll," Hell later recalled, "was the knowledge that you invent yourself. That's why I changed my name, why I did all the clothing style things, haircut, everything ... The idea of inventing yourself is creating the most ideal image you could imagine ... That's the ultimate message: if you just amass the courage that is necessary, you can completely invent yourself." Here, then, photographed in mentor Terry Ork's Chinatown loft—where Lloyd lived and Television rehearsed—are Tom Miller reinvented as Tom Verlaine; Richard Lloyd as a platinum blond; Richard Meyers as Richard Hell; and Billy Ficca (from left) with the band's namesake. "Television just seemed to fit that bill cause it's something that's in every home in America," Lloyd late said. "It's so obtrusive, it's unobtrusive."

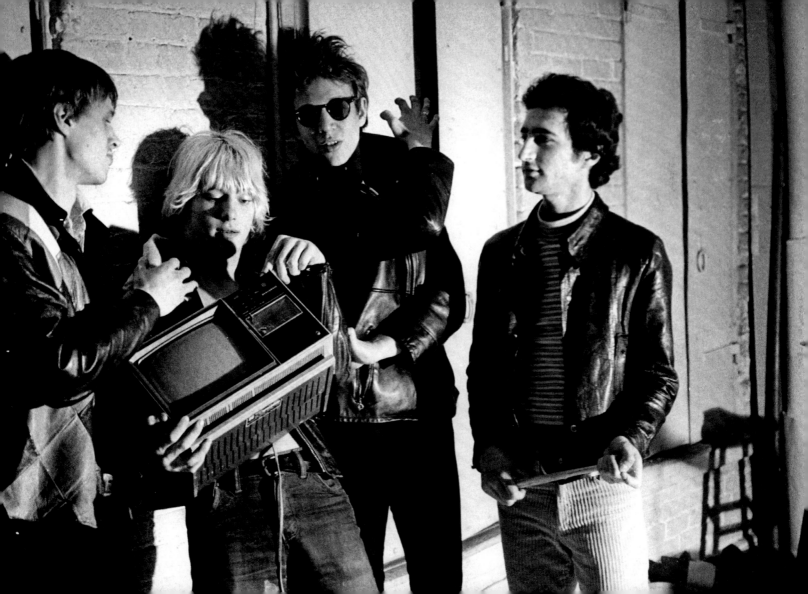

The Heartbreakers, 1975 photograph by Bob Gruen

After butting heads with Tom Verlaine for a year, Richard Hell quit Television in April. He was immediately invited by former members of the New York Dolls, who'd just broken up, to form a new band. Drummer Jerry Nolan (still donning his Dolls high heels), guitarist/vocalist Johnny Thunders, and Hell, who wrote and sang the majority of the band's songs, constituted punk's first supergroup. In this, the Heartbreakers' initial photo shoot with Dolls documentarian Bob Gruen, Thunders, Hell, and Nolan (from left) peruse their downtown kingdom—from a fire escape outside the Dolls' rehearsal space on West Twenty-third Street.

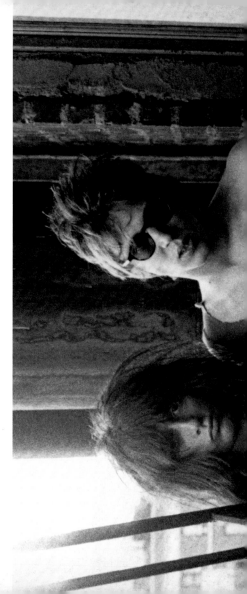

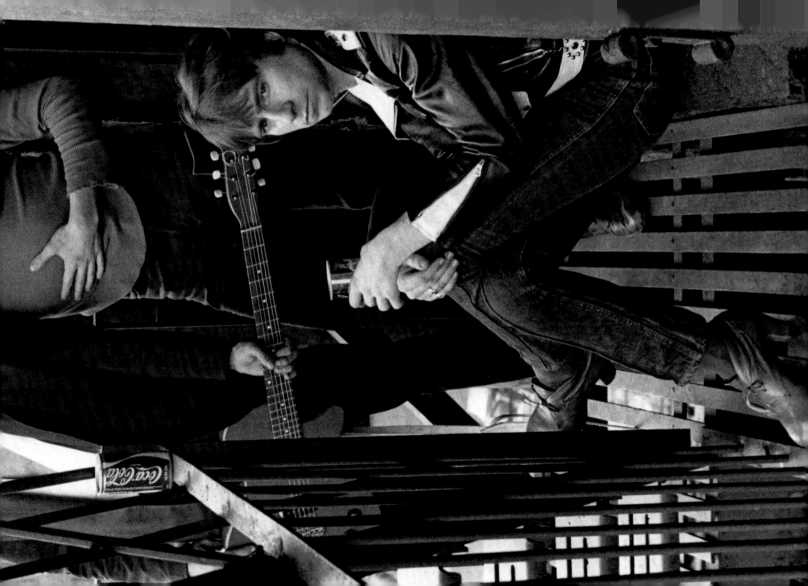

The Heartbreakers, 1975 photograph by Roberta Bayley

To beef up the guitar sound, the Heartbreakers brought Walter Lure (second from right) into the band. For this photo session—Roberta Bayley's first—Richard Hell (second from left) cooked up the idea of donning blood-stained shirts, which were executed using Hershey's chocolate syrup. Horribly, the notion seemed a prescient one when, in October, Jerry Nolan was attacked on the street and stabbed by a deranged assailant (fifteen years later he would play a gunshot victim in the underground film *What About Me,* which also featured Hell). The photo was an illustration for the slogan Hell had conceived to advertise a Heartbreakers gig: CATCH THEM WHILE THEY'RE STILL ALIVE.

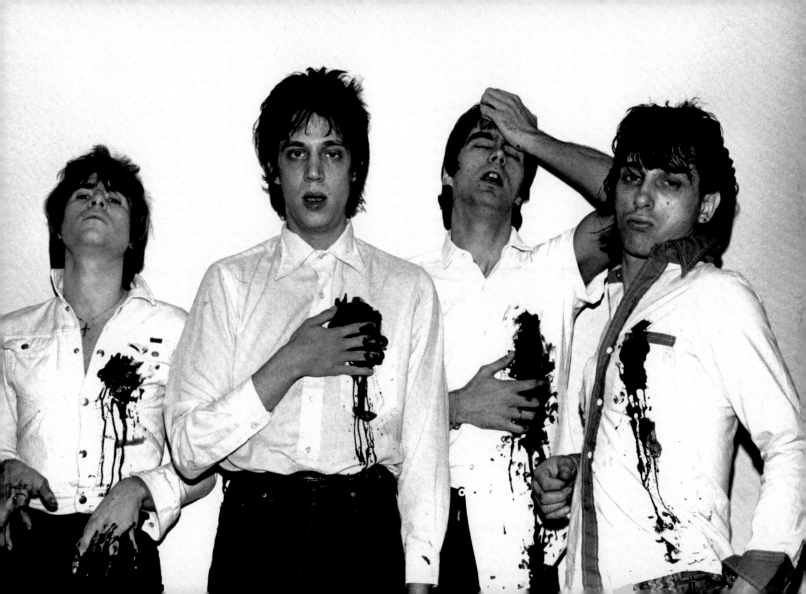

Max's Kansas City, 1977 photograph by Bob Gruen

A competition over bookings developed between Max's Kansas City and CBGB; some bands were encouraged by management to choose between the two venues, though most acts tried to play both. Each club released an album documenting its regular bands. In this photo, which graced the cover of *Live at Max's Kansas City,* such featured artists as Cherry Vanilla, Wayne County and the Electric Chairs, and the Fast gather in front of the nightspot. Former Max's habitué Danny Fields, for one, was not pleased with the club's being newly inundated with bridge-and-tunnel types: "To me, Max's Kansas City was always the downstairs back room. The really fun period ended as soon as they started bringing the bands in, because it brought in a lot of riffraff. Max's had been an exclusive downstairs enclave and only people who knew about it knew about it. As soon as there were lines in the street waiting to see the bands upstairs, it was the end of Max's."

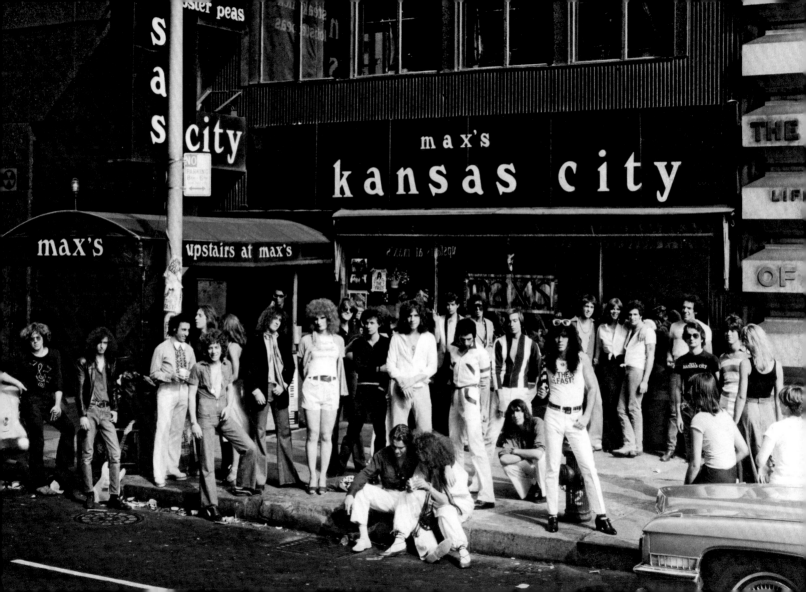

Talking Heads, 1976 photograph by Roberta Bayley

Rhode Island School of Design students seemed unlikely candidates to share numerous CBGB bills with the Ramones: But drummer Chris Frantz and guitarist / vocalist David Byrne, along with bassist Tina Weymouth, did exactly that. While attending RISD, Frantz and Byrne met Weymouth in 1970 and the trio collaborated on the song "Psycho Killer." After relocating to New York four years later, they formed Talking Heads. "[I] walked into CBGB one night and the Ramones were playing, and I realized, 'That's it!'" Frantz later recalled. "They really appealed to me. I liked black music as well as the Stooges and the Velvet Underground—fairly extreme white rock & roll, and the Ramones were *extremely* extreme." Shortly thereafter, the "ever-intriguing" Talking Heads (as described b Danny Fields in a 1975 blurb) opened for the Ramones and soon became onstage regulars. A woman on bass was unusual, as were Byrne's deer-in-headlights stage presence and unique halting vocals. Bayley took this shot while the group was being filmed for a local television show or the scary new music called punk rock.

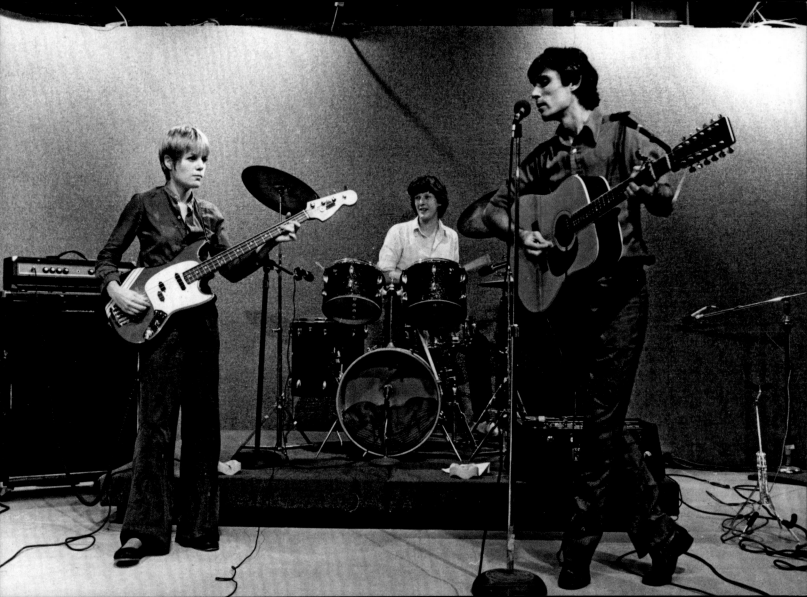

CBGB, 1975 photograph by Bob Gruen

Here, on this summer evening in 1975, some of punk's key players hang out. The watering hole, located at 315 Bowery, near the corner of Bleecker Street, had previously been a wino bar, and the Sunshine Hotel, a flophouse, was located next door. Sometimes the punks and derelicts commingled. Near the parked car are Johnny Ramone; Arturo Vega, the artist who designed the CBGB logo and also devised much of the Ramones' symbology; Tommy Ramone; and "fifth Ramone" Monte Melnick (in T-shirt), Tommy Ramone's partner at the Performance Space studio, who worked as the band's road manager for decades (from left).

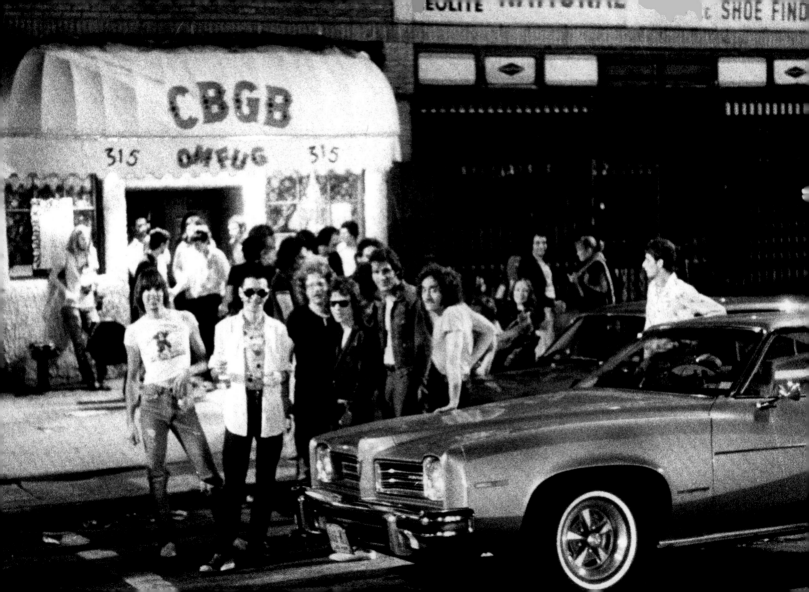

Television, 1977 photograph by Godlis

By 1977, Television—Richard Lloyd, Fred Smith (who had defected from Blondie), Tom Verlaine, and Billy Ficca (from left)—were considered by pundits to be the next big thing. In the fall of '75, the band had released its first single, the seven-minute, two-sided "Little Johnny Jewel," and broke attendance records at a packed CBGB. Verlaine and Patti Smith became an item for a while, and the band frequently gigged with the PSG. Finally, in 1977, Television released *Marquee Moon,* its long-awaited debut album, on Elektra (former label of the Stooges and the MC5).

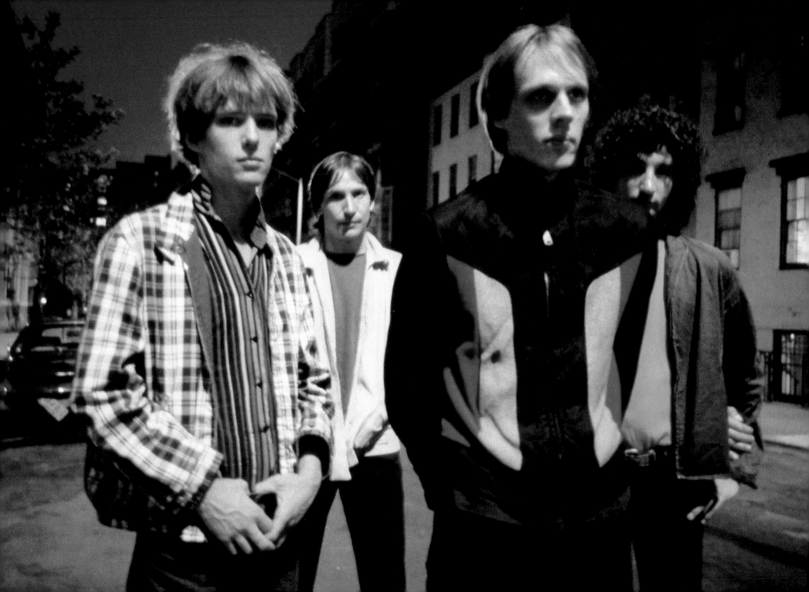

The Dead Boys, 1976 photograph by Roberta Bayley

When the Ramones played Youngstown, Ohio, in 1976, they got more than just another gig—they found a new pal in charismatic reprobate Stiv Bators, in the process of putting together the Stooges-inspired Dead Boys. In July, the Cleveland band played CBGB, thanks to Joey's recommendation to club owner Hilly Kristal; "I said to Hilly, 'This band are amazing!' and I hadn't seen them yet," Joey later recalled. "But I had a feeling they'd be good." Roberta Bayley took this shot of guitarist Cheetah Chrome, guitarist Jimmy Zero, vocalist Stiv Bators, and drummer Johnny Blitz (from left) the day of their first New York gig. John Holmstrom and Legs McNeil had plastered the East Village with handbills (seen above Stiv's head) trumpeting the arrival of their new music and comics zine. (When Debbie Harry saw the ubiquitous posters, she thought, "Here comes another shitty group with an even shittier name.")

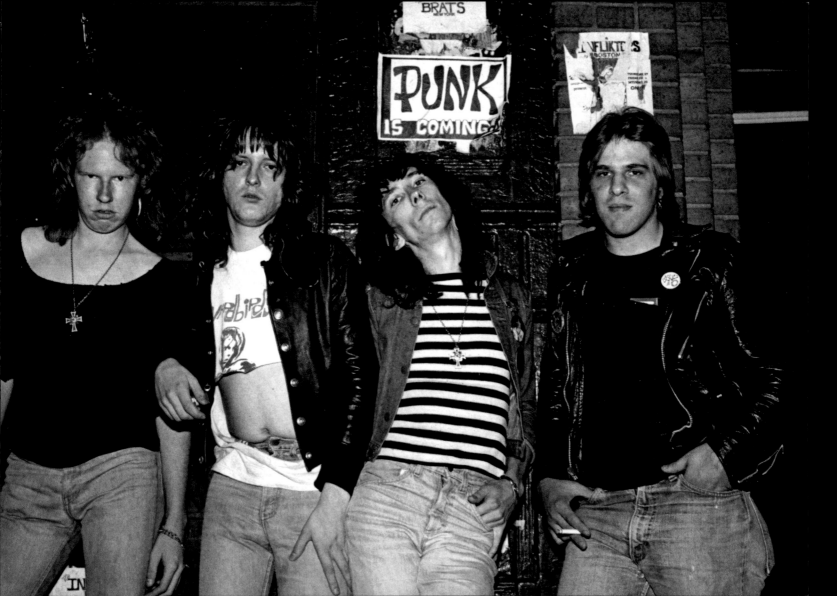

David Johansen and Tuff Darts Jeff Salen and Robert Gordon, 1976

photograph by Bob Gruen

Former New York Dolls front man David Johansen (left), on his way to becoming a solo artist, an actor, and a chameleonic band leader, here perches on the guitar case of Jeff Salen (center), hotshot lead guitarist for the Tuff Darts. Lumped in with the punk scene, the Tuff Darts were a bit more traditionally rockist, though their charismatic lead singer Robert Gordon (right) could grab audiences by the throat. When the band was offered a record deal by Sire Records, Gordon squabbled over terms and left the group. Though the band replaced him, they missed the target once Gordon flew the coop, and became best known for their song "(Your Love Is Like) Nuclear Waste" on their sole LP. The car, a 1954 Buick Special, became a legend in itself. Baby blue with a white top, "it floated over the streets like a cloud," remembers its owner, photographer Bob Gruen, who shot several bands posing next to it.

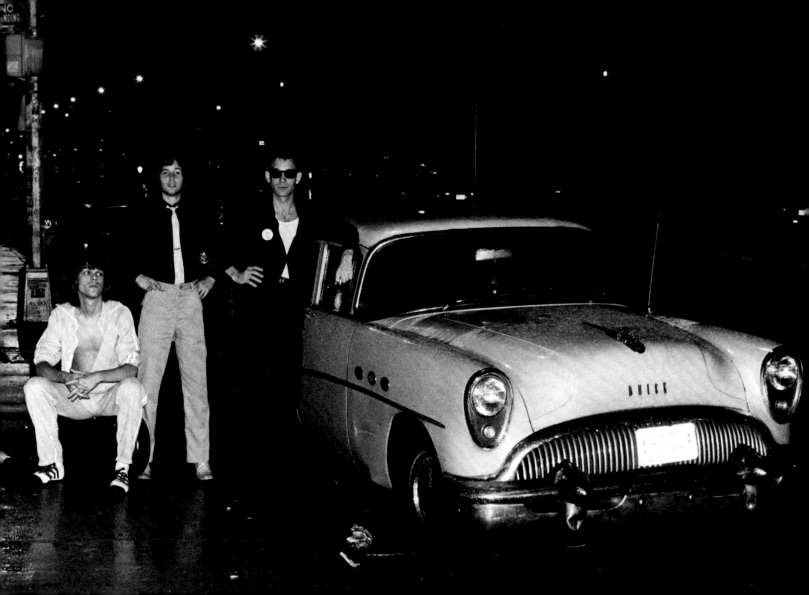

Debbie Harry and Chris Stein, 1976

photograph by Roberta Bayley

Numerous personnel shifts occurred in Blondie after Harry and Stein started the band in late 1975. The bassist Fred Smith left to join Television, the drummer quit to go to law school, and the rhythm guitarist Ivan Kral defected for the PSG. Finally, by 1976, the band comprised Clem Burke on drums, Gary Valentine on bass, and Jimmy Destri on keyboards, along with Stein on guitar; this combo recorded the first Blondie album, featuring the single "X Offender." Harry's sex-kitten-meets-B-girl-meets-op-art style and platinum do influenced countless wannabe punkettes. On this night at CBGB, she was sporting her Jean-Paul Belmondo–style Ray-Bans. Thanks to Harry and Richard Hell, shades became de rigueur after dark.

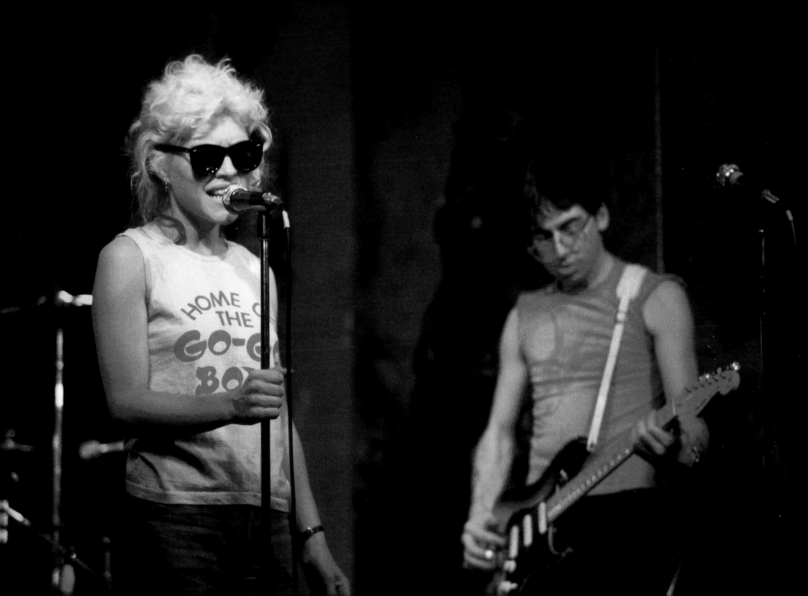

Suicide, ca. 1978 photograph by Stephanie Chernikowski

Long before Soft Cell or the Pet Shop Boys, there was an ominous twosome composed of Alan Vega and Marty Rev (from left), whose approach involved the former's haunting vocals and the latter's hypnotic keyboards. Ira Robbins and Dave Schulps, founders of cool music zine *Trouser Press,* describe the pair as follows in their notes to the punk anthology *No Thanks!*: "Equally mindful of the Velvet Underground, Can, and ? and the Mysterians, Rev would poke and prod crackling electronic tones out of a jury-rigged *Plan 9 from Outer Space* pos Farfisa contraption, while Vega would hurl himself onto onlookers, babbling and bellowing catchphrases."

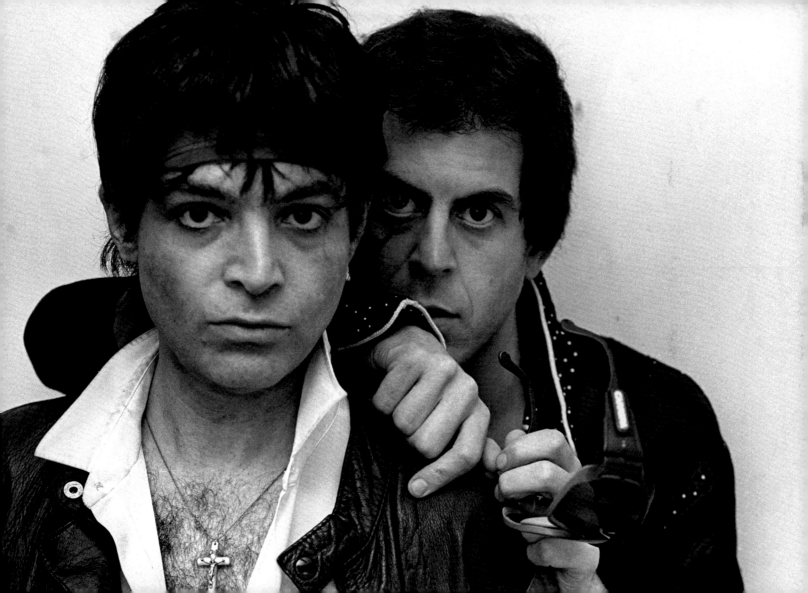

Joey Ramone and Debbie Harry, 1977 photograph by Roberta Bayley

B-movies like those made by Russ Meyer and Roger Corman—go-go girls and gore—inspired not only songs in the Blondie and Ramones songbooks, but *Punk* magazine's special theme issues. Roberta Bayley shot this scene for the zine's "Mutant Monster Beach Party," starring Joey Ramone and Debbie Harry. Another Bayley photo found Joey hoisting a surfboard across the dingy sands of Coney Island.

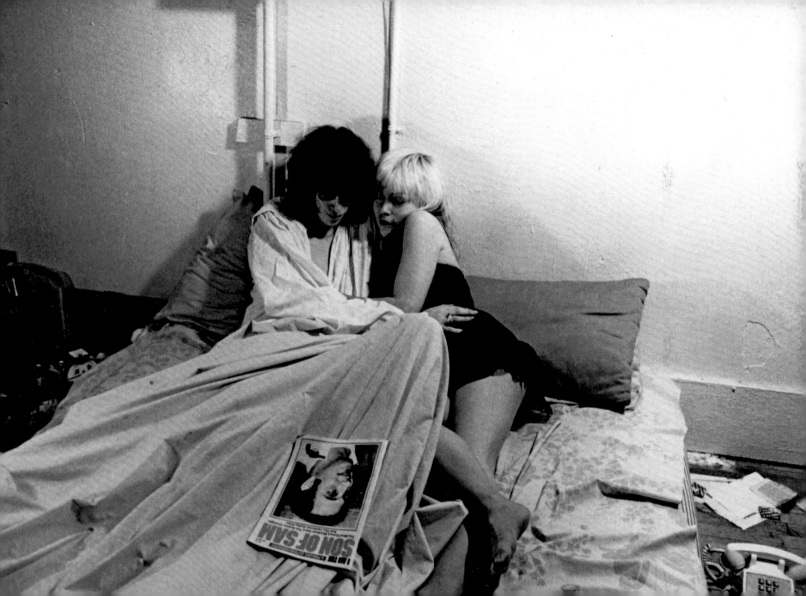

Richard Hell and the Voidoids, 1977

photograph by Roberta Bayley

In 1976 Richard Hell enlisted thirty-year-old balding guitarist Robert Quine (who turned out to be a brilliant axman) to form a new band. They enrolled Marc Bell, who had drummed for Jayne / Wayne County; they found guitarist Ivan Julian through his BAND WANTED ad, stating HAVE GEAR, WILL TRAVEL. Hell had performed such seminal originals as "(I Belong to the) Blank Generation" and "Love Comes in Spurts" in one form or another since 1974, and now the Voidoids gave those and other compositions the sonic underpinning he'd envisioned. An enthralling front man, Hell debuted his new outfit at CBGB on November 18, 1976. "Richard Hell running a frantic hand through his fork cut while Bob Quine (sunglasses, drooping cigarette) loitered on the sidelines, looking like the last word in best bedraggled cool—these are some of the snapshots one carries from the heralded early days of CBGB's," critic James Wolcott remembered. By January '77, Hell had a deal with Sire.

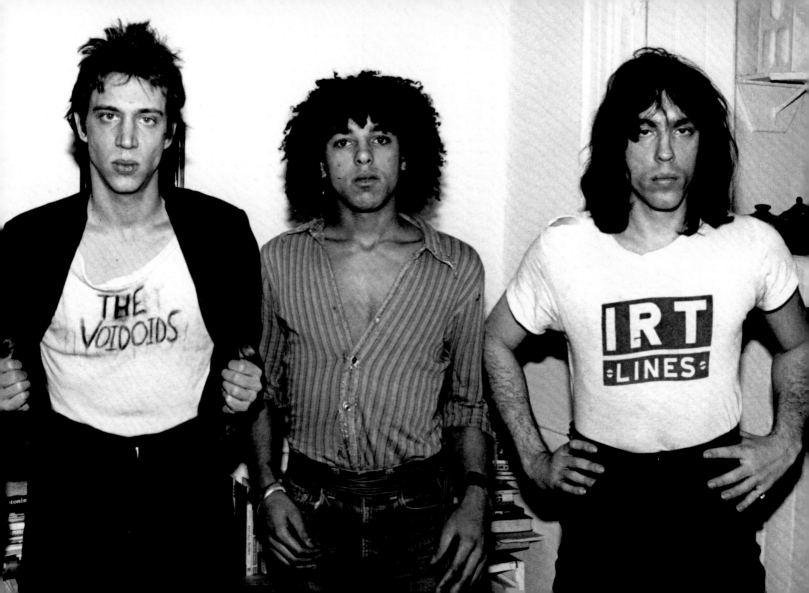

Alex Chilton, 1977 photograph by Godlis

A Man Called Destruction is an aptly named (latter-day) solo album by former teen idol Alex Chilton. In fact, by the time this photo was taken on the Bowery, just up from Chilton's favorite watering hole, he had embarked on the third of maybe a half dozen or so musical lives. In the 1960s, as sixteen-year-old lead singer of the blue-eyed soulsters the Box Tops, the Memphis native guzzled from the tin cup of success. In his early twenties, he cofounded Big Star, a dazzling garage-pop outfit whose three albums, all commercial flops, have continuously spawned new bands (one of which—the Replacements—even wrote a song called

"Alex Chilton"). He then released the torn and frayed *Like Flies on Sherbert* and moved to New York to play its songs live—since most people in his hometown didn't want to hear it. Between that album's tracks, edgy new originals like "Bangkok," and covers of Seeds songs, Chilton attracted a motley but vocal following to his Wednesday night sets at CBGB (the weekends were then largely monopolized by bands like the Voidoids). Chilton chose this photo for the sleeve of his "Bangkok" 45, the fourth release on tiny Ork Records (following Television and Richard Hell).

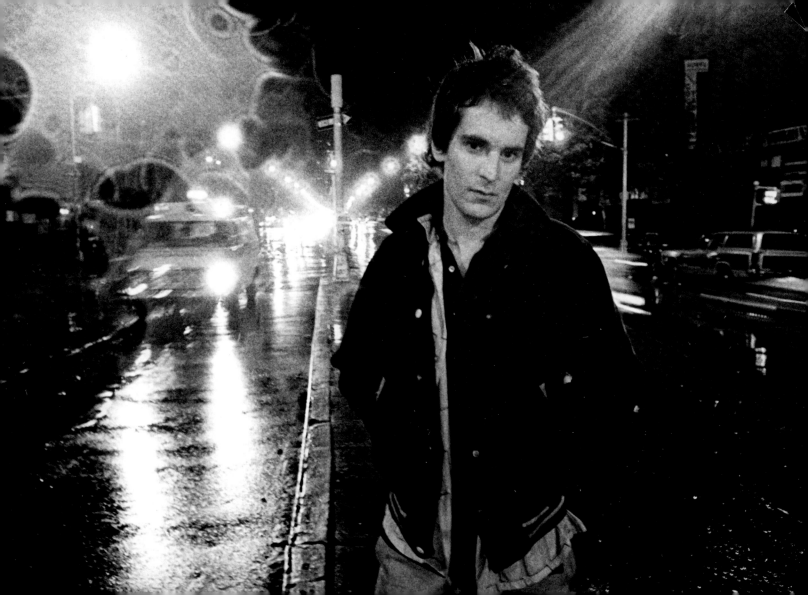

Lester Bangs, 1977 photograph by Stephanie Chernikowski

Creem magazine, based in the Detroit suburb of Birmingham, latched on early to punk bands. The irreverent zine's journalist Lester Bangs (in black T-shirt) became nearly as legendary as some of his subjects. In the mid-'70s he moved to New York, where he occasionally appeared onstage between interviewing the likes of Richard Hell and Lou Reed. On this night at CBGB, his band included Voidoid guitarist Bob Quine (obscured, far right) and (next to Quine) Jody Harris, an inventive axman who played with James Chance. Harris and Quine would later collaborate on an album, and Harris would form the instrumental combo the Raybeats; Bangs put together the band Birdland with Joey Ramone's brother, Mickey Leigh.

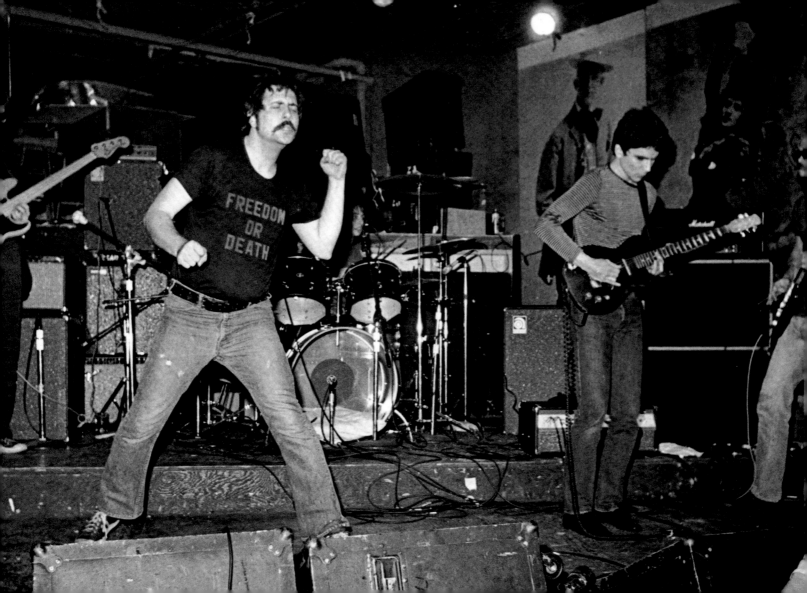

The Planets, 1977 photograph by Ebet Roberts

Performing the Max's Kansas City and CBGB circuit beginning in 1975, the Planets were the first group on the New York punk scene prominently featuring black musicians. Bassist Anthony Jones and vocalist Tally Taliaferrow—seen here onstage at Max's with guitarist Binky Philips (in a T-shirt promoting the cool new zine *Trouser Press*)—represented a rarity at the time. The Planets sounded akin to UK punks the Damned—with excess energy and fast tempos—but with a soul singer and occasional Brit-pop chord changes. Though CB's owner Hilly Kristal favored the band, a record deal eluded the Planets. "Our main singer was black, and just about no one in the biz—except the A&R guy at Warner Bros. who signed the Sex Pistols—could get their head around that," says Philips. After Taliaferrow left the band, "we turned ourselves into a Thin Lizzy / Aerosmith guitar extravaganza," Philips recalls, "and destroyed all the magic we'd created back in 1975–76 in about six months. The end."

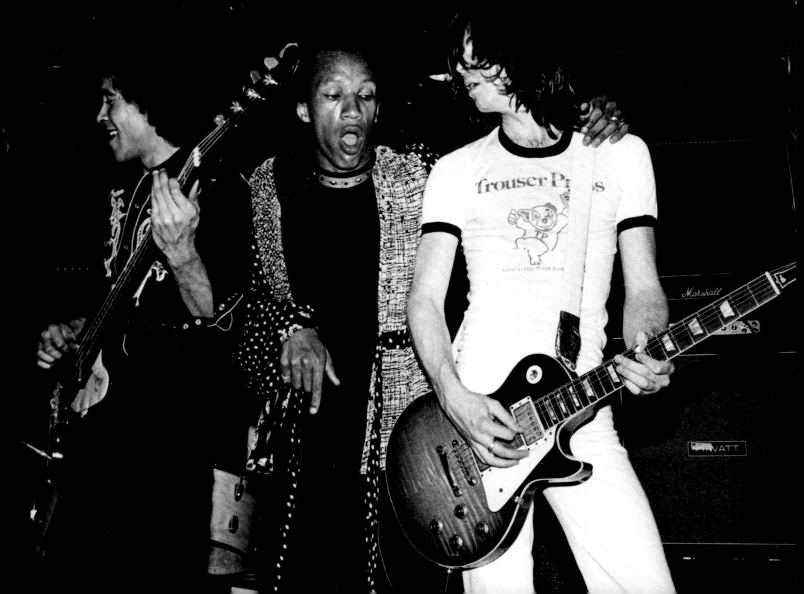

CBGB, 1977 photograph by Godlis

In 1977, stumbling into CBGB on any given night of the week might mean catching music that ran the spectrum from punk provocateurs Richard Hell and the Voidoids to the avant-garde No Wave group Mars, raunch 'n' rollers the Dictators, skittish popsters the Feelies, rockers like the Planets, and even such legends as Screamin' Jay Hawkins. If you played there, you got in—and sometimes drank—for free, so you could always find familiar faces lounging by the bar. A free fanzine called *Tuesday Night* covered the local scene that revolved around the club, and included headliners' set lists, local gossip, and "top ten charts" of LPs and singles sold at Bleecker Bob's, the record store located nearby on its namesake street. The September 27 issue posted the following:

BLEECKER BOB'S TOP TEN LPS

1 Elvis Costello
2 *Talking Heads '77*
3 Richard Hell & the Voidoids
4 Dead Boys
5 Rolling Stones *Love You Live*
6 Iggy *Metallic KO*
7 Clash
8 Boomtown Rats
9 Boys
10 Iggy *Lust for Life*

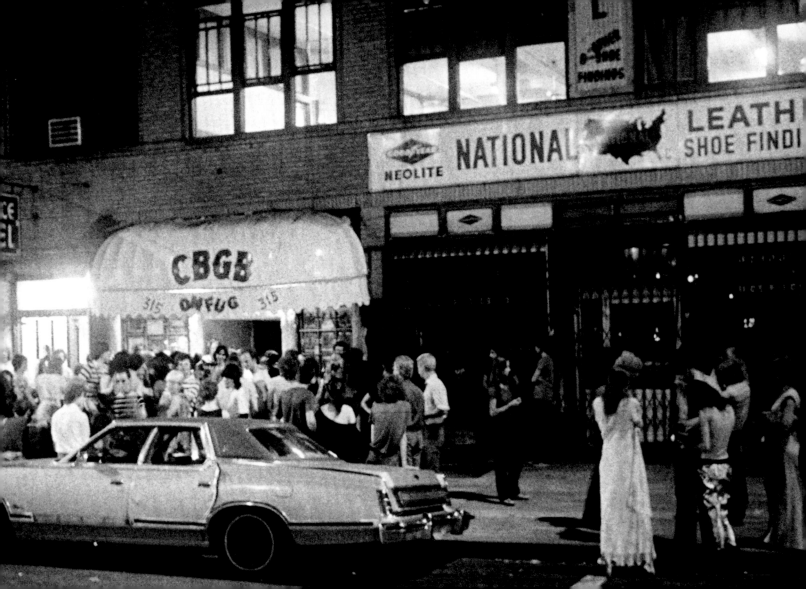

The Sic F★cks, 1977 photograph by Godlis

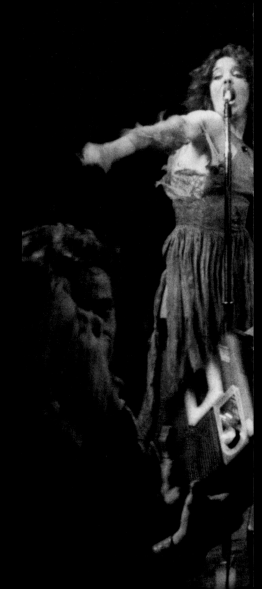

Tish and Snooky (from left) Bellomo, a pair of theatrical sisters on the scene, originally performed with Debbie Harry in an early version of Blondie. With guitarist Russell Wolinsky (center), they next formed the "schtick-rock" combo the Sic F*cks. Dressing as nuns one night, cancan girls the next, Tish and Snooky opened their own boutique, Manic Panic, on St. Mark's Place in 1977. In the 1990s, the gals' line of multi-color Manic Panic hair dye became hugely successful, embraced by a new generation of punk wannabes, such as Green Day's blue-haired lead singer Billie Joe Armstrong. Soon, all the kids wanted Day-Glo mops, and could have 'em—thanks to Tish and Snooky.

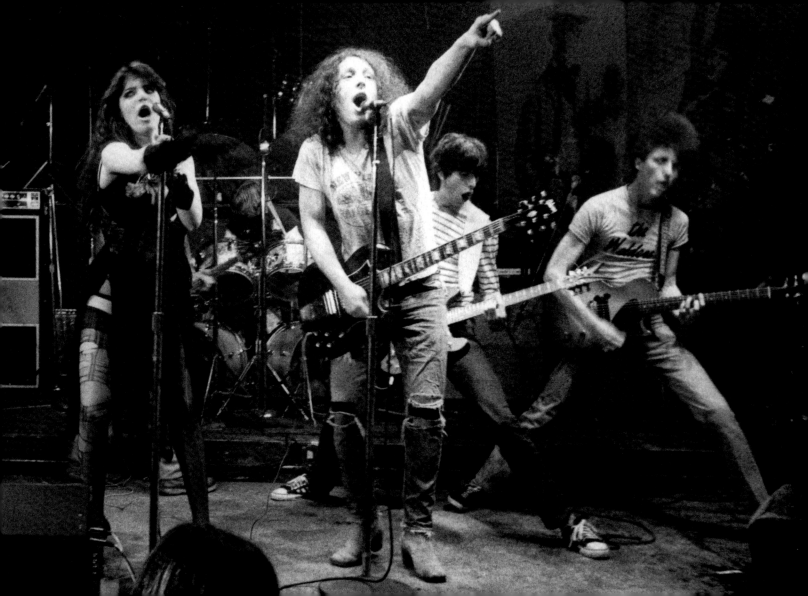

Talking Heads, 1977 photograph by Godlis

Not long before this CBGB gig, former Modern Lovers guitarist Jerry Harrison (far left) joined the Talking Heads, who had just garnered a record deal with Sire. Label head Seymour Stein recalled the effect the group's "Love—Building on Fire" had on him when he first saw the band at CB's: "I got goose bumps all over. I stood there frozen, and when they finished, I jumped up onstage and helped them with their equipment. I tried to sign them immediately, but it was the longest courtship ever at Sire Records—eleven-and-a-half months. They finally signed on November 1, 1976."

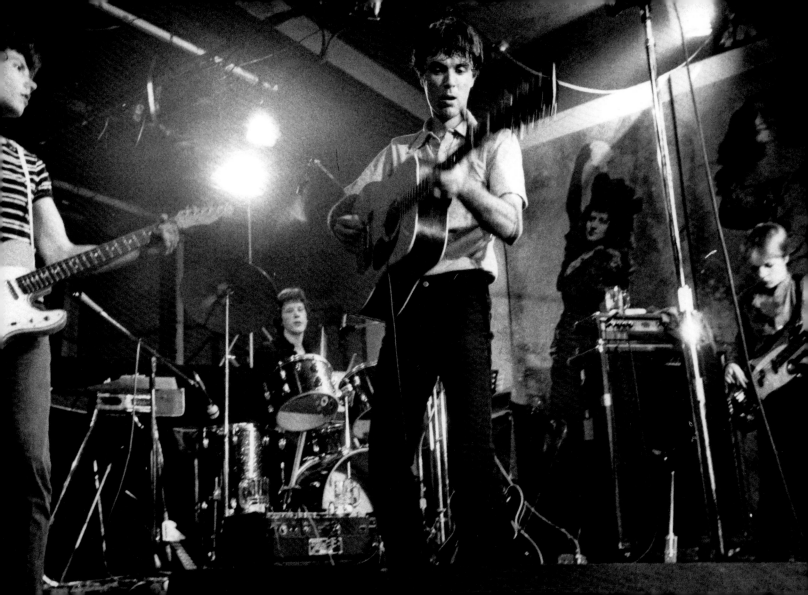

The Heartbeakers, 1976 photograph by Bob Gruen

This version of the Heartbreakers (bassist Billy Rath, guitarist Walter Lure, drummer Jerry Nolan, and guitarist / vocalist Johnny Thunders) recorded one album, *L.A.M.F.*, in London, released on the Tracks label. Nolan quit in disgust because of the LP's horrendous sound quality. Thunders stayed on in London and cut the solo album *So Alone,* featuring the moving "You Can't Put Your Arms Around a Memory." When he returned to New York the Heartbreakers played about a year's worth of farewell gigs before finally fizzlir out for good. His former mate in the Doll Sylvain Sylvain, used to call Thunders "the second hardest working man in sho business, because that baby, he played every fucking club there ever was. And he kept the New York Dolls alive by doing that, whatever band he was in."

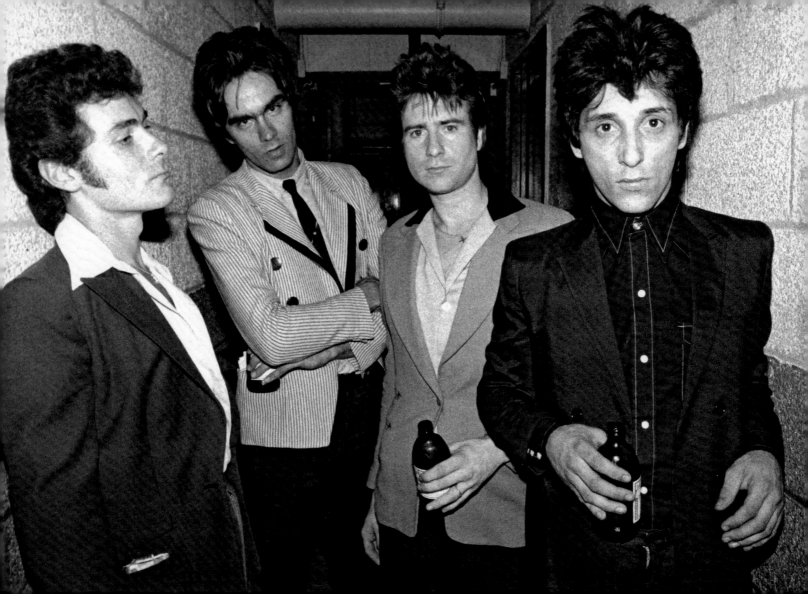

The Ramones at CBGB, 1976 photograph by Godlis

The Ramones played CBGB some fifty-seven times in 1974–75, sometimes on bills with the Talking Heads or Blondie. By the time of this 1976 gig, they had recorded their first album (in just over two weeks) and begun touring outside New York. Sire's Seymour Stein recalled, "I was tipped off to the Ramones by such respected music mavens as Danny Fields and Lisa Robinson [then a reporter for *Rock Scene*], but it was my ex-wife, Linda, who got to see them first, as I was very ill. She came back with such a glowing report that the next night, with a 103-degree fever, I rented a rehearsal studio for one hour and signed them. I only needed twenty minutes—that was about the length of their set, and they must have done fifteen or eighteen tunes.

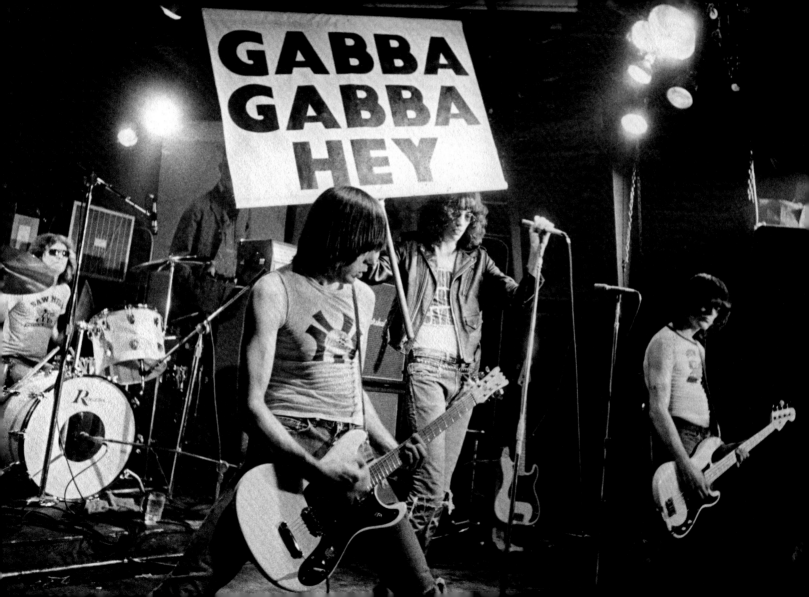

Members of the Ramones, the MC5, and the Stooges, 1977

photograph by Robert Matheu

On March 28, 1977, the Ramones played their first gig in the Detroit area, home to the Stooges and the MC5. The latter's guitarist Fred Sonic Smith opened the show at Ann Arbor's Second Chance club with his Sonic Rendezvous Band, which also included Stooge Scott Asheton. "This photo was taken at 3:00 a.m.," remembers Robert Matheu, "at the Ann Arbor house of Mike Davis [former MC5 bassist]." Pictured are Tommy Ramone, Johnny Ramone, Fred Sonic Smith, Scot. Asheton, and Ron Asheton (from left). "Tommy and Johnny were ecstatic to mee their heroes," according to Matheu.

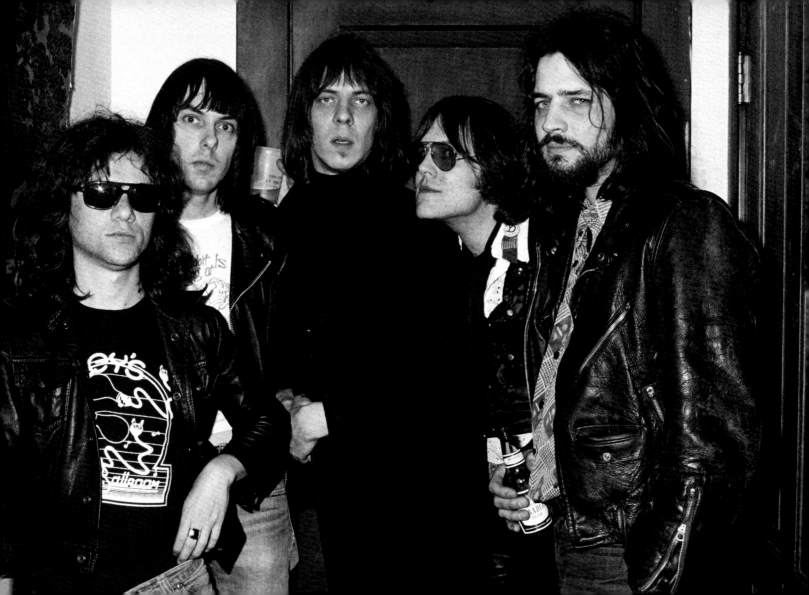

The Dictators, 1977 photograph by Ebet Roberts

In the Bronx, at the northern tip of New York City (far from CBGB's Lower East Side locale), another group of rock & roll misfits started a band in 1974 called the Dictators. The band's 1975 debut, *Go Girl Crazy!*, made a big impression on *Punk* magazine founder John Holmstrom: "I picked up the Dictators' first record and went nuts over their humor . . . The Dictators were crude and loud and dumb." Their second album, *Manifest Destiny,* came out around the time of this photo, when the lineup—here attacking the stage at CBGB—included drummer Ritchie Teeter, guitarist Scott "Top Ten" Kempner, vocalist Handsome Dick Manitoba (b. Richard Blum), bassist Mark "the Animal" Mendoza, guitarist Ross "the Boss" Funicello (from left), and keyboardist Andy Shernoff.

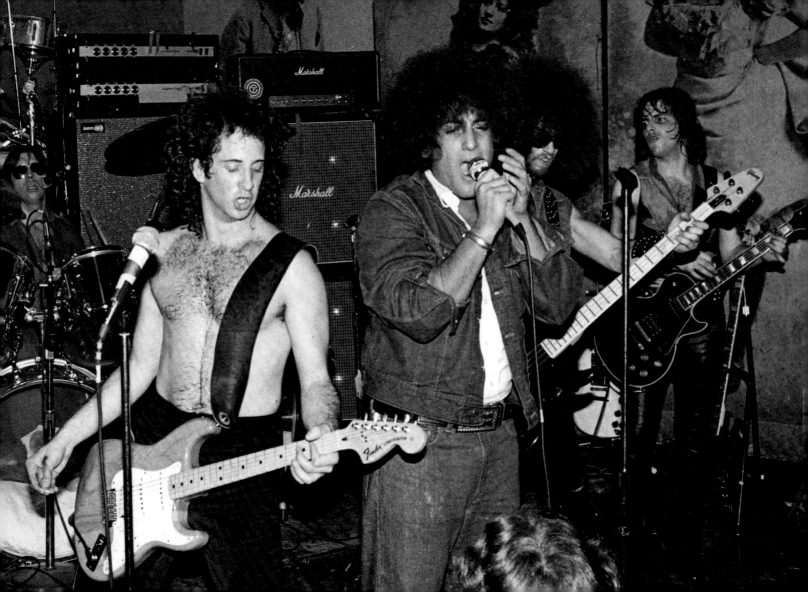

Patti Smith, 1976 photograph by Bob Gruen

Touring the country in support of the band's second album, *Radio Ethiopia,* the Patti Smith Group (PSG) won new converts to the sound coming from Lower Manhattan (via the PSG itself, the Ramones, Television, the Voidoids, and others). Things had exploded musically in London as well. In fact, many pundits date 1976 as the "official" birth date of punk. Smith was unlike anyone ever to grace the stage. A whirling dervish one minute, a back-bending acrobat the next, Smith mesmerized her audience. Soon after a mind-boggling gig in Chapel Hill, North Carolina, on January 21, 1977, she hurtled from a Tampa stage, seriously fracturing several vertebrae in her neck and back. Smith would be sidelined during much of the year, writing her fourth book of poetry, *Babel,* while recuperating.

Television, 1977 photograph by Godlis

Drummer Billy Ficca, vocalist/guitarist Tom Verlaine, bassist Fred Smith, and guitarist Richard Lloyd stroll down St. Mark's Place past the Holiday Cocktail Lounge, a bar that catered to Ukrainians populating the East Village in the 1970s. Bands like Television were increasingly moving into the neighborhood, where the tenements offered cheap rent to broke newcomers. St. Mark's Place served as the major thoroughfare, with this block (between First and Second avenues) offering an eclectic menu of vintage films at Theater 80; on the block between Second and the Bowery, punk boutiques and record stores began taking over. CBGB was only six blocks south, so stumbling home at 4:00 a.m. was a simple feat for the denizens of St. Mark's Place.

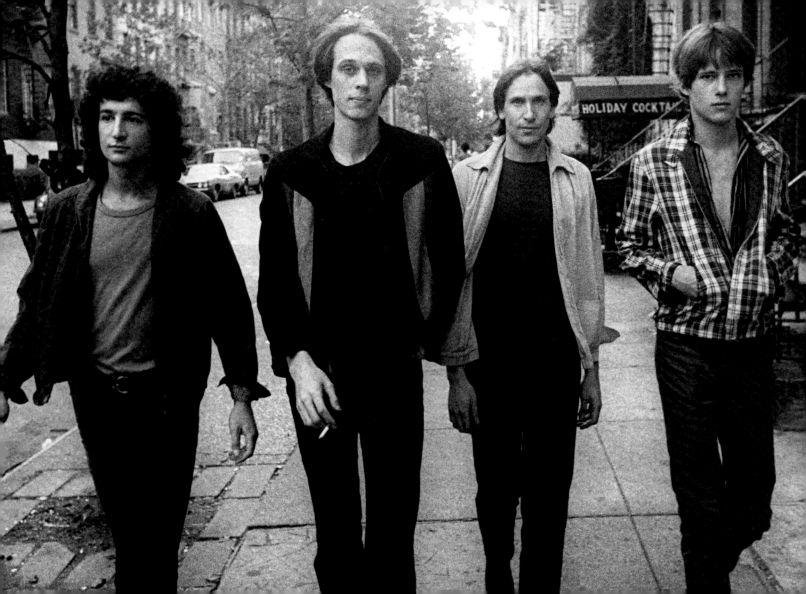

Blondie, 1977

photograph by Stephanie Chernikowski

By 1977, the Blondie lineup had changed again; with bassist Gary Valentine's departure the group enlisted guitarist/bassist Frank Infante and later in the year added Nigel Harrison. Stephanie Chernikowski remembers that during this shoot at her Bowery studio, "the band was still so poor that they used black electrical tape to wrap their pants' legs to look skinnier." (Debbie Harry's britches state Things go better with Coke.) Soon the group would switch labels and record *Parallel Lines,* which would yield Blondie's first chart topper, the disco-tinged "Heart of Glass" (1979). Seen here are Jimmy Destri, Debbie Harry, Clem Burke (with cigarette), Chris Stein, and Frank Infante (from left).

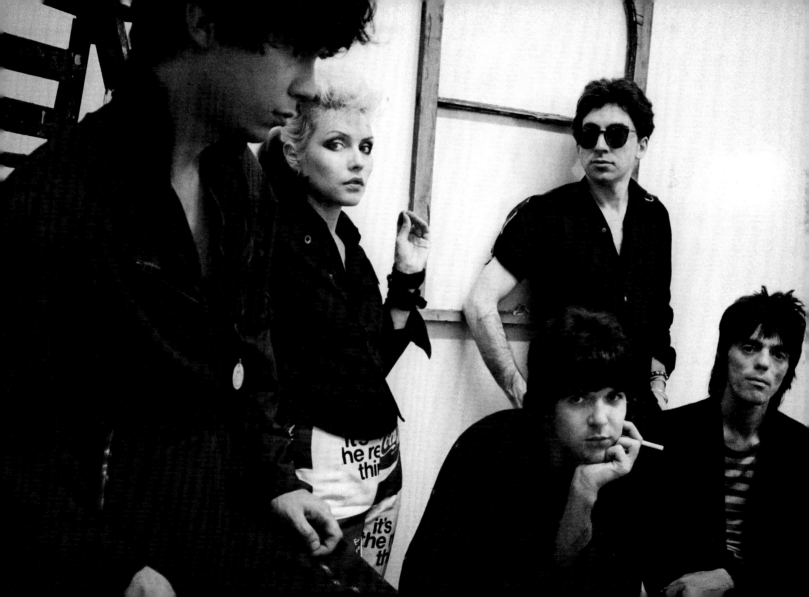

Steel Tips, 1977 photograph by Bob Gruen

Biker beast met Catholic schoolgirl in Steel Tips, who frequented the CBGB stage (as seen here) throughout the late 1970s. Subversive artist Joe Coleman was an early part of the group, and his vocals can be heard on Steel Tips' 1978 single "Krazy Baby"/"96 Tears." According to the *Trouser Press Record Guide,* "Steel Tips were one of the few punk bands in the late seventies to wallow in and lionize actual street-level violence, as opposed to costumes and makeup. At a time when sado shock was an easily marketable commodity, this New York group trafficked in genuine physical assault, attacking their jaded tuff punk audiences."

053

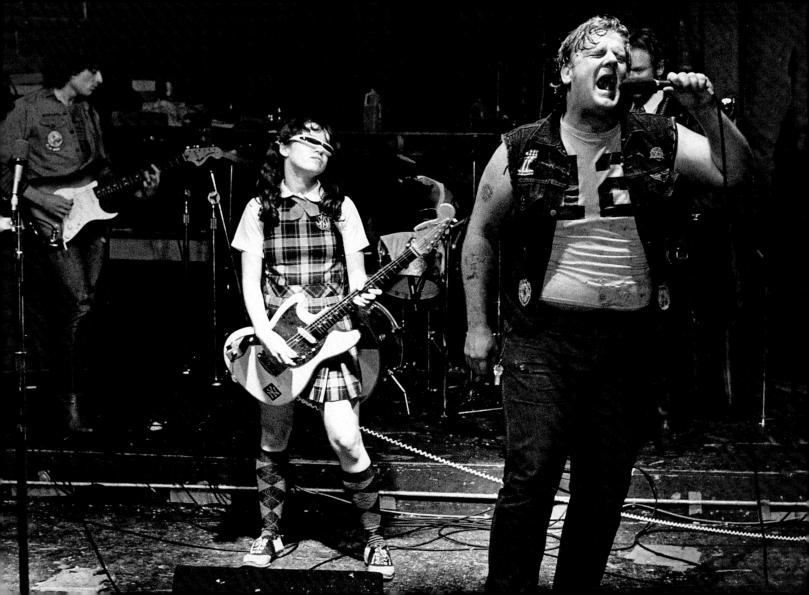

The Dead Boys, 1977 photograph by Godlis

It didn't take long for the Clevelanders—
Johnny Blitz, Jimmy Zero, Stiv Bators,
and Cheetah Chrome (from left)—to
make a new home for the Dead Boys in
New York's East Village. They relocated
to the city not long after passing their
"audition" at CBGB. They immediately
found kindred spirits at the club (where
they are performing in this photo)—as
well as a manager in owner Hilly Kristal.

Their catchy hooks in songs like "Sonic
Reducer" and "Caught with the Meat in
Your Mouth" and their outrageous behavi
garnered an early buzz. The Dead Boys
took Alice Cooper–esque stage antics to
the next level; onstage Bators would han
himself with a mic cord, and he once got
a blow job from a CB's waitress while th
audience watched.

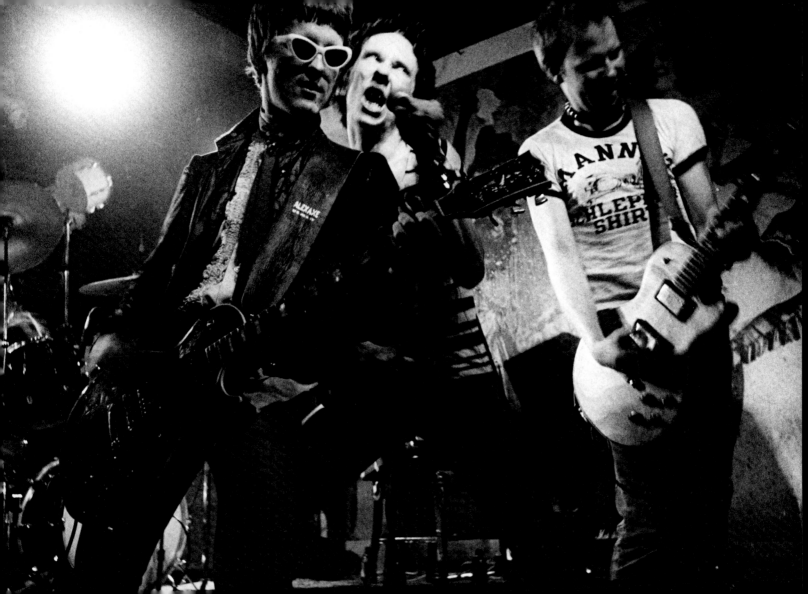

Iggy Pop and Debbie Harry, 1977

photograph by Bob Gruen

In 1977, Iggy Pop toured North America and Europe with David Bowie as his piano player. The pair had worked together on Iggy's new solo album, *Lust for Life* (the title track of which would be used twenty-five years later in a cruise-line commercial!). Blondie opened the shows on the North American leg, which embarked in March in Toronto, Canada. Bob Gruen took this portrait backstage that night in the dressing room, presumably while the bands were running a sound check.

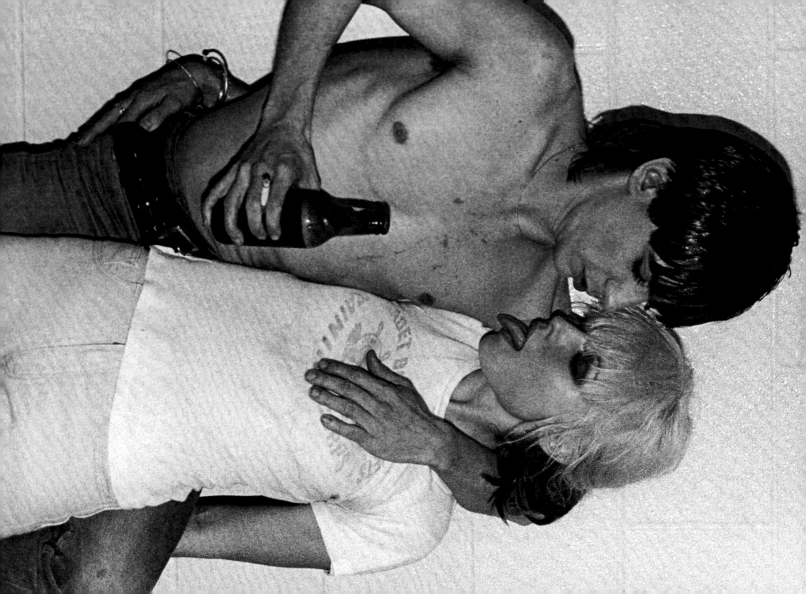

Richard Hell, Legs McNeil, and Andy Warhol, 1977

photograph by Roberta Bayley

Bon vivant Legs McNeil (center) was one of the founding scribes of *Punk*. His interview subject on this particular day was Andy Warhol. As he and photographer Roberta Bayley walked up Fourteenth Street to the Factory on Union Square, they ran into Richard Hell, who decided to tag along. Apparently, Hell, McNeil, and Warhol were competing to see who could look the most remote in the shot. Andy later acted the part of a mad scientist for the *Punk* "Mutant Monster Beach Party" issue.

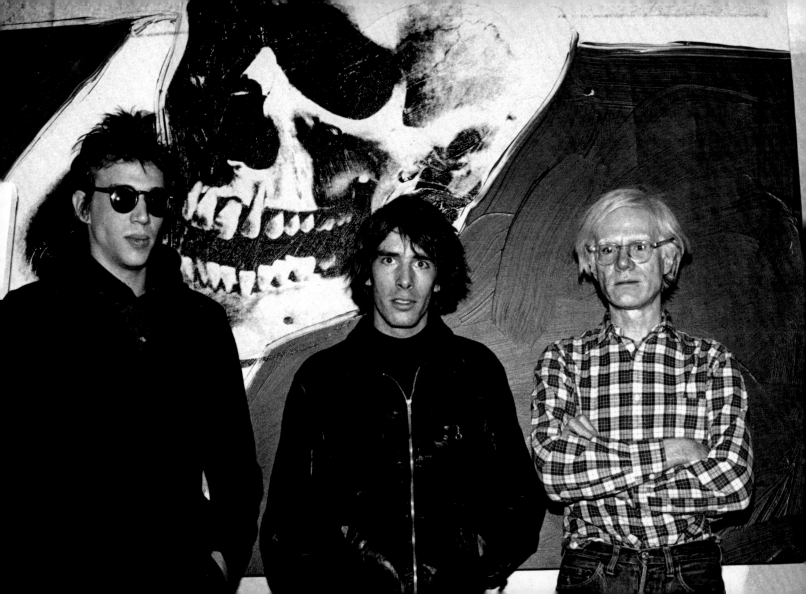

Dead Boys live, 1977 photograph by Stephanie Chernikowski

Stiv Bators (center) emulated Iggy and tried to outdo his outrageousness as a front man, while Cheetah Chrome (right) idolized Stooges guitarist James Williamson. In 1978, Dead Boys drummer Johnny Blitz (far left) and Blondie roadie Michael Sticca got into a predawn rumble with a gang. A knife fight ensued and Blit was repeatedly stabbed, nearly losing his life. To help pay medical expenses, a three-day concert kicked off at CBGB—a sort of "punk Woodstock," photographer Stephanie Chernikowski later quipped.

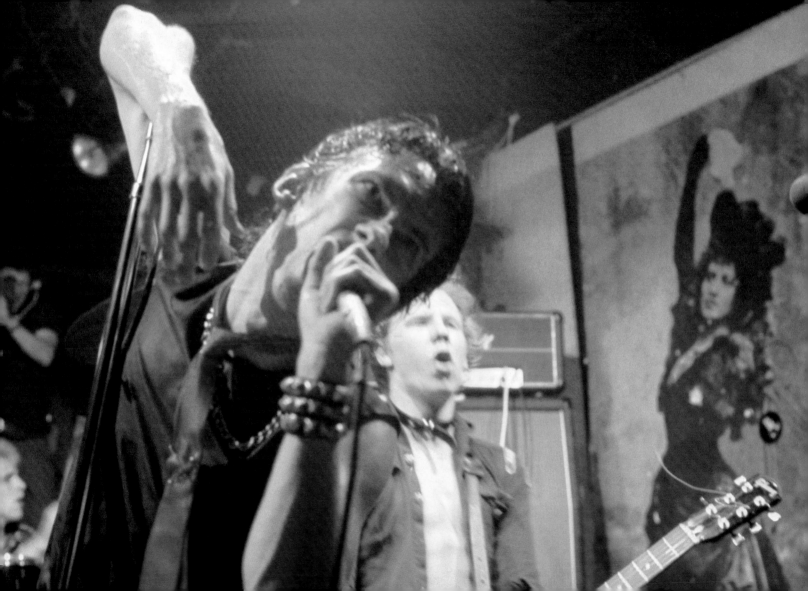

Stiv Bators and go-go "girls," 1977 photograph by Bob Gruen

On this steamy night in May, the Dead Boys were joined onstage by a few admirers. Divine, the cross-dressing star of such smutty early John Waters films as *Pink Flamingos* and *Female Trouble,* brought along a couple of friends to liven up the place. Both Divine and costar Edit "Egg Lady" Massey sometimes performe at CB's, and Waters loved punk. "I basical hated all music from the Beatles to punk, the director has said. "Punk put the dange back in music."

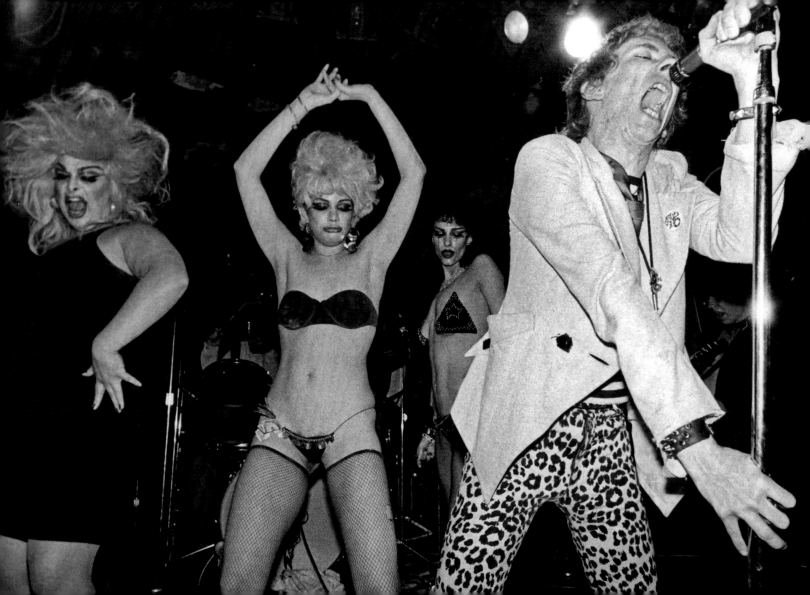

The Ramones at CBGB, 1978 photograph by Roberta Bayley

Touring nonstop in 1978, with three albums out, the Ramones made only one appearance at CBGB that year: the July 4 benefit for stabbed Dead Boy Johnny Blitz. The group's old pal, photographer Roberta Bayley, had also shot their very first album cover—the iconic image of the motorcycle-jacketed foursome standing against a wall. "The band didn't like the photos of them by the 'professional' photographer," according to Bayley. So the boys selected the one she had shot originally for *Punk* magazine. Sire paid Bayley $125 for the honor.

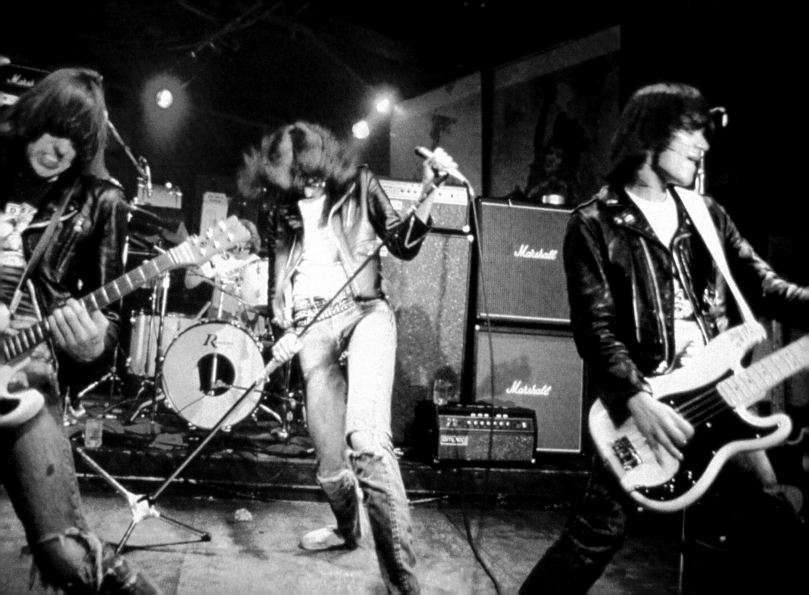

Richard Hell and Johnny Thunders, 1978 photograph by Gary Green

After Richard Hell left the Heartbreakers, he and Johnny Thunders remained friendly. They had a few things in common: The Heartbreakers spent time in England in 1976, touring with the Sex Pistols and making an album; Richard Hell and his new band, the Voidoids, toured Britain in 1977 with the Clash. Both Hell and Thunders got strung out on dope. Dee Dee Ramone, with Hell's finishing touches, had written the perfect follow-up to Lou Reed's "Heroin"—"Chinese Rocks"—and the Heartbreakers had released it as their first single in 1977. "Richard Hell, Johnny Thunders, and Dee Dee were all the same in that James-Dean-tortured 'I need to be saved by a woman' look," remembered scenester Eileen Polk in the preeminent punk chronicle *Please Kill Me.* "And all the women fell for it. They'd start out buying them drinks, and then they'd take them to buy dope." Here, in August '78 at the upstairs office at Max's Kansas City, Thunders is on the nod while Hell looks on.

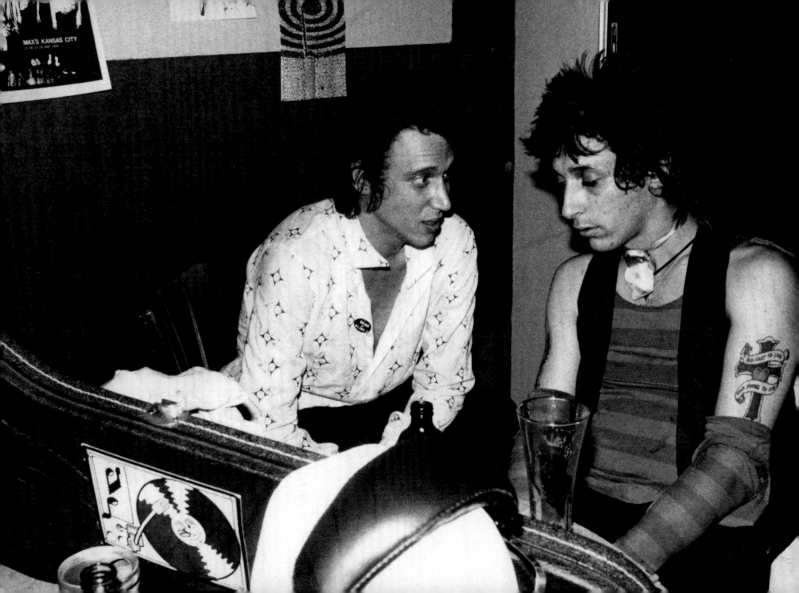

Th' Cigaretz, 1978 photograph by Russell Boone

Though most punk bands of the mid-'70s developed in such gritty urban areas as New York, Cleveland, and Detroit, in 1977, amid the sunnier environs of Raleigh, North Carolina, the Tar Heel State spawned a punk band of its own. Th' Cigaretz had a hard time finding gigs in the land of southern rock and singer-songwriters, but held down a residency in a dive bar called the Free Advice, near the campus of North Carolina State University. The band—bassist William Benjamin, guitarist/vocalist Jerry Williams, guitarist/vocalist Byron McKay, and drummer Scott Jarvis—trekked to Manhattan to play Max's and CBGB in the late '70s, and by '79 had relocated to New York. They recorded one album before disbanding; two members stayed on in the East Village, playing in various outfits and operating the 171 Recording Studio (which doubled as an after-hours club). They became an early part of the burgeoning hardcore scene, with Williams producing the Bad Brains' debut single, "Pay to Cum," and Jarvis producing then-hardcore combo the Beastie Boys' first EP, "Cookie-Puss."

Pere Ubu, 1978 photograph by Ebet Roberts

Formed in 1975 in Cleveland, Pere Ubu originally included guitarist and *Creem* writer Peter Laughner, who nearly joined Television when Richard Lloyd briefly left the band. By the time of this March 1978 gig at CBGB, Laughner was dead (from drugs and alcohol), and another original member, Tim Wright, had joined DNA. This long-running incarnation included founding vocalist David Thomas, who originally called himself Crocus Behemoth (second from left) and bassist Tony Maimone (far right), who replaced Wright

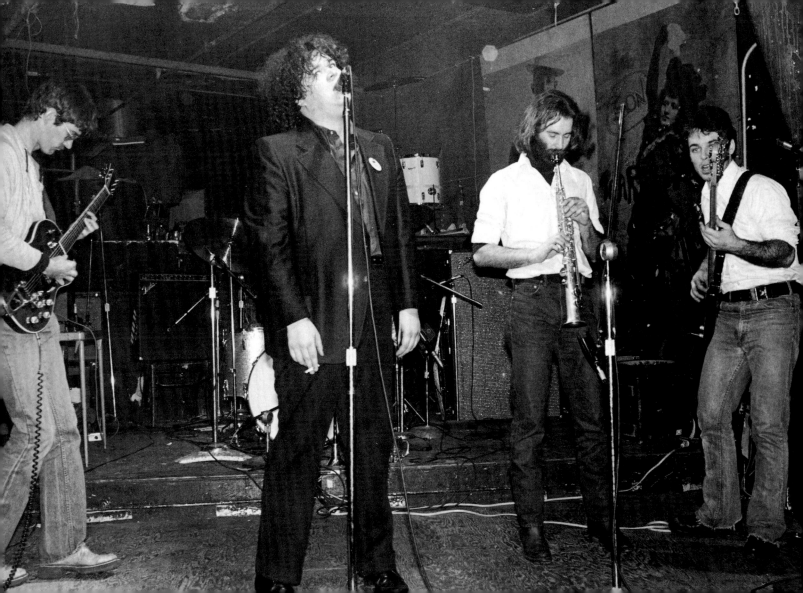

The Flamin' Groovies, 1978 photograph by Bob Gruen

Originally hailing from mid-1960s San Francisco, the Flamin' Groovies found a cult following in New York in the early '70s; their 1971 album *Teenage Head* showcased their stripped-down, British Invasion sound. But they really struck a chord in England, where they fit in with a loose aggregation of pub-rock bands. The sonic simplicity and ringing pop hooks contrasted greatly with the over-the-top prog rock so commercially successful at the time. The Groovies were an early signing of Sire Records' Seymour Stein, who would ink deals with nearly every CBGB punk band of note. Produced by Brit Dave Edmunds (himself king of the pub rockers), *Shake Some Action*—their Sire debut—featured a title track that may have been inspired—at least its title—by punk's pogo.

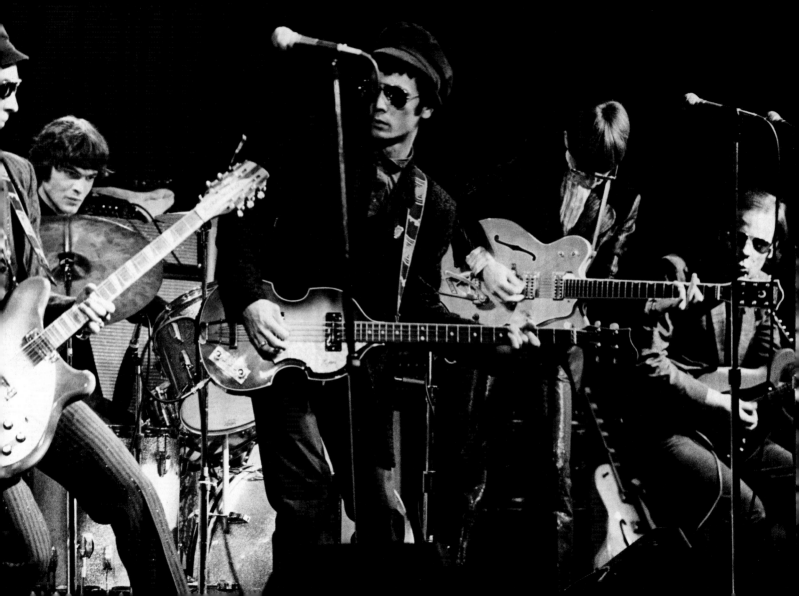

Devo, 1978 photograph by Bob Gruen

Hailing from Akron, Ohio, the brothers Mothersbaugh and brothers Casale (along with drummer Alan Myers) called themselves Devo, short for De-evolution. Their wacky, tongue-in-cheek concept of a dehumanized society included vocal effects and the members' homogenous automaton imagery. Around the time of the band's debut album, *Q: Are We Not Men? A: We Are Devo,* they performed at New York's Bottom Line nightclub; seen here are Mark Mothersbaugh, Jerry Casale, and Bob Mothersbaugh (aka Bob I) (from left).

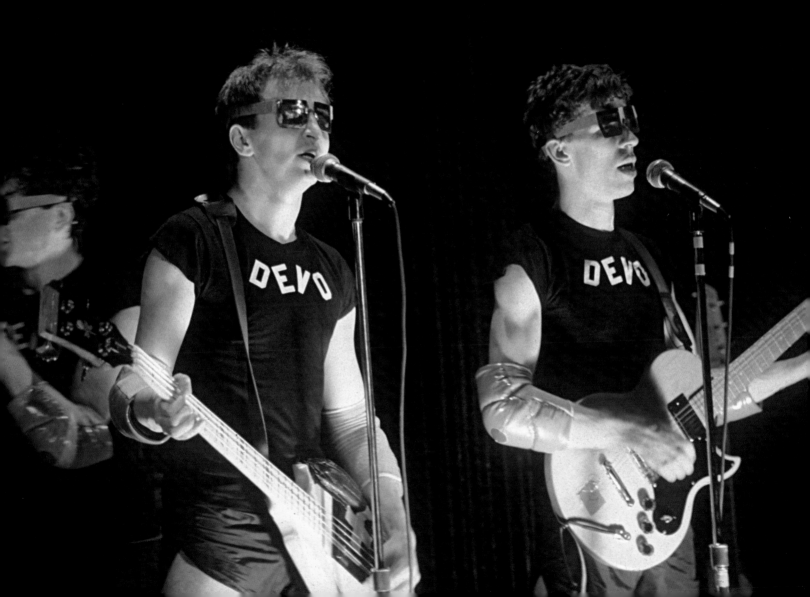

Devo and David Bowie, 1977 photograph by Bob Gruen

Devo made its New York City premiere
at Max's Kansas City in November 1977.
Fan David Bowie (second from right)
introduced the band onstage that night
and, after the show, visited with the
members in their dressing room. Bowie
collaborator Brian Eno (*Low* and *Heroes*)
would produce Devo's debut album for
Warner Bros. the following year.

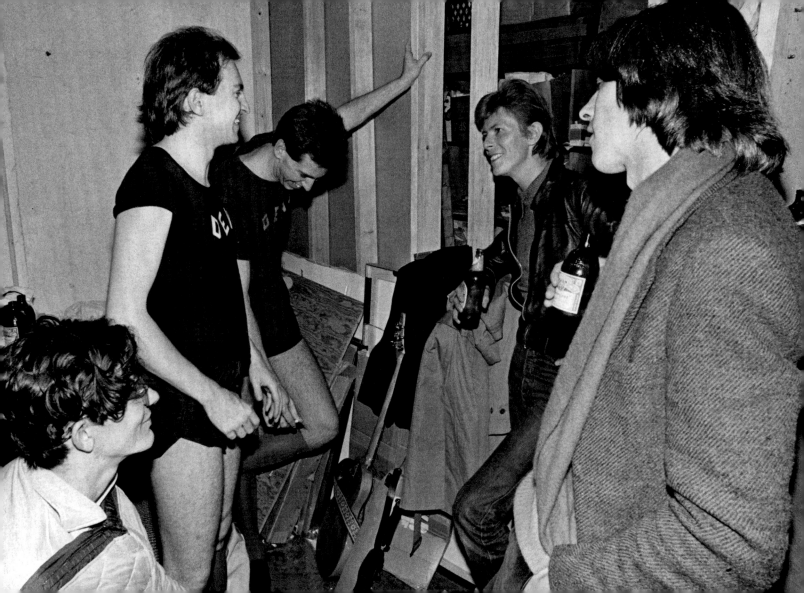

Booji Boy, 1977 photograph by Bob Gruen

Booji Boy, Devo's baby / robotlike mascot, "played" by Mark Mothersbaugh, figured prominently in the former art students' videos and concerts. The combo also named its own label Booji Boy Records, under which it released its debut single, "Jocko Homo" / "Mongoloid," in 1977. Devo, which formed in 1972 at Kent State University, was the first—and only—band to bring a playpen onstage—a prop that could have come in handy for several other groups.

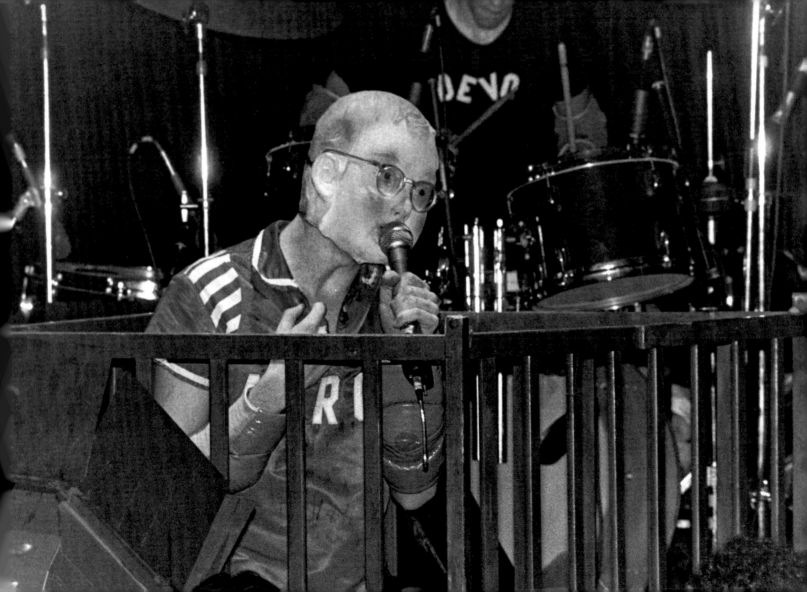

Patti Smith, 1978 photograph by Godlis

At this Times Square record shop, Patti Smith is surrounded by signs of the growing diversity of the 1970s music scene. On her left is a poster for the decade's most successful pop outfit: the boy-girl group Abba. On her right are posters for British angry young man Elvis Costello's new album—his second—*This Year's Model,* and London tunesmith/producer Nick Lowe's new *Pure Pop for Now People.* Smith's third release, the spiritually inclined *Easter,* yielded her sole smash hit, "Because the Night," cowritten by Bruce Springsteen. As the song moved up the charts to number thirteen in 1978, *Easter* became Smith's first Top Twenty album.

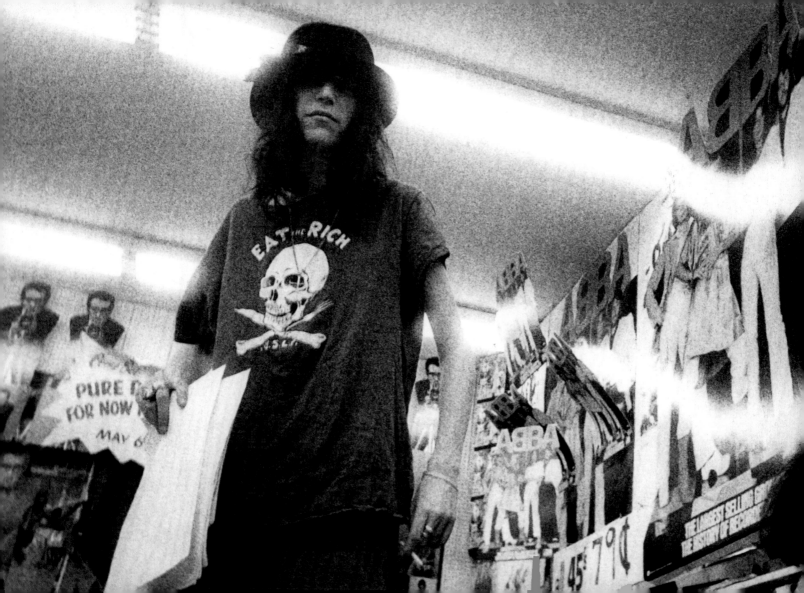

Richard Hell, 1978

In 1978, Richard Hell was cast to star in German director Ulli Lommel's feature film *Blank Generation*. Chernikowski shot this portrait between takes on location at CBGB.

"I belong to the ____ generation / But I can take it or leave it each time."
—"(I Belong to the) Blank Generation"
by Richard Hell

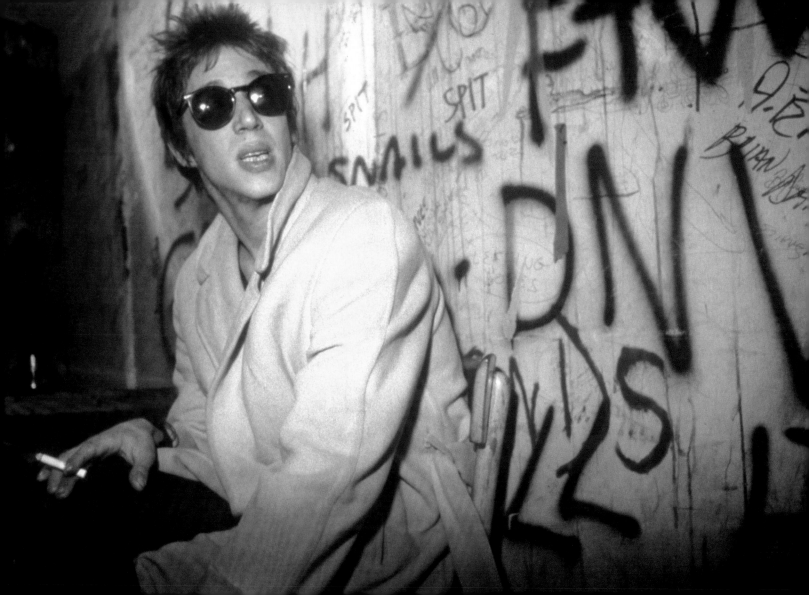

Debbie Harry, 1978 photograph by Bob Gruen

The queen of cool, Harry already had paid her dues as a Playboy Bunny, a folkie (fronting a group called the Wind in the Willows), and a Max's waitress before singing with the Stillettos. She and Chris Stein then masterminded Blondie. As doyenne of CBGB, Harry took JD attitude and B-flick style to new levels—in her lyrics, wardrobe, and stage presence.

"It was a funny thing being a girl singer during the punk era," Harry once related. "It was an odd position to take. Since I was a front for a bunch of guys, it was like some of their perspective came through me, so I couldn't be 'real cute.' I *was* cute, but I had to be tough, too. So that helped me in a way. It made me become … uh … *schizophrenic.*"

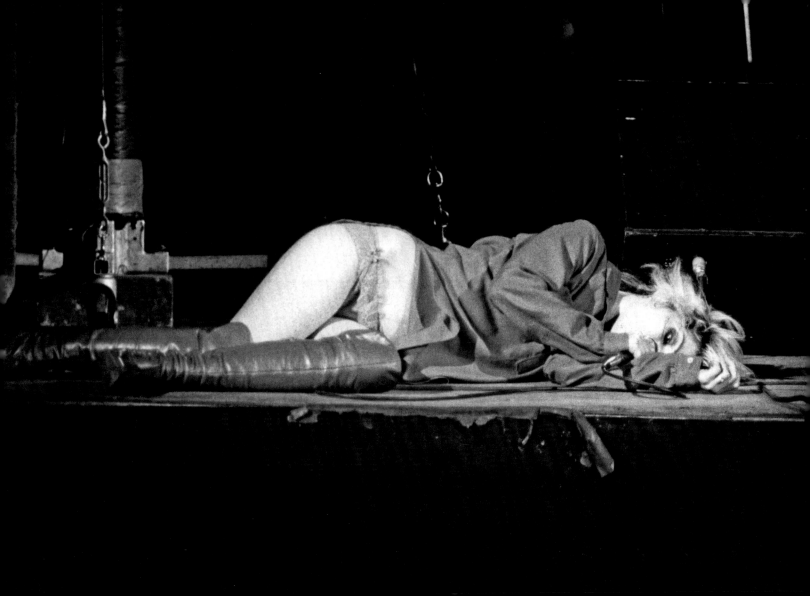

The Dictators, 1978 photograph by Ebet Roberts

CB's bands started making the trek to Long Island to play the suburb's major venue to feature punk bands, My Father's Place, in Roslyn. Just before a Dictators gig there, hanging out for a portrait, are Andy Shernoff, Ritchie Teeter, Handsome Dick Manitoba, Ross "the Boss" Funicello, and Scott Kempner. Having just released their third album, *Blood Brothers,* the Dictators would split up (at least temporarily) by year's end.

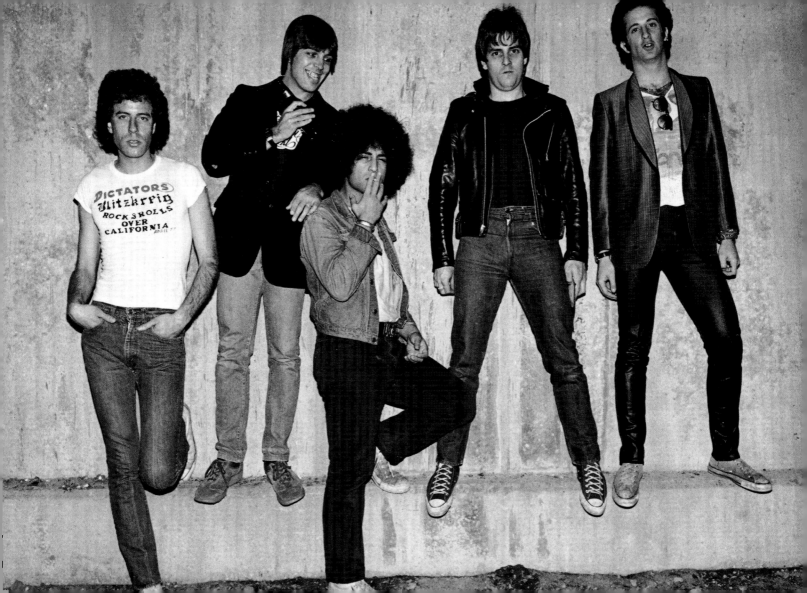

Joey Ramone, 1978 photograph by Godlis

"We all were kind of loners and outcasts—and that's our audience. We also shared thi
dark, black sense of humor that only a few people understood."

—Joey Ramone

071

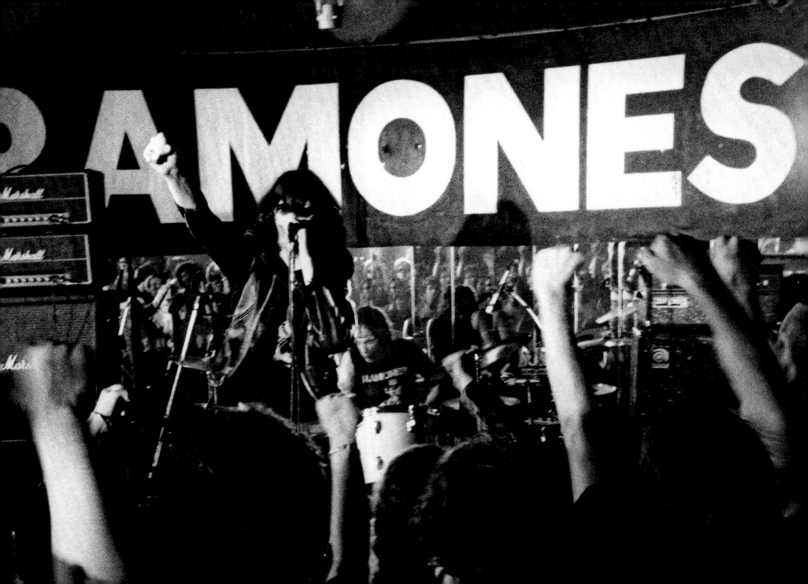

CBGB bathroom, 1977 photograph by Godlis

Though the stench could be unbearable, it was sometimes hard to extricate yourself quickly from the bathroom at CBGB. The graffiti was unsurpassable, free "gifts" of contraband abounded (on occasion), and stumbling upon the type of activity normally found at a Times Square peep show was not unheard of. It was hard to look away.

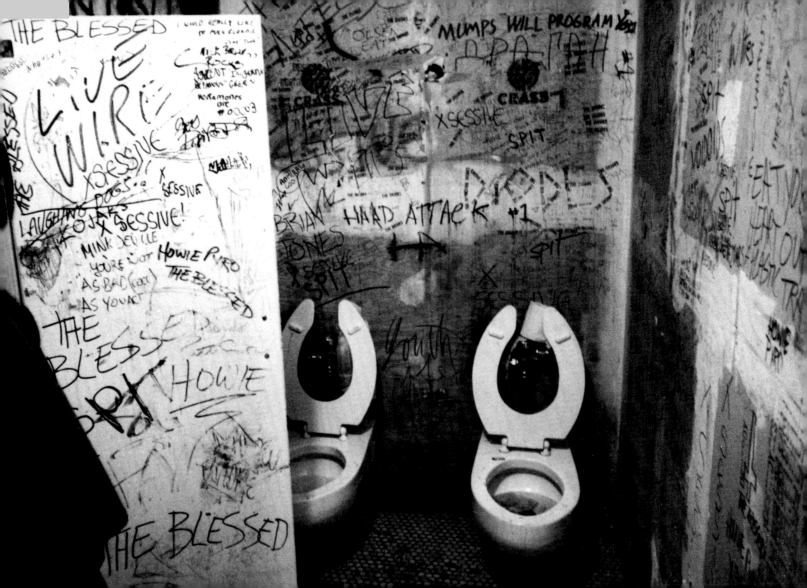

Cheetah Chrome and Gyda Gash, 1978 photograph by Stephanie Chernikowski

Hanging in the bathroom at CBGB, tempestuous punk couple Cheetah Chrome (Dead Boys guitarist) and Gyda Gash take a downstairs break from the benefit for Cheetah's fallen bandmate Johnny Blitz. After initially taking up with Dead Boys vocalist Stiv Bators, Gyda switched to Cheetah, and the two tall, skinny redheads seemed two sides of the same coin—Cheetah/Gyda—for years. By the twenty-first century, though, Gyda had dropped Dead Boys for dachshunds and Cheetah had traded New York life for Nashville and a family.

Debbie Harry, 1978 photograph by Stephanie Chernikowski

BLONDIE IS A BAND! read a late
1970s bumper sticker. But it was the face
of the band, Debbie Harry, that "launched
a thousand photographs," says Stephanie

Chernikowski. The night this photo was
taken, Harry was one of many downtown
stars performing in the benefit at CBGB
for Dead Boys drummer Johnny Blitz.

074

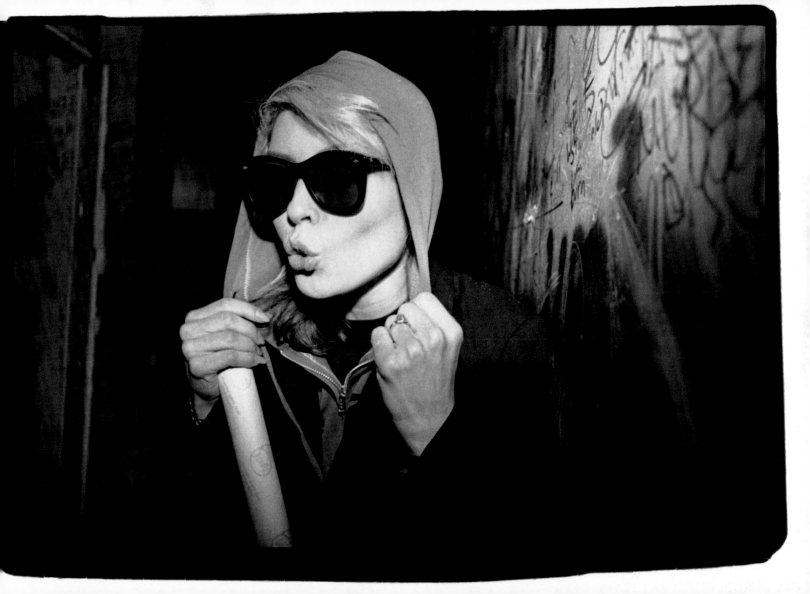

Richard Hell and Elvis Costello, 1978 photograph by Roberta Bayley

Elvis Costello (at right), one of the leading lights of England's pub-rock scene, early on proved himself to be impossible to categorize. By 1978, he'd released a couple of albums and toured America. On this night, he joined in the fun at CBGB to raise money for St. Mark's Church, where Patti Smith had first performed as part of its St. Mark's Poetry Project in 1971. Richard Hell, a participant at the Poetry Project, headlined the benefit to help finance a building fund following a devastating fire. Having toured England with Hell, Costello stopped by and joined the Voidoids onstage for two numbers: "You Gotta Lose," by Hell, and "Shattered," by the Stones.

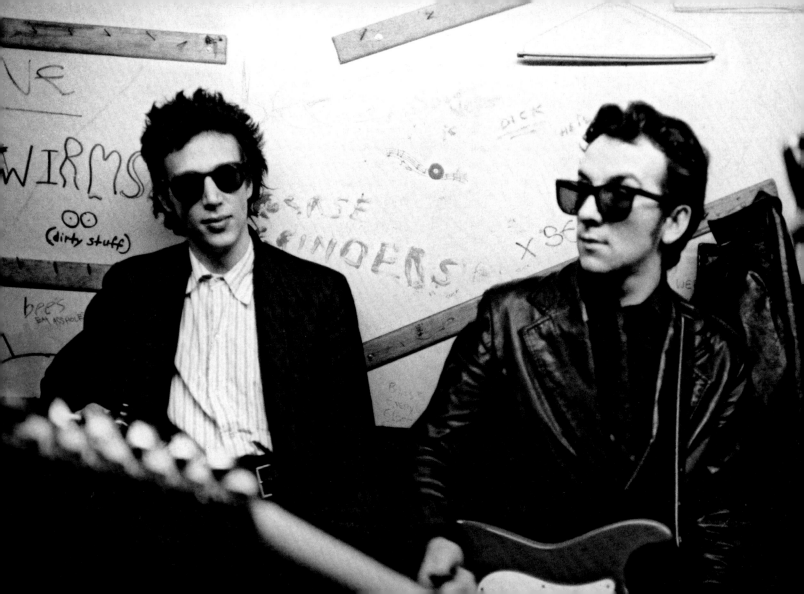

No Wavers, 1978 photograph by Godlis

By 1978, a new crop of punk-styled bands had emerged in downtown New York. No Wave—a stark, often discordant sound—developed via such groups as DNA, the Contortions, Mars, and Teenage Jesus and the Jerks. All would be featured on a Brian Eno–produced anthology called *No New York.* Poppier punk had been labeled *New Wave*—primarily by publicists afraid of the mainstream's backlash against punk. *No Wave* was a kind of ironic comment on that. Here, sitting in front of CBGB are prominent No Wavers and fellow dissidents Harold (last name unknown), Kristian Hoffman (of the Mumps, *not* a No Wave band), Diego Cortez, Anya Phillips, Lydia Lunch (of Teenage Jesus and the Jerks), James Chance (of the Contortions), Jim Sclavunos and Bradley Field (both of Teenage Jesus), and Liz Seidman. Cortez and Phillips, CB's regulars and trendsetters, had formed a little rabble-rousing clique called the Esoterrorists. An S&M-inspired fashion innovator, the Voidoids Fan Club founder, and the Contortions' manager, Phillips was a major mover and shaker.

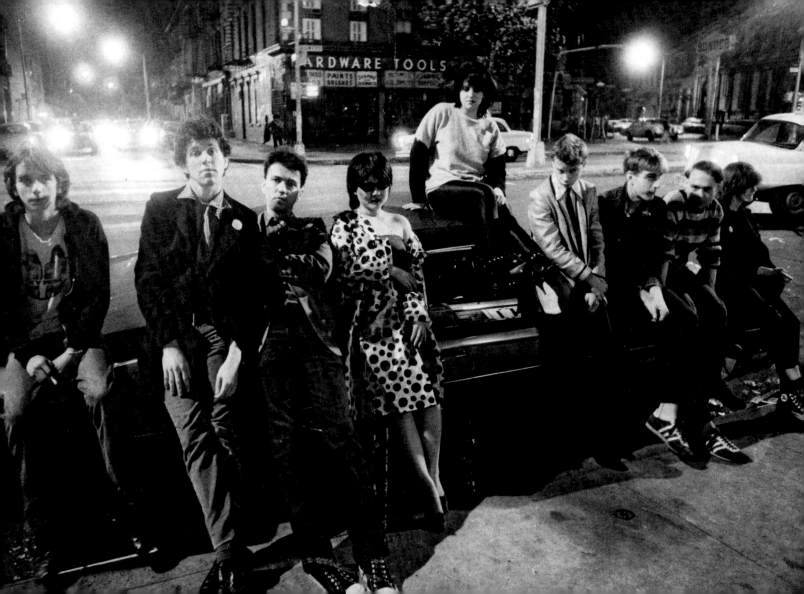

Teenage Jesus and the Jerks, 1978 photograph by Godlis

Not long after fourteen-year-old Lydia Lunch boarded a Greyhound and fled her native Rochester, New York, for Manhattan, she fell in with the punk scene at CBGB, where she scored a job waitressing. She formed Teenage Jesus and the Jerks with drummer Bradley Field (center), saxophonist James Chance (who soon quit to start the Contortions), and a succession of bassists, including Jim Sclavunos (who would later switch to drums). A linchpin of the No Wave movement, Lunch (left) moaned and shrieked nihilistic lyrics and atonally assaulted her guitar, performing what she called "aural terror." (A Teenage Jesus song could last only twenty seconds, a relief to some audiences.) Voidoid Bob Quine produced two singles for the group, which was also featured on the *No New York* compilation. Lunch went on to make a solo album, *Queen of Siam;* to form other bands; and then to focus on doing spoken-word performances and writing books of prose and verse.

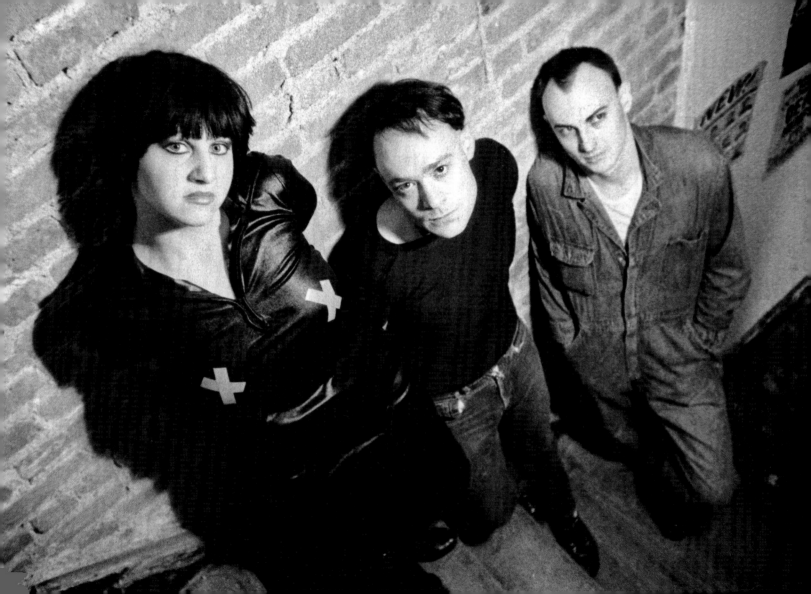

Lydia Lunch, 1978 photograph by Godlis

"New York did not corrupt me. I was drawn to it because I had already been corrupted … New York was a giant candy store, meat market, insane asylum, performance stage. Surrounded by five million other junkies, addicts, alcoholics, rip-off artists, dreamers, schemers, and unsuspecting marks, New York afforded me the luxury of anonymity. The devil's playground."

—Lydia Lunch
Paradoxia, A Predator's Diary

The Cramps, 1978 photograph by Stephanie Chernikowski

Formed in 1976 by vocalist Lux Interior, guitarist Poison Ivy Rorschach, and guitarist Bryan Gregory, the Cramps billed themselves as a psychobilly band. Equally enamored of the Stooges, horror flicks, and obscure '50s rockabilly numbers, the band cooked up a voodoo stew of all three ingredients. Their warped sensibility, depraved lyrics, and primitive sound attracted Alex Chilton ("they're the best rock & roll band in the world!"), who took them to his native Memphis to record the first singles and, eventually, an album. Around the time of the release of their 45s—"The Way I Walk"/"Surfin' Bird" and "Human Fly"/"Domino"—Stephanie Chernikowski took this portrait of the band on a burned-out pier by the Hudson River—Lux Interior, Ivy, Bryan Gregory, and drummer Nick Knox (from left).

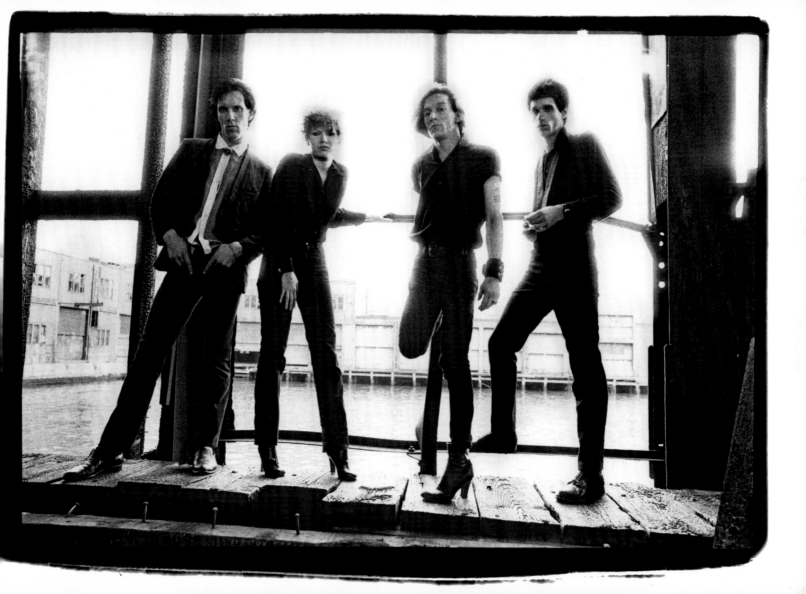

Cramps Bryan Gregory and Lux Interior, 1979

photograph by Ebet Roberts

Live, the Cramps, with their outrageous antics, were as shocking in the late '70s as the Stooges had been a decade earlier. After writhing around onstage, Lux (right) sometimes projectile vomited into the crowd; a deadpan Ivy stoically soldiered on, playing her reverbed-up guitar, while Bryan (left) resembled a "skull on the end of a stick," noted one observer. Lux later remembered the band's debut gig (on All Soul's Day, 1976) at CBGB: "We changed the strings on the guitar right before we went onstage . . . We didn't know about strings going out of tune when they're new, so it was totally horrible sounding, totally bizarre—and we got three encores."

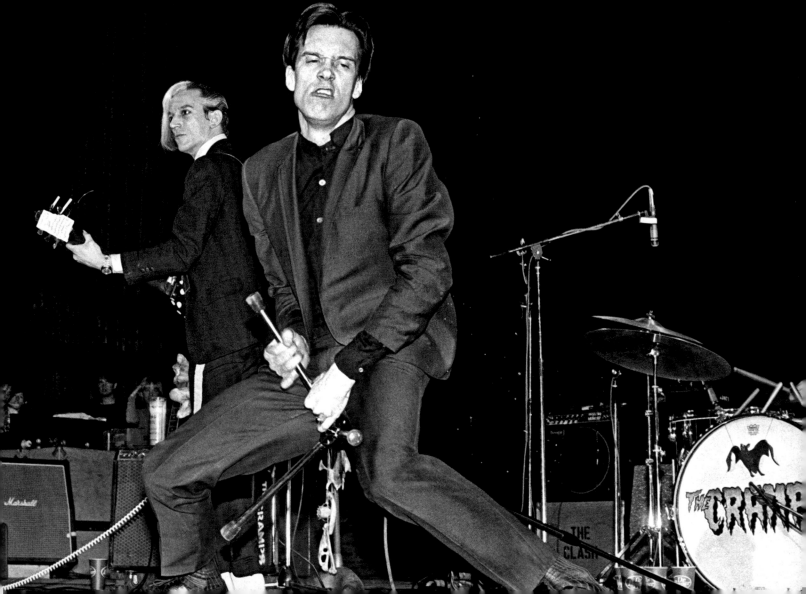

David Byrne, 1979 photograph by Stephanie Chernikowski

David Byrne checks his equipment before a 1979 Talking Heads concert at Central Park. Photographer Stephanie Chernikowski remembers Byrne as being "incredulous that tickets for the show were being scalped." The guitarist/vocalist once explained his crowd-pleasing vocal style to journalist Scott Cohen: "My singing voice is not my natural voice. It seems to jump up there when I sing because I get excite I think, with more practice, I'll be able to sing in my natural voice and then I might be able to convey more emotions, rather than everything being a squeal, which gives the song the wrong impression. Sometimes I want to sing words that are very heartfelt, but they come out soundin like I'm being strangled."

The B-52's, 1979 photograph by Stephanie Chernikowski

Named for a sky-high hairdo favored by southern ladies of a certain age, the B-52's brought their refreshing look at life—Athens, Georgia, style—to New York City in the late 1970s. David Byrne asked the group to open for the Talking Heads at a sold-out Central Park show in '79, and they played in front of a big-city mob for the first time—the crowd loved 'em. "We have always appealed to people outside of the mainstream," according to Kate Pierson (right), seen here in the dressing room with Fred Schneider and Cindy Wilson. "Constantly, we get people coming up to us and saying 'I was just the freakiest one in high school' ... More people feel like they're outside of the mainstream these days. More people are doing their own thing, feeling it's not bad to be a weirdo and respecting other people's difference, and all that goes into the big ol' B-52 philosophy."

Mark Mothersbaugh of Devo, 1978 photograph by Robert Matheu

Devo took its theories of de-evolution to America in 1978, touring the country to promote the group's first album. Here, Mark Mothersbaugh greets Detroit. After Devo devolved into inactivity in the mid-'80s, Mothersbaugh composed music for children's television, including *Pee-wee's Playhouse*, *The Rugrats*, and *The Simpsons*.

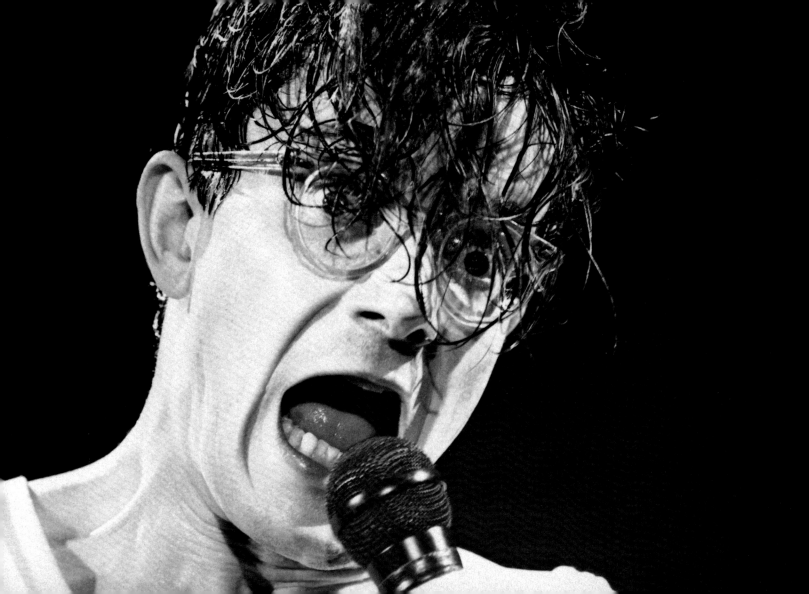

The Mumps, 1978 photograph by Gary Green

Led by keyboardist Kristian Hoffman and vocalist Lance Loud (holding mic), the Mumps performed bouncy numbers like "Crocodile Tears" at CBGB and Max's. This 1978 CB's performance was reviewed by a *Soho Weekly News* critic, who contrasted the then-current incarnation with "an earlier version of the band—[that was] not so dynamic, a not so new wave British vaudevillesque [group]. Today's Mumps are a hard-driving, pulled-together powerhouse package with a genuine teen idol out front." Lance Loud had gained fame earlier, in *An American Family*—the predecessor to the reality show—in which PBS cameras documented the everyday life of the suburban Loud family. Before this CBGB gig, Loud told the *Soho News* reporter, " look upon my role in the band as the orga grinder's monkey who mesmerizes the audience for their gram of interest. Once they see what I'm dancing to, they'll realiz the overall importance of the band."

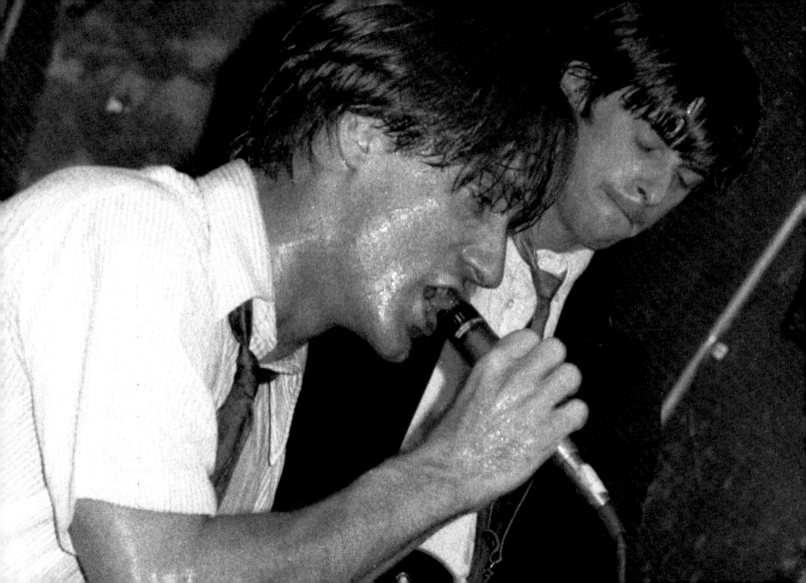

Dee Dee and Vera Ramone, Richard Robinson, and Lenny Kaye, 1979

photograph by Bob Gruen

Everyone on the scene ascended the steep narrow staircase to the second floor of Max's Kansas City to check out the band playing that night. On this evening, the Ramones bassist is accompanied by his wife Vera. At the bottom of the steps are a pair of rock scribes: at left, Richard Robinson, who along with his wife Lisa wrote constantly about punk bands, and Patti Smith Group guitarist Lenny Kaye, an erstwhile rock critic who reviewed early Velvet Underground discs, among others. The following year, Max's closed down; today the building houses a Korean deli.

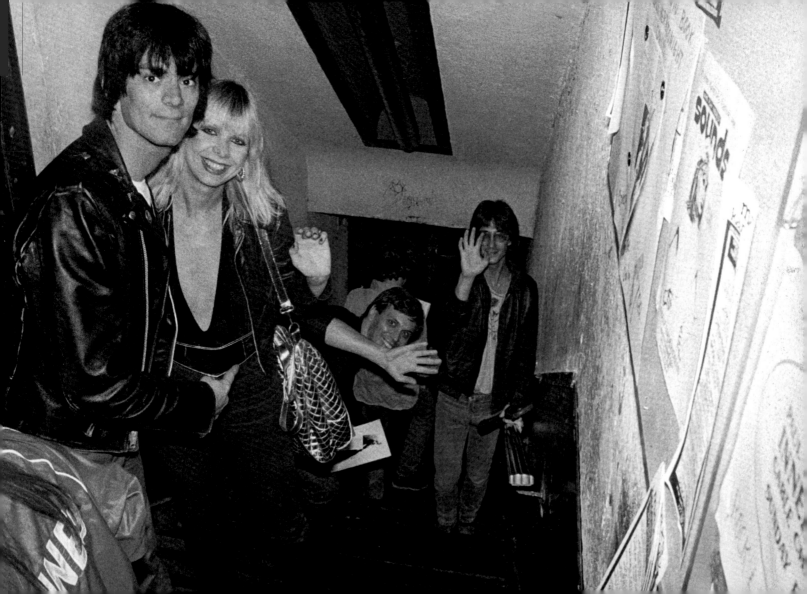

The Ramones, 1978 photograph by Robert Matheu

By January 14, 1978—the night the Ramones played Detroit's Masonic Auditorium—the band had spent practically an entire year playing one-nighters across America, Europe, and the United Kingdom. The new year would bring more of the same, plus the release of the band's fourth album, *Road to Ruin,* and a new drummer in Marky Ramone (the former Marc Bell). Tiring of the grind Tommy Ramone quit the band, opting to wear the producer hat instead. Here, the Ramones—Marky, Johnny, Joey, and Dee Dee (from left)—play one of their first gigs with Bell on drums.

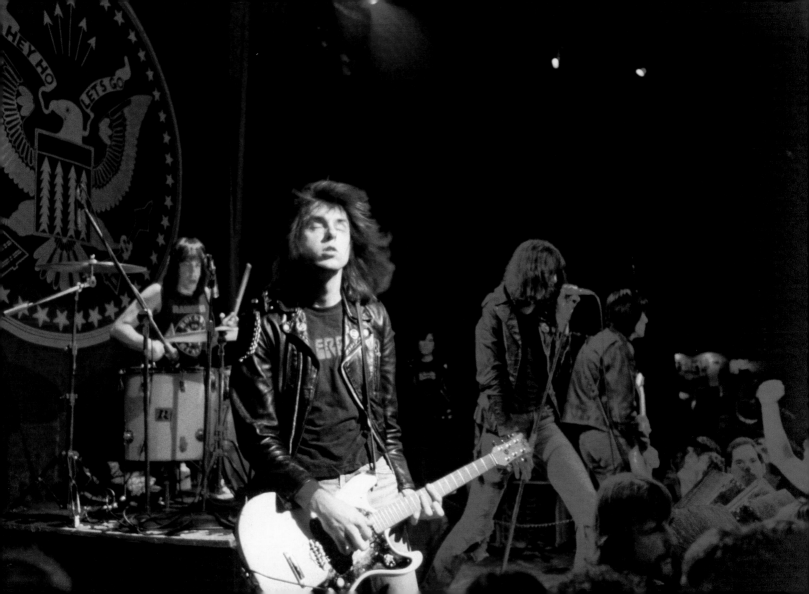

Wendy O. Williams of the Plasmatics, 1979 photograph by Bob Leafe

With former porn star Wendy O. Williams up front, the Plasmatics used a calculated outrageousness to make a name for themselves. Often bare-breasted (except for black electrician's tape used as pasties), Wendy performed such onstage stunts as attacking an electric guitar with a chain saw. The band's sound was meta meets-protohardcore, courtesy of six-foot-five guitarist Richie Stotts, who had a blue Mohawk and frequently dressed in a nurse uniform, and African American bassist Jean Beauvoir, who sported a platinum Mohican.

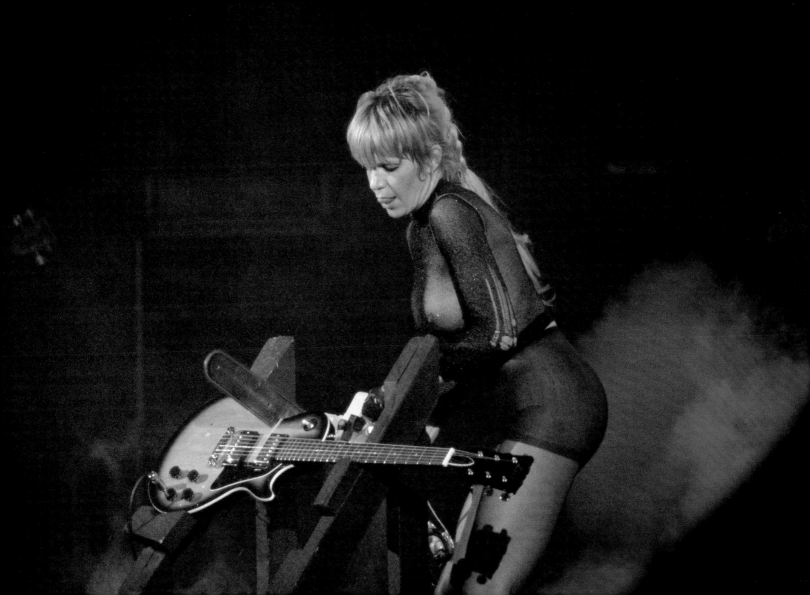

James Chance, 1980 photograph by Ebet Roberts

After leading the Contortions in the late 1970s, confrontational vocalist and saxophonist James Chance formed a new outfit, the funky James White and the Blacks, in 1979. With numbers like "Stained Sheets" and an off-kilter version of Irving Berlin's "Tropical Heat Wave," James White and the Blacks played alluring sets—but any minute the combative Chance (b. Siegfried, in Milwaukee) could strike, as he did this night at Manhattan's uptown New Wave "disco" Hurrah. "The whole postpunk era . . . filled the gap left by some of the rest of us," David Byrne later wrote. "Some bands like DNA or the Contortions brought newer and sometimes more radical music . . . In a way they kept our promise for us. They continued to make raw and innovative music."

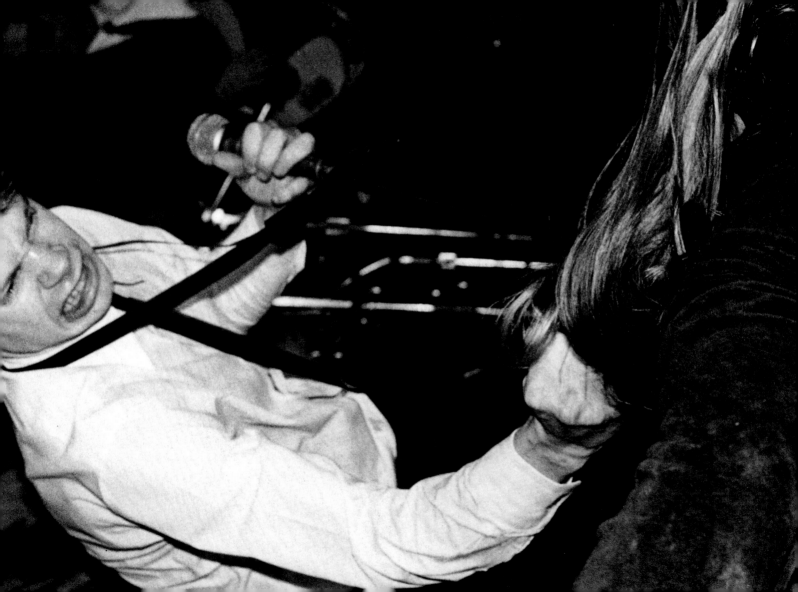

ACROSS THE POND

The Sex Pistols, 1976 photograph by Bob Gruen

It all started with Sex and the Dolls— English impresario Malcolm McLaren's Sex Boutique, where bassist Glen Matlock worked, and the New York Dolls, whom McLaren briefly managed in 1975. The Dolls triggered McLaren's scheme to concoct a savagely antirock combo, and when Matlock and his bandmates' drummer Paul Cook and guitarist Steve Jones told him they were looking for a singer, McLaren thought of a loutish loiterer who sometimes worked at his shop—one John Lydon. The Sex Pistols were born, the nineteen-year-old Lydon soon being dubbed Johnny Rotten (by

Jones). From the group's first gig on November 6, 1975, the Pistols caused havoc and controversy anywhere they played—or were kept from playing. Still, the notoriety won them bids from multiple record labels, and on the day this shot was taken at their Denmark Street rehearsal studio they signed a contract with EMI. Bob Gruen remembers that the band had been drinking beer all day, and after champagne toasts in EMI's office, some members promptly threw up in the parking lot. Ready to celebrate: Johnny Rotten, Glen Matlock, Steve Jones, and Paul Cook (from left).

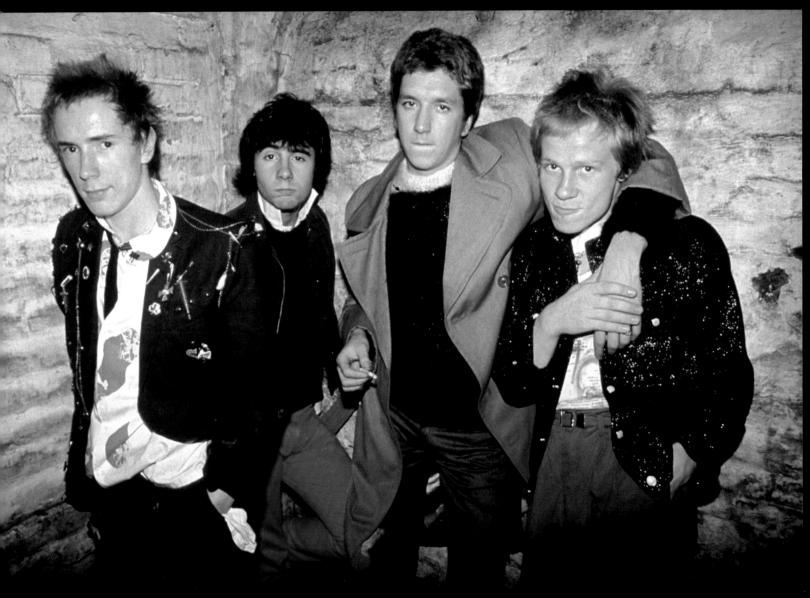

The Sex Pistols, 1976 photograph by Robert Matheu

Nearly everywhere the Pistols managed to perform, audience members were inspired to form their own bands—giving rise to the Clash, the Buzzcocks, Siouxsie and the Banshees, X-Ray Spex, and Joy Division, among others. One spectator not so impressed, however, was Detroit-based photographer Robert Matheu, who saw this gig at the Leeds Polytechnic on December 6, 1976. "I was dragged to thi show by some friends on my first visit to the UK," he recalls, "and I hated them. I hadn't heard any of their stuff yet, and I was just starting to listen to the Ramones After being a huge fan of the Stooges and MC5, I really didn't understand the anger that was projected at the gig." Seen here are Matlock, Rotten, and Jones (from left)

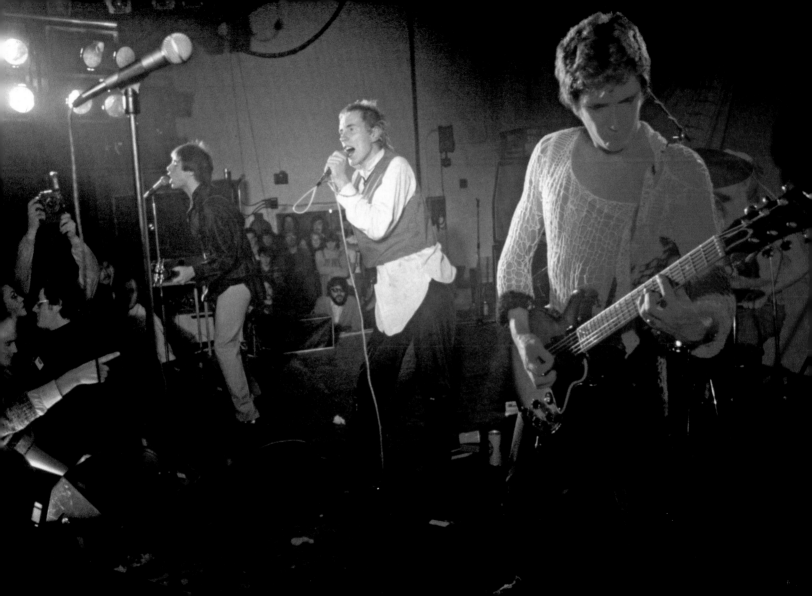

Inside Sex, 1976 photograph by Bob Gruen

On King's Road, Malcolm McLaren and his partner, the designer Vivienne Westwood, opened a provocative shop that became another ground zero for punk. They specialized in fetish clothes, in which in-your-face punks could flaunt the outrageous and forbidden. Anti–fashion plate Jordan, Sex's first full-time clerk and "model," recalled her workaday commute: "I had a lot of trouble, but what did I expect? Sometimes I'd get on a train and all I had on was a stocking and suspenders [garters] and a rubber top, that was it. Some of the commuters used to go absolutely wild, and they loved it. Some of the men got rather hot under the collar, papers on the lap." Here, seen inside Sex, fashion anarchist Johnny Rotten (center, in profile) carouses with his mates.

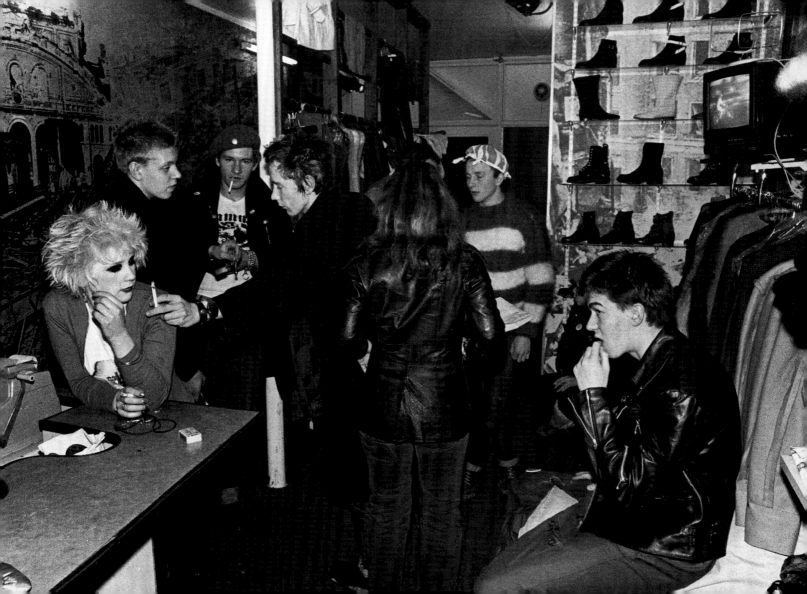

Sue Catwoman and friends, 1976 photograph by Bob Gruen

Sue Catwoman (center) helped to create the punk look in London; a protégé of Vivienne Westwood, she came up with outrageous dos and eye-catching gear. Here, wearing a dress that's been safety-pinned together, she hangs out at London's Club Louise. To her left is Marco Pirroni, who would briefly play guitar with Siouxsie and the Banshees, and in 1980 join Adam and the Ants. Right behind Sue is a baby Billy Idol, who had just changed his name from William Broad and gone from playing in the Bromley Contingent (a loose aggregation of Sex Pistols fans) with Pirroni to a short stint in Chelsea to founding Generation X with Tony James.

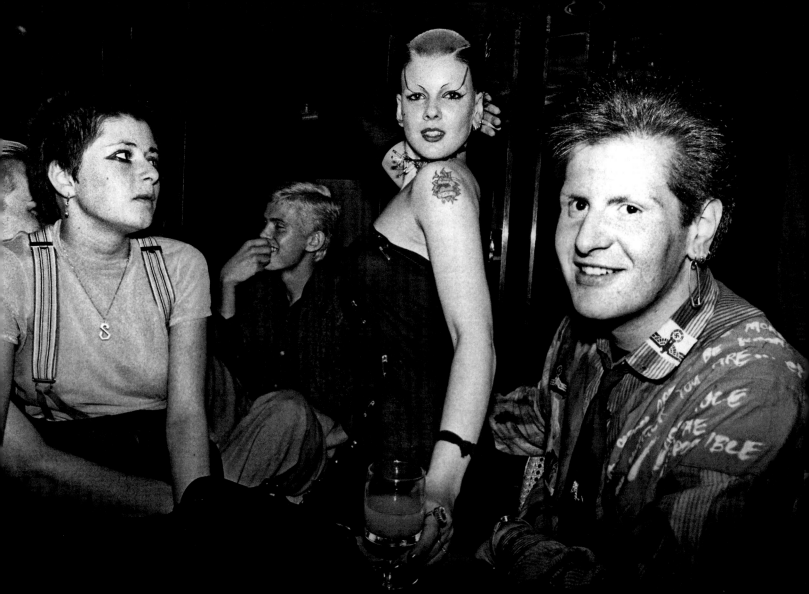

The Ramones in London, 1976 photograph by Jill Furmanovsky

On July 4, 1976, the Ramones celebrated America's bicentennial by starting another revolution that rocked British shores. Opening for their label mates, the Flamin' Groovies, the Ramones played such a propulsive set at the Roundhouse club (pictured here) that nearly every teenager in London wanted to start a punk band (the gig was followed up by a night with the Stranglers at Dingwall's). "I was trying to get a band together when I saw them at the Roundhouse," Pretenders founder Chrissie Hynde said. "The punk scene in London was very close-knit and anti-everything. The Ramones were the only 'outside' band that everybody looked up to. Sid Vicious learned to play guitar by shooting speed and staying up all night and listening to Ramones records."

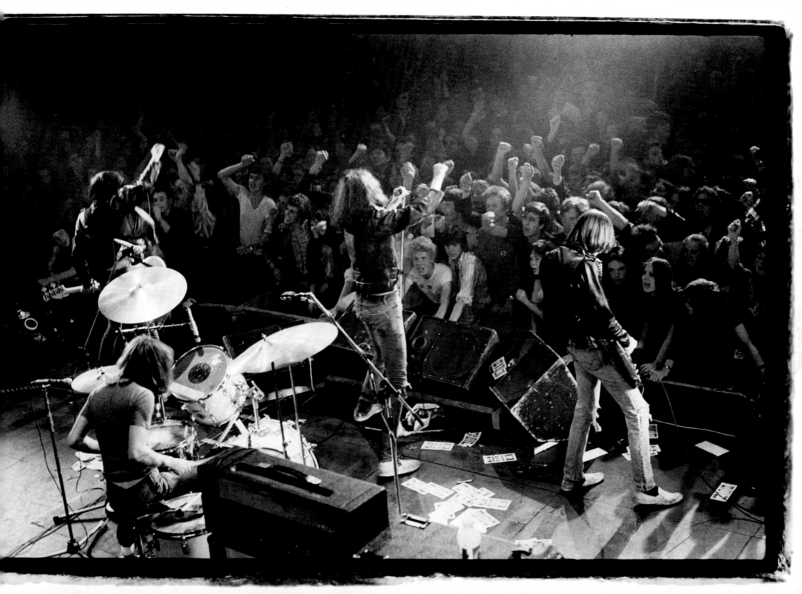

The Ramones in London, 1976 photographs by Danny Fields

When the Ramones hit town for their July gigs, the punks of London gave them the royal welcome. The band's debut had been London's number-one import album. "Now I Wanna Sniff Some Glue," which the band played at the Roundhouse, inspired a new UK fanzine, *Sniffin' Glue,* to start up. This contact sheet documents the Ramones on the town in ol' Blighty; among the images, Dee Dee can be spotted making time with Sex It Girl Jordan. Also here are Sire's label chief Seymour Stein and then-wife Linda Stein, who co-managed the band with Danny Fields. "The Ramones were the single most important group that changed punk rock," according to Generation X bassist Tony James. "When their album came out, all the English groups tripled speed overnight."

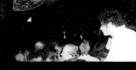

KODAK SAFETY FILM 5063

Malcolm McLaren, 1977 photograph by Bob Gruen

Through his long friendship with the New York Dolls, New York photographer Bob Gruen had already met Malcolm McLaren; beginning in 1976, McLaren gave the lensman carte blanche to photograph the Sex Pistols. Gruen recalls that the day he took this picture of McLaren in his Shaftesbury Avenue office, both UK music weeklies, *NME* (*New Musical Express*) and *Melody Maker* (seen here on McLaren's desk), had Gruen's photos on their covers. Before forming Generation X, Tony James met McLaren who told him "what would happen" once the Sex Pistols formed. "That a group would com along and completely shake up the music business and alter things utterly. And it al came grizzily true."

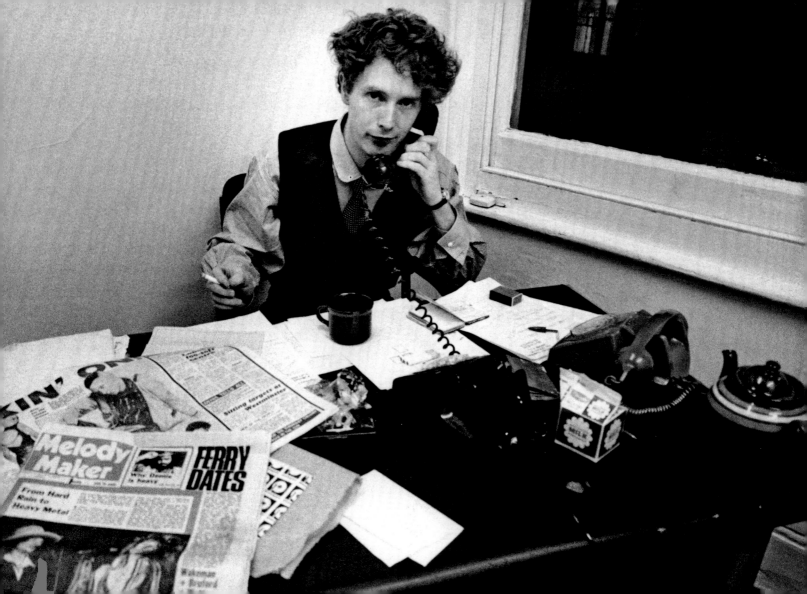

The Sex Pistols, 1977 photograph by Janette Beckman

Bassist Glen Matlock was dumped by the Pistols in early 1977 for writing songs that were too pop. "Glen was a mummy's boy," Rotten complained. "The best musician out of the lot of us, but too bogged down in the Beatles." He was replaced by John Simon Ritchie, whom "mentor" Johnny Rotten dubbed Sid Vicious after showing him a few bass licks. Sid played his first gig with the band on February 13. After Rotten, he would become the most notorious Sex Pistol. Soon the poster boy of punk, he found himself living up to his name. Bringing in the trash: Sid Vicious, Johnny Rotten, Steve Jones, and Paul Cook (from left).

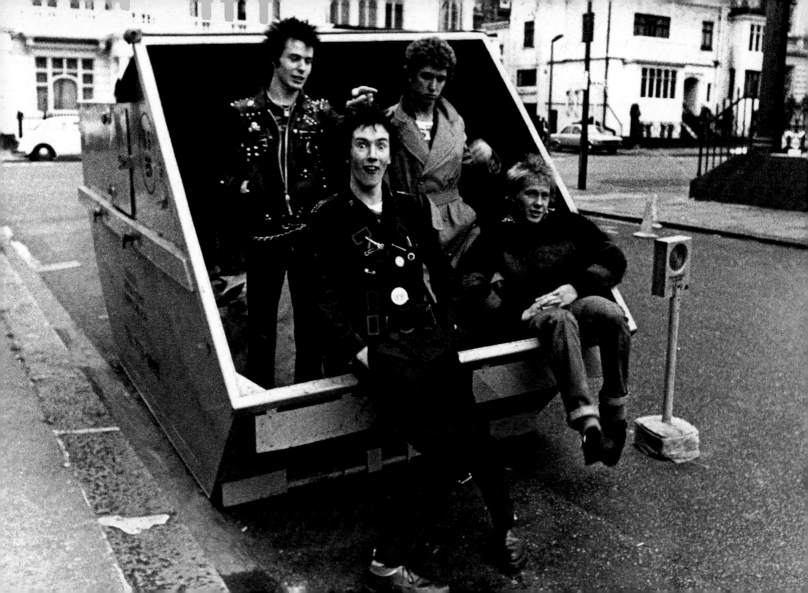

Vivienne Westwood, 1976 photograph by Bob Gruen

"In its glory days, punk fashion followed Iggy Pop's instructions for forgotten boys and girls to gain notice—Search and Destroy," *L.A. Times* chief music critic Ann Powers once noted. "Punk gave contemporary fashion a juvenile-delinquent phase. Its self-made style icons gleefully trashed conventions of beauty and glamour while pickpocketing from the coolest underground styles of the previous century." Punk imagemaker Vivienne Westwood created designs sold in the Sex boutique that helped spread the antifashion described by Johnny Rotten as "anything that annoys." Westwood has remained a fashion anarchist ever since. In 1992, when she received the Order of the British Empire, she wore a see-through blouse and no underwear. Photographed inside Sex in October 1976, Westwood is accompanied by her protégés Jordan and Sue Catwoman, seen hanging out in the background.

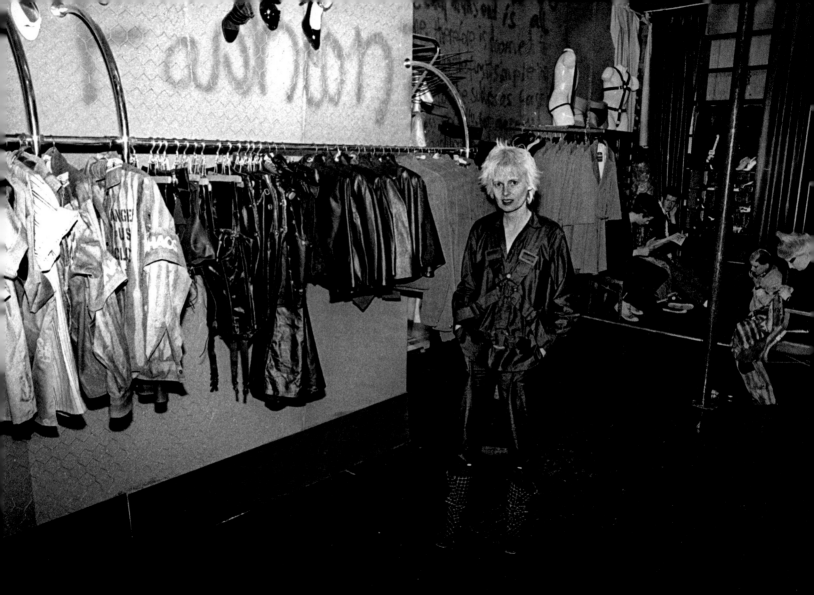

Sex, 1976 photograph by Bob Gruen

When Gruen shot the King's Road facade of Sex in October 1976, the boutique's windows displayed naked mannequin torsos. Shortly thereafter, following a December 3 TV appearance during which the Sex Pistols cursed crotchety host Bill Grundy, UK tabloids ran lurid headlines—THE FILTH AND THE FURY!—and vandals began attacking the storefront. Eventually, Malcolm McLaren and Vivienne Westwood installed a wire barricade in front of the glass to protect it against an onslaught of rotten vegetables and other debris tossed by angry Londoners. In his autobiography, John Lydon (aka Johnny Rotten) described Sex as selling "rubber wear and bondage gear, which, of course, was highly appealing to any teenager who wanted to be decadent." The shop ultimately shut down, and McLaren and Westwood opened a new one called Seditionaries.

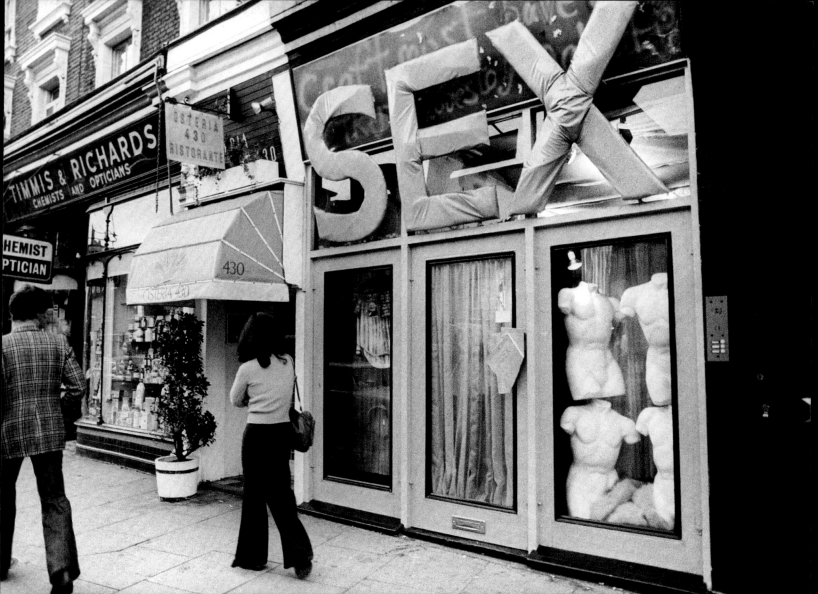

The Sex Pistols, 1977 photograph by Janette Beckman

Sid Vicious, Johnny Rotten, Paul Cook, and Steve Jones (from left) at a London club. "I didn't know how to play, but once we got John in the band I had to learn guitar seriously. I'd wake up in the morning at our studio on Denmark Street, take a black beauty, and play along with an Iggy Pop record and the New York Dolls' first album . . . I would learn those bits along with what we were rehearsing the previous night. I barely got my barre chords together to play songs. I threw a little bit of Chuck Berry in the lead and that was it."

—Steve Jones

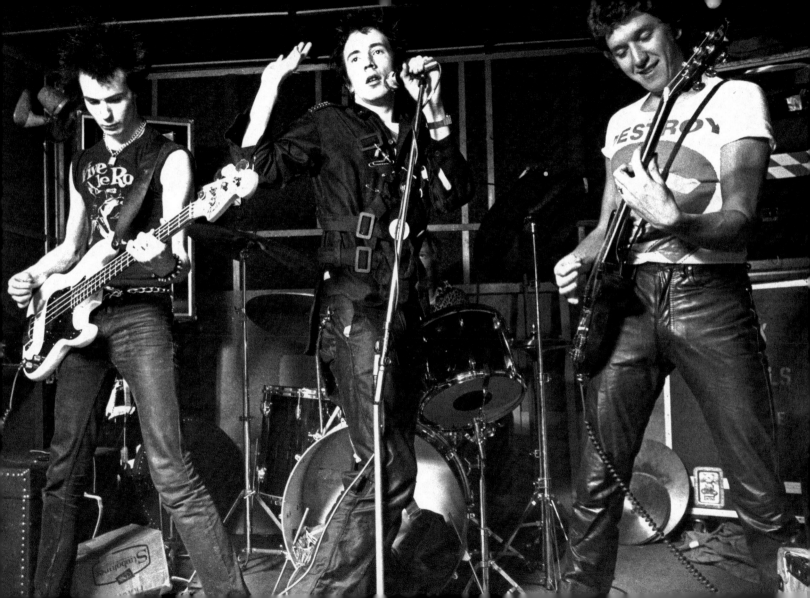

The Sex Pistols, 1977 photograph by Bob Gruen

In March 1977, the Sex Pistols signed a new contract with A&M Records, only to be dropped days later after getting into a fracas at the label office. The group then inked a deal with Virgin, which released the band's second single, "God Save the Queen." Paul Cook, Johnny Rotten, Steve Jones, and Sid Vicious (from left) traveled to tiny Luxembourg to broadcast on Radio Luxembourg, the offices of which had served as a Nazi headquarters during World War II. Bob Gruen recalls that the building's history inspired the Pistols to behave even worse than usual. Upon arrival inside, Steve Jones promptly pulled his pants down, which outraged the radio personnel, who began to argue over whether or not to permit the band to go on the air. On September 20, 1977, the *New York Post* reported, "Inspired by a 'fascist-like' TV performance by the Sex Pistols, the newspaper of the Young Communist League in the Soviet Union has brought its Marxist wrath to punk rock: 'The music and lyrics of punk rock provoke among the young fits of aimless rage, vandalism and the rage to destroy everything they get in their hands. No matter how carefully they try to clean it up, it will remain the most reactionary offspring of the bourgeois mass culture.'"

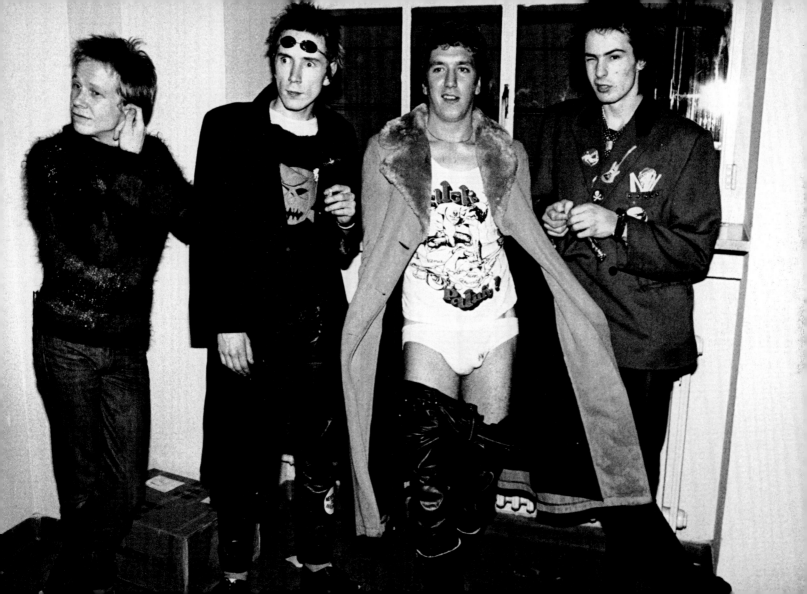

The Sex Pistols, 1977 photograph by Bob Gruen

En route to Luxembourg, the Pistols
stopped along the way for 11:00 a.m.
libations—vodka & OJ. "They were very
much like the Marx Brothers," Gruen
recalls of Johnny Rotten, Sid Vicious,
Steve Jones, and Paul Cook (from left).
"If I said, 'Group picture!' they would
either jump up and do something funny o
they would run in the opposite direction.
They would never just pose for a picture.
If one of them got an idea for a photo, the
other three would just spontaneously fall
into it—they were very much in sync."

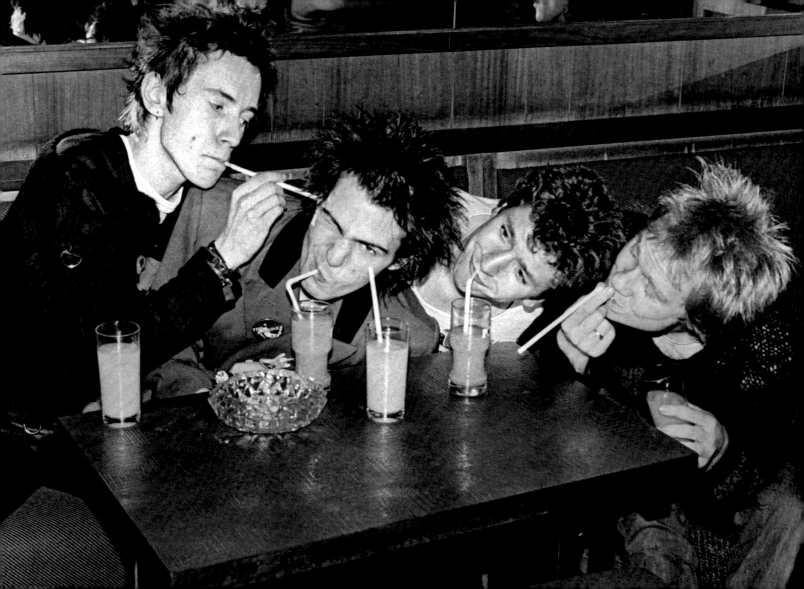

The Clash's Joe Strummer and Paul Simonon, 1977

photograph by Jill Furmanovsky

The Clash became the premier political punk outfit to emerge in London, eventually dubbed "the only band that matters." Singer/guitarist Joe Strummer (b. John Graham Mellor), who had been playing with pub rockers the 101ers, joined forces with art student–cum–bassist Paul Simonon (at right) and members of the London SS. The latter's guitarist/vocalist Mick Jones and drummer Tory Crimes (b. Terry Chimes), along with axman Keith Levene, constituted the original quintet, dubbed the Clash (by Simonon, inspired by newspaper headlines). The band's first gig was opening for the Sex Pistols, with whom they soon embarked on the Anarchy tour of Britain (as a quartet, minus Levene, whom the band fired). The Clash's incendiary live shows helped them garner, in early 1977, a deal with CBS Records—which infuriated some fans who accused the band of selling out. The melee that erupted at London's prestigious Rainbow Theatre—the audience ripped out the seats—at the May 9 finale of the band's White Riot tour "was a massive punk statement," said Mark P, founder of the fanzine *Sniffin' Glue.* "It was brilliant mayhem ... The Clash played a storming set in a theatre that was regarded as being at the center of the rock establishment ... Punk was now big time."

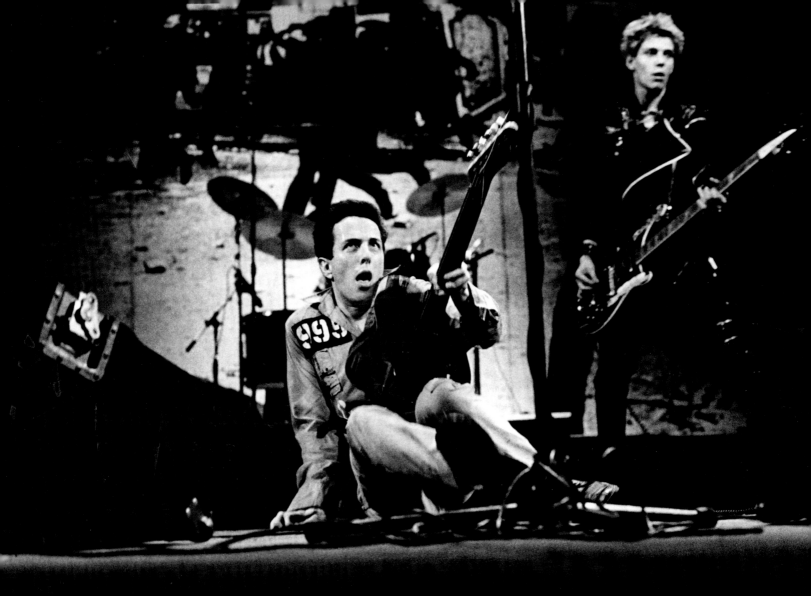

Chrissie Hynde, Jordan, and Jayne/Wayne County, 1977

photograph by Jill Furmanovsky

American expat Chrissie Hynde (left), hanging at the 100 Club, had fled Kent State to live in London. While attempting to get a band together, she wrote for the *NME*. She taught Johnny Rotten a few guitar chords and briefly played with future members of the Damned in an outfit called Masters of the Backside. Fellow émigré Jayne/Wayne County had also relocated to London, perfecting a new persona as Queen Elizabeth there. The 100 Club had been the primary breeding ground for punk bands, hosting some of the Sex Pistols' early gigs and the two-day Punk Festival the previous September. Located at 100 Oxford Stree in London's West End, the club had long been a venue for jazz and rock groups. But the management soon tired of the damage and chaos becoming part of the punk shows; during the Punk Fest, one audience member was injured when a broken glass was hurled into the crowd. Not long after this photo was taken, punk gigs were banned from the club.

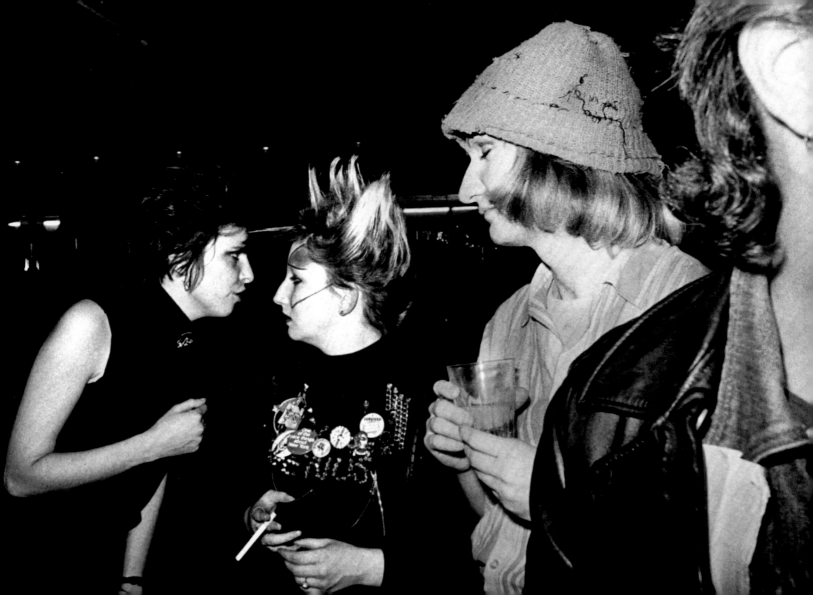

The Saints, 1977 photograph by Jean-Gras Veuige

Down Under, punk was brewing too—the Australian band the Saints, founded in 1975 by guitarist Ed Keupper and vocalist Chris Bailey, was a garage band with a driving sound behind catchy hooks. Their "(I'm) Stranded," with its snarling vocals, was anthemic punk. Around the time of their first album ('77), the group—Keupper, drummer Ivor Hay, bassist Kim Bradshaw, and Bailey (from left)—relocated to London. Two years later, Keupper departed, and the Saints moved into poppier, almost folkie terrain.

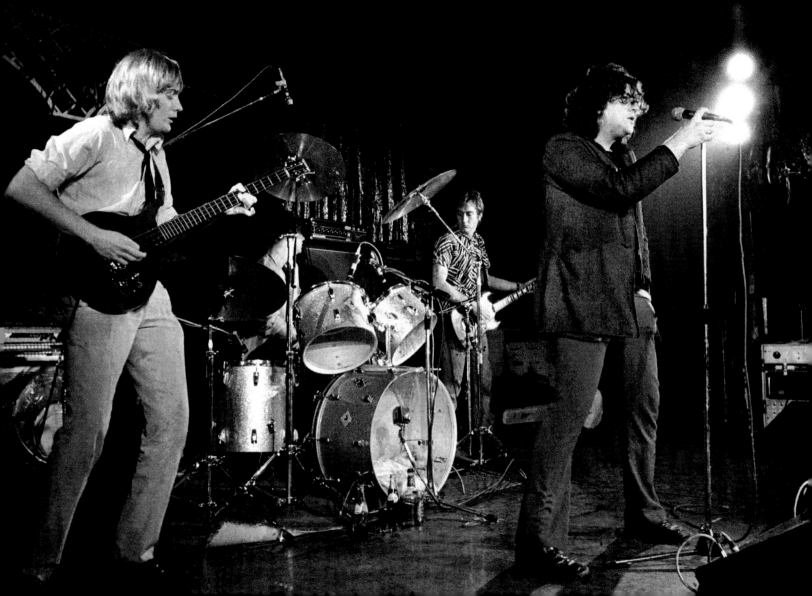

X–Ray Spex, 1977 photograph by Bob Gruen

Another band formed under the sway of the Sex Pistols, X-Ray Spex was led by belting nineteen-year-old vocalist Poly Styrene, whose churning "Oh Bondage Up Yours," "Identity," and "The Day the World Turned Day-Glo" became punk anthems in Britain and America. Born Marion Elliott to Somali and English parents, Poly Styrene placed an ad in *Melody Maker* for "young punx who want to stick it together," and X-Ray Spex—originally featuring sixteen-year-old sax player Lora Logic—was born. The band held down a longtime residency at the pub Man in the Moon and made its first single after just three gigs.

105

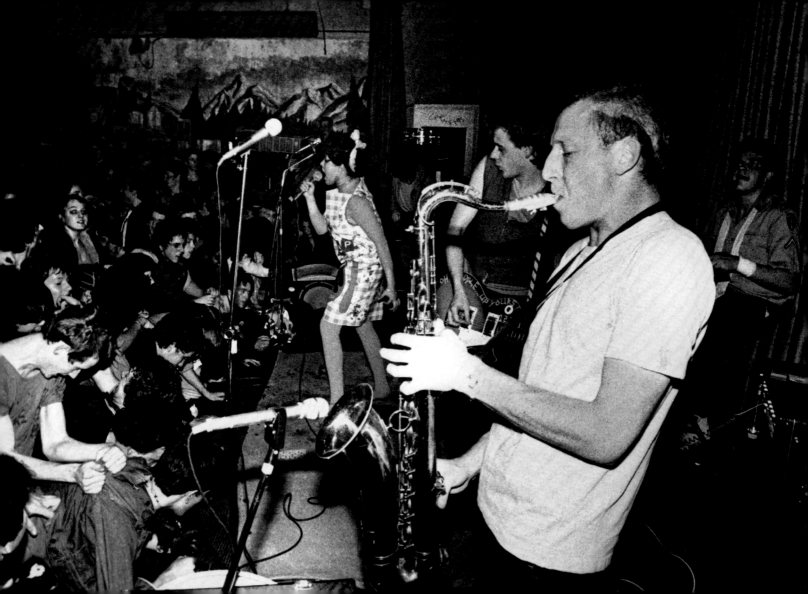

The Stranglers' Hugh Cornwell, 1977 photograph by Jill Furmanovsky

When they formed as the Guildford Stranglers in 1974, vocalist/guitarist Hugh Cornwell's group predated punk but, with their amped-up sonics, fit into the scene. Their album *Rattus Norvegicus IV* was the first commercially successful punk album, hitting the UK Top Ten in May 1977. Around that time, the band played London's Rainbow Theatre (where Cornwell is shown). The front man would later run into trouble with the law; in 1980, he was busted for possession of heroin, cocaine, and pot, and was sentenced to five weeks in jail.

Sniffin' Glue staffers, 1977 photograph by Jill Fumanovsky

At the Ramones' July 1976 Roundhouse gig, there was no souvenir program for fledgling punk rockers to take home. Instead, the premier issue of singular punk fanzine *Sniffin' Glue ... and Other Rock 'n' Roll Habits* was distributed by its founder, Mark P; the title, in addition to referencing the Ramones' song about the nasty habit, was derived from a Lenny Bruce bit. "The first issue was very primitive, but extremely enthusiastic," Mark P recalled in his book *And God Created Punk.* "No photos, just badly typed text with bold felt-tipped titles and page headings." Here, Mark P, photographer Harry Murlowski, and writer/editor Danny Baker dash through Dryden Chambers off Oxford Street, home to *Sniffin' Glue.* The zine's offices were first lent by Geoff Travis of Rough Trade, the record label that sprang from a record shop, and then by I.R.S. Records founder Miles Copeland.

Siouxsie Sioux and Steve Severin, 1976 photograph by Bob Gruen

Siouxsie Sioux (b. Susan Dallion) was a
key member of the Bromley Contingent,
composed of audience members from
an early Sex Pistols gig. With Steven
Havoc (aka Severin), she made her first
onstage appearance at the Punk Fest
on September 20, 1976, at the 100
Club. With Sid Vicious on drums, they
performed feedback-drenched versions
of "The Lord's Prayer" and Dylan's
"Knockin' on Heaven's Door." In 1977,
Siouxsie and the Banshees rehearsed in
earnest, wrote some songs, and honed
their live attack. By the next year, they had
a deal with Polydor and released their firs
album, *Scream.*

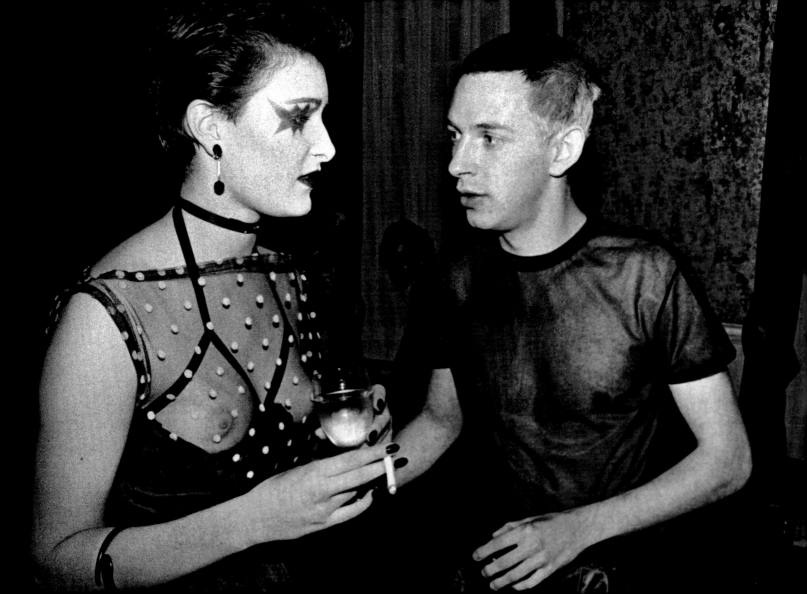

Generation X, 1977 photograph by Jill Furmanovsky

William Broad—another member of the Bromley Contingent with Siouxsie Sioux and Steve Severin—changed his name to Billy Idol and signed on as guitarist for a band founded by the owner of a trendy punk boutique called Boy. The group, Chelsea, also featured bassist Tony James and drummer John Trowe. Deciding they could do without lead singer Gene October, the band split and formed Generation X, with Idol taking over the front-man spot. They played their first gig at the Central London College of Art (Joe Strummer's alma mater) in December 1976. Here, the band performs in the London suburb of Deptford, not far from Idol's home in Bromley. Among the poppiest of the punk bands, Generation X released several hit singles in '77, including "Your Generation" and "Ready Steady Go," and was the first punk group to appear on *Top of the Pops.*

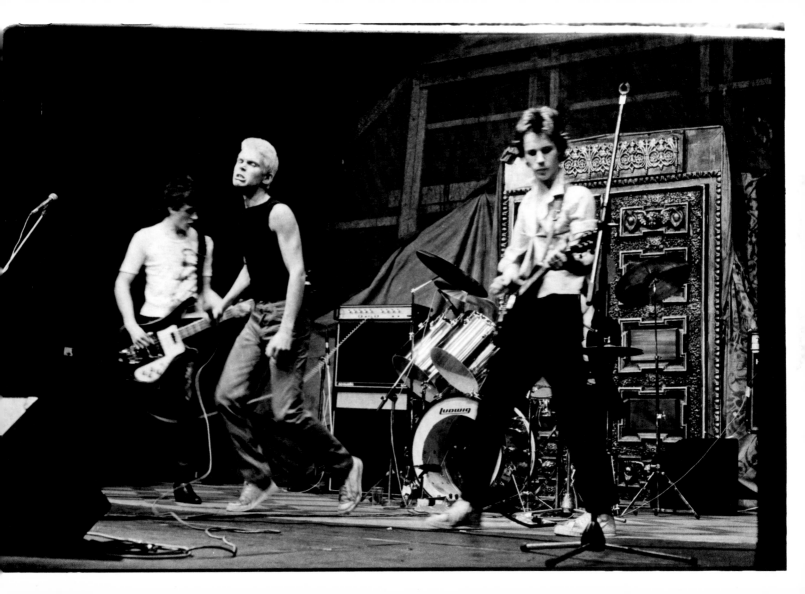

The Buzzcocks, 1977 photograph by Jill Furmanovsky

Manchester's first punk band, the Buzzcocks, formed soon after the Pistols played that city in 1976. According to founding member Pete Shelley, "There's a difference between what punk was and what it appeared to be. For me, it wasn't the physical appearance that was the important thing. It wasn't how the Sex Pistols dressed or the actual records themselves. It was the actual *doing* of them—and the humor that was involved ... Viewed as an artistic thing ... it was a performance art. It was avant-garde. It was an adventure, something you launched yourself into. It was an alternative lifestyle. And after they [the Sex Pistols] swore on TV, it then became a way to show rebellion and opt out. But before that, it was a very lonely way of being different." This photo of guitarist Steve Diggle, drummer John Maher, vocalist / guitarist Pete Shelley, and bassist Garth Smith (from left), which Furmanovsky took in a Manchester bookshop, inspired the song "Fiction-Romance" on the Buzzcocks' 1978 album *Another Music in a Different Kitchen.*

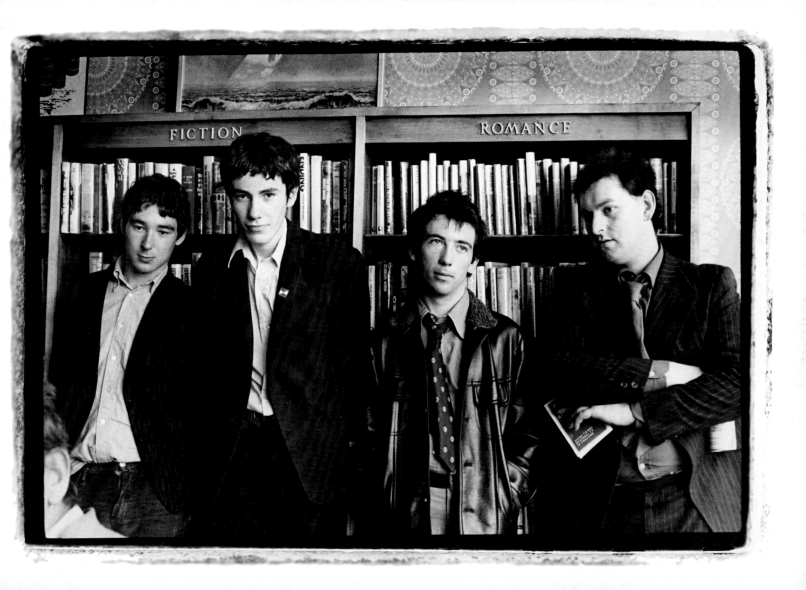

Slaughter and the Dogs, 1977 photograph by Jill Furmanovsky

Hailing from Manchester, Slaughter and the Dogs formed in 1976, inspired by David Bowie, MC5, and, of course, the Sex Pistols. The band began making trips into London to play the Roxy, where most punk bands gigged in '77. They put out their first single, "Cranked Up Really High," the same year. Dissension within the group caused Slaughter and the Dogs to implode in 1978, around the time of their debut LP, *Do It Dog Style.* A latter-day version of the group, briefly re-formed, included guitarist Billy Duffy and lead singer Steve Morrissey, but after failing a recording audition, the band disintegrated again. Duffy would go on to form the Cult, and Morrissey would start the Smiths.

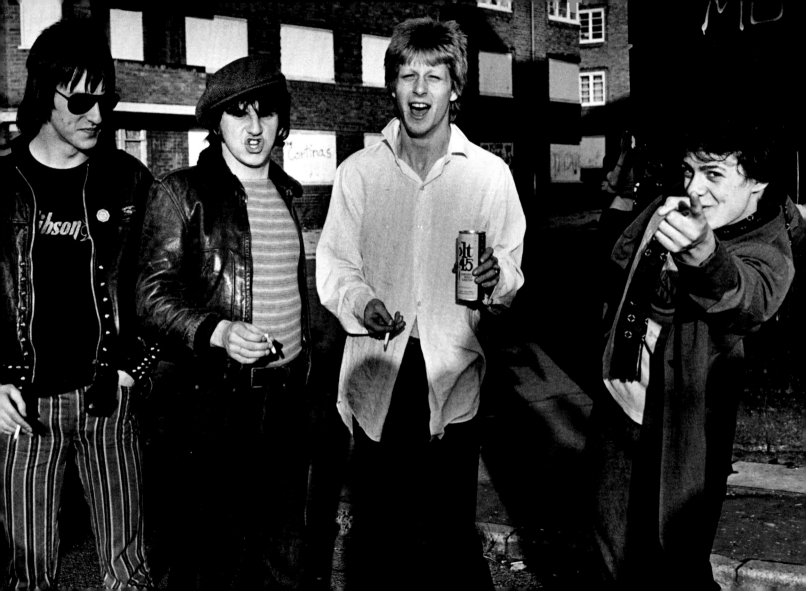

The Cortinas, 1977 photograph by Jill Furmanovsky

Like so many others, the seventeen-year-old members of the Cortinas—originally an R&B combo from provincial Bristol, England—got swept up in the sound of the Sex Pistols. "[The Cortinas] epitomized the teenage groups that were forming all over Britain as a response to the punk rock explosion," according to *Sniffin' Glue*'s Mark P, who eventually released singles by the band on his Step Forward label. Their 45s "Fascist Dictator" and "Defiant Pose" demonstrated their political leanings, but during the sessions, remembered Mark P, "they treated the whole thing as a great day out."

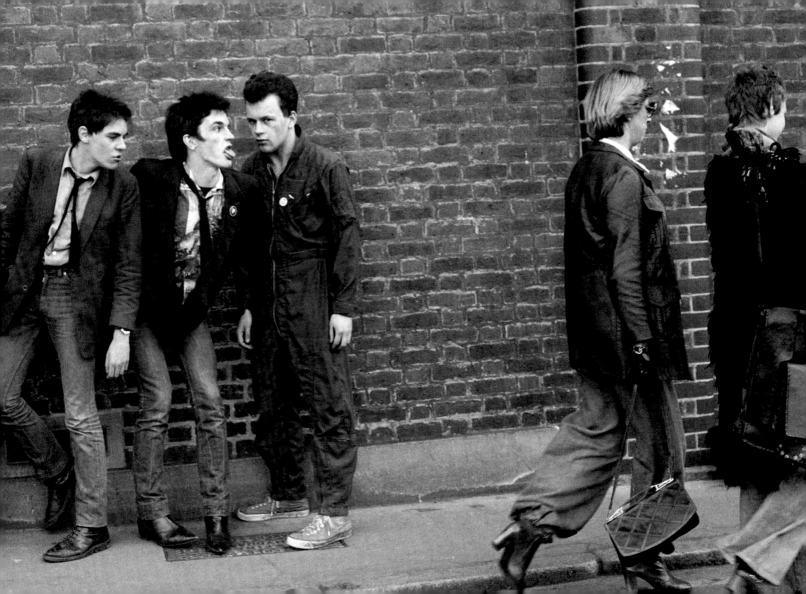

Chelsea, 1977 photograph by Jill Furmanovsky

Formed in 1976, Chelsea had a continually revolving membership. Vocalist Gene October (center) had to recruit a new lineup when his original instrumentalists departed to form Generation X with former Chelsea guitarist Billy Idol. Membership continued to evolve, with October the on constant. Chelsea's self-titled first albun was released on the Mark P / Miles Copeland label Step Forward in 1979.

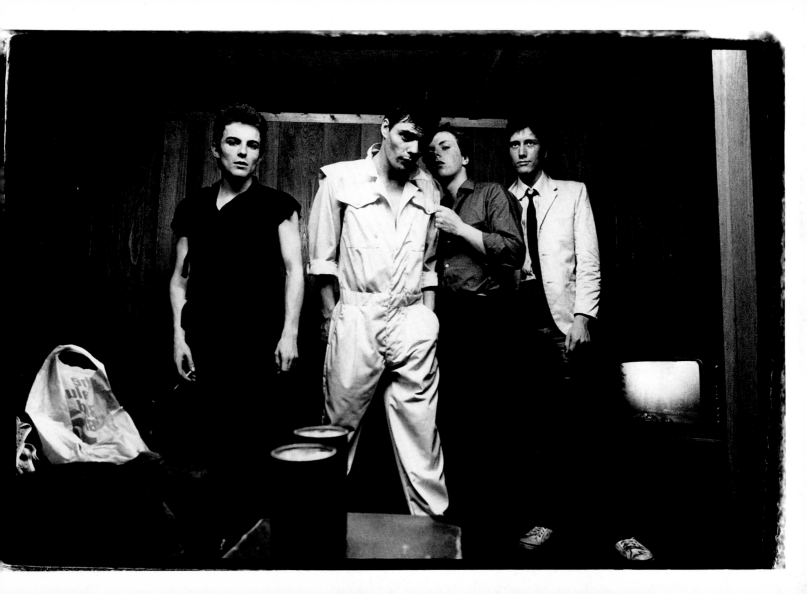

Menace at the Roxy, 1977 photograph by Jill Furmanovsky

At the Roxy, the action on the dance floor could be just as intense as the action onstage. The grimy club became the epicenter of punk after various incidents of violence led some venues, like the 100 Club, to ban punk groups. Don Letts, a Rastafarian from Brixton, manned the DJ "booth" at the Roxy, turning young pogoers on to Jamaican dub 'n' bass. Andy Czezowski had opened the club on December 21, 1976, with a show by Generation X, who Czezowski managed. Its heyday lasted for just a few months, until May 1977, after which it changed hands and lost some of its vibe. Punk bands continued to play there, but the original crew had moved on to bigger venues—similar to what happened when Television, the Ramones, Patti Smith, Richard Hell, and the Talking Heads stopped playing CBGB.

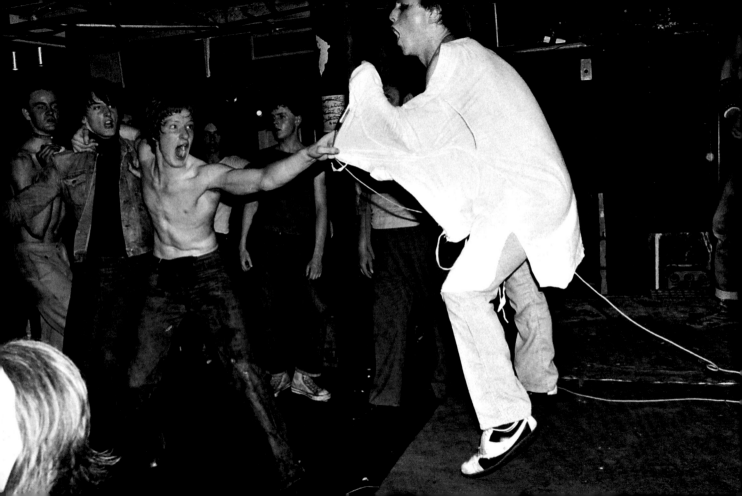

Here bathed in a green light, Elvis Costello played theaters across America with the Attractions (including drummer Pete Thomas, also shown) in 1977. That year, Costello's debut album, *My Aim Is True*, hit the Top Forty in America. "When I started, I swore to myself I'd always try to avoid writing songs about hotel rooms," Costello once told UK journalist Nick Kent. "But then inevitably many of my most lurid experiences in the past have taken place in hotel rooms, so that's just part of the job." After the tour, Costello returned to England to record his second album, *This Year's Model*, with the Attractions.

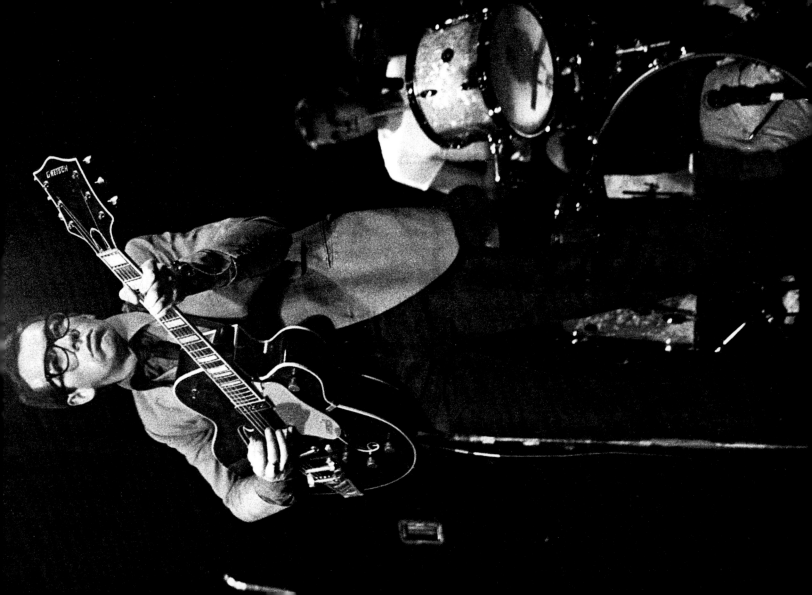

Graham Parker & the Rumour, 1978 photograph by Jill Furmanovsky

A fan of the Beats who'd hitched around Europe, busking along the way, Graham Parker was another singer-songwriter who fit into the punk scene thanks to his angry-young-man stance. He was discovered in 1975 by Dave Robinson, who would soon start the seminal UK label Stiff Records. Robinson became Parker's manager and introduced him to a group of pub-rock veterans, the Rumour. The former members of Brinsley Schwarz and Ducks Deluxe superbly backed Parker's soulful vocals on a pair of 1976 albums, *Howlin' Wind* (produced by Brinsley Schwarz's Nick Lowe, who also produced Elvis Costello in '77) and *Heat Treatment*. These were followed by four more collaborative LPs. Here, at London's Venue in November '78, the Rumour and Parker perform: bassist Andrew Bodnar, drummer Stephen Goulding, Parker, and guitarist Brinsley Schwarz (from left).

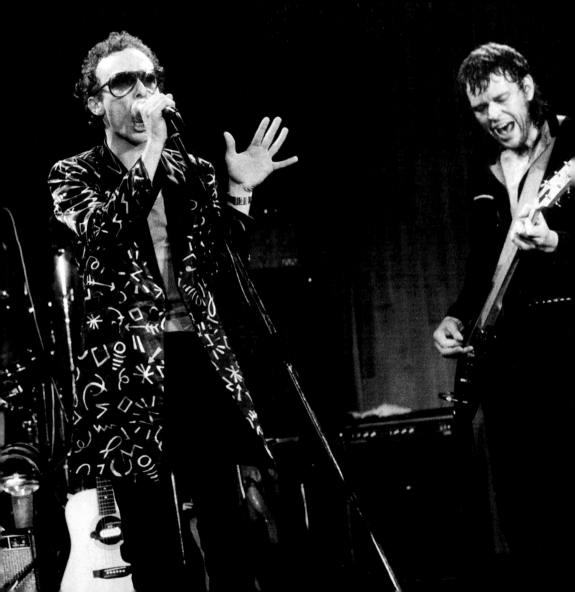

Ian Dury, 1980 photograph by Janette Beckman

Another member of the loose-knit pub-rock crew, Ian Dury became one of Stiff Records' first artists, croaking catchy songs with a thick Cockney accent. Though he was older than most members of punk bands and had suffered the debilitating side effects of polio, his working-class sensibility and dark humor endeared him to punk fans. His first releases, in 1977, were the anthemic single "Sex & Drugs & Rock & Roll" and the album *New Boots and Panties* (both Stiff releases). Soon after, he formed the Blockheads with pianist Chaz Jankel, which produced such hits as "Hit Me with Your Rhythm Stick" and "Reasons to Be Cheerful." Here, Dury performs in Aylesbury, England.

Wreckless Eric, 1979 photograph by Robert Matheu

Stiff artist Wreckless Eric was born Eric Goulden but was christened with his new name thanks to, well, reckless behavior. Among his catchy tunes was "Whole Wide World," which returned to the public consciousness nearly thirty years later when used in the 2006 Will Ferrell film *Stranger Than Fiction*. Wreckless Eric frequently toured as part of the Stiff Records package tour and on his own. Here, he hangs out backstage at Detroit's Bookies Club 870—Motor City's first and only punk club, according to photographer Robert Matheu.

Elvis Costello, 1978 photograph by Roberta Bayley

At a tour stop in Philadelphia, Roberta Bayley photographed Costello; his badge reads RICH and was purchased at a truck stop. "No one ever bought one of my records because of my looks," Costello once said. "I could have gone without the glasses, worn contacts and tried to look handsome … but actually my early image looked kind of sexy. Who would have thought it?"

Graham Parker, 1978 photograph by Stephanie Chernikowski

Here photographed on the rooftop of Manhattan's Gramercy Park Hotel, Graham Parker was in 1978 in the midst of a Stateside tour. Many UK bands stayed at the then somewhat down-at-the-heels hotel, located next to Manhattan's only private park, off Twentieth Street (the hotel underwent renovations in 2006 and now costs five hundred dollars a night). In a 1996 short story entitled "The Evening Before," Parker described those late-'70s punk days via the goings-on of a fictitious protagonist whose band had just played New York: "The Evening Before Pills came to me, like many gifts of dubious merit, backstage at a New York club gig. There, my band and I, the Debilitators, had given a rip-snorting performance to a packed house of rabid, leather-clad lunatics whose sole reason for being at the show—it appeared from my view on the stage—was to project streams of beer and spittle into my mouth and to severely damage themselves either with substance abuse or the now-quaint ritual of mass pogoing."

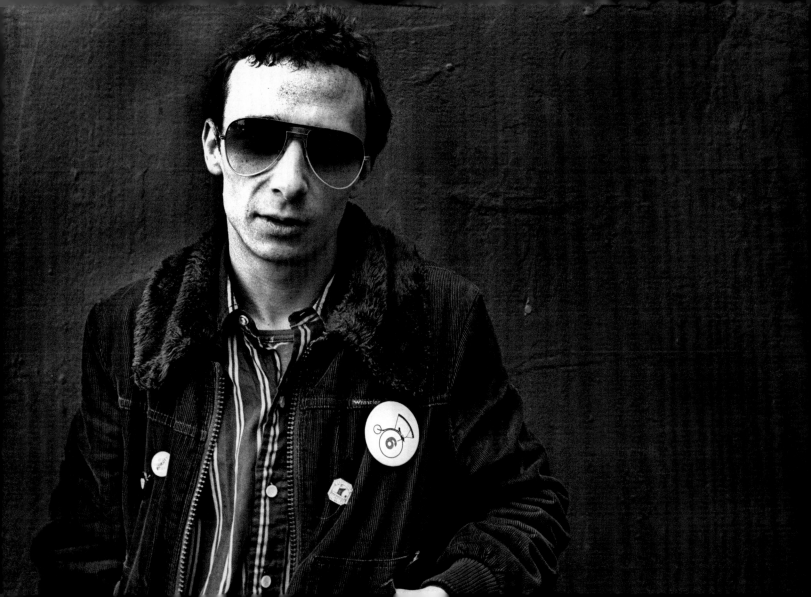

The Slits, 1977 photograph by Jill Furmanovsky

Formed in the wake of an early Sex Pistols gig, the Slits became one of the most influential all-woman bands to emerge in London. Drummer Palmolive (born Paloma Romano in Spain) and guitarist Viv Albertine, the latter of whom had played in a group called the Flowers of Romance (with Sid Vicious on drums), started the band in January 1977; fourteen-year-old Arianna Forster, who changed her name to Ari (or Arri) Up, soon signed on as lead singer. Her mother had been a concert promoter in Europe, and would eventually marry Johnny Rotten (after he'd reassumed the name John Lydon). Two of the original members, Kate Korus and Suzy Gutsy, left and joined the poppier all-female punk outfit the Modettes. With bassist Tessa Pollit, the Slits embraced reggae and used dub rhythms behind confrontational lyrics, in songs like "Typical Girls." Mark P recalls seeing the Slits' first gig, when they opened for the Clash in March. "I've got to admit they scared the shit out of me . . . Ari-Up danced around screaming the lyrics like a wailing banshee . . . They were dangerous and their very presence threatened those that considered rock to be a male-only pursuit. To me their existence was liberating: part of punk's attempt to push down barriers and change the rules." Here, Pollit, Up, Albertine, and Palmolive (from left) play London's Music Machine.

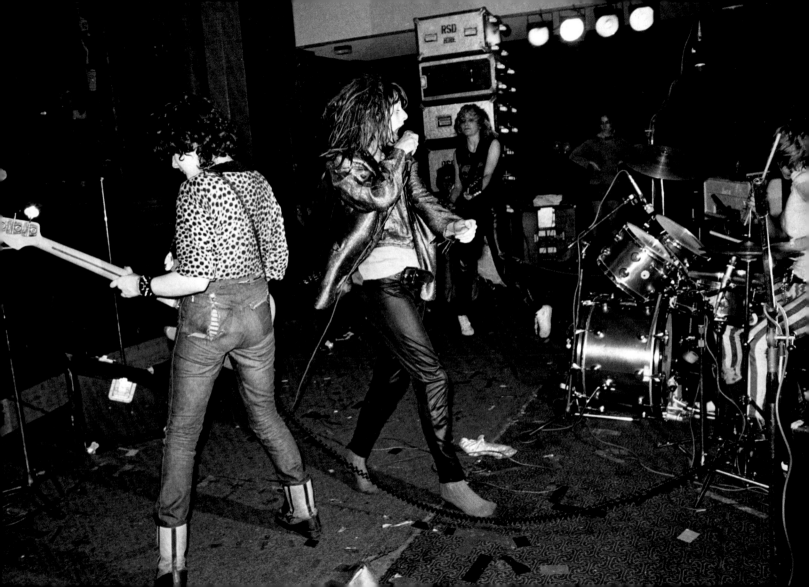

The Damned, 1976 photograph by Bob Gruen

Photographer Bob Gruen recalls being totally shocked at the violence he witnessed, while accompanied by Chrissie Hynde, at this gig by the Damned. The band had become renowned as the clown princes of punk, thanks to the antics of bassist Captain Sensible and drummer Rat Scabies. Front man Dave Vanian, who had worked as a gravedigger, gave birth to the goth look with his draconian do and makeup. At this particular London club show, Gruen remembers first witnessing stage diving and moshing—a few years before becoming commonplace among hardcore punk fans in Los Angeles and New York. The Damned finished this performance by destroying a piano and with Captain Sensible "pissing onto the audience," according to Gruen.

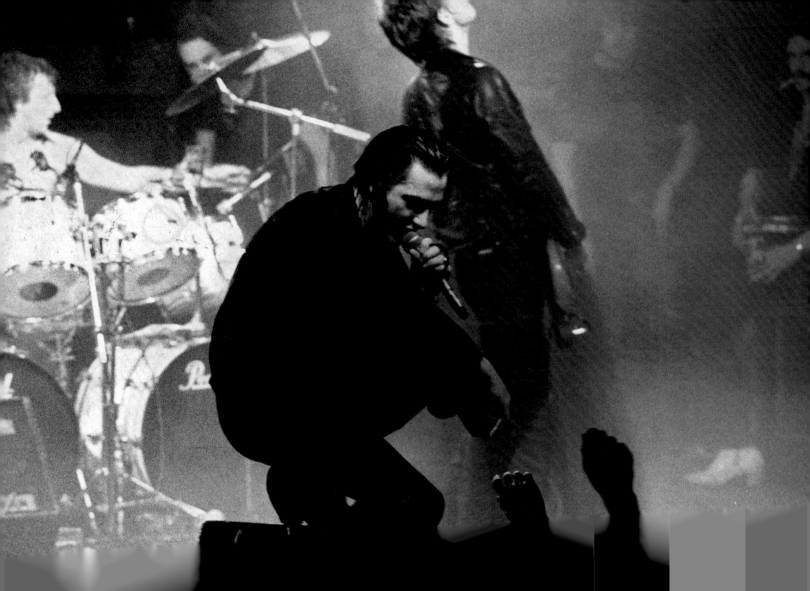

The Jam, 1977 photograph by Jenny Lens

The mid-'60s mod scene, typified by the early Who, was another influence in the mid-'70s punk scene, primarily among the Jam. Formed by Paul Weller, the trio fastidiously dressed and played the same instruments as their British counterparts did circa 1966. They were known for their amazing live sets and won over many U.S. fans during tour stops in New York and Los Angeles beginning in '77. Here, the Jam—guitarist / vocalist Paul Weller, bassist Bruce Foxton, and drummer Rick Buckler—play the Whisky a Go-Go on October 6, 1977.

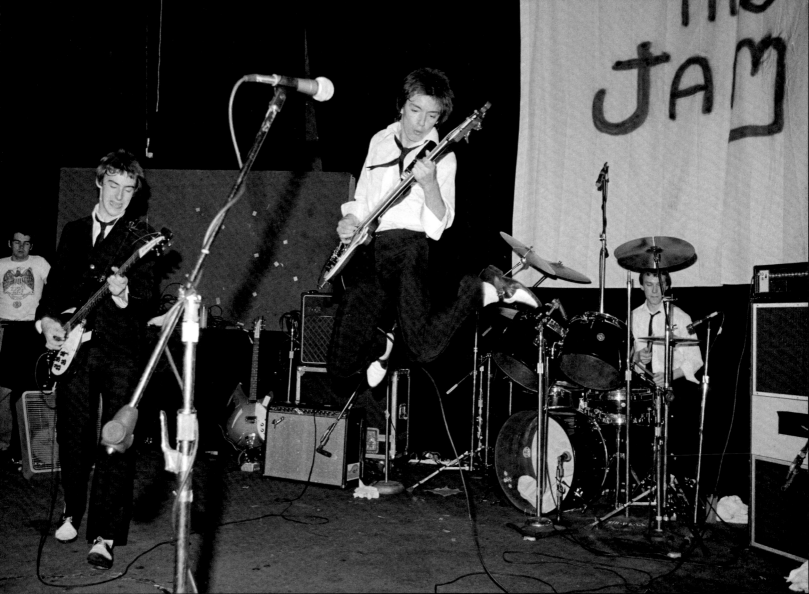

Jimmy Pursey under arrest, 1977 photograph by Jill Furmanovsky

This photo of Sham 69 vocalist / mastermind Jimmy Pursey being arrested outside the Vortex Club in London was chosen to illustrate the picture sleeve for the band's live single "Ulster Boy" on Step Forward Records. Sham 69 had played on the rooftop of a building on Hanway Street, just as the Beatles had for *Let It Be.* But Sham 69 was not the Fab Four, and authorities arrested Pursey and put an end to the gig, which included the band's growing number of skinhead followers. The skins took to Sham's working-class anthems and misinterpreted their political motivation, mistakenly invoking Sham lyrics in their own neo-Nazism. Their cries of "Sieg Heil" at Sham 69 gigs became increasingly disruptive.

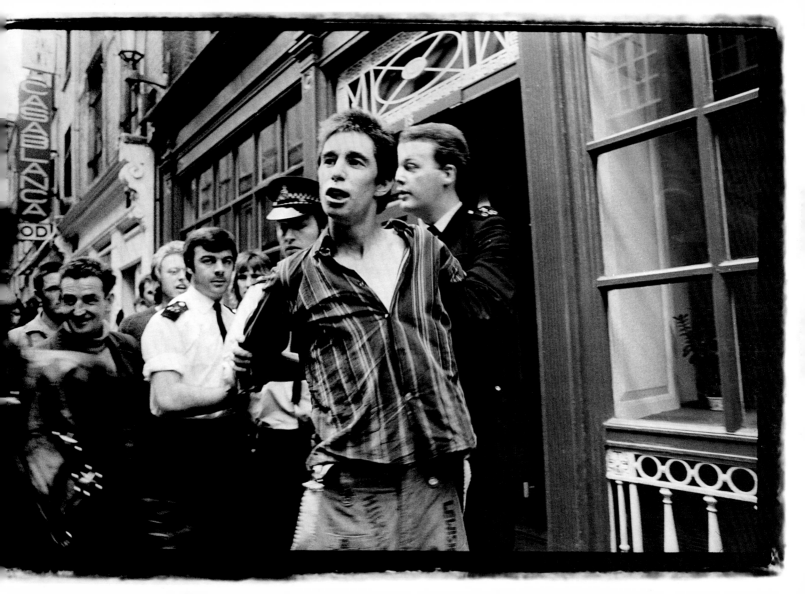

Boy, 1979 photograph by Janette Beckman

By 1978, one of the hippest King's Road spots to have emerged for punk apparel was Boy; as had the scene in general, the shop attracted some kids going for the skinhead look, as popularized by neo-Nazis in the National Front. What had been used as ironic, in-your-face symbology by Westwood and McLaren, Siouxsie Sioux, and the Pistols—such as swastikas—was taken seriously by some young punks. The shorn hair, jackboots, and fascist imagery became another "style" that invoked horror and dread in bystanders. Boy's owner John Krivine featured such garb as "T-shirts with dried animal blood, with mockup death pictures of Gary Gilmore [who had just been executed in Utah], and jewelry made out of hypodermic syringes and contraceptive packets. On the walls were framed newspaper front-pages, each with 'Boy' in the headline, like 'Boy of 12 on Murder Charge,'" according to Jon Savage's authoritative study of UK punk, *England's Dreaming.*

125

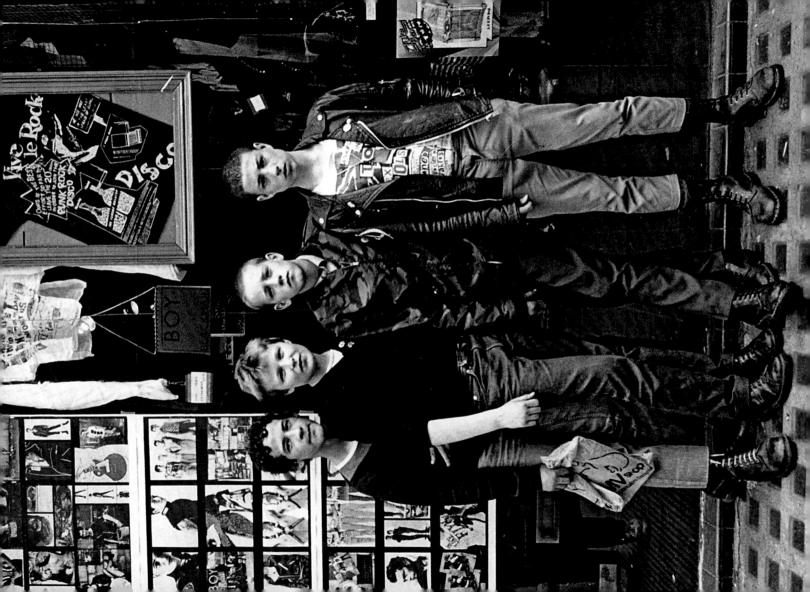

The Soft Boys, 1978 photograph by Jill Furmanovsky

With an aptitude for writing surrealistic lyrics and a penchant for Syd Barrett's solo oeuvre, Robyn Hitchcock (second from right) formed the Soft Boys in Cambridge in 1976. He had already led a number of bands, with names like Maureen and the Meatpackers. The various Soft Boys lineups included guitarists Alan Davies and Kimberly Rew, bassists Andy Metcalfe and Matthew Seligman, and drummers Morris Windsor and Jim Melton. Though their first single, "(I Want to Be an) Anglepoise Lamp" didn't make much noise, their "I Want to Destroy You" caught the attention of punk rockers. The band gained a following in pockets of America, where they toured in 1980 before breaking up the following year. Robyn Hitchcock then formed the Egyptians before going solo; he later played in outfits with such Soft Boys fans as Peter Buck, guitarist for R.E.M.

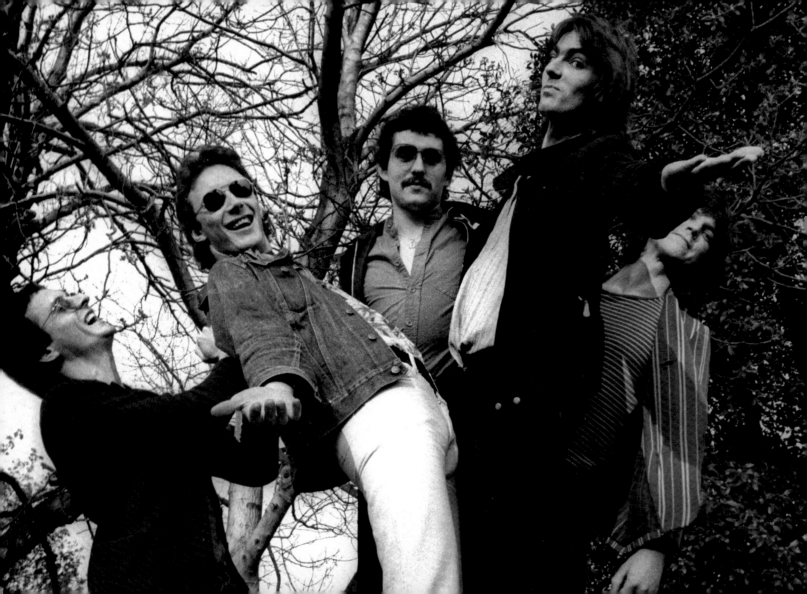

The Clash, 1978 photograph by Bob Gruen

Terry Chimes had quit the Clash in 1976 and was replaced by Topper Headon (far left), also a former member of the London SS with Clash founder Mick Jones. The group—Headon, Joe Strummer, Paul Simonon, and Jones (from left)—traveled to the States to do some recording in San Francisco and New York City. After working at the Record Plant in Manhattan, they spent time with photographer Bob Gruen, visiting his loft for dinner and checking out the video footage he had shot of the New York Dolls in 1973. Big fans of the Dolls, the Clash knew how important a band's visual presentation was to its image. "It was Paul Simonon who really gave the look to the Clash," Joe Strummer once said. "A large part of it for me was the look as well as the sound. A new world was taking over, and I mean we wouldn't stop. It was a twenty four hour experience, day or night… "

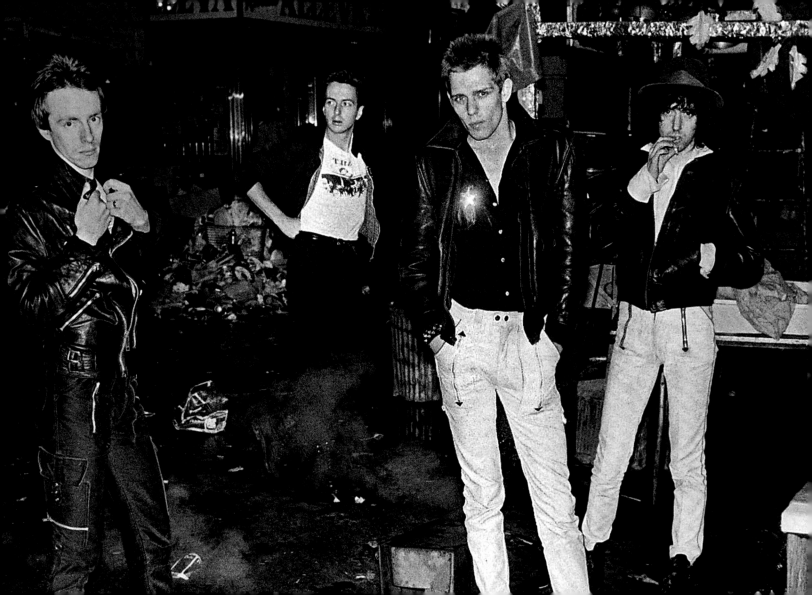

The Clash, 1978 photograph by Janette Beckman

Performing at London's Music Machine, in a December benefit to raise money for Sid Vicious' legal fees, the Clash's Mick Jones (left) and Joe Strummer made an ideal songwriting team. Strummer focused on the lyrics, which he usually banged out on a manual typewriter, and Jones wrote music based on the ideas in the words. "Lyrics tell you what the tune is a lot of the time," said Jones. "You just read the lyrics and you hear it. It's the way the words go. If they already have that musicality, it's a song."

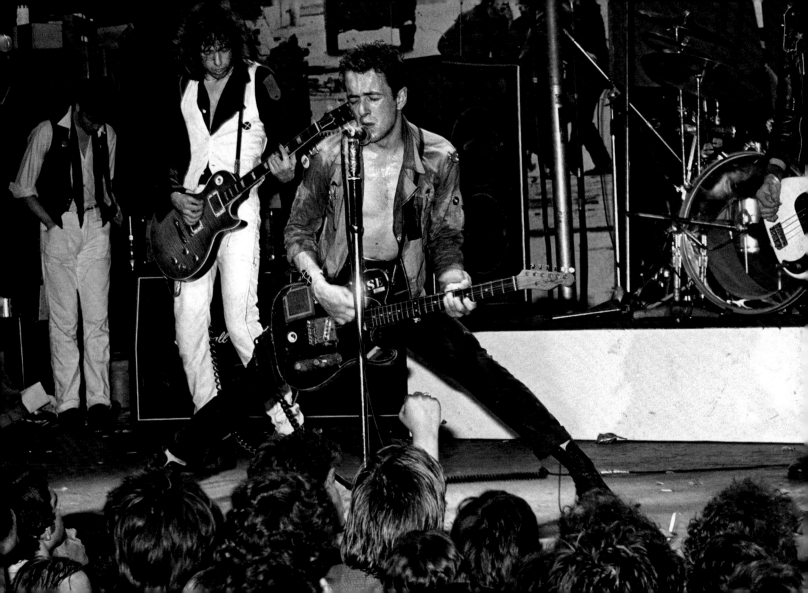

The Rich Kids, 1978 photograph by Jill Furmanovsky

After Glen Matlock (center) got the boot from the Pistols—for being too pop—he started the unabashedly power-pop Rich Kids with Midge Ure, Steve New, and Rusty Egan. The band's first records employed David Bowie's Spiders from Mars guitarist Mick Ronson as producer. Here, the Kids play around backstage at Acklam Hall in London, around the time their first single, "Rich Kids," sailed into the UK Top Ten. Follow-up efforts failed, however, and the group split soon after the release of their first album. Ure went on to found the band Visage, then started Ultravox. Matlock eventually played with Iggy Pop, and in the mid-1990s did a string of shows with the re-formed Sex Pistols.

The Undertones, 1979 photograph by Janette Beckman

From Northern Ireland, the Undertones played a high-energy pop-punk characterized by the trilling vocals of Feargal Sharkey (center). Photographed here in Birmingham, the group became a favorite of Sire Records' Seymour Stein after he heard them on John Peel's (BBC) Radio 1 show. "Radio DJ John Peel was such a major force in introducing new music to the UK," Stein remembers. "An avid fan of Peel's show, I remember like it was yesterday driving down to Southend-on-Sea to see the Searchers with Paul McNally, who looked after Sire's UK office. We were listening to Peel's show when all of a sudden this fabulous record came on. We were traveling so fast I couldn't hear it very well. I started screaming, 'Pull off the road!' Paul McNally turned white. He must've thought I was having a seizure. I just wanted a closer listen. The record was 'Teenage Kicks' by the Undertones . . . Feargal Sharkey had the most amazing voice, and the song was a fuckin' teenage anthem! Peel played the song twice, back to back. I'm told that was the first and only time he's done that." Stein signed the group, and McNally became their manager.

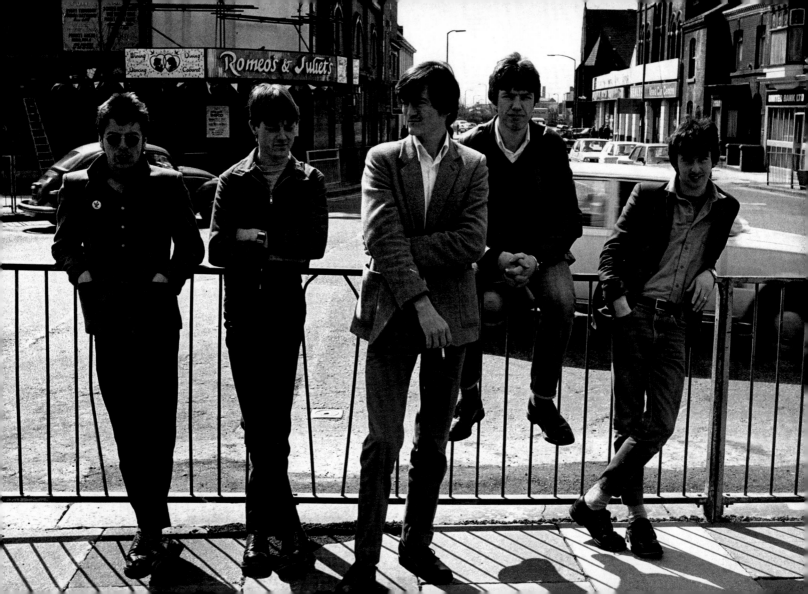

The Tourists, 1978 photograph by Jill Furmanovsky

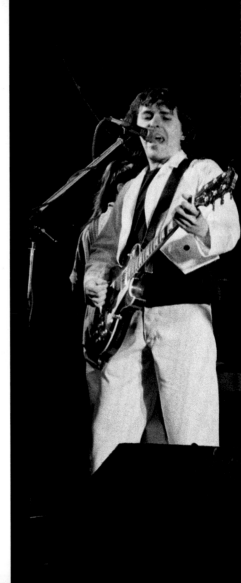

More a MOR rock band than a punk group, the Tourists were mainly notable for what became of their lead singer, Annie Lennox (center), and their guitarist, Dave Stewart (right). As Eurythmics, they rode the "new wave" to pop success by merging punk's attitude with Lennox's diva-style vocals and Stewart's inventive chops. Here the Tourists perform at London's venerable Marquee Club (where the Rolling Stones and the Who got their start) in July 1978.

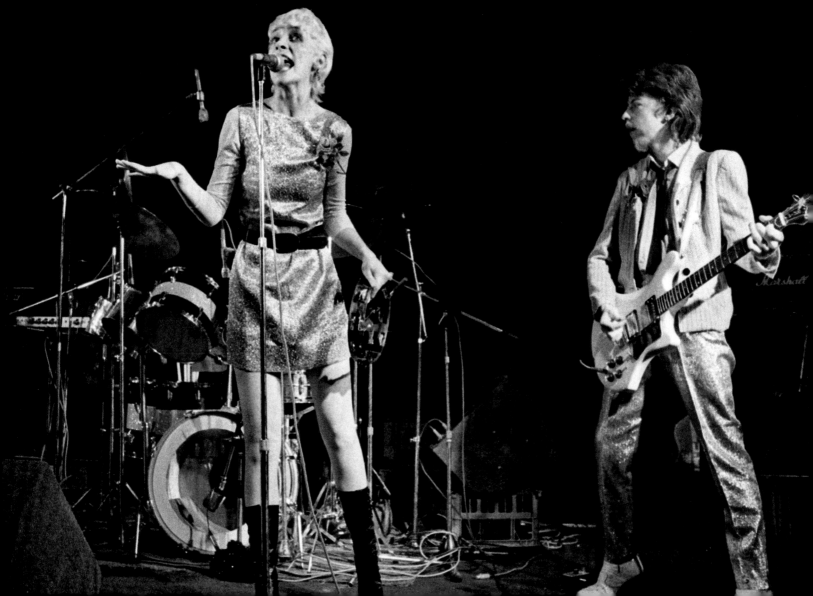

Billy Idol, 1978 photograph by Roberta Bayley

With his poster-boy looks and Elvis-like sneer, Billy Idol became the first punk heartthrob. He had spent part of his childhood in Long Island, and would eventually return to the States to live in New York City—after Generation X broke up in 1981. Idol's pretty-boy image, with his platinum-blond coif and his black leather pants, destroyed his credibility among Generation X's early following. In a bid for pop stardom, the group shortened its name to Gen X and recorded the disco-ish "Dancing with Myself"; it didn't become a hit until Idol recut it as a solo artist, making it even slicker. "Billy was a total sweetheart when he moved to New York," recalls downtown scenester Ellen Kinnally. "He was equally influenced by *Star Trek*'s Captain Kirk and Elvis Presley."

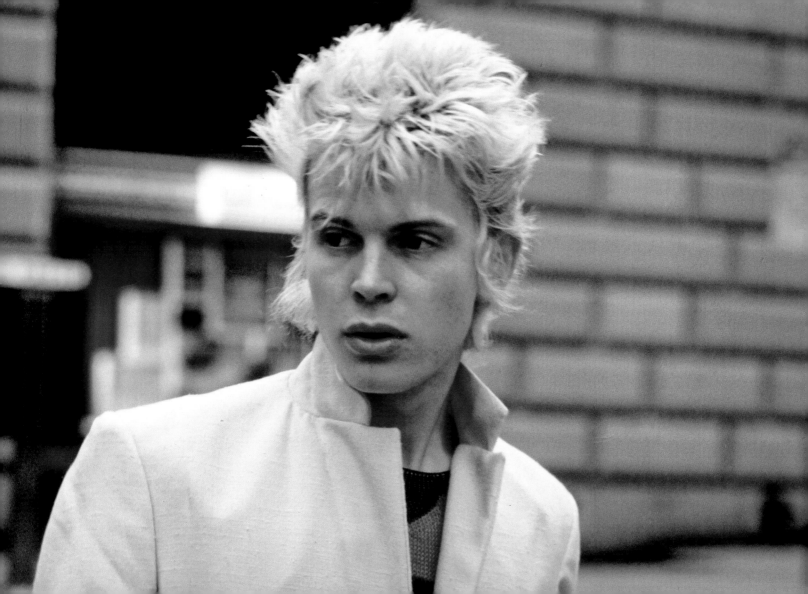

Sid Vicious, 1978 photograph by Bob Gruen

The Sex Pistols unleashed their ferocious audio assault on America during a havoc-filled tour in January '78. Manager Malcolm McLaren had insisted on bookings in the South, at clubs where punk rock was considered a wild beast that needed caging—thus the violent receptions at venues in Atlanta, Memphis, San Antonio, and Tulsa. After a January 5 gig at the Great Southeast Music Hall in Atlanta, the band flew to Memphis for their second show. Here, Sid Vicious stands outside the venue, the Taliesyn Ballroom—which has since been razed and is now home to a Taco Bell.

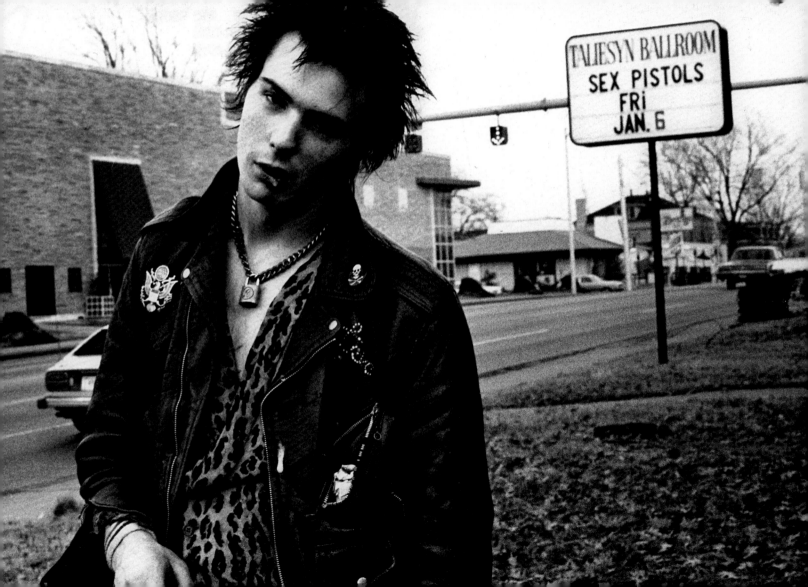

The Sex Pistols, 1978 photograph by Bob Gruen

Johnny Rotten, Sid Vicious, Steve Jones, and Paul Cook (from left) stand beside their tour bus in Tulsa, Oklahoma. "It was so calm and peaceful on the bus," remembers Bob Gruen, who traveled with the band for their twelve-day tour. "We just drank beer and listened to reggae tapes." Off the bus, however, was a different story. The third stop of the junket, at Randy's Rodeo in San Antonio, Texas, was the most intense, as Gruen recalls. Death threats had been issued against th Pistols, and a melee broke out between them and audience members looking for a fight. The next day, local papers called i a "shoot-out," but Jones at least got away with a cowboy hat—black, of course.

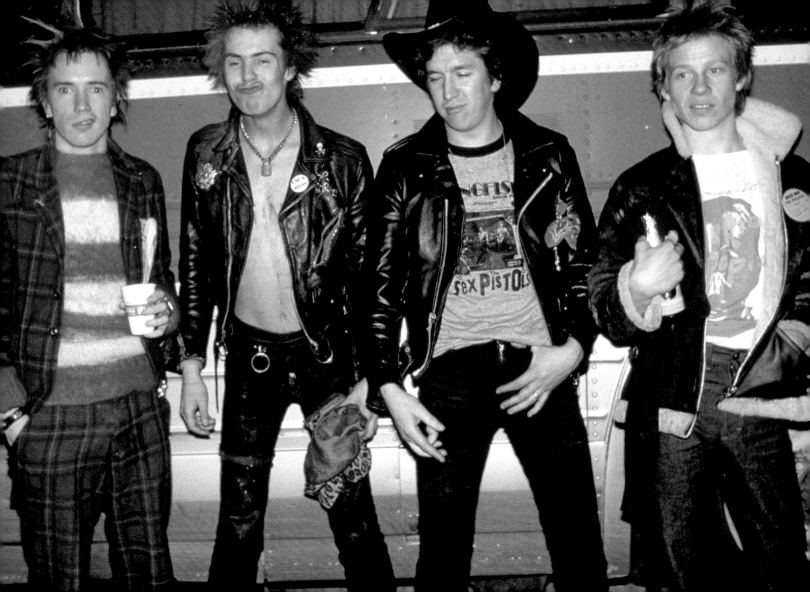

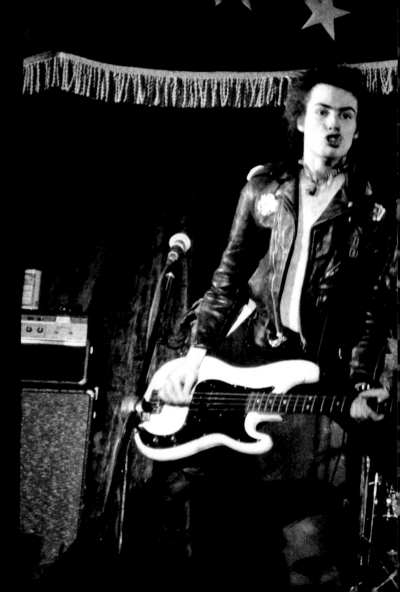

The Sex Pistols, 1978

photograph by Roberta Bayley

On January 11, Sid Vicious, Paul Cook, Johnny Rotten, and Steve Jones (from left) graced the stage of the venerable Tulsa, Oklahoma, dance hall Cain's Ballroom, where Bob Wills—the father of western swing—and His Texas Playboys had ruled in the 1940s. When the Sex Pistols arrived for their gig, evangelical protesters awaited them, handing out leaflets that warned:

"NO FUTURE FOR YOU!!! So says Johnny Rotten and it's not all lies—Punk rock exposes the joke of man trying to save himself from the curse: THE SOUL THAT SINS WILL SURELY DIE! ... There is a Johnny Rotten inside each of us and he doesn't need to be liberated—he needs to be crucified. TURN FROM YOUR PUNK WAYS AND BE BAPTIZED INTO THE DEATH AND LIFE OF JESUS."

135

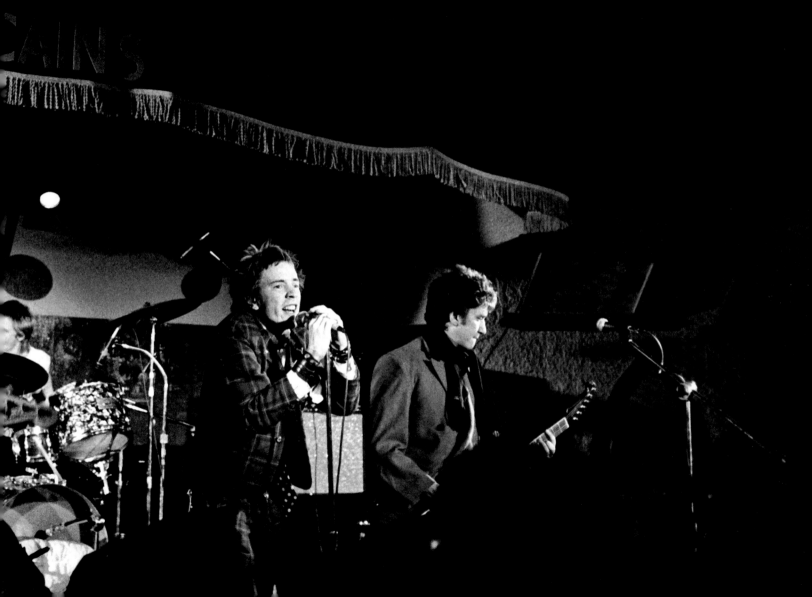

Sid Vicious and Boogie, 1978 photograph by Bob Gruen

After missing the band's bus from San Antonio to Baton Rouge, Sid Vicious, British road manager John "Boogie" Tiberi (at right), and Bob Gruen hopped a flight to catch up with the band. At the airport, Gruen documented the attention Sid Vicious attracted—even while quietly reading a copy of *Mad* magazine. "There was a certain repulsive quality to rock in the '50s that didn't come back until the Sex Pistols," pointed out Jim Dickinson, the great piano player (the Stones' "Wild Horses") and producer (Alex Chilton, the Replacements) who saw the band in Memphis. "They are such a vicious assault on the audience, something that is traditionally supposed to be a part of rock & roll." Dickinson was particularly fond of Sid Vicious, whom he once described as "Frankenstein-half-naked-drinking-blood."

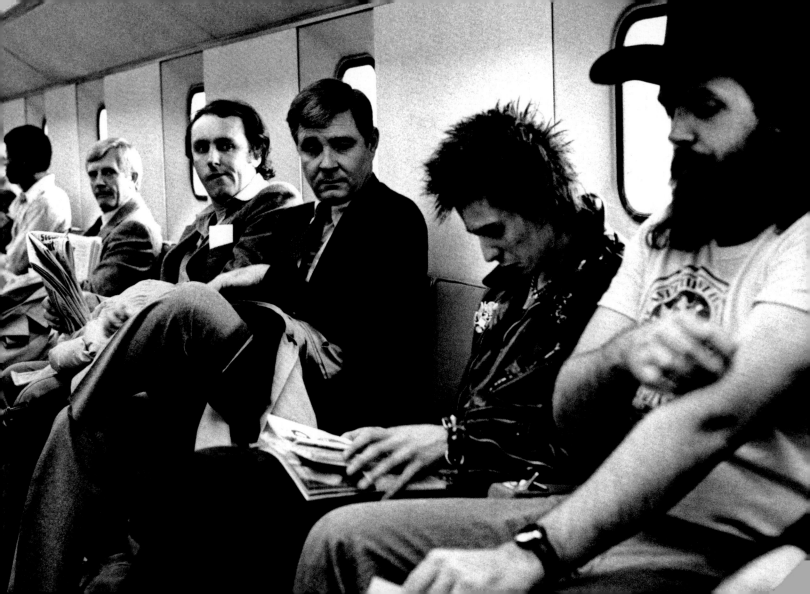

The Sex Pistols, 1978 photograph by Bob Gruen

The last stop on the Sex Pistols' twelve-day U.S. tour in January 1978 was San Francisco. Their dressing room at Winterland was painted with a large portrait of the band, commissioned by either promoter Bill Graham's crew or photographer Annie Leibovitz, who was shooting the band for *Rolling Stone*. Steve Jones, Sid Vicious, Johnny Rotten, and Paul Cook (from left) hated the portrait and refused to pose for Leibovitz in front of it. When Gruen happened in, camera in hand, however, the band actually managed a smile, which he snapped as a candid.

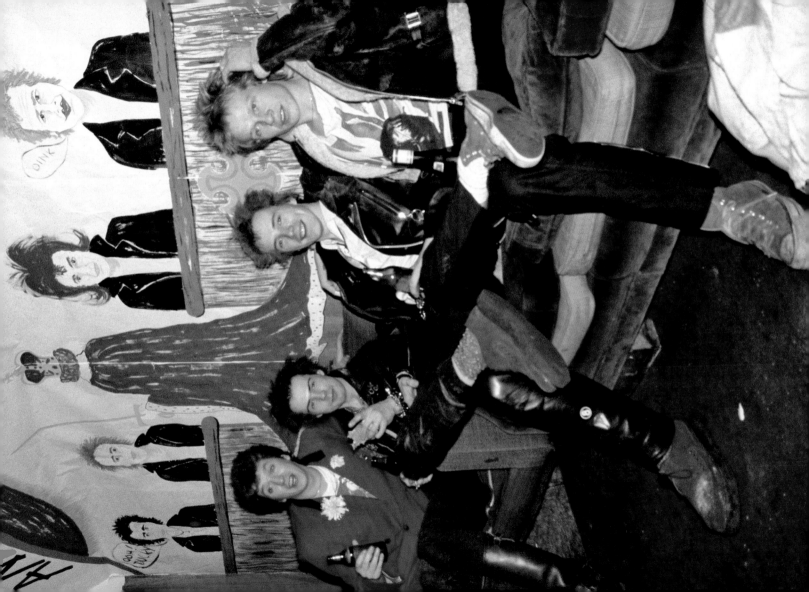

The Damned's Rat Scabies and Brian James, 1979 photograph by Janette Beckman

Drummer Rat Scabies and guitarist Brian James (from left), here hanging out in the *NME* offices. For a while, before forming the Damned, they backed journalist Nick Kent in his group the Subterraneans, with bassist Ray Burns (aka Captain Sensible). In June 1977, after recruiting singer Dave Vanian, the newly christened Damned opened for the Sex Pistols at the 100 Club. The band gobbed at their audience, which initiated the UK trend of audiences spitting at bands onstage. When this photo was taken, the Damned had recently reunited after breaking up the previous year.

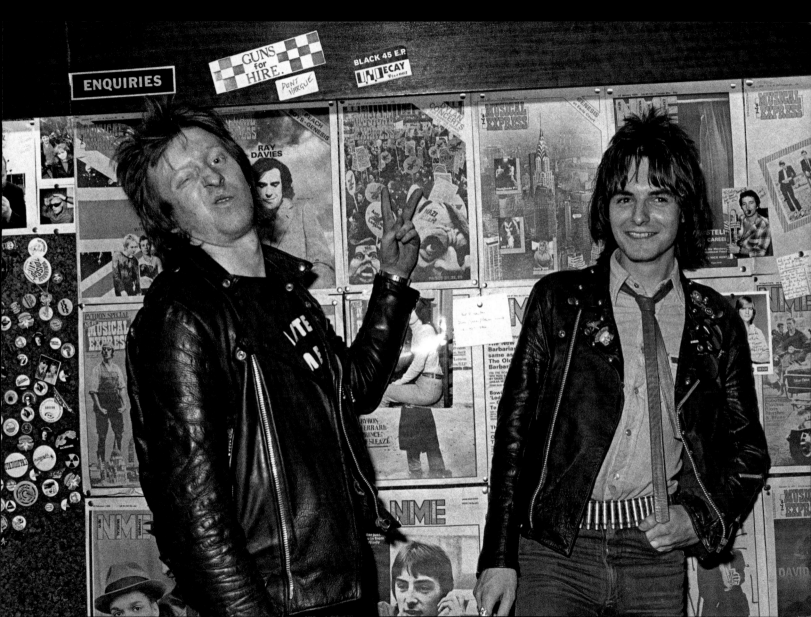

Mark P of ATV and *Sniffin' Glue,* 1977

photograph by Jill Furmanovsky

Punk stalwart Mark P was a true believer in the era's DIY ethos and backed it up with his fanzine and band, both of which stuck to the indie way. He refused to sell out—even as so many of the punk bands signed contracts with major record labels—and instead formed Alternative TV (ATV) with Alex Fergusson. "Alex and I were not into the idea of re-creating a punk dirge," Mark P wrote in *And God Created Punk.* "We tried out experiments with tapes and white noise and our aim was to become like a British Velvet Underground. We took chances when most other bands were following punk's well-established rules—keep it loud, fast, and angry."

Sham 69, 1979 photograph by Jill Furmanovsky

Mark P eventually started his own indie record labels, one of which, Step Forward, originally signed Sham 69. "Unlike a lot of other 'punk bands,'" Mark P noted, "Sham 69 were very real. [Vocalist] Jimmy [Pursey, in midair] was an absolute nutter who was very committed to all the stirring rhetoric he spouted onstage ... As far as I was concerned, Sham 69 were the real successors to the Pistols and the Clash, without any of those bands' fashionable and arty trappings."

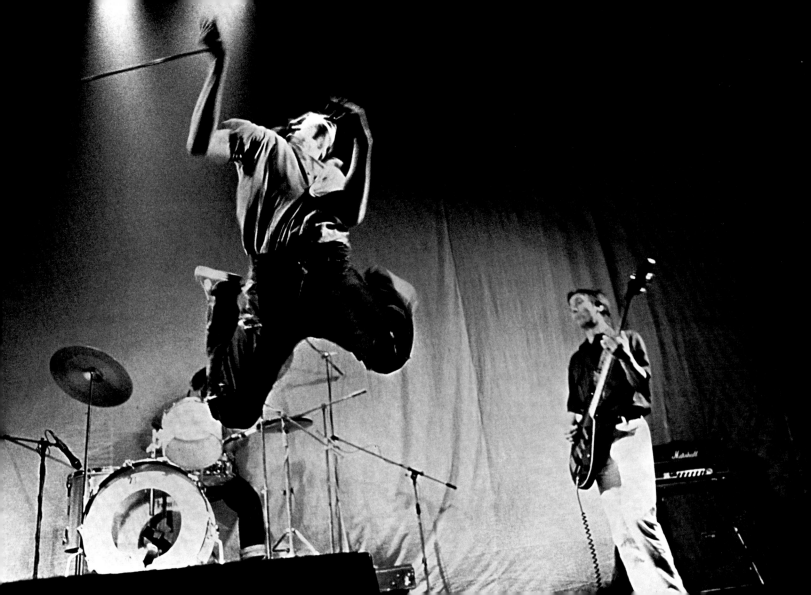

The Clash, 1979 photograph by Bob Gruen

"I don't want to see punk as another slavish attitude and image and everything is pre-planned and pre-thought out for you to slip in comfortably. Like, say, mod is. 'Let's all put on mod suits and feel less nervous.' I vote for the weirdo. I vote for the loonies. I vote for the people off the left wall. I vote for the individuals."
—Joe Strummer

Joe Strummer (reflected in mirror), Mick Jones, Topper Headon, and Paul Simonon await showtime in a theater dressing room.

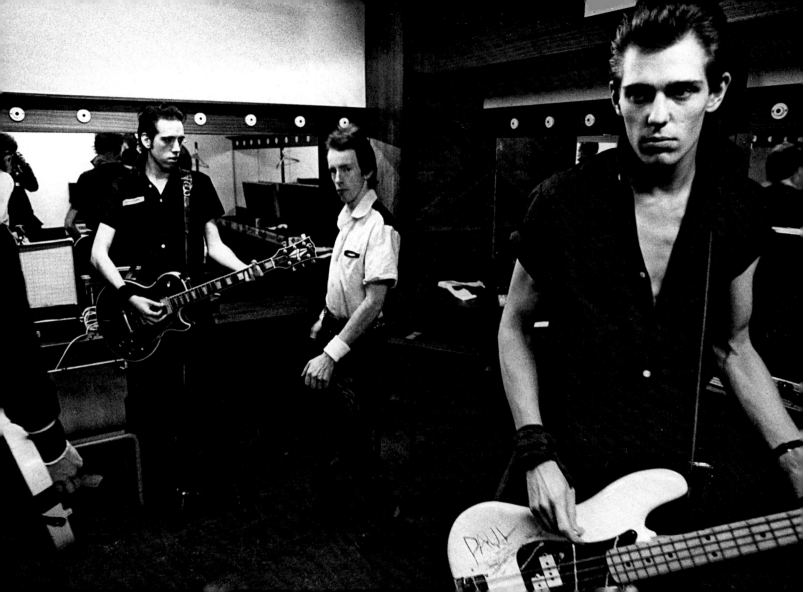

The Buzzcocks, 1979 photograph by Ebet Roberts

"For me, it would be hard to imagine music without Buzzcocks. I'm always struck when they come up to me and say, 'If it wasn't for you ...' The list is quite long. I've had it from Offspring. Thom Yorke said that without Buzzcocks, there'd be no Radiohead, R.E.M., Peter Buck. Very tired and emotional in a bar la at night. He said that listening to Buzzcoc inspired him to form a group. So I think in that inspirational sense, there's ... that sense of anybody can do it."

—Pete Shelley

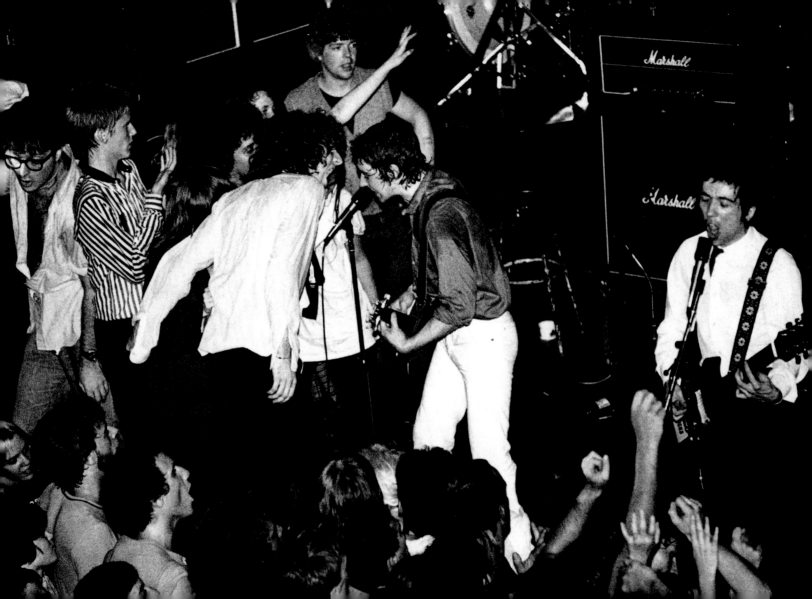

Plastic Bertrand, 1978 photograph by Jill Furmanovsky

Plastic Bertrand (b. Roger Jouret) was the sole Belgian artist to score a punk-rock hit. In 1978, his catchy sing-along novelty "Ça Plane pour Moi" (translated alternately as "This Life's for Me," "That's Alright by Me," and "I'm High Because of It All") became a smash in England, the rest of Europe, and America. Of his "punque smash internationale," Plastic Bertrand explained, "If you are naive, the effect will be naive. If you are perverse, the effect will be perverse, and if you are clever, the effect will be clever."

143

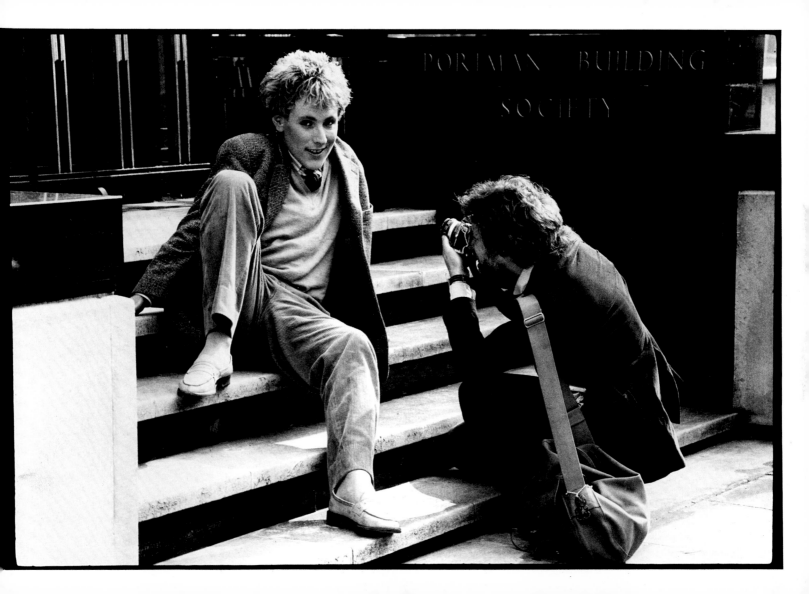

Sid Vicious and Nancy Spungen, 1977 photograph by Jill Furmanovsky

The Romeo and Juliet of punk rock, the Sex Pistol and the Jersey girl (well, Philadelphia), had become lovers in London when Spungen showed up there to visit the Heartbreakers. Both heroin addicts, the two—photographed here at London's Rainbow Theatre on New Year's Eve—had a tumultuous relationship (to say the least). In 1978, the couple moved to New York, where Vicious played the occasional gig at CBGB and Max's Kansas City. Sid and Nancy resided in room 100 at the Chelsea Hotel, and it wa there, on October 12, 1978, that Nancy was found dead of a knife wound to the abdomen. Sid was arrested and charged with second-degree murder. Less than four months later, on February 2, 1979, while out on bail and awaiting trial, he overdosed on heroin.

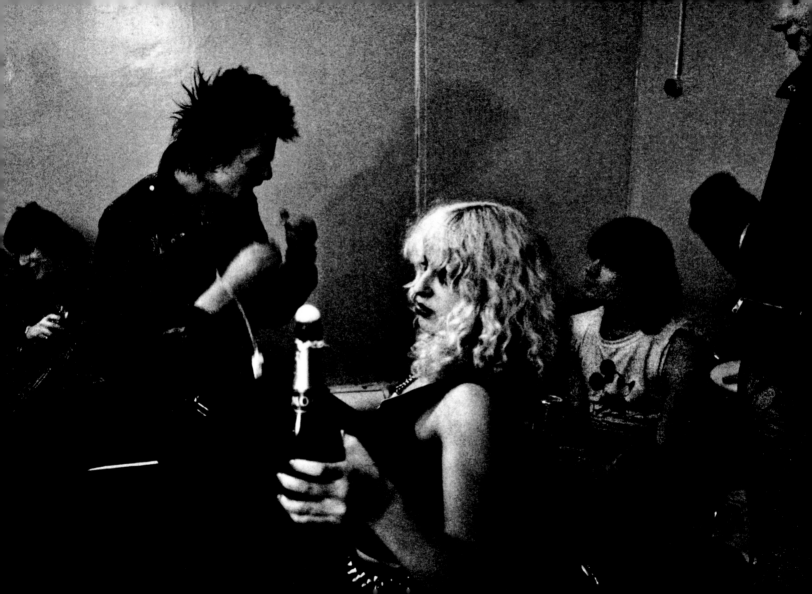

Sid Vicious, 1978 photograph by Ebet Roberts

"I still think of Sid," John Lydon wrote in *Rotten: No Irish, No Blacks, No Dogs.* "I wish he was around but only the way he was originally ... All that self-destruction was just too much ... Sid was a lost little boy utterly beyond help." In *England's Dreaming,* Jon Savage contextualized Sid's death, "From the days when Richard Hell and Tom Verlaine transformed themselves, punk was infected by a Rimbaudian script: live fast, disorder your senses, flame brightly before self-immolation ... Sid Vicious went for this as hard as possible: his protracted demise, [which became] worldwide news, was the ultimate statement of punk's inbuilt drive to failure."

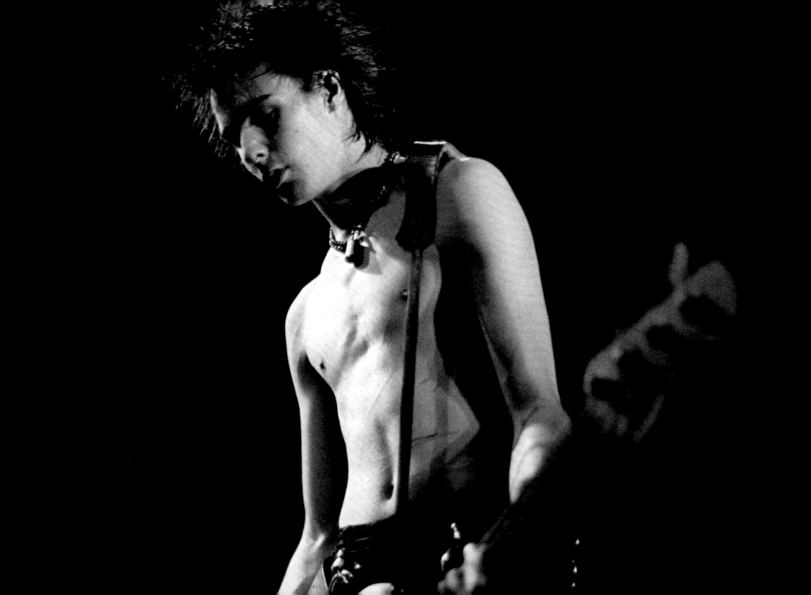

All the young punks gathered in London to honor their fallen hero's death. Referenced on one punk's jacket, "Belsen Was a Gas" was an original number Sid Vicious recorded for Virgin Records in 1978, along with a cover of the Frank Sinatra classic "My Way." Horribly, Sid's mother dropped the urn containing her son's ashes at Heathrow Airport, causing his remains to spill helter-skelter onto the floor. "He became a martyr to many kids who were turned on by the nihilism of punk," Mark P said of Sid, "but the truth was that he ended up being a sad junkie who ended his own life."

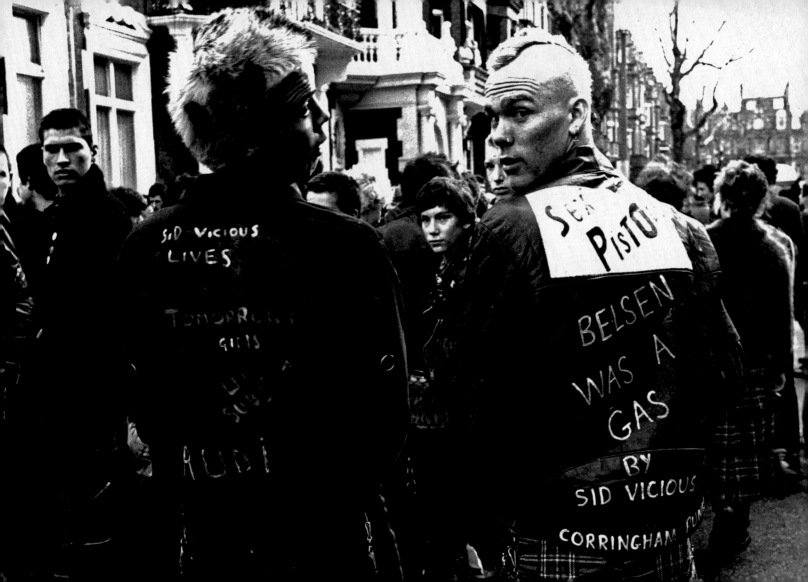

The Fall, 1979 photograph by Godlis

Mark E. Smith's poetic—sometimes Dadaist—lyrics and singular vocals have characterized the Fall through a long, fractured career. Mancunian Smith (second from left) formed the band in 1977, and with a repertoire of off-kilter but memorable songs ("That's How I Met Elastic Man"), the band has endured into the twenty-first century—with umpteen personnel changes and Smith sometimes landing in jail for assaulting bandmates onstage. This photo, taken backstage at CBGB, was shot during one of the group first trips to New York.

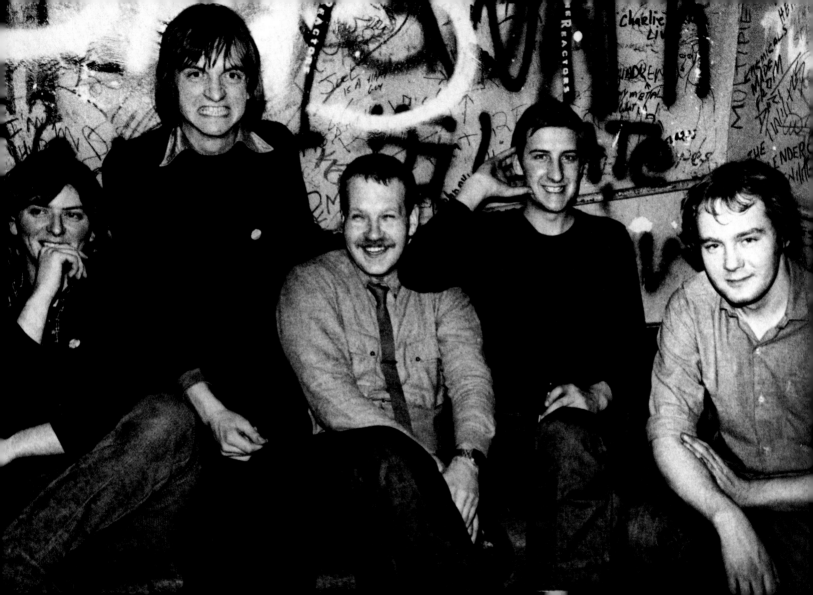

XTC, 1978 photograph by Jill Furmanovsky

Clever wordsmith, twisted-pop architect, and guitarist/vocalist Andy Partridge (second from right) dreamed up XTC (for Ecstasy) in 1977. Original members included former King Crimson keyboardist Barry Andrews (who subsequently left in '79 and was replaced by Dave Gregory), bassist Colin Moulding, and drummer Terry Chambers. The band released two albums in '78; while touring Europe, they were photographed in Hamburg, Germany, by Jill Furmanovsky. Early '79 saw the group's breakthrough single "Making Plans for Nigel."

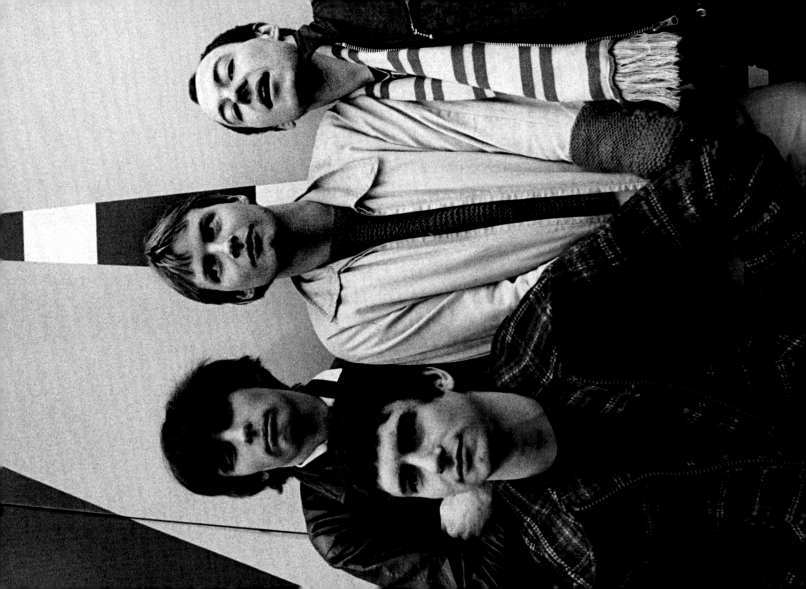

Wire, 1978 photograph by Ebet Roberts

Art school dropouts Colin Newman, Bruce Gilbert, Graham Lewis, and Robert Gotobed (b. Mark Field) subscribed to the avant-garde minimalist approach to sonics. As Wire, the group released three seminal albums between 1977 and 1979—*Pink Flag, Chairs Missing,* and *154*—that influenced artists as diverse as Robert Smith of the Cure and Michael Stipe of R.E.M. Wire's best-known single was "Map Ref. 41 Degrees N, 93 Degrees W," named for the geographic coordinates of Des Moines, Iowa. Indeed Wire did travel to America, where this photograph was taken—in New York. Although the band broke up in 1980, they regrouped nearly a decade later; Wire would eventually be considered the godfathers, of sorts, of techno.

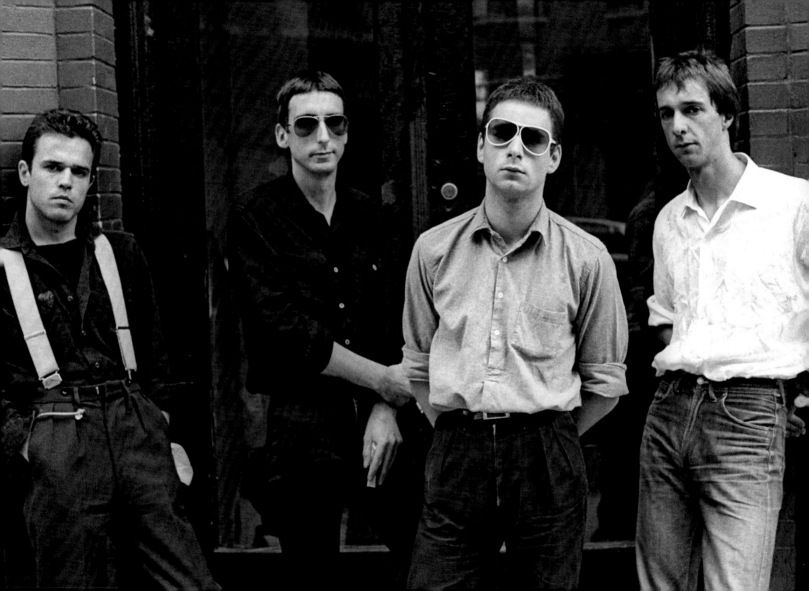

The Raincoats, 1979 photograph by Janette Beckman

The Raincoats formed in late 1978, and after a few personnel changes solidified with the lineup of vocalist/guitarist Ana Da Silva, vocalist/violinist/guitarist Vicky Aspinall, vocalist/bassist Gina Birch (from left), and drummer Palmolive, who had defected from the Slits (as had early Raincoat Kate Korus, who moved on to form the Modettes). Janette Beckman documented the group in their cramped rehearsal studio in London. With angular rhythms and pointed lyrics, the Raincoats presented a feminist philosophy, in punk clothing. Their 1979 single "Fairytale in the Supermarket" and primal version of the Kinks' "Lola" would later be hailed by such artists as Kurt Cobain as major influences. John Lydon said in 1980, "I think music has reached an all-time low, except for the Raincoats."

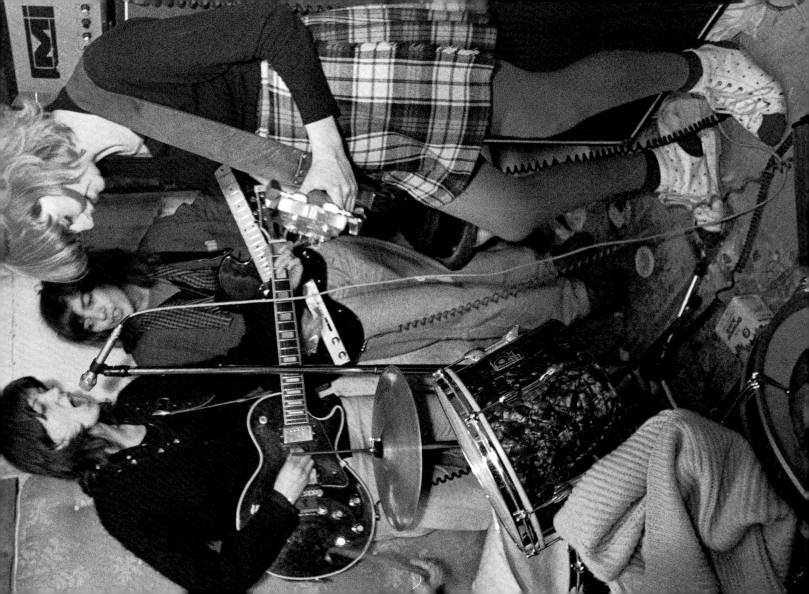

The Clash, 1979 photograph by Bob Gruen

During the Clash's first U.S. tour—dubbed Pearl Harbor '79—each show opened with a fiery "I'm So Bored with the U.S.A." Among the eight dates was a stop in Boston, where Bob Gruen took this photo. *Time* magazine's Jay Cocks previewed the Clash tour with the following rave: "Out of the pieces of a shared precarious existence, the Clash has fashioned music of restless anger and hangman's wit, rediscovered and redirected the danger at the heart of all great rock." Quite a different sensibility from the 1977 *Time* cover story

"Anthems of the Blank Generation," whic described the punk milieu at the Rat in Boston: "Musicians and listeners strut around in deliberately torn T-shirts and jeans; ideally, the rips should be joined with safety pins. Another fad is baggy pants with a direct connection between fly and pocket. These are called dumpies Swastika emblems go well with such outfits. In London, the hair is often heavily greased and swept up into a coxcomb of blue, orange, or green, or a comely two-tone. Pierced ears may sport safety pins, some made of gold or silver."

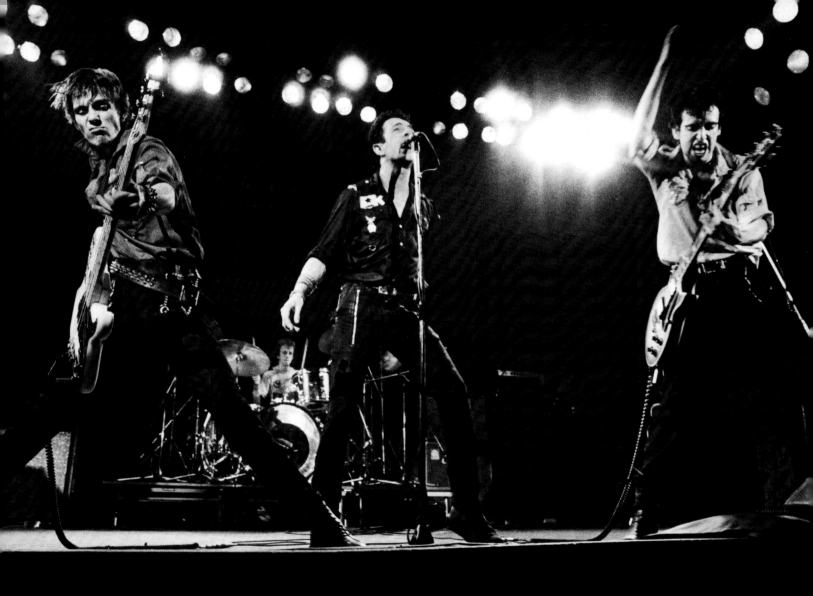

The Undertones, 1979 photograph by Janette Beckman

Initially formed in Londonderry, Northern Ireland, the Undertones comprised guitar-playing brothers John and Damien O'Neill, bassist Michael Bradley, and drummer Billy Doherty, who enlisted their school chum Feargal Sharkey on vocals. Beginning in 1975, the group gigged locally and released "Teenage Kicks" on a Belfast indie label. After they were signed to Sire, the group scored several hits, including "Jimmy Jimmy," "My Perfec Cousin," and "Wednesday Week." In Birmingham, Janette Beckman managed to find an ominous billboard of then NATO commander Alexander Haig under which to photograph the band.

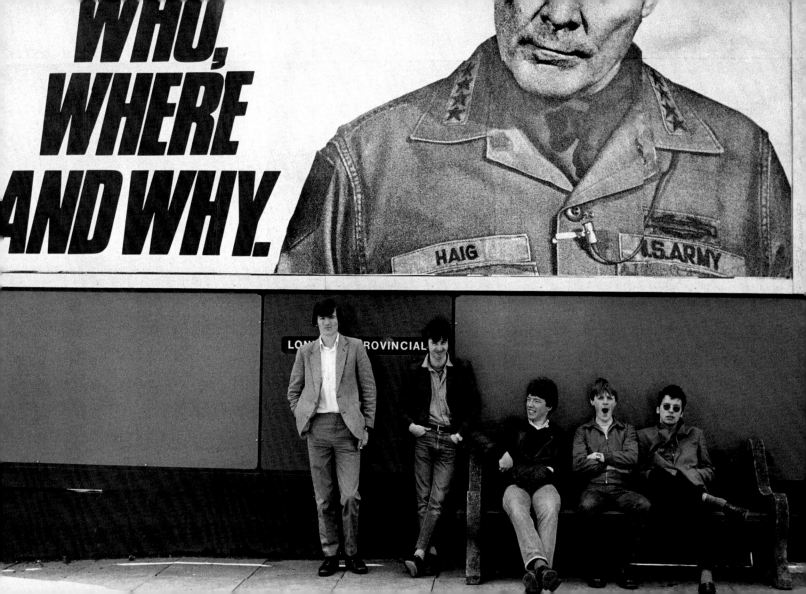

The Angelic Upstarts, 1979 photograph by Jill Furmanovsky

Formed by vocalist Mensi (b. Tommy Mensforth) (second from left) in the environs of hardscrabble Newcastle, England, the Angelic Upstarts projected a working-class political leaning in their strident punk. Protégés of Sham 69's Jimmy Pursey, the Angelic Upstarts released their first single, 1978's "The Murder of Liddle Towers," as a protest against police brutality. The band's hard-edged sound would prove to be a forerunner of the early '80s hardcore-punk movement.

153

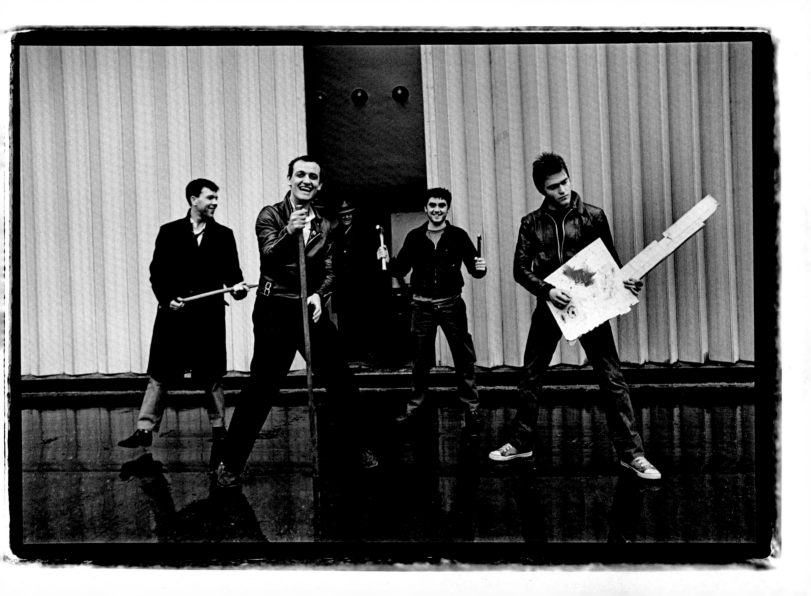

Joe Strummer, 1979 photograph by Ebet Roberts

"It's a great relief for me to be twenty-seven in a way, 'cos I think the worst time of my life was when I was twenty-four, 'cos I used to lie about my age, make myself younger, say I was twenty-two or something. I was so paranoid about it. It was the early days of the Clash, like 'Fuck if they find out how old I am that's it, I'm in the bunker, the dumper.' And then I thought, 'Fucking hell, I feel great.' I feel like, 'cos I'm older than this lot, I've got a little bit extra to add. Kind of experience."
—Joe Strummer

154

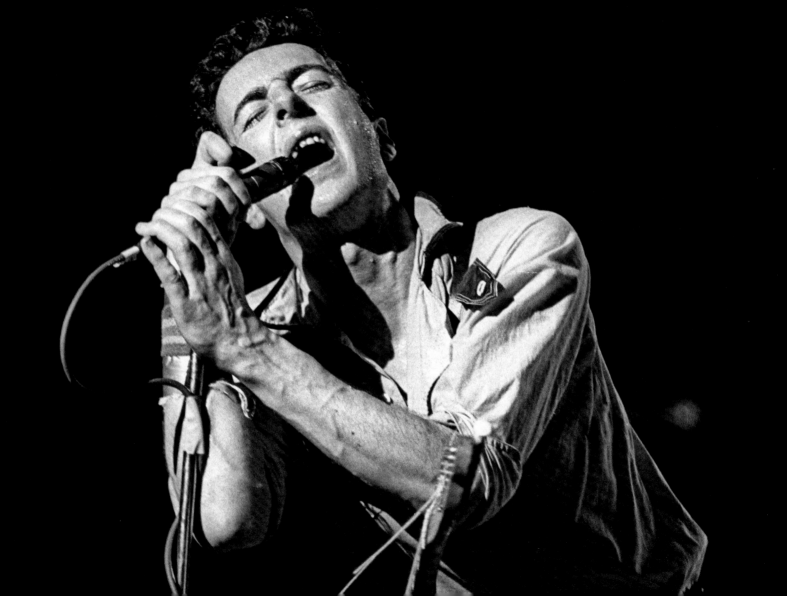

The Clash, 1980 photograph by Jenny Lens

By June 1980, when California-based photographer Jenny Lens snapped this photo of the Clash onstage in England, the band was rarely at home in London. Most of their time had been spent touring Europe and the States and in recording sessions. "The Clash always delivered the most passionate, energetic, throbbing, riveting shows," Lens remembers. "I loved the spontaneous interaction between all of them—something that is very rare in most bands. They felt every word, every note—they were heroes in England. Although I had stage access, I needed to watch and shoot the entire group dynamic. When it came to the Clash or the Ramones, I was just as much a fan as I was a photographer. I had to be out there in the audience."

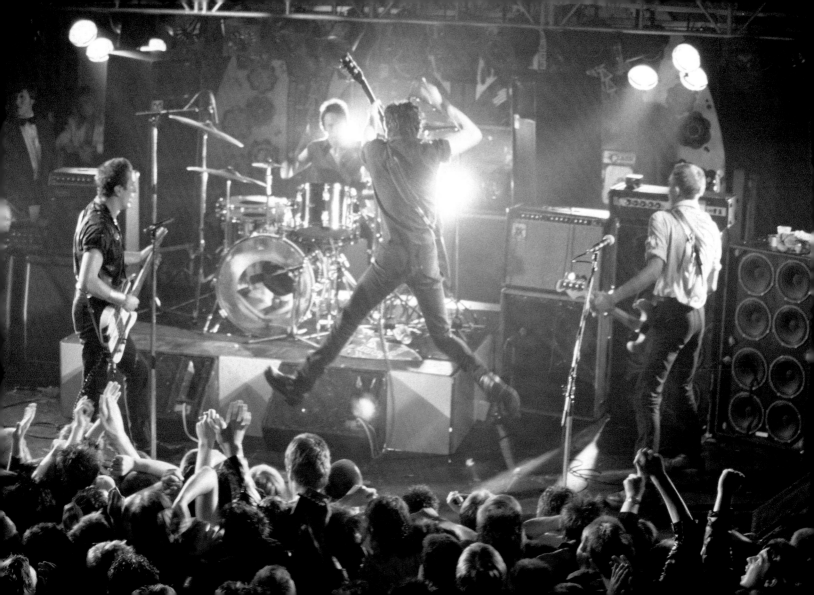

Captain Sensible, 1979 photograph by David Arnoff

Climbing the wall was only one of Captain Sensible's stupendous feats. Here, on the Damned's Machine Gun Etiquette tour, the bassist was photographed backstage at the Whisky a Go-Go in Hollywood. According to *Sniffin' Glue*'s Mark P, the Damned "sounded like an English version of the Stooges, each song hammered out with a relentless riff ... Their energy was contagious—they were the fastest, loudest, most fun band in the whole of the punk scene."

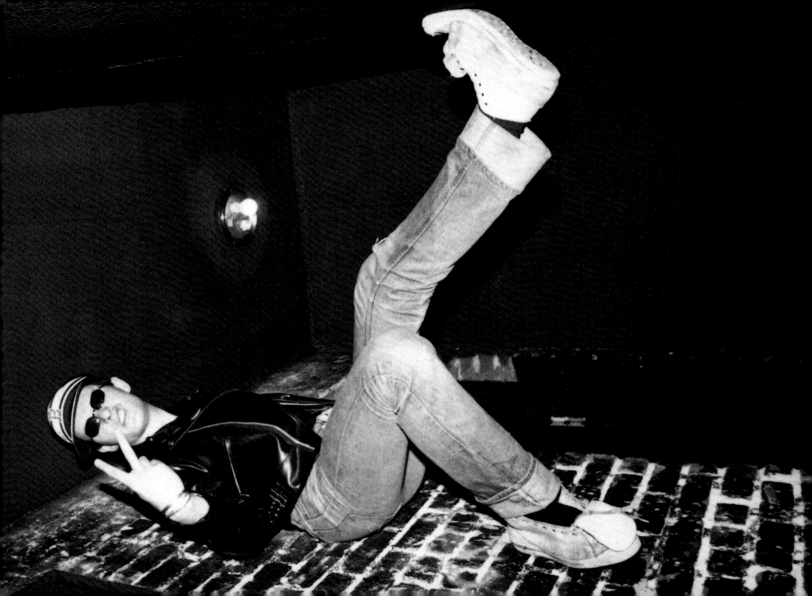

Punks in Hyde Park, 1979 photograph by Janette Beckman

By 1979, the main fury of punk had fizzled, but the style remained. The Sex Pistols were long gone, the Clash frequently took to the road, and some of the early punk bands had broken up. But kids all over England continued to dress like punks—including these two lassies hanging about Hyde Park. In London, punk had become a tourist attraction and the locals would permit onlookers to take their photograph for a pound or two.

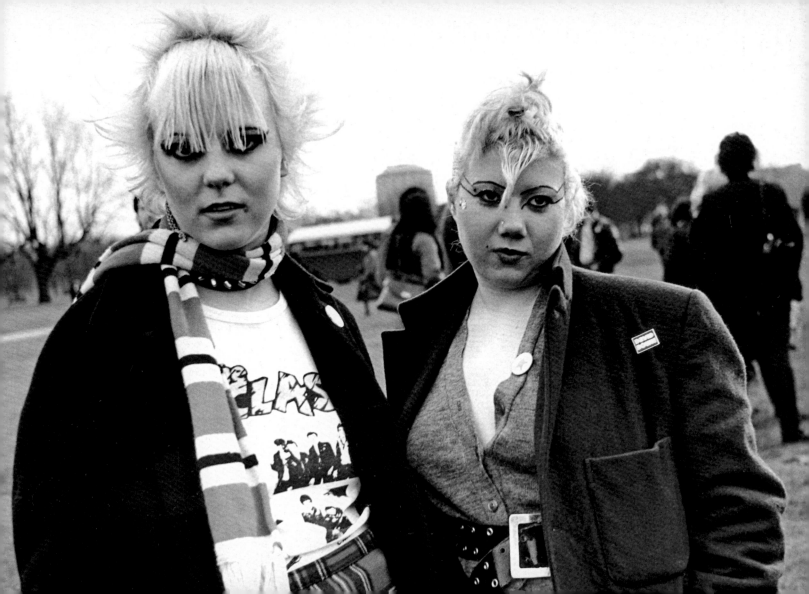

Punks on the King's Road, 1979 photograph by Janette Beckman

Though Sex had shut down and Seditionaries—the second shop owned by Malcolm McLaren and Vivienne Westwood—seemed to cater more to poseurs than the "real-deal" punk bands, the King's Road continued to attract young punks. Spiked hair and leather jackets had become the new uniform, and the road—long the strip for fashionable boutiques—was still the place to find the gear. Punks lounged around on the main drag's generous benches. "There was always a scene on the King's Road on a Saturday afternoon," recalls Janette Beckman, who was then photographing for *Melody Maker* and *The Face*. "The punks and skinheads would get up late, buy a few beers, and hang around near the old Town Hall on King's Road, getting smashed and having a good time."

158

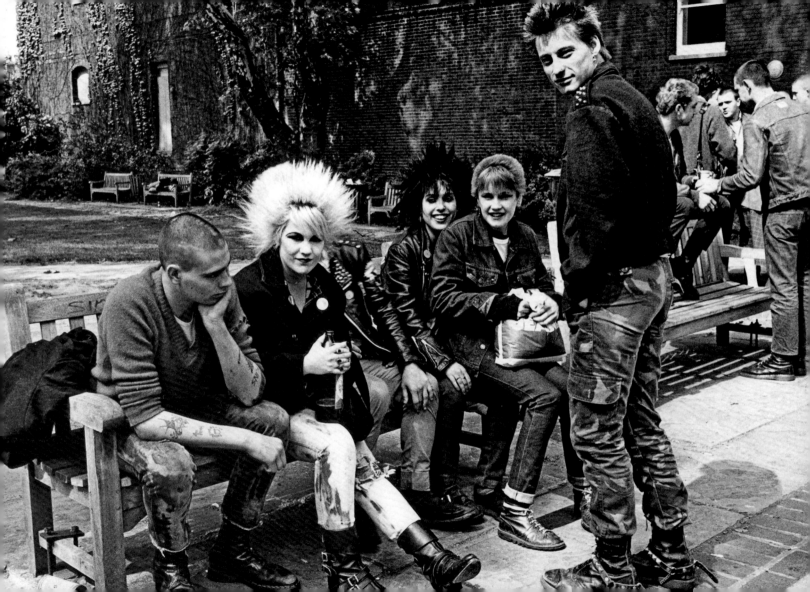

John Lydon, 1978 photograph by Jill Furmanovsky

Soon after the breakup of the Sex Pistols at the end of their brief U.S. tour, Johnny Rotten reverted back to his earlier name, John Lydon, and formed Public Image Ltd., or PiL. The band's songs and imagery were meant to answer the media frenzy over the Pistols and what Lydon considered the hypocrisy and charlatanism of the whole "rock & roll swindle." Embroiled in a lawsuit against Malcolm McLaren, Lydon put his creative energy into exposing the thwarted manipulation and financial exploitation the Pistols had endured under McLaren's management. PiL's catchy debut single, "Public Image," released in October, brilliantly summarized Lydon's take on the whole thing. Here, Public Image performs at London's Rainbow Theatre in December.

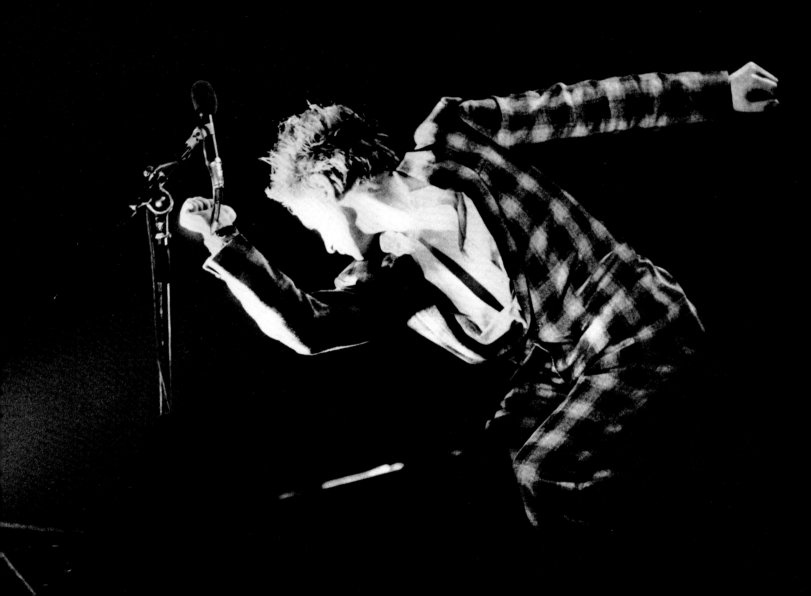

Public Image, 1979 photograph by Janette Beckman

Guitarist Keith Levene, bassist Jah
Wobble, and vocalist John Lydon
(from left), with drummer Jim Walker,
constituted the original version of PiL.
The band also listed as official members
Jeannette Lee as videographer and
Dave Crowe as handler of business and
finances. Levene, an inventive axman,
had played briefly in the first lineup of
the Clash, and Wobble, a schoolmate
of Lydon's, was steeped in dub and
reggae. The band's artistic vision included
performing at New York City club the
Ritz behind a screen, which was pelted
with beer bottles by angry hecklers, and
releasing the 1979 album *Metal Box*
as an embossed circular tin with three
twelve-inch 45s inside. Friction within
the group resulted in a revolving door of
membership—Lydon the only constant.

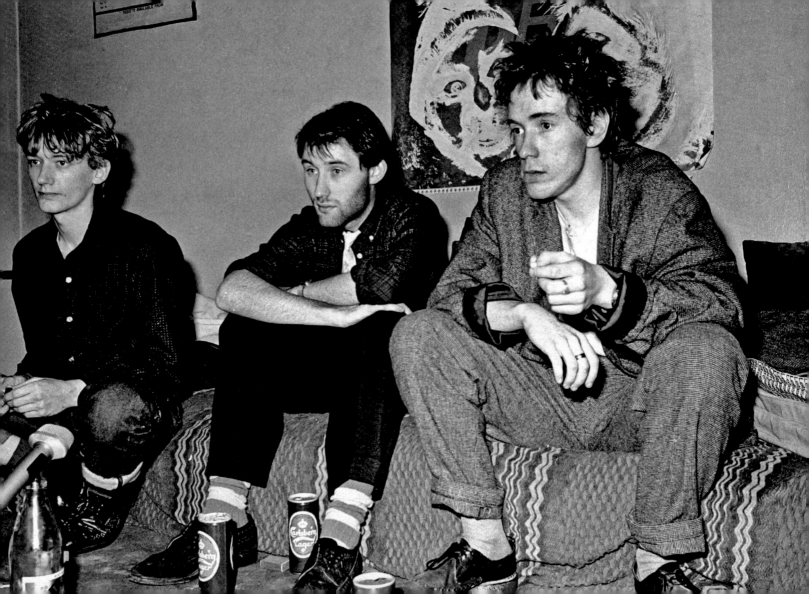

Joy Division, 1979 photograph by Jill Furmanovsky

"Love Will Tear Us Apart" was the eerily prescient hit that put Joy Division on the map; another Manchester band inspired to form after the Sex Pistols blew through town, they came together in 1976. The group's moniker derived from the name given to prostitute compounds at Nazi military bases during World War II. In 1979, guitarist Bernard Sumner, vocalist Ian Curtis, drummer Stephen Morris, and bassist Peter Hook released their debut album, *Unknown Pleasures,* on the local indie label Factory. The Velvet Underground–inspired sonics and Curtis' powerful, haunting vocals immediately made an impact. "He was a catalyst for the rest of the band," Bernard Sumner said. "He would cement our ideas together. We would write all the music but Ian would direct us. He'd put the lyrics in later." The introverted front man's dark, brooding lyrics seemed to predict his untimely end.

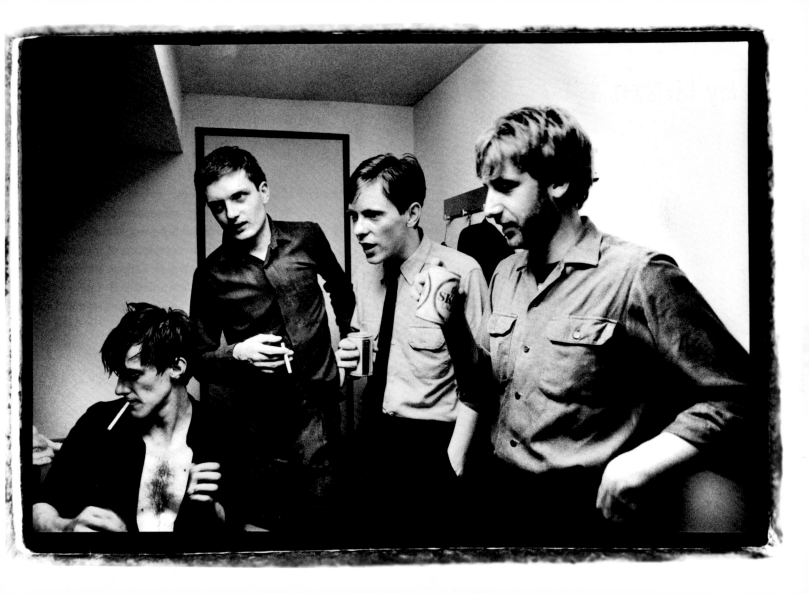

Joy Division onstage, 1979 photograph by Jill Furmanovsky

Following the success of their first album, Joy Division spent a great deal of time touring England and Europe. Ian Curtis (left), who suffered from epilepsy, became renowned for his jerky, dancelike movements onstage. His wife, Deborah, called them "a distressing parody of his offstage seizures. His arms would flail around, winding an invisible bobbin, and the wooden jerking of his legs was an accurate impression of the involuntary movements he would make." Soon after the completion of Joy Division's second album, *Closer,* and on the eve of the band's first U.S. tour—May 18, 1980—Curtis hung himself while listening to Iggy Pop's *The Idiot.*

162

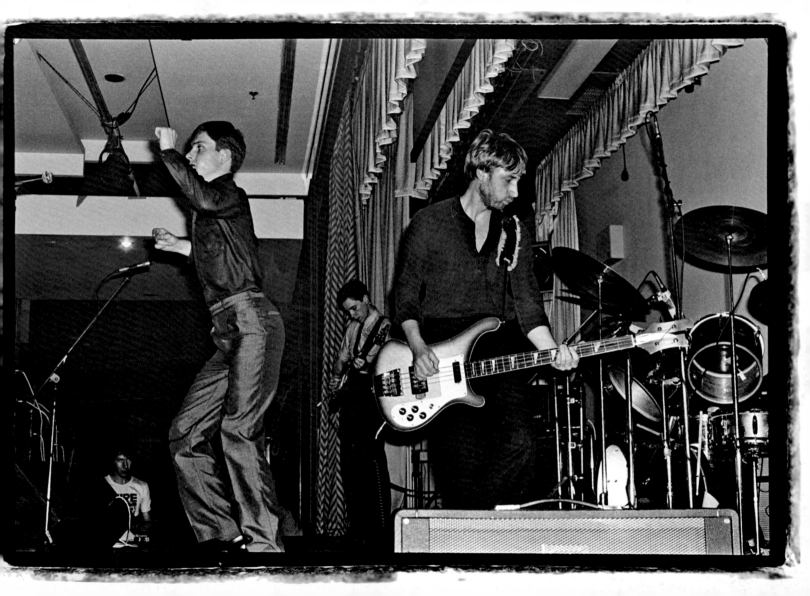

The Boomtown Rats, 1980 photograph by Bob Gruen

"I Don't Like Mondays" caused a stir in 1977; the Boomtown Rats' single details a child's murderous school-yard rampage, and the motive given to police: "I don't like Mondays." Charismatic front man Bob Geldof (at right) would later found Live Aid, the charity concert that kicked off a return to social consciousness among roc & rollers. Seen here in Tokyo, the group members donned the uniforms of Japanes schoolboys—and proceeded to act the part by flirting with Japanese schoolgirls, photographer Bob Gruen recalls.

163

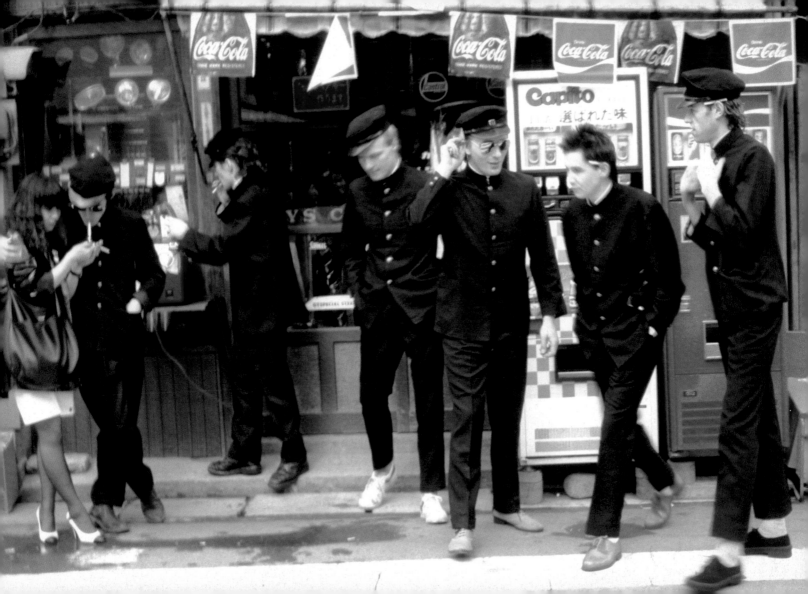

Devo, 1980 photograph by Jill Furmanovsky

After the massive—and unlikely—success of 1980's "Whip It," Devo toured the world. Here, photographer Jill Furmanovsky captured the band relaxing in London's Hyde Park. The group's follow-up hits were mechanized versions of Johnny Rivers' "Secret Agent Man" and Lee Dorsey's "Working in the Coalmine."

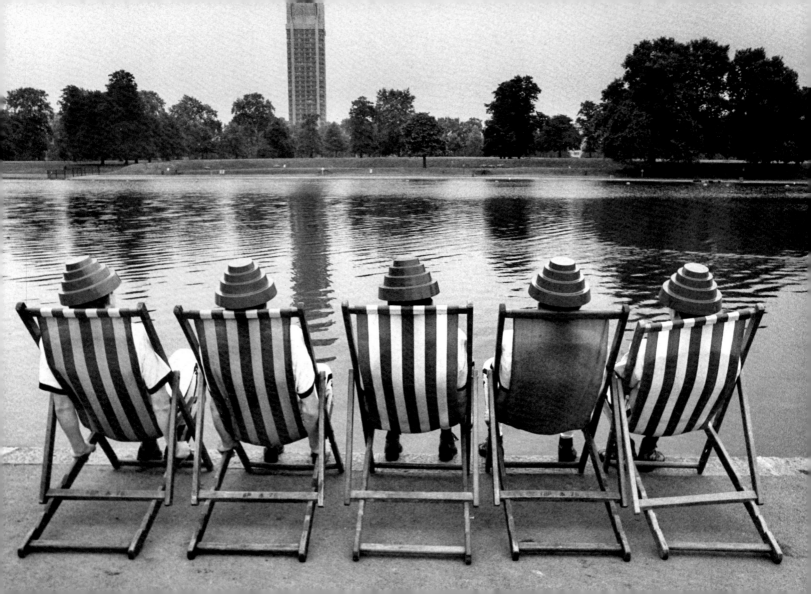

Devo, 1980 photograph by Jill Furmanovsky

Continuing their quest to spread the message of de-evolution throughout the world, Devo sought out photographers willing to collaborate on their vision. Furmanovsky fit the bill nicely

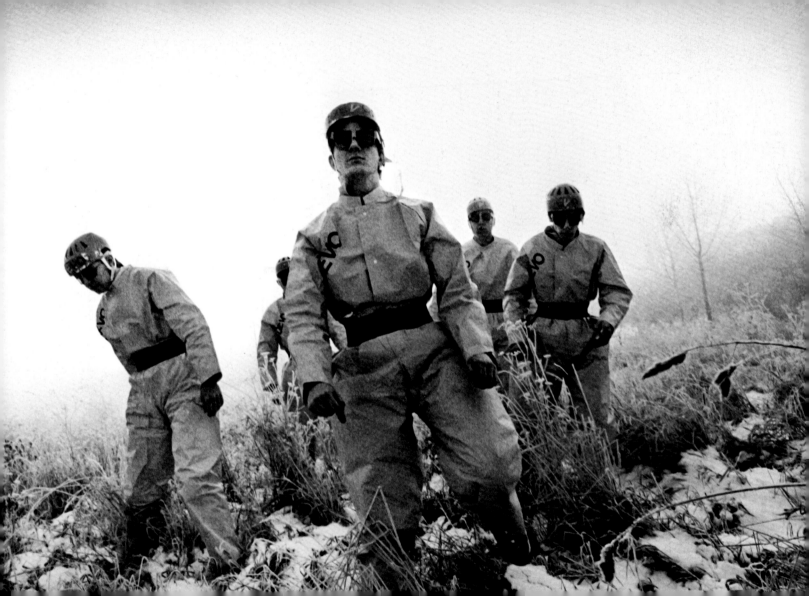

The Cockney Rejects, 1980

photograph by Janette Beckman

More protégés of Sham 69's Jimmy Pursey, the Cockney Rejects formed in working-class East London in 1978. Composed of brothers Stinky Turner (on vocals) and Mickey Geggus (on guitar), Vance Riorden (on bass), and Andy Scott (on drums), the Cockney Rejects released their first single, "Flares and Slippers," in 1979. According to Barry Lazell, author of *Punk!*, "because the majority of their material was a sort of musical variation on the football hooligan chant, combining yobbish assertiveness with anti-establishment gripes, the Rejects became role models for the burgeoning Oi movement." As skinheads proliferated in the United Kingdom, so did bands like the Cockney Rejects.

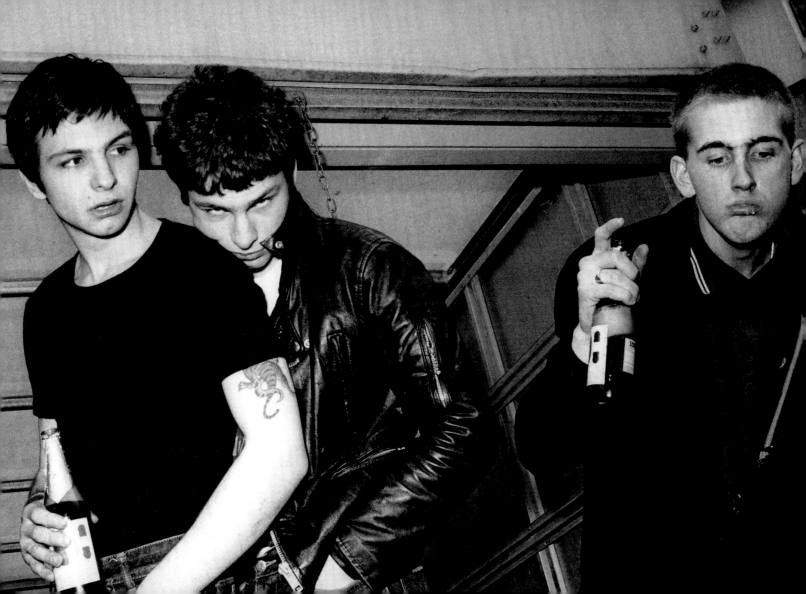

The Cockney Rejects, 1980 photograph by Janette Beckman

Drinking beer, sloganeering, and sporting tattoos—along with hairless noggins—characterized the UK Oi movement. Its Stateside equivalent, hardcore punk, turned into the "straight-edge" scene on the East Coast, whose members proselytized against alcohol and sex.

Shane MacGowan, 1981 photograph by Janette Beckman

Rabid Sex Pistol and Ramones fan Shane MacGowan had been busking for spare change before he formed his first band, the Nipple Erectors (later shortened to the Nips). Before that, he made his own handwritten fanzine, called *Bondage*. His punk reputation was clinched when his ear was partially bitten off by a gal pal at a Clash gig. After being ejected by his bandmates in the Nips (for his unruly drunkenness), he formed Pogue Mahone (Gaelic for "kiss my ass"), playing sped-up, sloppy versions of traditional Irish tunes. That name was eventually shortened to the Pogues, and the group, which made use of a pennywhistle along with guitars, an accordian, and a banjo, showcased MacGowan's gift for songwriting, as well as his charisma as a front man.

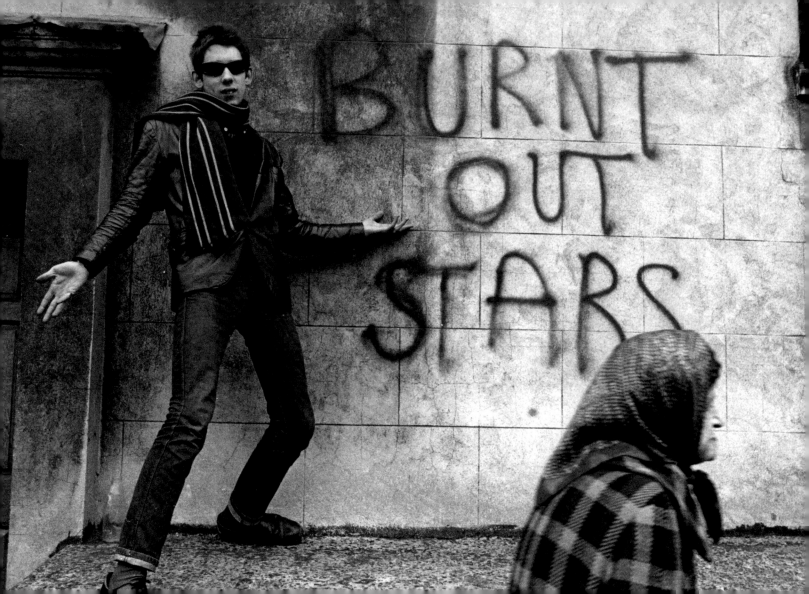

Don Letts, 1982 photograph by Bob Gruen

Filmmaker, DJ, and tastemaker Don Letts served as a sort of reggae guru to many of the UK progenitors of punk. From his days working in a Camden vintage-clothing stall to his stint manning the turntable at pivotal punk club the Roxy, Letts was always where the action was. Friendly with John Lydon, Mick Jones, and Joe Strummer, he turned the Pistols and the Clash on to obscure dub and reggae tracks. He directed all of the Clash's videos and filmed numerous Clash gigs—at this one Bob Gruen captured him backstage next to an antiquated lighting panel.

169

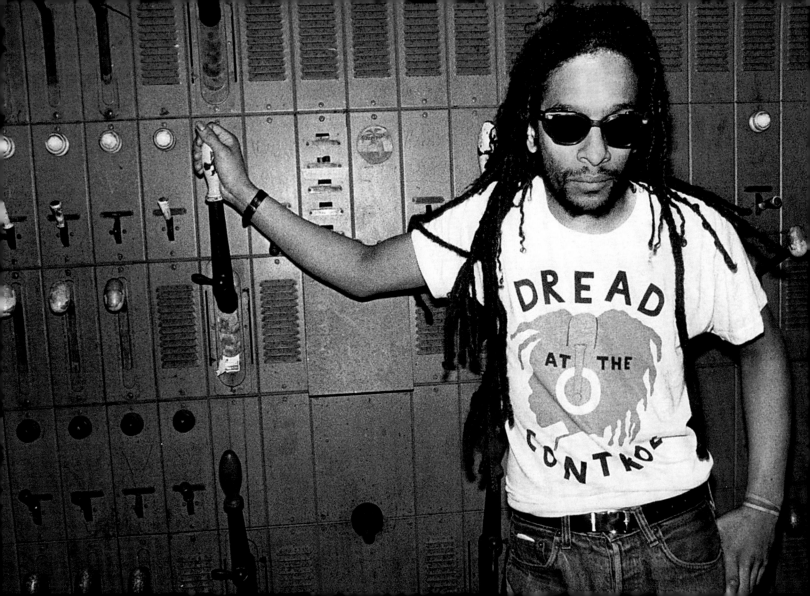

Chrissie Hynde and Don Letts, 1979

photograph by Jill Furmanovsky

When this photo was taken at a gig by the 2-Tone band the Specials, both Chrissie Hynde and Don Letts were on the road to great things. Hynde, a singer, songwriter, and guitarist, after years of trying to get a band together, had formed the Pretenders. The band's first single, the Nick Lowe–produced "Stop Your Sobbing," had just been released. It entered the UK pop charts, as did the group's next 45, "Kid," and shortly thereafter the Pretenders would record their groundbreaking debut album. For his part, Letts would soon make the riveting video for the Clash's breakthrough title track "London Calling."

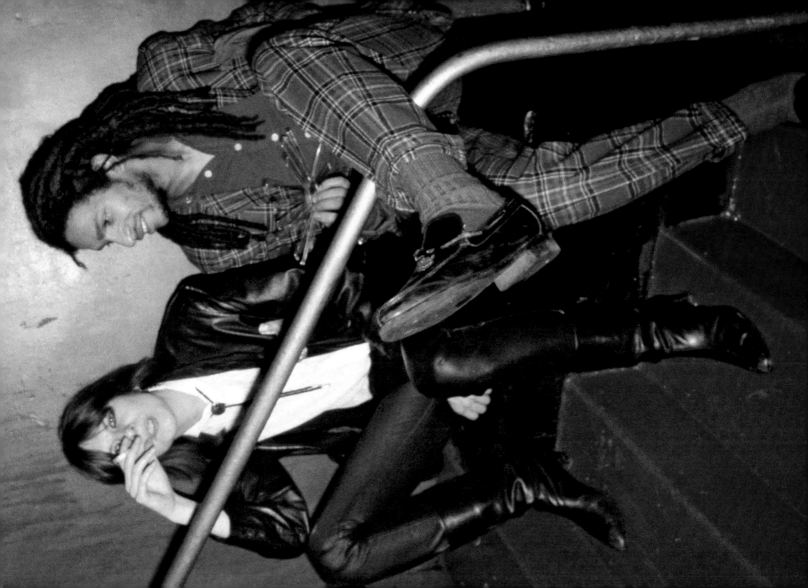

The Pretenders, 1980 photograph by Ebet Roberts

James Honeyman-Scott, Martin Chambers, Chrissie Hynde, and Pete Farndon (from left) spent much of 1980 on the road. Their critically and commercially successful debut LP yielded a UK Top Ten single, "Brass in Pocket." It was the album "Precious," though, with its "fuck off!" that became the band's signature song.

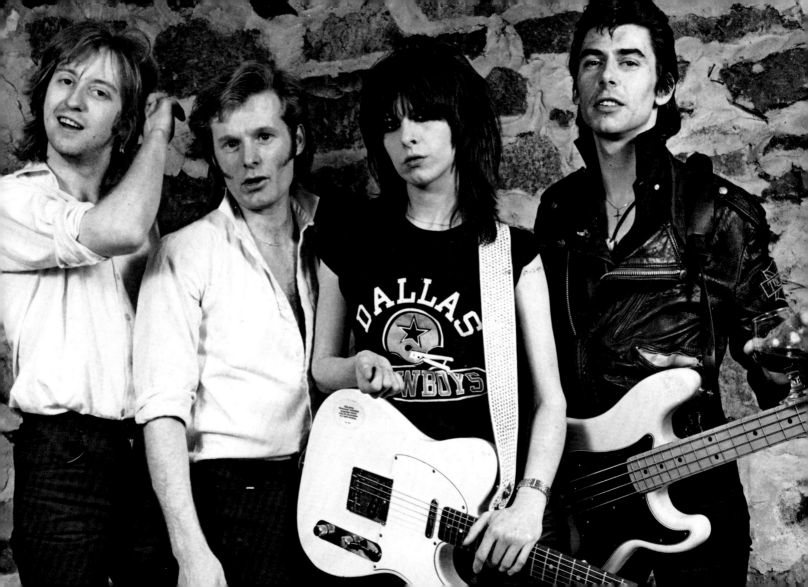

Cabaret Voltaire, 1980 photograph by David Arnoff

In 1973, dissonant noise trio Cabaret Voltaire formed in Sheffield, England, where members Chris Watson (on electronics and tapes), Richard H. Kirk (on guitar), and Stephen Mallinder (on bass and vocals) had a hard time finding an audience. Punk opened up new sensibilities for "metal machine music," which Cabaret Voltaire created with tape loops of found sounds, treated vocals, and distorted guitars—setting the stage for such postpunk sounds as industrial and techno. Cabaret Voltaire's cacophonous single "Nag Nag Nag" made it onto many punk rockers' playlists in 1979. Here, David Arnoff photographed the group in the unlikeliest of places—a bathroom in Los Angeles.

John Cooper Clarke, 1981 photograph by Godlis

The poet laureate of UK punk, John Cooper Clarke—rarely seen without shades—performed cutting-edge, sometimes comic spoken-word verse in a thick Mancunian accent. His hairdo owed much to *Don't Look Back*–era Dylan, but the rapid-fire delivery of his wordcraft looked more toward the future of rap. Often backed by a Manchester group called the Ferretts, Clarke frequently opened shows for the Buzzcocks. In the mid-'80s, he became the paramour of the Velvet Underground's Nico.

Dave Vanian, 1985 photograph by David Arnoff

In the latter days of the Damned, Dave Vanian—here with then wife Laurie's hand clutching his face—looked the part of a Transylvanian count. For a while, in 1978, the Damned (minus Brian James) billed itself as the Doomed.

Delta Five, 1980 photograph by David Arnoff

The rhythmic Delta Five—bassist / vocalist Bethan Peters (right), guitarist / vocalist Juiz Sales, drummer Kelvin Knight, bassist Roz Allen, and guitarist Alan Rigs—came out of the same Leeds scene that yielded the Mekons and the Gang of Four. With a bass-heavy sound and somewhat shrill vocals, the band produced such catchy pro-fem singles as "Mind Your Own Business" and "Anticipation." The success of these records led to a U.S. tour, during which Arnoff photographed the Five playing in Los Angeles.

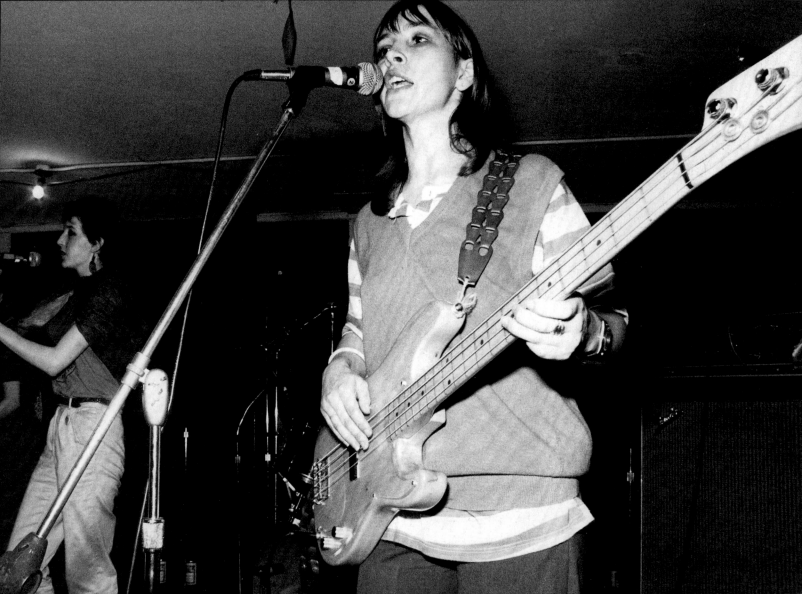

The Members, 1982 photograph by Janette Beckman

The Members, another band to play their first gig at London's Roxy club, formed in Surrey in 1977. They were one of the first punk bands to embrace reggae, as reflected in their early singles. Steve Lillywhite—the brother of Members drummer Adrian Lillywhite—produced the group's first album; he soon became one of England's most prominent producers.

With lead singer Nicky Tesco (his name inspired by a supermarket chain), the Members garnered a 1979 smash with "The Sound of the Suburbs." By 1982, when this photo was taken during an excursion to Los Angeles, the band was in its final days; the Members broke up the next year.

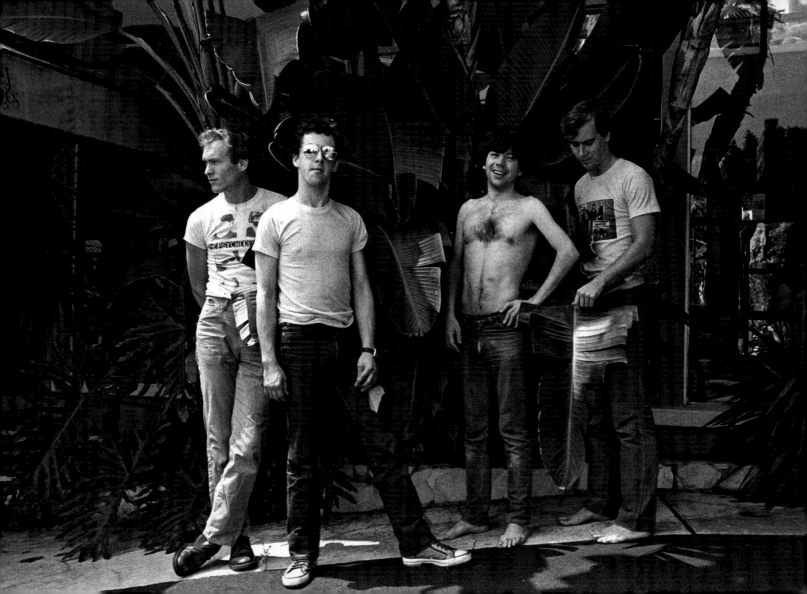

Peter Perrett of the Only Ones, 1980 photograph by David Arnoff

Peter Perrett's "Another Girl, Another Planet" became one of punk's classic songs, later covered by the Replacements, among many other bands. His group the Only Ones, which included such veteran rockers as former Spooky Tooth drummer Mike Kellie, backed up Johnny Thunders on his album *So Alone*. Perrett shared the New York Doll's fondness for smack, which caused problems when it came to touring. Here, photographer David Arnoff snapped Perrett at the Tropicana, where he stayed when the Only Ones played L.A.

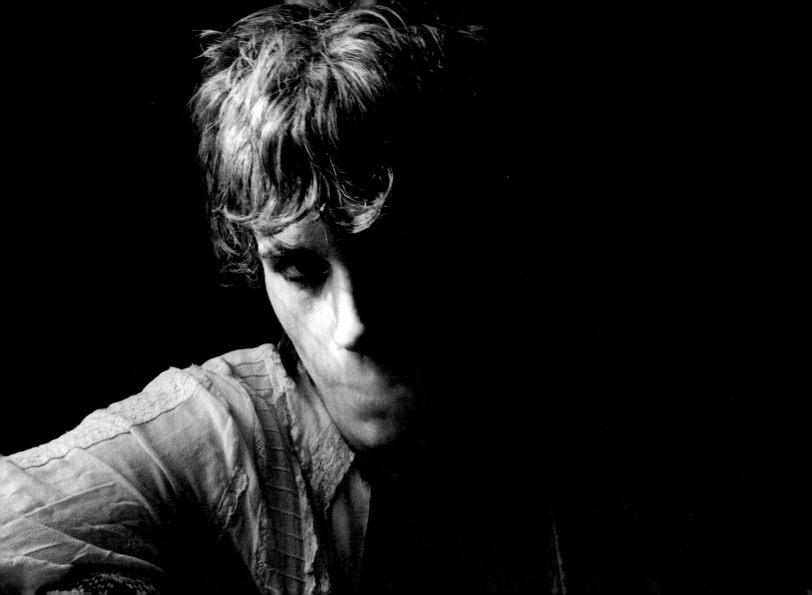

Stiff Little Fingers, 1980 photograph by Ebet Roberts

Belfast's strident punk band Stiff Little Fingers first found success with the 1978 single "Suspect Device," about the Troubles in Northern Ireland. After relocating to London, the band issued their debut album, *Inflammable Material,* on Rough Trade in '79. They then moved to Chrysalis and began extensively touring Europe and the States. Here seen in front of the Manhattan Irish pub Molly Malone's Stiff Little Fingers played several gigs in the New York area in 1980.

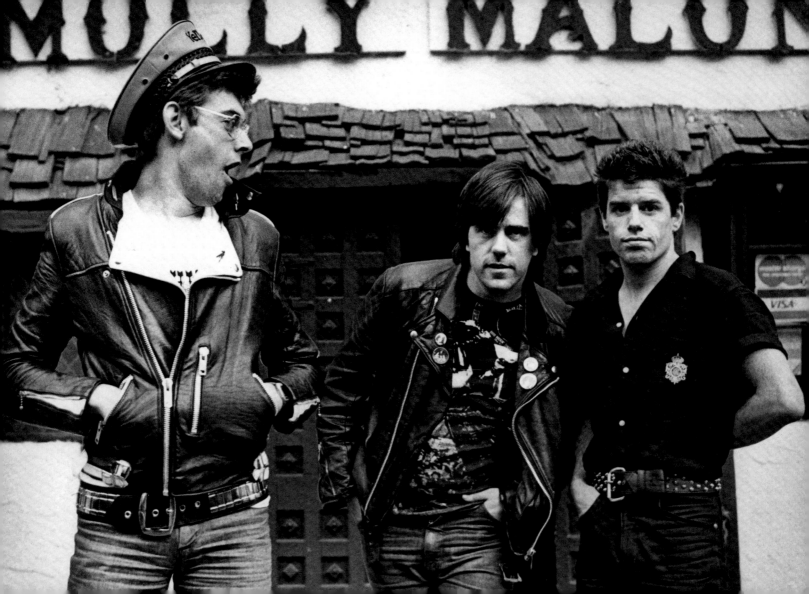

UK Subs, 1982 photograph by Jill Furmanovsky

Short for United Kingdom Subversives, the UK Subs were formed by pub-rock veteran Charlie Harper, an R&B-tinged vocalist and harmonica player whose previous band had been called the Marauders. The band's career peaked in the late 1970s, when the group scored several hit singles in England, including "Stranglehold" and "Tomorrow's Girls." In 1980, the band released the live album *Crash Course,* which, according to punk chronicler Barry Lazell, accurately documents "their kamikaze stage act, in which you can hear the audience growing ever more rowdy as the band breaks down into more and more chaos."

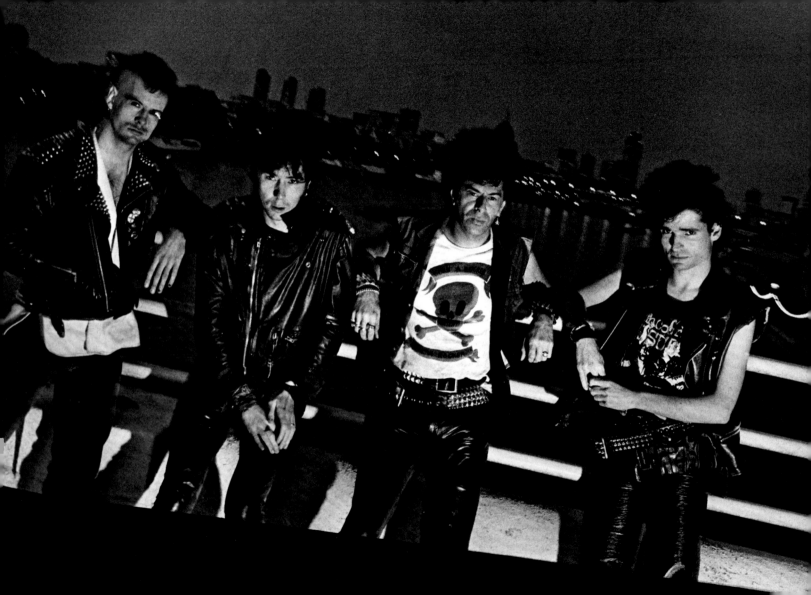

The Jam, 1981 photograph by Bob Leafe

Having produced several hit singles and albums (*This Is the Modern World, All Mod Cons*) in Britain—and even having had their name partially inspire the London fanzine *Jamming!*—the Jam tried to break out in America. In 1981, they appeared on the NBC television program *Tomorrow with Tom Snyder*—here, Snyder, vocalist/guitarist Paul Weller, drummer Rick Buckler, and bassist Bruce Foxton (from left). About a year after the appearance, in October 1982, the Jam broke up. Weller announced, "It really dawned on me how secure the situation was, the fact that we could go on for the next ten years, making records, getting bigger and bigger ... That frightened me because I realized we were going to end up like the rest of them." Weller returned to the States a few years later with his soul outfit, the Style Council, and has since worked as a solo artist. "Weller is a god in the UK," says *Jamming!* founder and writer Tony Fletcher. "He's his generation's Eric Clapton."

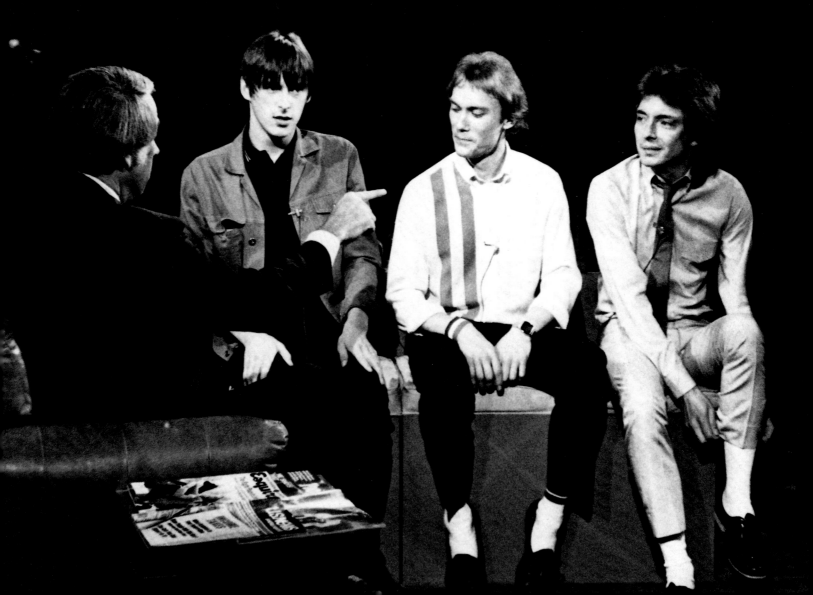

WAY OUT WEST

Suzi Quatro, 1974 photograph by Chuck Krall

During the punk era, women plugged in their instruments and took to the stage like never before. One of the earliest to do so was rocker Suzi Quatro, a leather-clad American guitarist who moved to London in 1970 and found some success there in the glam scene. "I had to kick the door down," she later said of the barriers to joining rock's "boys club." Born in Detroit—natch—she returned to America in 1974, touring as an opening act for Alice Cooper. Seen here playing at San Francisco's Winterland in June 1974, Quatro eventually settled in Los Angeles, where she was cast as Leather Tuscadero on *Happy Days.* Quatro had a major influence on a fourteen-year-old guitarist named Joan Jett, who was a regular club-goer in Hollywood.

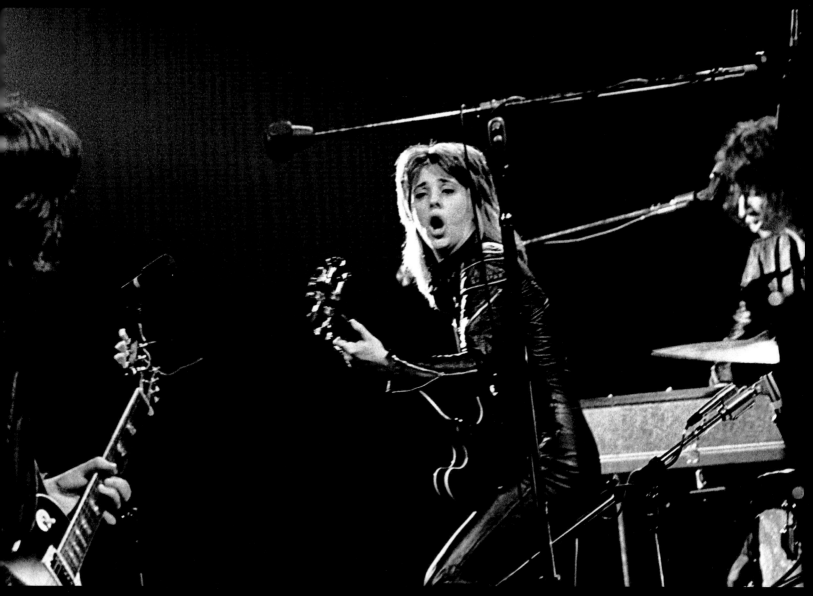

The New York Dolls, 1973 photograph by Bob Gruen

Hollywood had never seen the kind of glamour that the New York Dolls brought with them in 1973 during their first tour of the West Coast, which was documented by Bob Gruen with his video and still cameras. After posing outside Hollywood Boulevard's most famous lingerie shop, Johnny Thunders and David Johansen (from left) made their way inside, where they most likely went on a shopping spree.

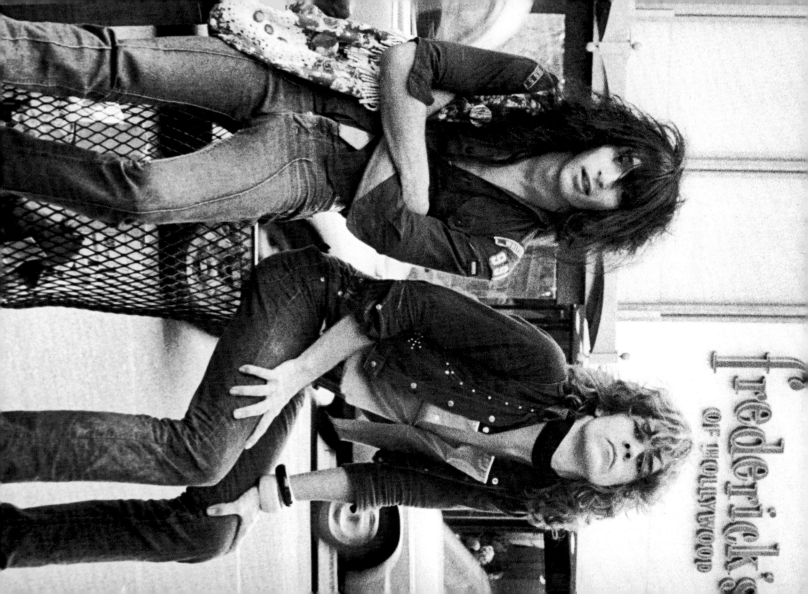

The New York Dolls, 1973 photograph by Bob Gruen

Here, Arthur "Killer" Kane, David Johansen, Johnny Thunders, Jerry Nolan, and Sylvain Sylvain relax in the California sun, on the (high) heels of the New York Dolls' debut album. Kane was unable to play the gigs—his girlfriend had tried to cut off his thumb just before the band's departure from New York. One more album would follow the next year, *Too Much Too Soon,* before the group splintered.

Thunders overdosed in 1991, and Nolan died nine months later. In the twenty-first century, the living members—Kane, Johansen, and Sylvain—reunited for a special concert in London, presented by Dolls fan Morrissey. Three weeks after the extremely well-received gig, Kane died suddenly of leukemia. Johansen and Sylvain carried on, and a new Dolls album was released in 2006.

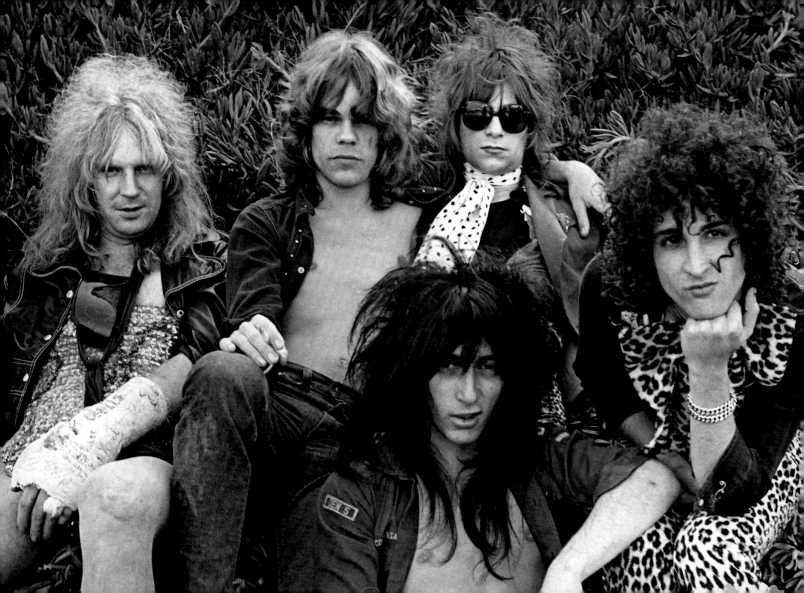

The Runaways, 1976 photograph by Bob Gruen

Formed in Los Angeles in 1975, the Runaways were a little bit New York Dolls, a little bit Kiss, with Suzi Quatro and the Shangri-Las mixed in for good measure. In 1975, guitarist Joan Jett, bassist Jackie Fox, drummer Sandy West, vocalist Cherie Currie, and guitarist Lita Ford (from left) were L.A. impresario Kim Fowley's wet dream. "Cherry Bomb" on the band's 197 debut album became their calling card. "We're different because we're young an our songs are about death, sex, drugs, and violence and the things that teenager really care about," Joan Jett told New Yorker Danny Fields when he caught one of the band's Hollywood rehearsals.

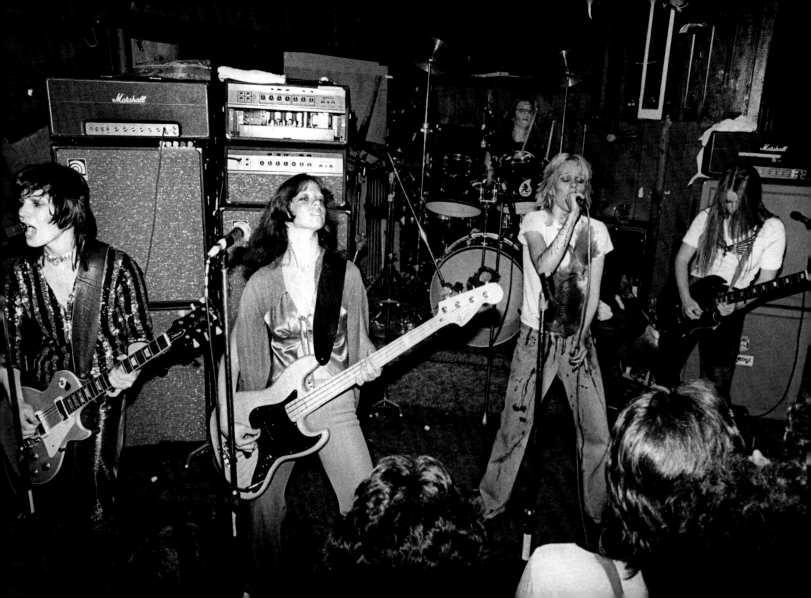

Kim Fowley, 1977 photograph by Chuck Krall

Before masterminding the Runaways, Kim Fowley had dabbled in the glam scene in London and managed to score a recording deal as a solo artist. Upon his return to L.A., he hung out at Rodney Bingenheimer's English Disco, a magnet for jailbait. At a party in 1975, Fowley met thirteen-year-old Kari Chrome who liked to write songs about sex. The two began collaborating on material and seeking teenage girls to perform it. Lita Ford was the only Runaway in his new band who had experience, but the other girls were fast learners. The group played their first-ever gig in the living room of Phast Phreddie Patterson, editor of a fanzine called *Back Door Man.* "This one is going to turn me into the Brian Epstein / Colonel Tom Parker that my enemies have always been terrified I'd become," Kim Fowley told all who would listen. The band "singlehandedly relit the Hollywood firmament," crowed Fowley, who became known as the Runaways' Svengali, a reputation he has yet to live down. Chuck Krall shot this portrait at Fowley's West L.A. apartment.

The Runaways, 1976 photograph by Bob Gruen

With attitude galore, Lita Ford, Joan Jett, Cherie Currie, Jackie Fox, and Sandy West (from left) inspired numerous gals to start a band. "We shared the dream of girls playing rock & roll," Jett asserts. "We changed the world."

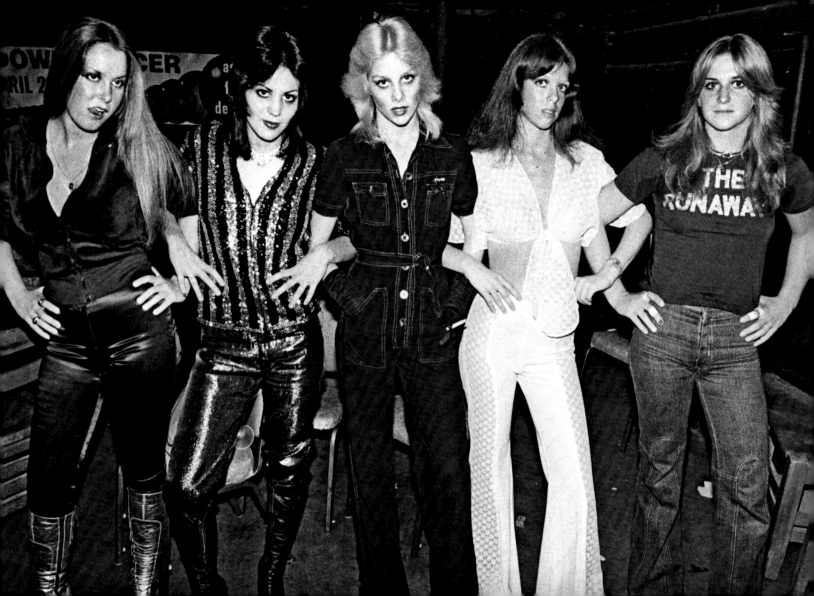

The Patti Smith Group, 1975

photograph by Chuck Krall

The first CBGB band to hit the West Coast was the Patti Smith Group, who played a standing-room-only show at San Francisco's Boarding House in November. Photographer Chuck Krall, who'd gone to high school with guitarist Lenny Kaye, presented the band with limited-edition Bob Marley buttons he'd created. Backstage sporting their badges are drummer Jay Dee Daugherty (who'd recently left the Mumps to join the PSG), pianist Richard Sohl, Czech-born guitarist Ivan Kral, Patti Smith, and Kaye (from left).

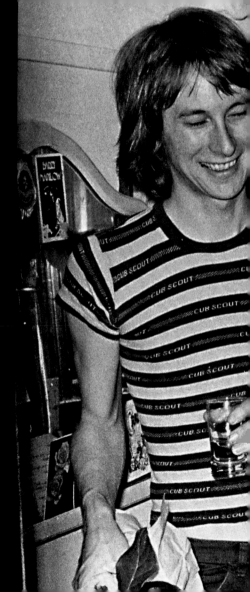

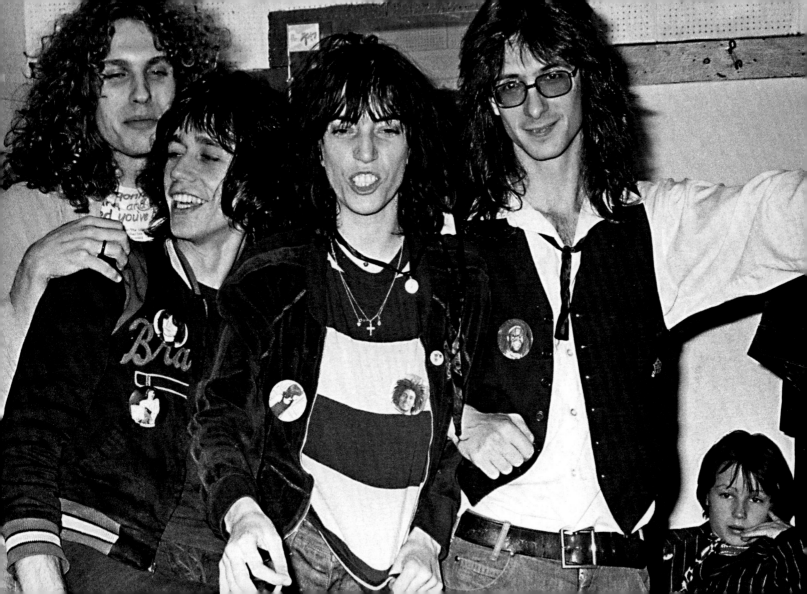

Patti Smith and Lenny Kaye, 1975 photograph by Chuck Krall

When he compiled the seminal 1972 anthology *Nuggets,* guitarist Lenny Kaye (flanking Patti Smith at this San Francisco performance) introduced listeners to and/or reacquainted them with obscure '60s garage bands. Featuring such groups as the Seeds, the Chocolate Watchband, the Standells, and the Barbarians, the album offered stripped-down sonics and urgent vocals that reminded those who were fed up with the grandiosity of prog rock what primal rock & roll was all about. Punk bands from the Clash to the Pistols and postpunkers from the Replacements to R.E.M. cut their rotten little teeth on Kaye's noisy two-disc vinyl collection.

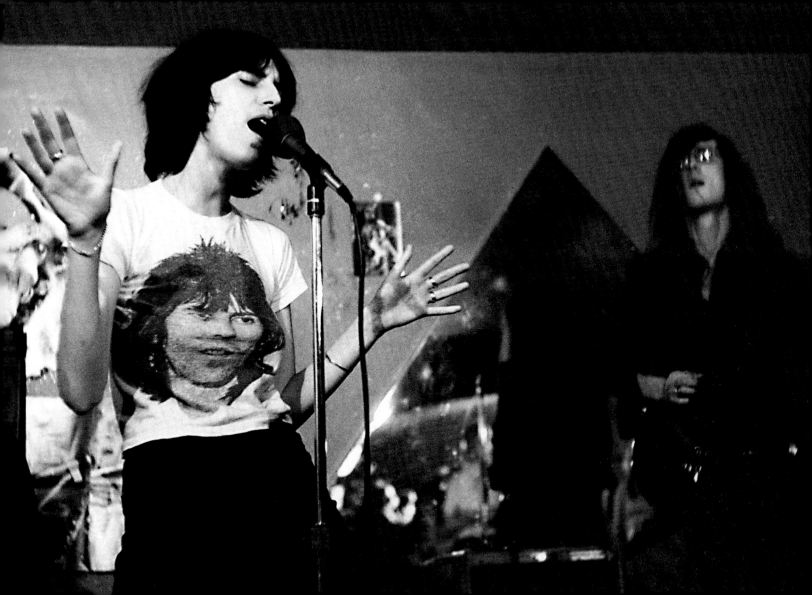

The Ramones in California, 1977 photograph by Chuck Krall

The Ramones won numerous converts
when they debuted in L.A. (with the
Flamin' Groovies) during the summer of
1976. Scenemaker Art Fein reviewed
the band's first show at the Roxy club,
spinning off a comment Jon Landau
had famously made a few years earlier
about Springsteen: "I have not seen the
future of rock & roll, but I have seen the
Ramones and that may be even better . . .
They stood there pounding monotonously
and mercilessly with their own cretinous
originals and some other people's with no
regard for pronunciation or 'art,' blasting
musical pretensions to dust, and encoring
with Chris Montez's 'Let's Dance,' which
for me, at least, beats the hell out of
Bruce Springsteen doing the Ronettes."
The band returned to California in early
'77, and Chuck Krall took this shot on
February 20, after the band had finished
their sound check at the Whisky a Go-Go

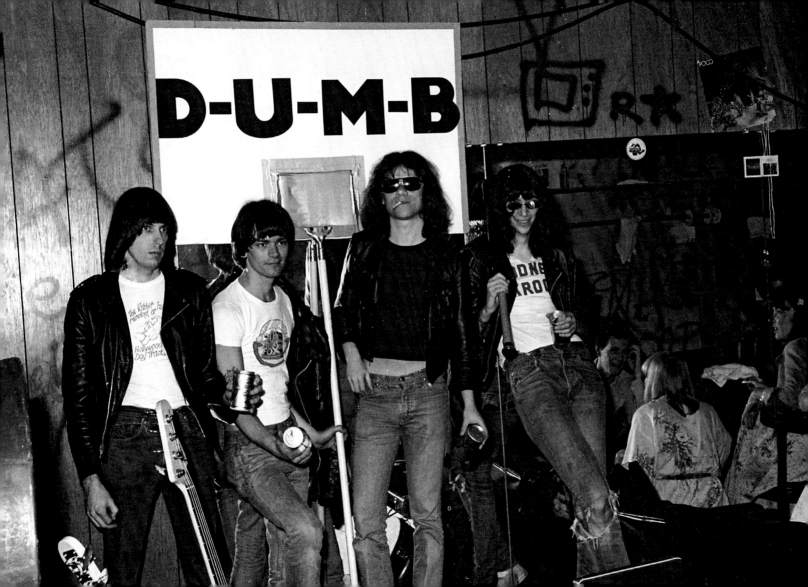

Joey and Johnny Ramone and Rhino's Harold Bronson, 1977

photograph by Jenny Lens

"We were never comfortable taking pictures," Johnny Ramone once said. "I still feel very foolish doing it. You want the band to look cool, because image is very important, and the photographer says, 'Do something!' But we don't do nothing. You don't want to put your arms around somebody, so you all just stand there, and then they make you feel more uncomfortable." Here, the Ramones pose in front of L.A.'s Rhino Records, a shop catering to punk and obscure 1960s releases (cofounded by Harold Bronson) that would transmogrify into an equally cool record label the following year.

190

The Ramones, 1977

photograph by Chuck Krall

On February 17, following the previous night's gig at the Whisky, Chuck Krall captured Joey, Tommy, Johnny, and Dee Dee (from left) lounging around their Hollywood hotel room on the Sunset Strip. "When the Ramones started, we didn't call what we were playing punk rock. We just knew that we were playing an exciting new kind of rock & roll . . . To me punk is about being an individual and going against the grain, and standing up and saying, 'This is who I am.' To me, John Lennon and Elvis Presley were punks, because they made music that evoked those emotions in people. And as long as people are making music that does that, punk rock is alive and well."

—Joey Ramone

The Nuns, 1977 photograph by Chuck Krall

San Francisco's punk scene evolved gradually in the mid-1970s. One of its first exemplars, the Nuns, featuring Alejandro Escovedo on guitar (left) and Ritchie Deitrich on vocals, had been inspired by the Stooges, the Dolls, and the Velvets. The Nuns originally formed, according to Escovedo, for a student film he was making that needed "the worst band in the world." On April 12, 1977, the band opened for Television at the Boarding House. Blondie was in town, and at one point, Debbie Harry and Gary Valentine joined the Nuns onstage. In January 1978, the Nuns were the first act on the bill for the Sex Pistols' final show.

Rodney Bingenheimer and Debbie Harry, 1977

photograph by Chuck Krall

DJ, publicist, nightclub impresario, and always-enthusiastic music fan Rodney Bingenheimer has been called the mayor of the Sunset Strip. Since his early days working as a gofer for Sonny and Cher, the music aficionado has surrounded himself with the ever-changing faces of pop. He spent the early '70s swirling in London glam, then opened Rodney Bingenheimer's English Disco, with backing from Ziggy himself—David Bowie. He caught on early to punk, and when he garnered his own Sunday night radio show—*Rodney on the ROQ*—on Los Angeles station KROQ, he frequently debuted punk singles that no other station would play. Here, Rodney and Debbie Harry schmooze backstage at the Whisky during a February '77 Ramones show.

193

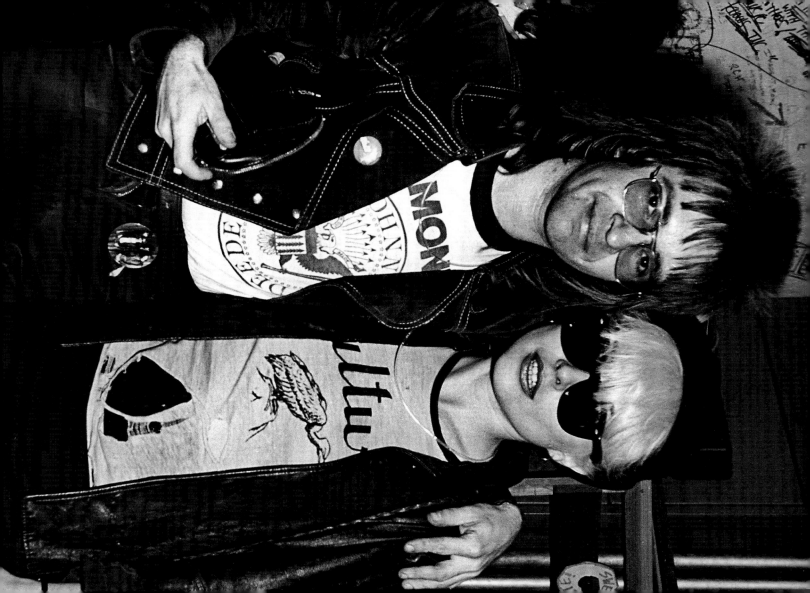

Venus and the Razorblades, 1976

photograph by Chuck Krall

In addition to producing four albums for the Runaways, Kim Fowley worked with another all-female band, Venus and the Razorblades. Not as notorious as the younger combo, the Razorblades released the Fowley-produced album *Songs from the Sunshine Jungle* in 1977. Here, on December 5, 1976, they play the Starwood, a hard-rock club on the cusp of becoming a major punk venue.

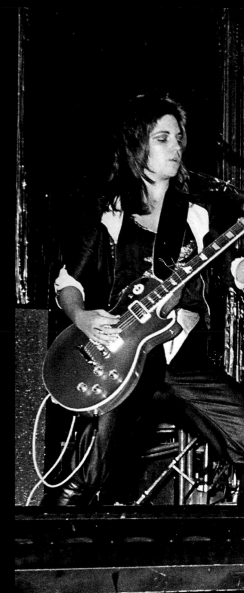

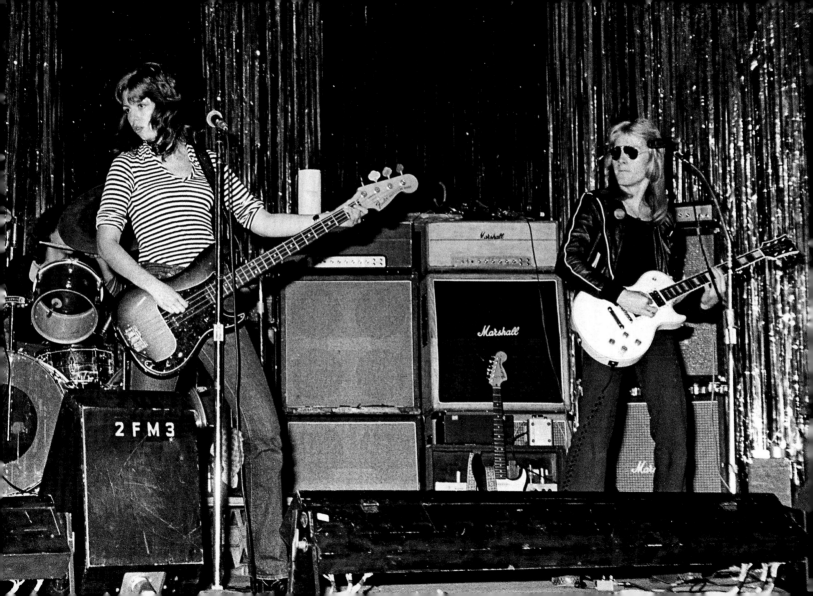

The Dictators, 1977 photograph by Chuck Krall

Following an April 8 gig in San Francisco at the new punk club the Mabuhay Gardens, the Dictators showed what they thought of the town that invented the Summer of Love. The back of a Holiday Inn—where Handsome Dick Manitoba, Mark "the Animal" Mendoza, Scott "Top Ten" Kempner, Andy Shernoff, Ritchie Teeter, and Ross "the Boss" Funicello (from left) are lurking—looks about the same no matter where it is.

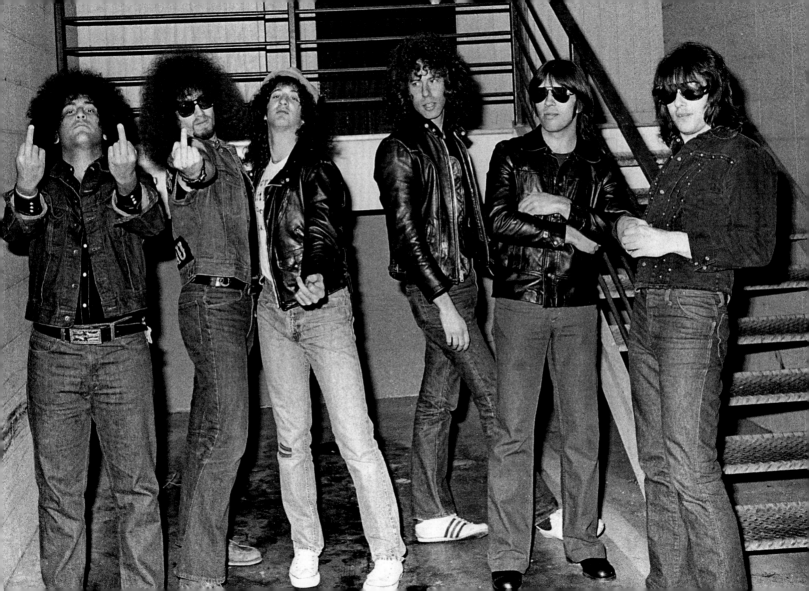

Hellin Killer, Pleasant Gehman, and Bobby Pyn, 1977

photograph by Jenny Lens

With the original nom de punk Bobby Pyn, the anti–Beach Boy later known as Darby Crash (right) had debuted in April with preeminent L.A. punk band the Germs. On this particular evening at the Starwood, Devo provided the background music. Scenester Hellin Killer (left)—clearly influenced by Sue Catwoman's feline do, and flourishing the requisite cat-o'-nine-tails—and scribe/party gal Pleasant Gehman prepare to pogo with their punk rocker pal. L.A. punk style was initially under the studs-'n'-safety-pin sway of the Sex Pistols and their London fans—though Bobby Pyn actually seemed to favor paper clips for neck adornment. "The L.A. scene took on its own unique clothing style very quickly," says photographer Jenny Lens. "We combined glam, thrift store items, and bright colors."

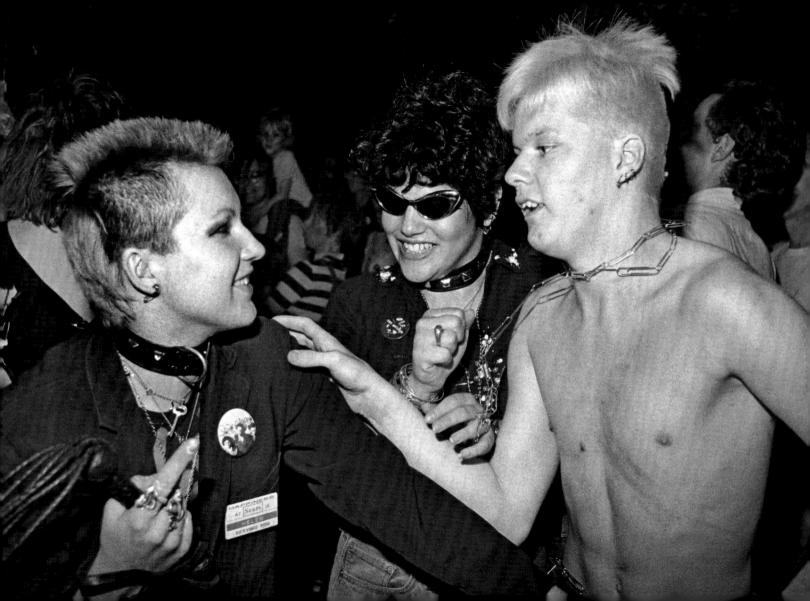

The Screamers, 1977 photograph by Jenny Lens

One of L.A.'s first punk bands, the Screamers made a visual impact early on. One of the band members, drummer K.K. Barrett, went on to become a production designer for such films as *Marie Antoinette.* Seen here, helping to kick-start the homegrown L.A. punk scene at the debut Screamers gig (May 28, 1977), are Tomata du Plenty, K.K. Barrett, and Tommy Gear (from left). The gig took place at the office loft belonging to *Slash* magazine, L.A. punk's early cheerleader. Parties at Tommy Gear and Tomata du Plenty's abode, the Wilton Hilton, were legendary.

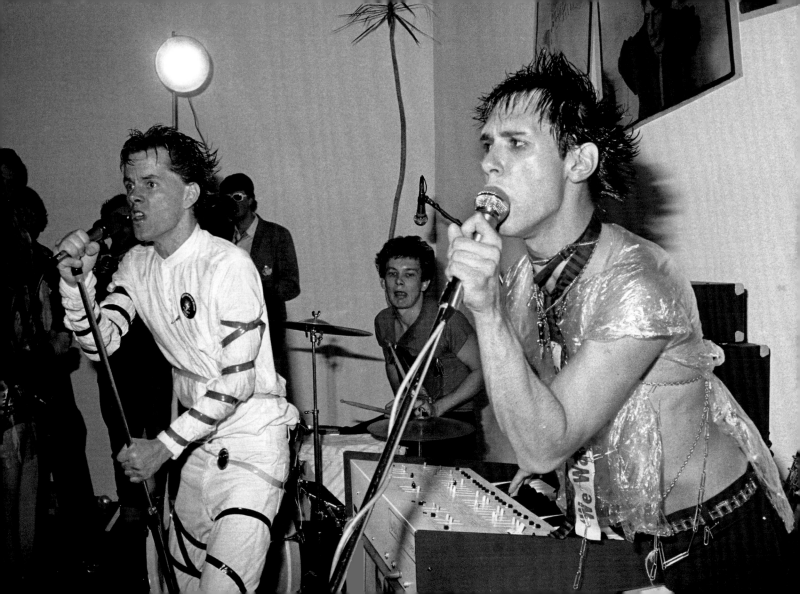

Lance Loud, 1977 photograph by Jenny Lens

With prodigal son Lance Loud as lead singer, the Mumps were welcomed to Hollywood when they arrived from New York in May to play a gig at the Whisky a Go-Go. Here, Lance lounges in the dressing room of the Whisky. "The Mumps have been criticized for not being punk enough and about being too intellectual," Loud sniffed the following year, back in New York. "To think is so passé. Someday we'll have programmed them enough ... Then we'll open Mumps institutes, which only will be second to EST."

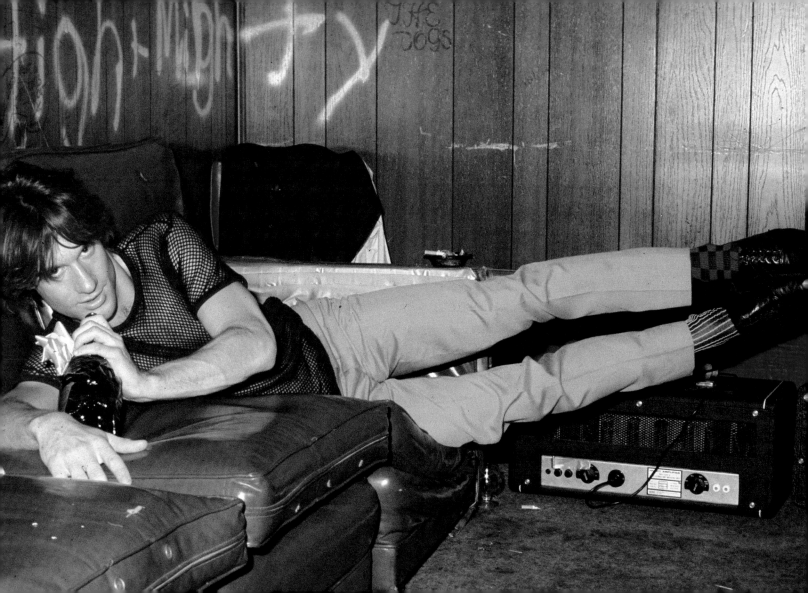

Darby Crash, 1977 photograph by Jenny Lens

L.A.'s original punk Darby Crash in safety pin–studded jeans, proves he's a gutter boy on the Sunset Strip, across from Tower Records. Jenny Lens' images from this first-ever photo session of the Germs were to accompany Pleasant Gehman's interview with Darby that ran in *Slash,* the punk zine that would later spawn a record label (which would, in some cases release albums by its former scribes). Crash modeled himself after Iggy Pop an Sid Vicious and became as extreme as both in his over-the-top performances and self-destructive nasty habits.

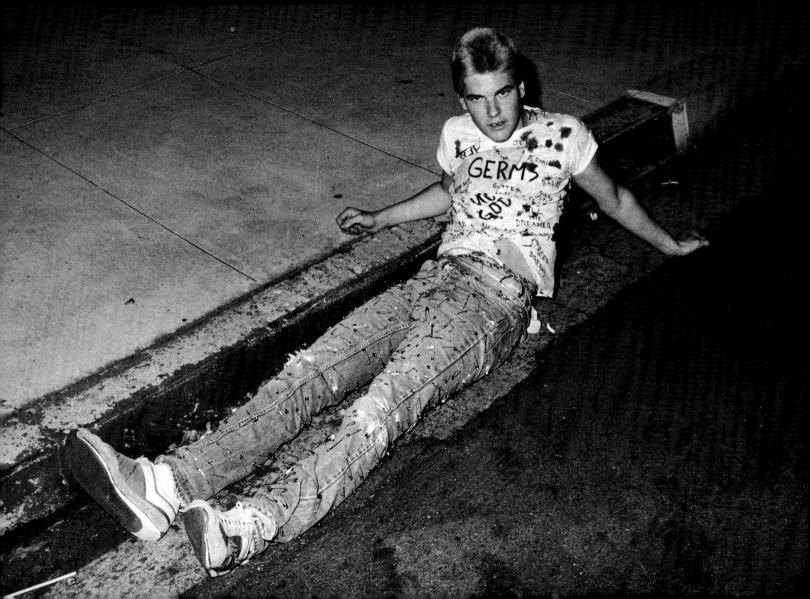

Pleasant Gehman and Randy Kaye, 1977 photograph by Jenny Lens

Founding editors of punk zine *Lobotomy* Pleasant Gehman and Randy Kaye (from left) hang out at the L.A. equivalent of CBGB or the Roxy, the Masque. Originally opened as a rehearsal space, the Masque became an illicit club in the summer of 1977 when Scotsman-turned-Angeleno Brendan Mullen decided to provide a venue for the town's new punk bands. The squalid nightery was located in an alleyway behind the seedy Pussycat Theater on Hollywood Boulevard. "Once inside, one had to deal with passed-out punks, indeterminable liquid on the floor—either overflow from the toilets or spilled beer mixed with bodily fluids of some sort—and the dark and noise," recalls Phast Phreddie Patterson, editor of seminal zine *Back Door Man*. "But its graffiti-decorated walls were home to many of us, a safe haven from the modified, petrified hypocrites of the outside world."

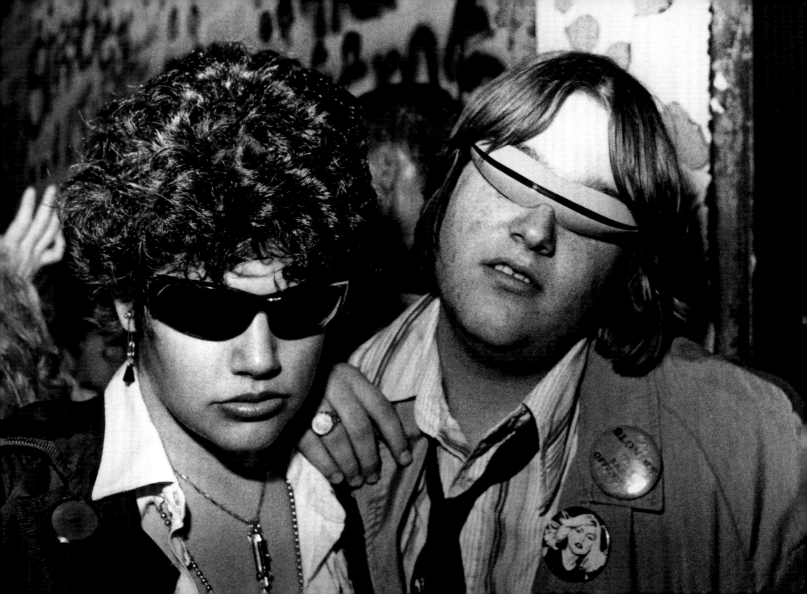

The Zeros, 1977 photograph by Jenny Lens

Among the highlights of the early days of L.A.'s burgeoning punk scene was the Punk Rock Invasion show, held at the Orpheum in April. In addition to the Weirdos and the Nerves, there was a surprise appearance by the Damned, who had just played the Starwood. The Invasion opened with a set by the Zeros, a band of Mexican-American teens who hailed from San Diego. On guitars were Javier Escovedo (second from left)—brother to Alejandro Escovedo of San Francisco band the Nuns—and (at right) Robert Lopez, who found success as El Vez, the Mexican Elvis, in the 1990s.

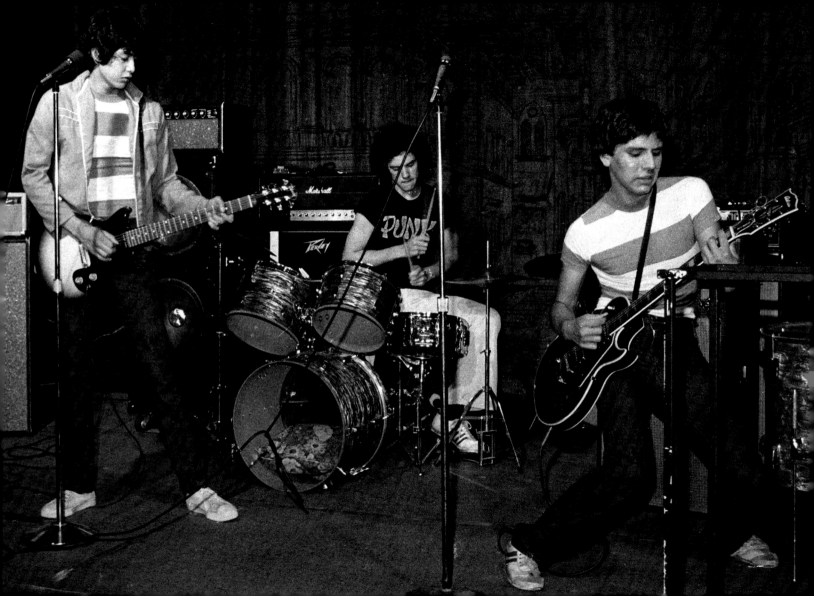

The Dead Boys, 1977 photograph by Jenny Lens

The Starwood was packed on November 13, 1977, when the Dead Boys made their first Hollywood appearance. Seen here, Stiv Bators and Cheetah Chrome (from left) show Angelenos what "Sonic Reducer" is all about: "I'll be ten feet tall / And you'll be nothin' at all!"

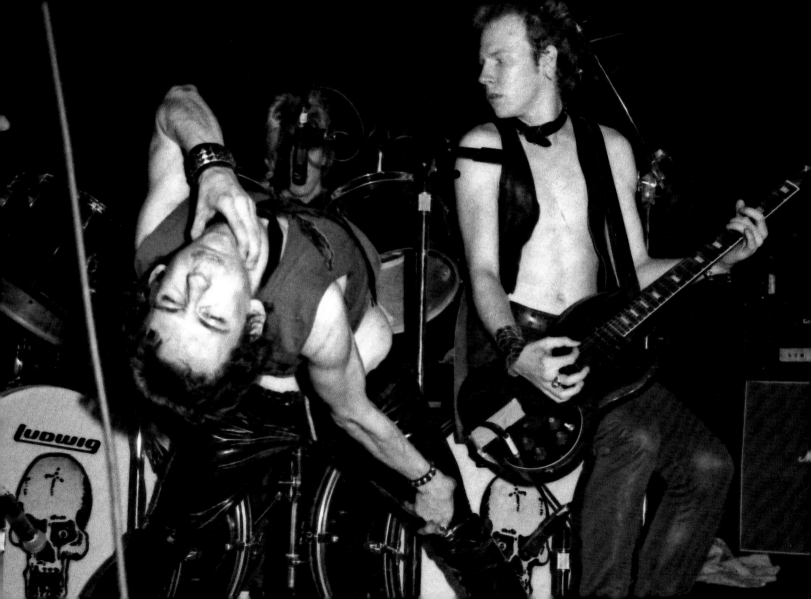

Stiv Bators at Bomp Records, 1977 photograph by Chuck Krall

Vinyl emporium Bomp Records, founded by Greg and Suzy Shaw, in North Hollywood became one of the must-stop spots for visiting bands from New York and London. On November 5, 1977, the Dead Boys dropped by to autograph copies of their debut album, *Young, Loud and Snotty*. Fans were very impressed by the many talents of Stiv Bators, including his ability to wash his tattoo with his tongue.

203

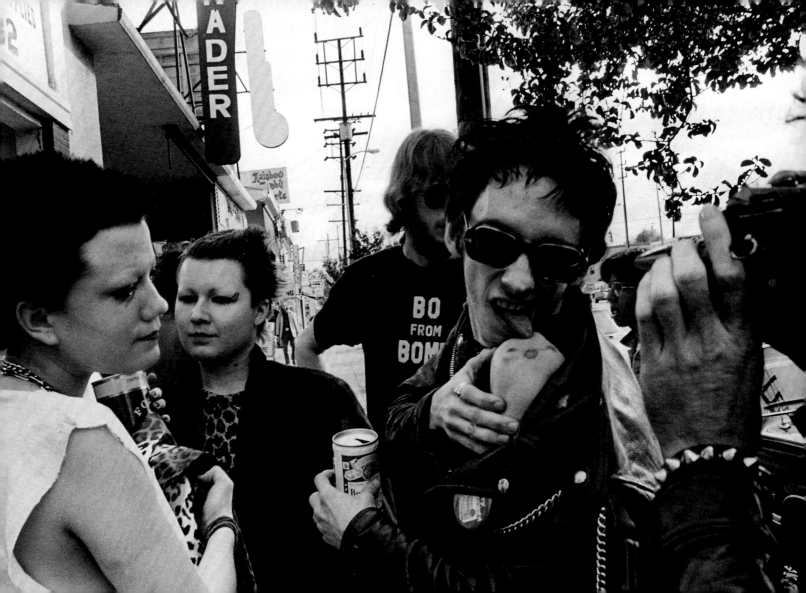

The Screamers, 1977 photograph by Jenny Lens

Loitering on the bus stop outside Gower Gulch, where cowboys waiting to get cast in B-Westerns in the 1930s and '40s traditionally hung out, the Screamers do their best to scare grandma—punk buckaroos David Brown, K.K. Barrett, Tomata du Plenty, and Tommy Gear (from left). Although the Screamers would eventually pack the Whisky, they never released a record.

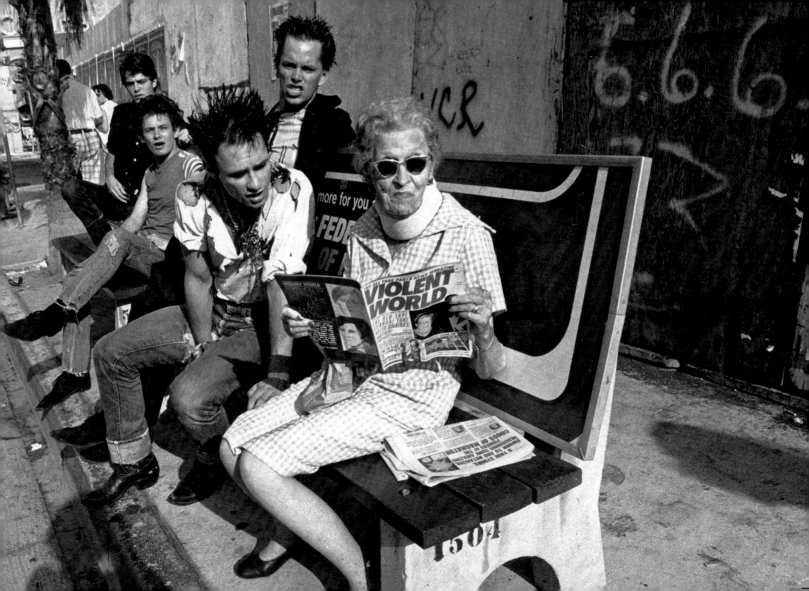

The Weirdos, 1977 photograph by Jenny Lens

Described by writer Barney Hoskyns as "manic art-terrorists," the Weirdos were another fixture on the early L.A. punk scene. They used their bodies as canvases, and duct tape and op-art clothes to make a unique visual statement. Their EP *Destroy All Music* was released on Greg Shaw's label, Bomp Records. The Weirdos played regularly at the Masque, which band member John Denney described as being "like a funeral and a celebration all at once. The funeral was for the death of rock music as we knew it, the celebratory aspect for the dawning of a new era."

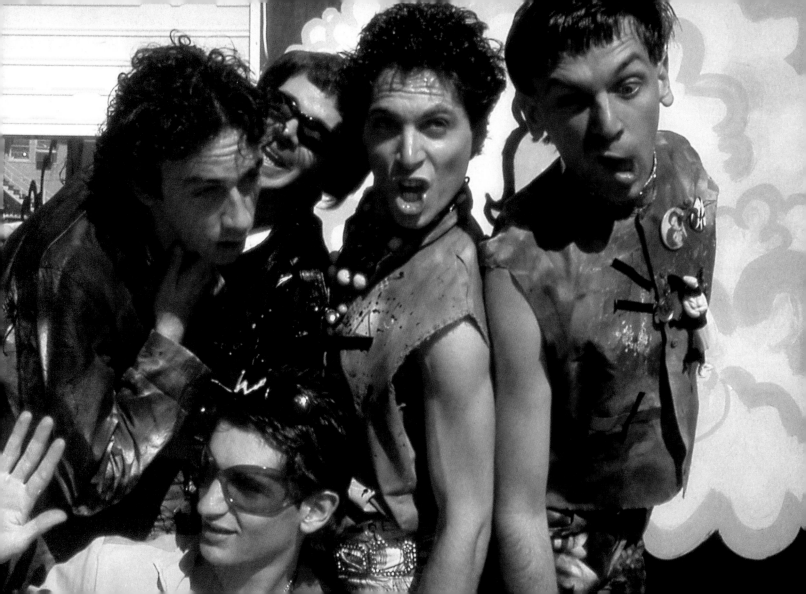

The Eyes, 1977 photograph by Jenny Lens

Onstage at the Masque this November 23, 1977, a short-lived band called the Eyes, composed of future Go-Go's guitarist Charlotte Caffey on bass, soon-to-be X drummer D. J. Bonebrake, and bassist Joe Ramirez playing guitar (from left). Jaded rock critic Richard Meltzer became reinvigorated by the local scene, raving, "From mid-'77 though somewhere in '80 or possibly, on the outside, '81, L.A. (believe it 'cuz it's true!) was not only the hottest, hardest-core punk-rock venue in the U.S. but the second most-vital such culture-seat in the world (behind the UK). With bands like the Germs, X, the Screamers, the Plugz, the Bags, the Weirdos, the Controllers, the Flesh Eaters, Black Flag, B-People, Black Randy & the Metrosquad, Fear, Nervous Gender, UXA, 45 Grave, Vox Pop, Monitor, Catholic Discipline, and Gun Club, and a couple of swell mags, *Flipside* and my all-time favorite rockmag, *Slash*, this shithole came as close to being a fertile musical oasis as any I've stumbled over."

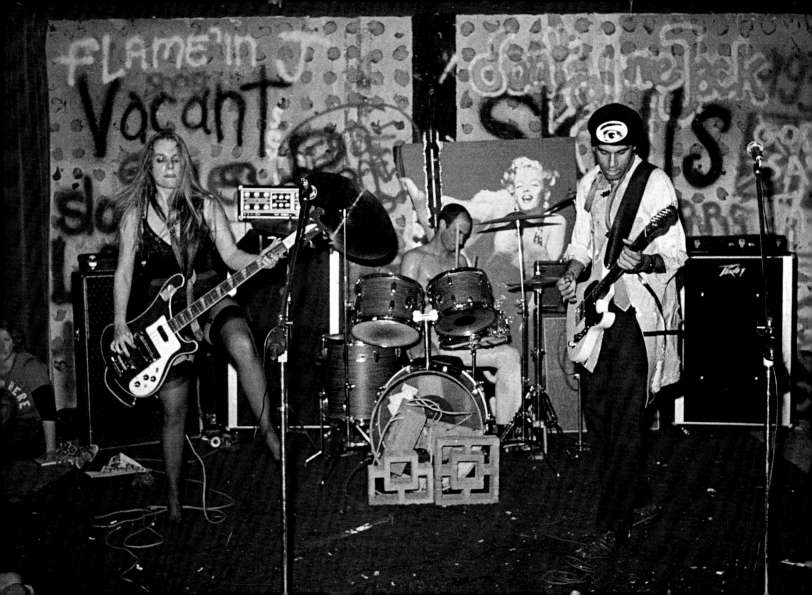

Slash benefit at the Larchmont, 1977 photograph by Jenny Lens

Throughout the latter half of 1977, *Slash* magazine put on a number of benefit gigs at peculiar venues, beginning with this one at Larchmont Hall on July 8. The goal of the benefit was to earn the seventy-two dollars or so required to publish an issue of *Slash,* which sold at record stores like Rhino and Licorice Pizza for fifty cents. The relationship between the bands and the zine mirrored that between the CBGB bands and *Punk* a year earlier. Making the scene at the first-ever *Slash* benefit was a who's who of L.A.'s punk movers and shakers: Weirdos drummer Nickey Beat, who would occasionally play with newcomers the Germs and the Bags; Bobby Pyn, soon to be Darby Crash; guitarist Pat Smear, a founding Germ who would later play with Nirvana and the Foo Fighters; Runaways guitarists / vocalists Joan Jett and Lita Ford; and DJ / scenemaker Rodney Bingenheimer (from left). "Hollywood in those days was like one big sick prom," nonstop reveler Pleasant Gehman later recalled.

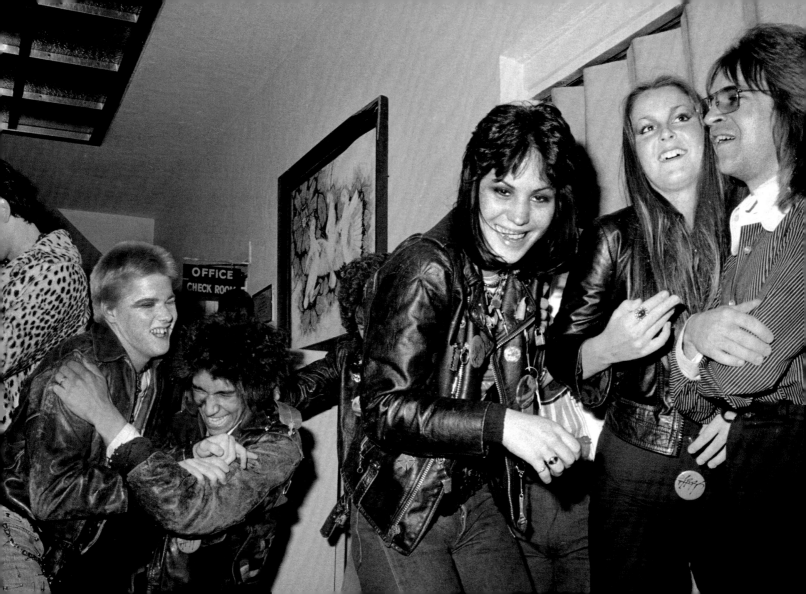

John Cale, 1977 photograph by Theresa Kereakes

Founding Velvet Underground provocateur John Cale had just released the aptly titled *Guts* when he played the Starwood on March 9, 1977. It happened to be his thirty-fifth birthday, which he celebrated with an audience of punk rockers young enough to be his own crazed "children of the damned." "The fact that the most aggressive milieu for [punk] in America was found in L.A. was reinforced by a social dynamic in which the distance between rich and poor was most marked," Cale opined. "These were very captive audiences, no matter what the size."

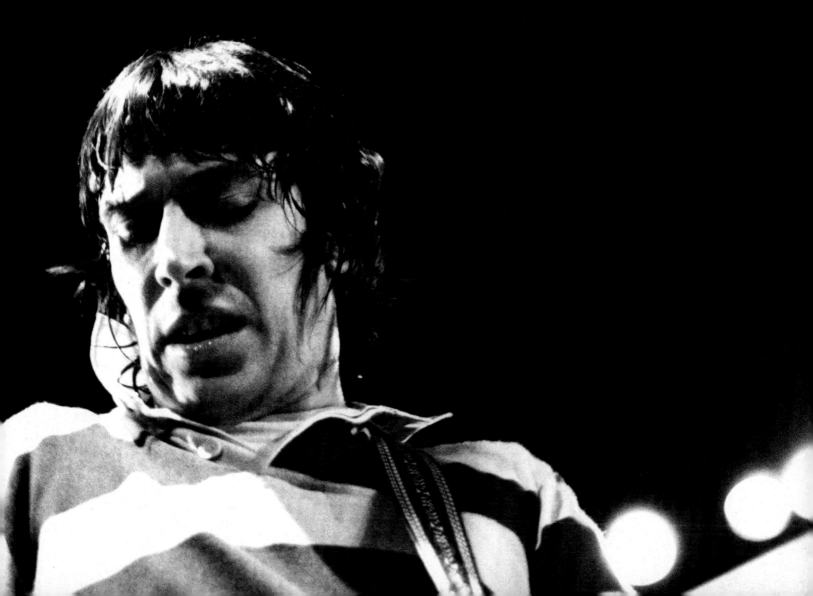

The Bags, 1978 photograph by Dawn Wirth

Formed by Alice Bag (b. Armandariz), the Bags included bassist Patricia Morrison—who would eventually play with Jeffrey Lee Pierce's blues-soaked Gun Club and UK goth gods Sisters of Mercy—along with Mark Moreland and Craig Lee (from left). Alice's beau, Weirdo drummer Nickey Beat, often took that hard-to-fill drum seat. In those days, punks knew better than to cross Alice, who had a reputation of being fast with her fists. "Many punks had come from social situations where they had been the outsiders," said Craig Lee. "Having escaped suburbia ... they now had their own group from which they could sneer and deliver visual jolts to the unimaginative dumb suburban world."

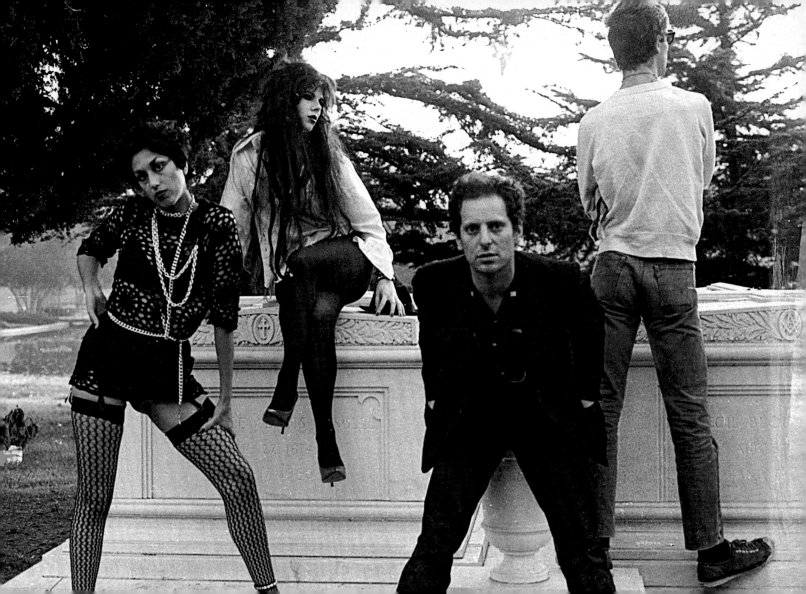

The Bags' Craig Lee, 1978 photograph by David Arnoff

Around the time David Arnoff snapped this image of Bags member Craig Lee in front of the Masque, the club was shuttered by the LAPD—one of several moves in a brewing war between cops and punks. "The Masque was a filthy, illegal basement club / rehearsal hall / crash pad / homeless shelter off Hollywood Boulevard," its founder Brendan Mullen once fondly reminisced, "which upended and ruined my life as it became the social and creative focal point of the early Hollywood party scene."

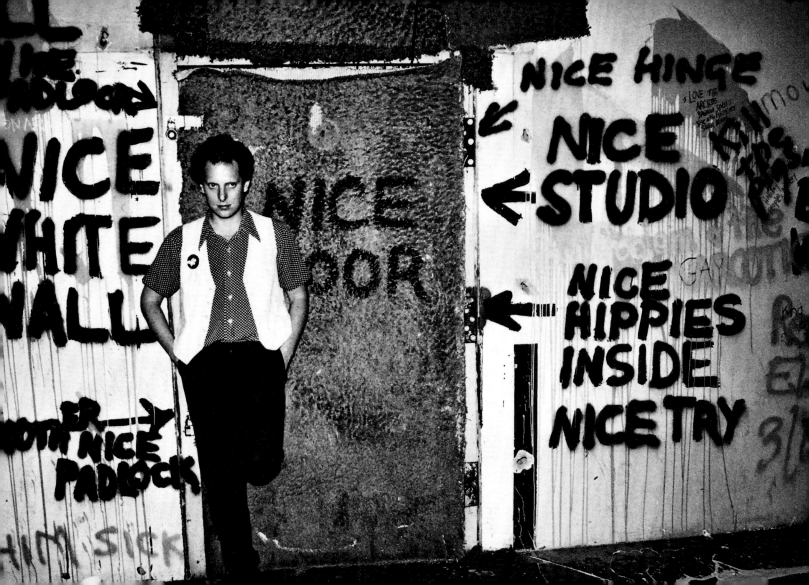

The Dickies, 1978 photograph by Jenny Lens

San Fernando Valley boys the Dickies specialized in playing sped-up versions of rock stalwarts—from Black Sabbath's "Paranoid" to the Moody Blues' "Nights in White Satin." Stan Lee, Billy Club, Leonard Graves Phillips, and their bandmates did anything for a laugh, including appearing on this NBC TV show, *C.P.O. Sharkey,* on March 7, 1978. Among the audience members are punksters Trixie, Kid Congo Alice Bag, Spaz Attack, and Mary Rat, but missing from the scene was Dickies keyboardist Chuck Wagon, who would later take his own life.

211

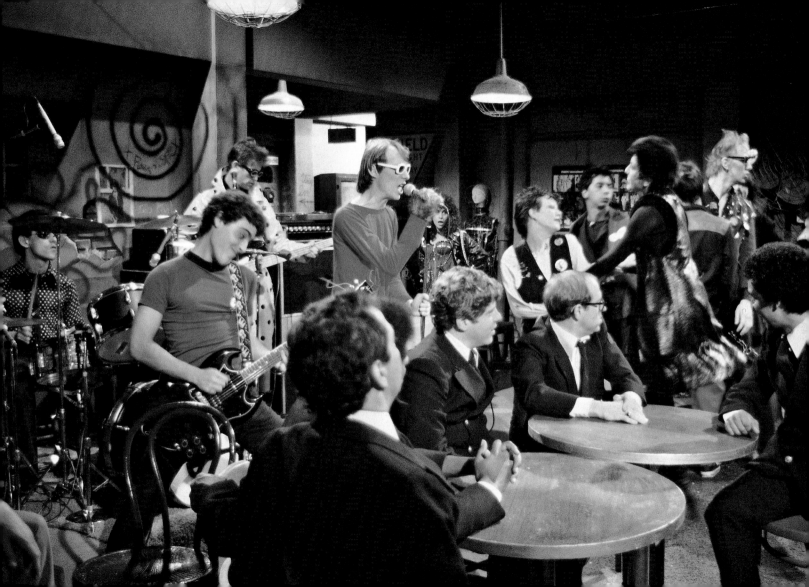

The Bags, 1978 photograph by Jenny Lens

When the Masque was shut down by the LAPD, Hollywood punks rallied to raise money so the notorious nightspot could reopen in a new location, which it did for a while. This February 24 benefit at the Elks' Lodge, near MacArthur Park, featured the Bags: Mark Moreland, Patricia Morrison, Alice Bag, and Craig Lee (from left). "Clubs sprang up overnight, sometimes for just one night, in odd venues like Foreign Legion halls and Chinese restaurants," according to Pleasant Gehman. "These places were pretty much being run by people, for the people, so even though punk-rock capitalism did exist, commercialism hadn't really set in yet. There was a heavy DIY ethic, a feeling of everyone being in this thing together, and not having to adhere to the rules."

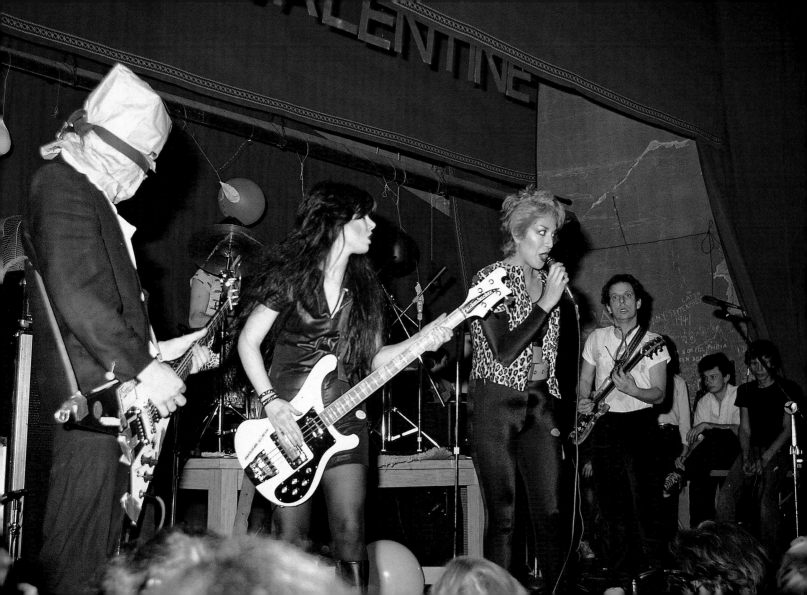

The Germs, 1979 photograph by Jenny Lens

Just as Darby Crash had soaked up Iggy and Sid, various future hardcore-punk bands would learn from the Germs—one future Germs fan was Kurt Cobain, who would enlist Germs guitarist Pat Smear to play in Nirvana. At this Germs gig at the Culver City Auditorium, members of Black Flag, Social Distortion, and TSOL were among the audience. "Darby loses you by keeping everything basically at one overwhelming speed (super-overdrive)," observed Richard Meltzer. "And when he slows things down in a song like 'Manimal' it's like he's got peanut butter in his mouth anyway."

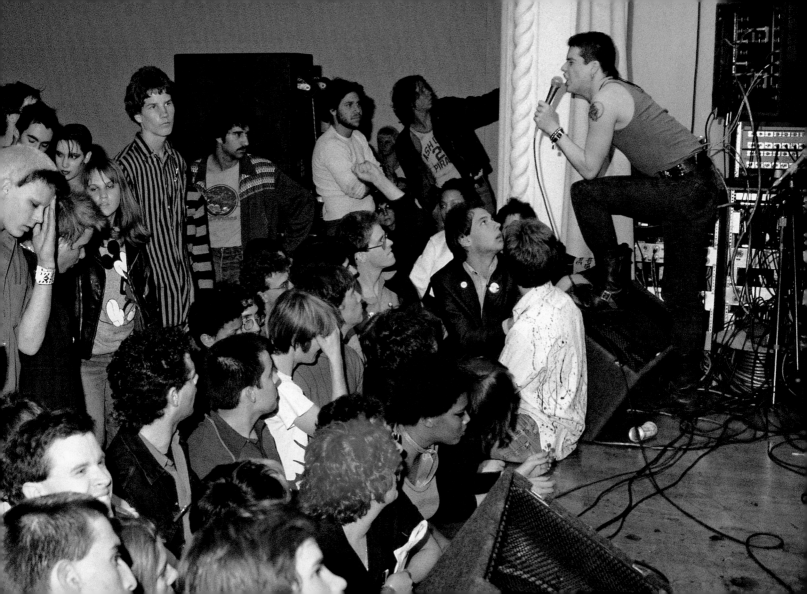

The Dils, 1979 photograph by Jenny Lens

Brothers Chip and Tony Kinman (center and right) formed the agitprop punk group the Dils in San Francisco in 1977. Their politically driven songs like "I Hate the Rich" and "Class War" made them the closest band the West Coast had to the Clash. At this August 30 gig the Dils played the Stardust Ballroom, which had been converted into a punk venue and today is a drugstore. The Dils occasionally played on double bills with the Nuns, whose guitarist, Alejandro Escovedo, would eventually join the Kinmans in the pioneering cowpunk band Rank + File.

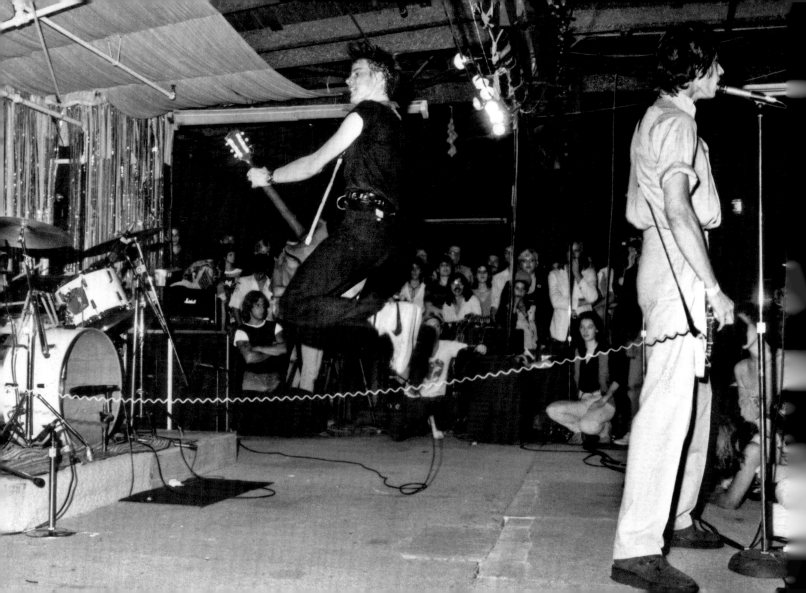

The Cramps, 1979 photograph by Theresa Kereakes

While in L.A., the Cramps—Ivy, Lux Interior, Nick Knox, and Bryan Gregory (from left)—stayed at the Tropicana in West Hollywood, a place where much mischief was made. "Me and Lux coulda been like Charlie [Starkweather] and Car [Fugate] or Bonnie and Clyde," Ivy once said, "but we had this little band instead. They went on killing sprees, but somehow we ended up with a healthy outlet."

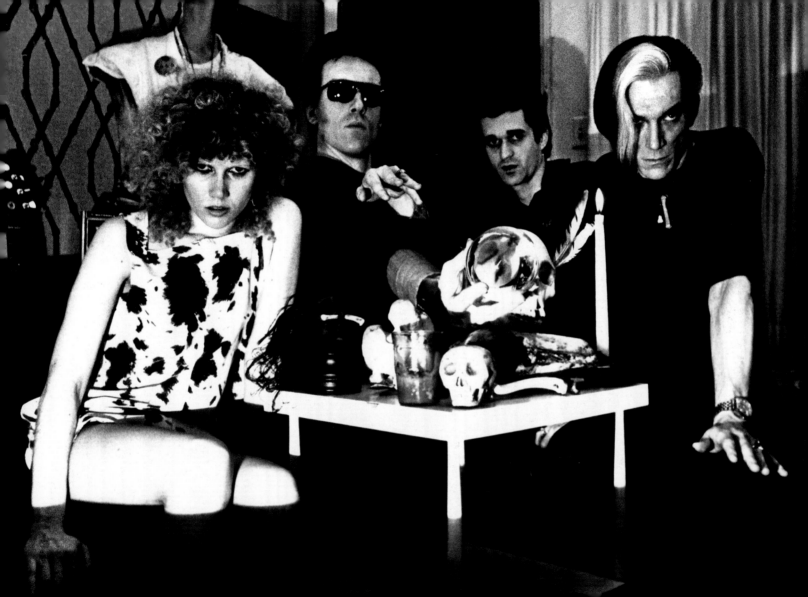

X, 1980 photograph by Jenny Lens

Formed by poet/writer Exene Cervenka (b. Christine Cervenkova), her then-beau John Doe (b. John Duchac), and rockabilly-tinged guitarist Billy Zoom (b. Tyson Kindell), X became one of the most successful bands to emerge from the L.A. punk scene. Exene and John Doe, who later married and divorced, met while working at a poetry workshop at Venice Beach. "I didn't know anything about singing, songwriting, or playing an instrument, but John thought what I was writing naturally lent itself to becoming songs," Exene later recalled. "It had the rhythm and he wanted to put my work to music, but I thought that was unfair. At that point, anybody could start a band, so why shouldn't I sing my words instead of him?" Seen here performing at Club 88 in West Los Angeles are Billy Zoom, Exene, and D. J. Bonebrake (from left); the gig was filmed by Penelope Spheeris for the L.A. punk documentary *The Decline of Western Civilization.*

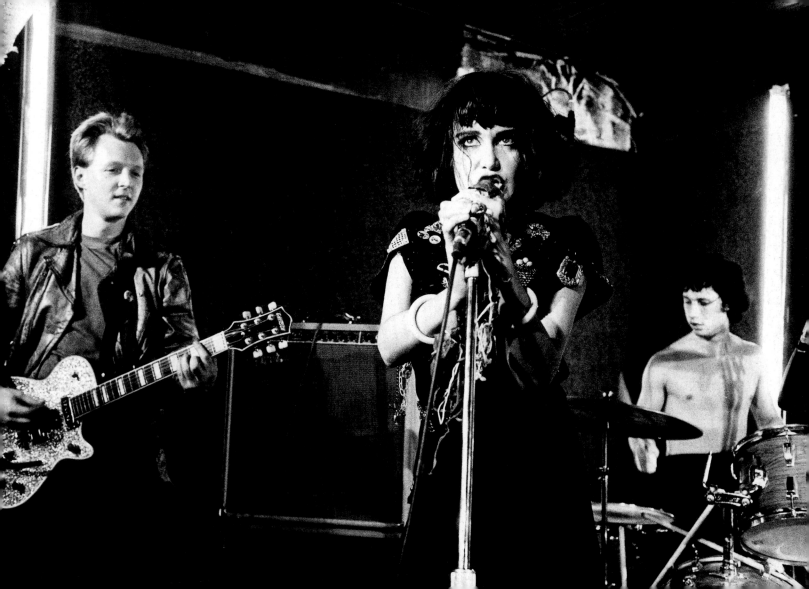

Exene and John Doe, ca. 1981 photograph by David Arnoff

Here photographed in their West L.A. abode, Exene and John Doe wrote such punk anthems as "We're Desperate" ("get used to it!"), "Los Angeles," and "Johnny Hit and Run Pauline." I was completely against structure," said Exene, "and I didn't want anything edited out. I wanted everything to be exactly how it was when I wrote it. I didn't understand anything about how things were put into song form. I was very rebellious even within the context of X."

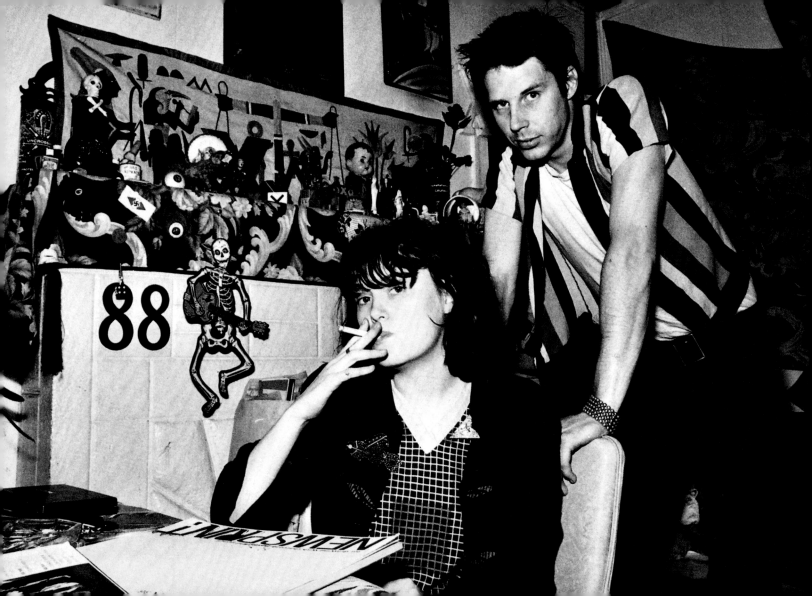

Penelope Houston and Rodney Bingenheimer, 1978

photograph by Theresa Kereakes

One of San Francisco's best punk bands, the Avengers featured Penelope Houston on vocals. The band had the dubious distinction of playing at the Sex Pistols' last gig at Winterland, which proved quite disillusioning for Houston. With a penchant for the political, the Avengers did guitar-crunchy songs like the catchy "We Are the One": "we are the leaders of tomorrow / we want the power." Here, Houston appears on Rodney Bingenheimer's highly influential Sunday-night radio show *Rodney on the ROQ.*

218

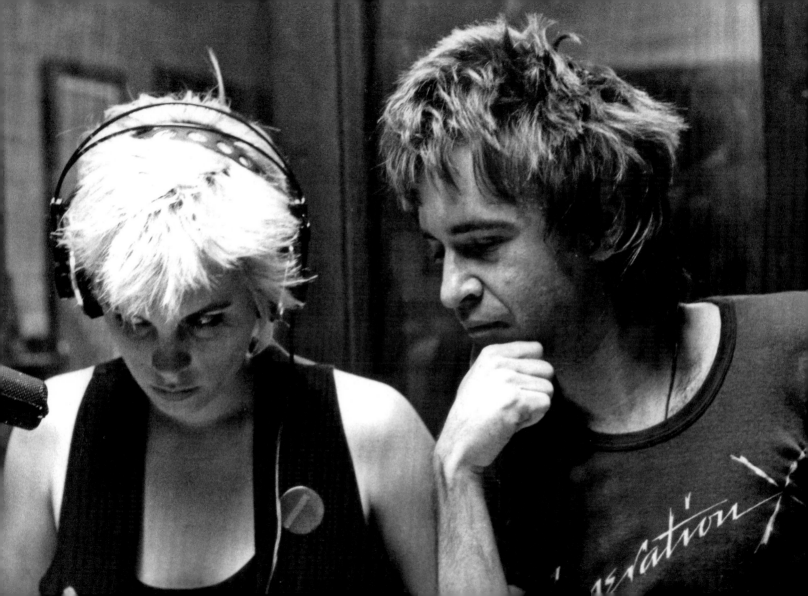

The Zeros, 1979 photograph by Dawn Wirth

With members Hector Penalosa, Robert Lopez, and Javier Escovedo, the Zeros released the single "Don't Push Me Around," on Greg Shaw's Bomp label. "L.A. punk made perfect sense to me," Shaw told journalist Barney Hoskyns. "I think it was a more authentic expression of the real intrinsic spirit of Hollywood than English punk was of England.

L.A. has always been phoney and self-deprecating and goofy and cartoonish and pop-culture-obsessive, and that's what you got with the Germs and Weirdos." "El Vez," who sprang from the Zeros, also fit that bill. In the mid-1980s, Javier Escovedo would form the punk-fueled band True Believers in Austin, Texas, with his brother Alejandro.

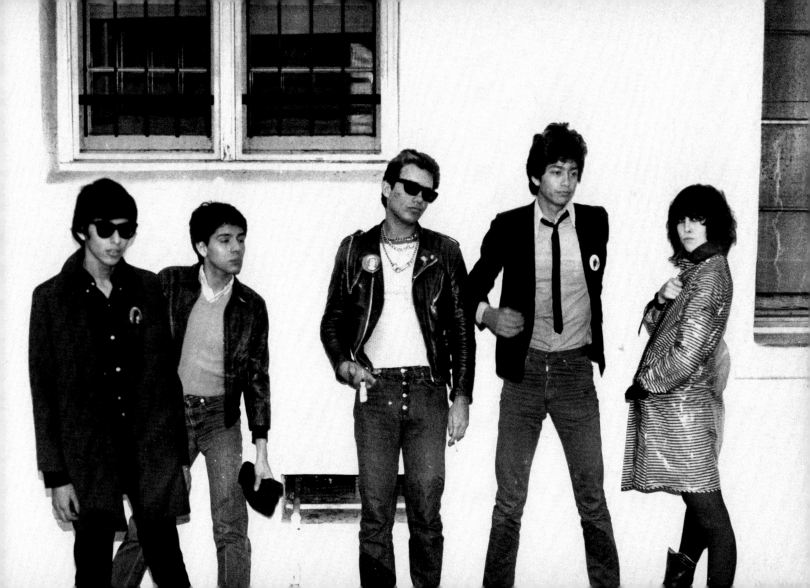

The Cramps, 1979 photograph by David Arnoff

Drawn to the most tarnished of Tinsel Town, the Cramps relocated to Hollywood after recording their second album, *Songs the Lord Taught Us.* "Tell me some good rock & roll that's come out of New York besides the Dolls and the Velvets," Lux Interior (center) said at the time about the group's move. "Tell me how much success they had at the time too. The town is filled with dancers and actors—it really isn't a breeding ground for rock & roll." Here, Bryan Gregory, Nick Knox, Interior (with hands full o' bones), and Ivy in an outtake from the *Songs* album cover session.

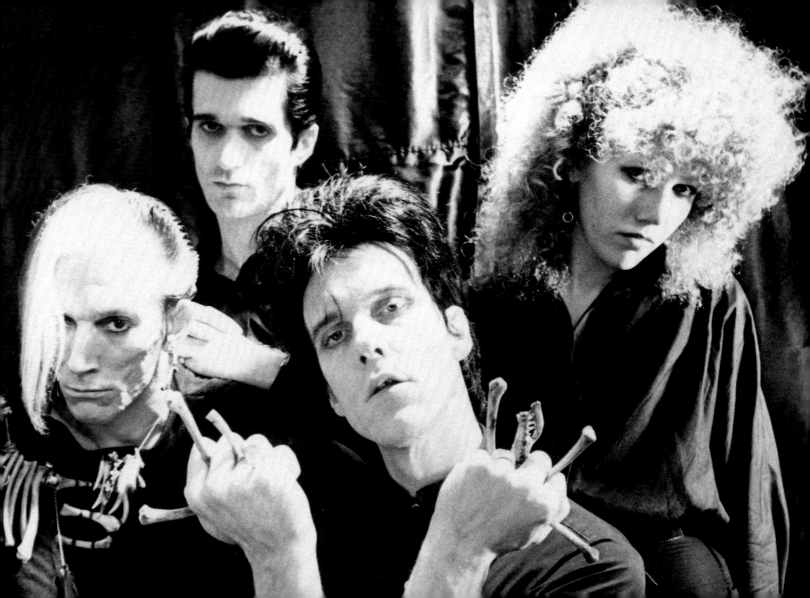

Phast Phreddie Patterson, 1981 photograph by Chuck Krall

After establishing the seminal fanzine *Back Door Man,* Phast Phreddie Patterson became the Zelig of the L.A. scene. The Runaways played their first gig in his parents' living room. He witnessed and reported on countless gigs, lived to tell the tale, and sang in such bands as Phast Phreddie and Thee Precisions and the Love Supremes. He also built up a formidable collection of rare R&B 45s along the way and became *the* soulfulest white-boy DJ at such L.A. clubs as the Cathay de Grande and Club Lingerie. After relocating to the East Coast in the 1990s, he became the resident DJ of the Subway Soul Club in New York.

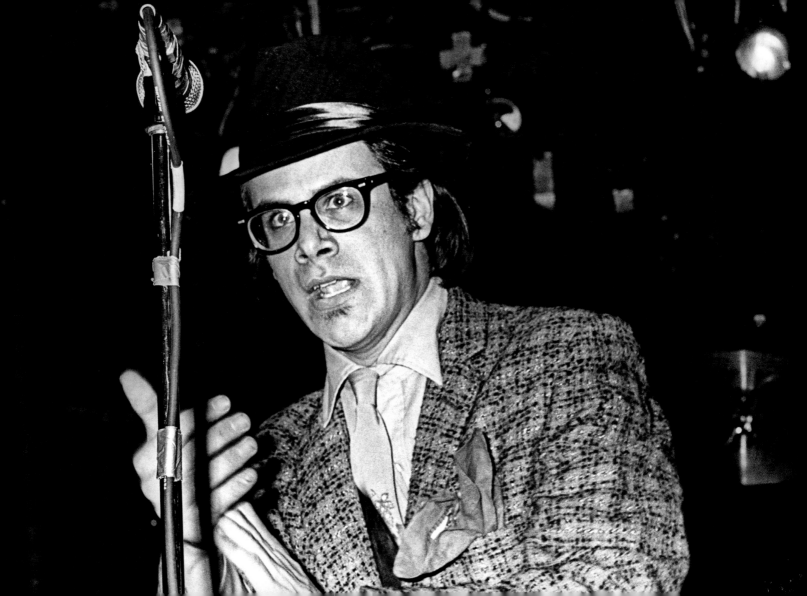

Richard Meltzer, 1978 photograph by Chuck Krall

Pioneering rock critic Richard Meltzer left the East Coast for Los Angeles in the early 1970s and missed the CB's scene. But he embraced the L.A. punk scene and was asked to emcee the final Sex Pistols show in San Francisco. His incitement of the audience got him kicked out of the venue. As his protégé Lester Bangs did in New York, Meltzer began performing onstage, fronting a confrontational little ensemble called Vom (short for *Vomit*). The band only played eight gigs, one of which was at the Fleetwood, a Redondo Beach punk club where this picture was taken.

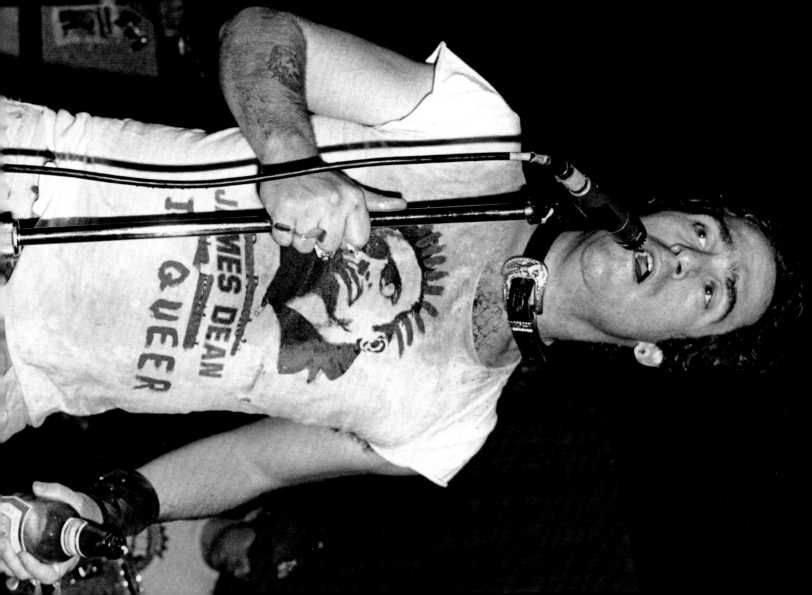

The Avengers, 1978 photograph by Jenny Lens

Avengers vocalist Penelope Houston and drummer Danny Furious ascend the staircase from the depths of the Masque on January 17, 1978, the last night the club was officially open. It managed to go on a bit longer before being padlocked. The Avengers also would shut down, two years later. "At the beginning of the whole punk rock thing," Houston later remarked "all the bands were really distinct. You wouldn't confuse Devo with Crime or the Nuns. It was like everybody had their own thing. We were sort of straightahead classic punk before punk turned into its really boring 1980 version, which it continued to be forever and ever."

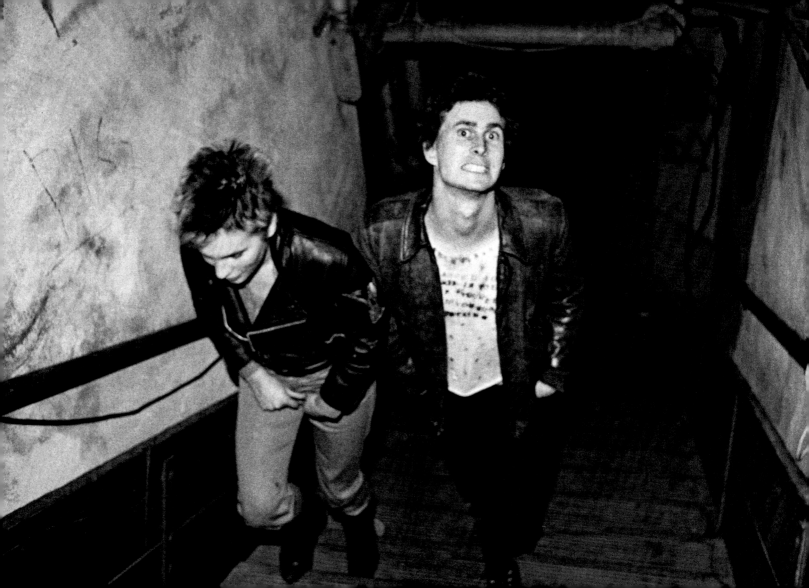

Bryan Gregory, 1979 photograph by David Arnoff

Here, following a Cramps gig in Hollywood in 1979, Bryan Gregory poses on Hollywood Boulevard. In response to the band's L.A. show the previous year, Pleasant Gehman had reported in *Slash* with awe, "Bryan is one of the weirdest creatures I have ever seen. He eats his cigarettes, boys and girls, and I'm not kidding! He poses with his polka-dot Flying V guitar like one of those plaster flamingos people put on their front lawn."

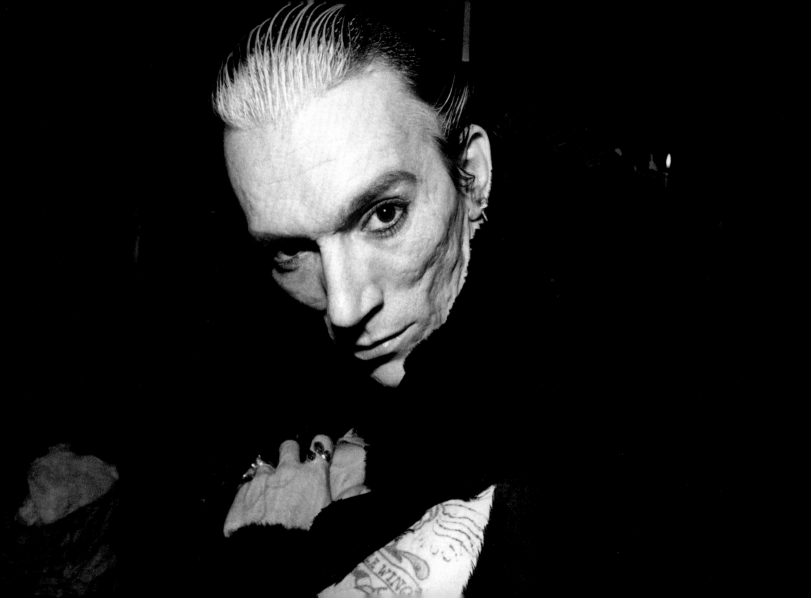

999, 1979 photograph by David Arnoff

UK punk bands made regular sojourns to L.A. in the late '70s. One of London's most explosive live acts, 999, played the Whisky to much acclaim. Here, backstage at the club, are Jon Watson, Nick Cash, Pablo Labritain, and Guy Days (from left).

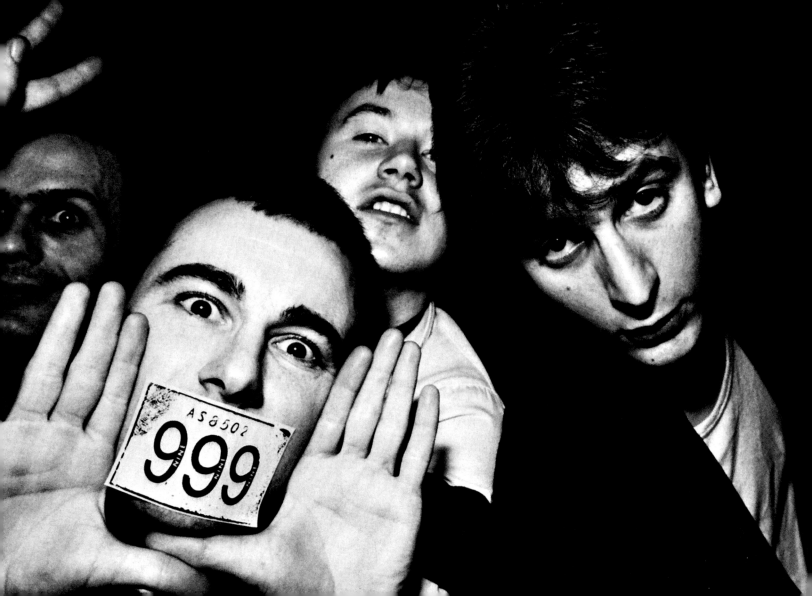

Sham 69, 1979 photograph by Jenny Lens

Surely there were aspiring skate punks in the audience the night (December 7) Sham 69 played the Whisky. Just as Oi bands composed of skinheads had begun proliferating in the UK, so would L.A. bands take their cue from Sham 69 and Black Flag (of Huntington Beach).

The UK custom of bands clashing with audience members, which had started at Sex Pistols gigs, turned into stage diving and would soon intensify in L.A. Seeing the freedom of the leap—demonstrated here by Jimmy Pursey—motivated fans to take a DIY approach.

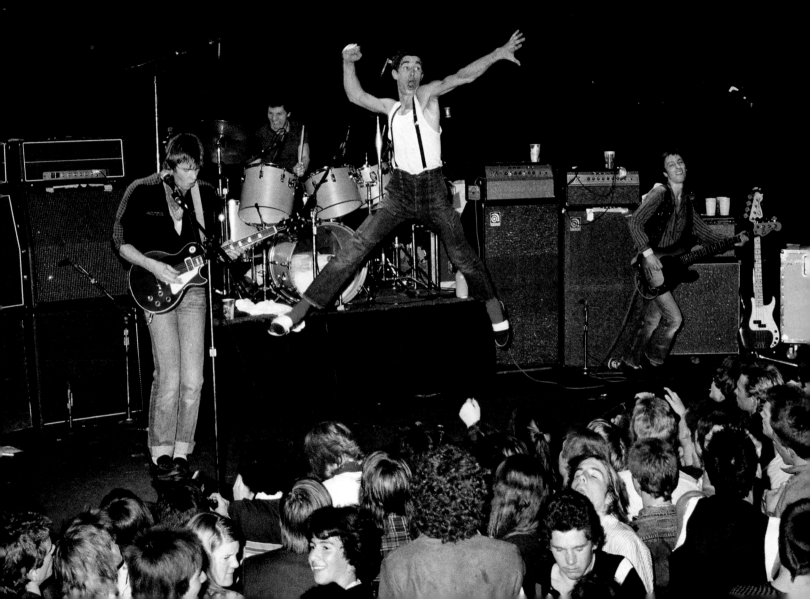

Ian Dury, 1979 photograph by David Arnoff

The English pub-rocker Ian Dury came to L.A. for the first time in 1979. There, David Arnoff photographed Dury trespassing on the Hollywood Hills property that originally belonged to Bela Lugosi. Dury's "Sex & Drugs & Rock & Roll" became the anthem of the early punk scene in Hollywood. "I can recall countless nights at the Zero, dancing to George Clinton's 'The Atomic Dog,' doing coke in the notorious Backroom, bartending with hip scene chicks Iris Berry and Alice Miller, having sex on one of the battered brocade sofas that had been hauled in from the street for a second lease on life," Pleasant Gehman wrote in *Make the Music Go Bang!*

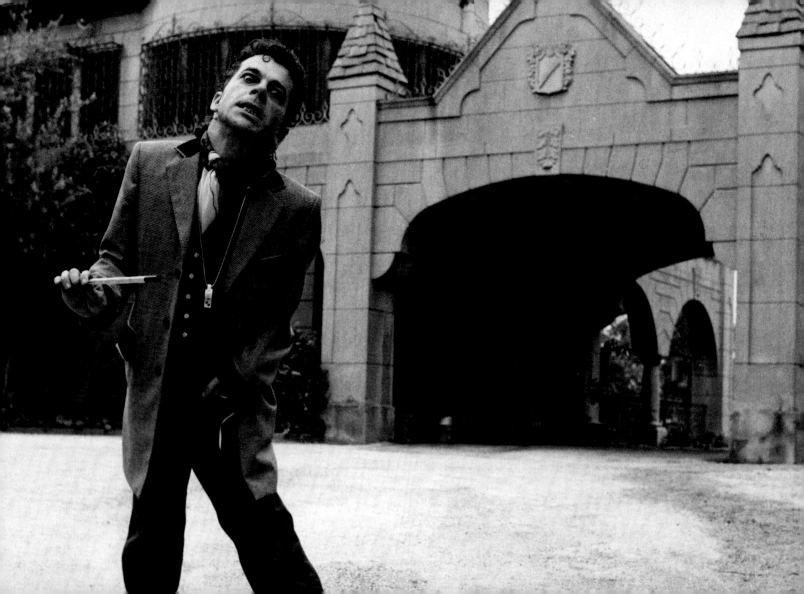

Boomtown Rats, 1979 photograph by Jenny Lens

Bob Geldof (center) and his Boomtown Rats donned antler hats on April 4, 1979, when they managed to play inside Frederick's of Hollywood, the lingerie store in front of which the New York Dolls had posed six years before during their visit to town. "They got their hats from the now long-gone Bullwinkle and Rocky store on the Sunset Strip," says Jenny Lens. "Hooray for Bullwinkle."

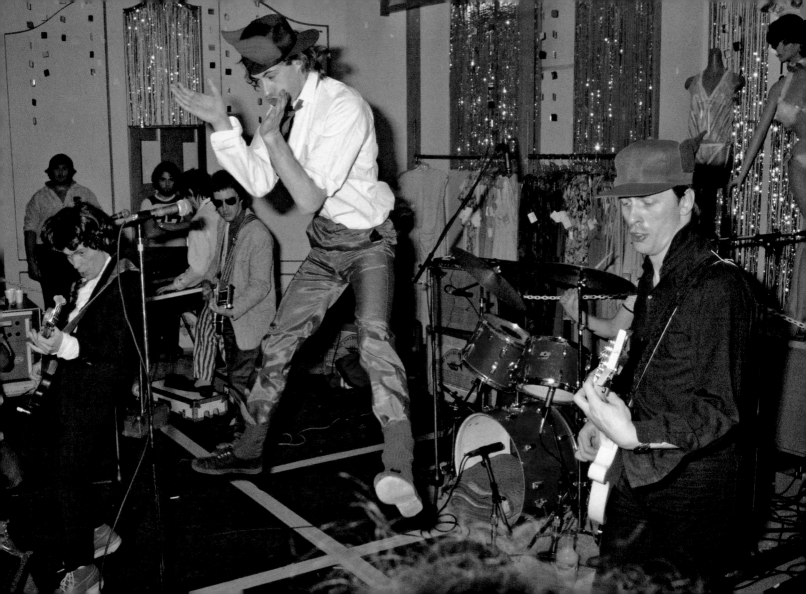

Iggy Pop and Glen Matlock, 1979 photograph by Ebet Roberts

By the late 1970s, there were plenty of punk-band veterans to back up their godfather, Iggy Pop. For this 1979 tour, Iggy enlisted Sex Pistols bassist Glen Matlock (right), Patti Smith Group guitarist Ivan Kral, and the Damned's guitarist Brian James.

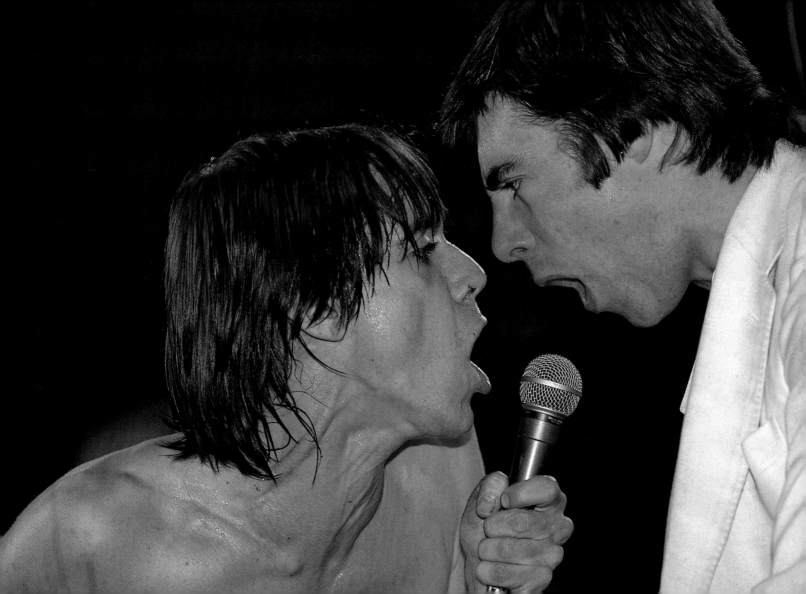

The Plugz, ca. 1981 photograph by Sumishta Brahm

Electrify Me was the name of the first record put out by the Plugz, and, indeed, the Tex-Mex trio, which included guitarist/ vocalist Tito Larriva and bassist Tony Marsico, put on high-voltage shows—at joints like Al's Bar in Los Angeles. When the Plugz were asked to open for PiL at the Olympic Auditorium, they in turn asked an East L.A. group called Los Lobos to join the bill, thus introducing an important Chicano group to the punk scene. Los Lobos got a rocky start, however, recalled member Louis Perez in *Make the Music Go Bang!*: "We survived about ten minutes through a tidal wave of spit and eighty-five hundred middle fingers before finally making a break for it when the serious projectiles began to fly . . . Once our hearts stopped pounding and the adrenaline rush subsided, we knew we were onto something. Our adventure had just begun."

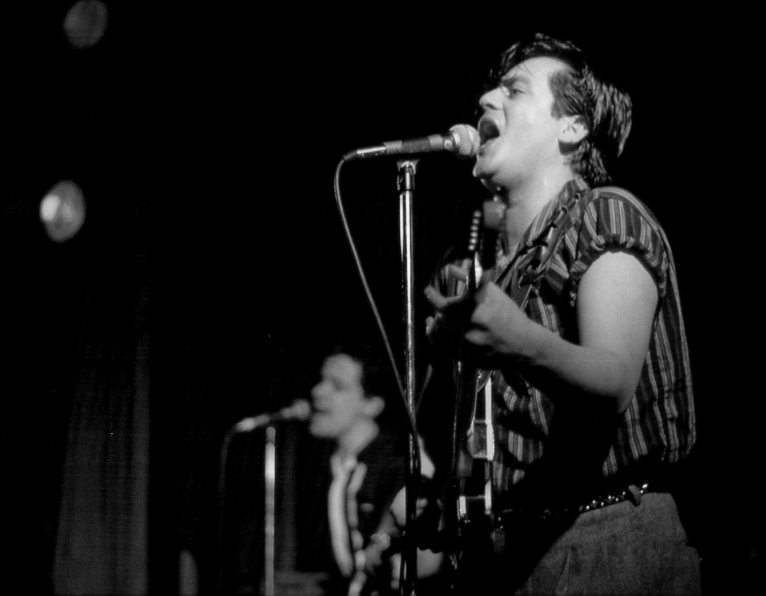

The Go-Go's, 1980 photograph by Jenny Lens

The Go-Go's started playing together in 1978 as a motley crew of partyers: Charlotte Caffey had played in the Eyes, and Belinda Carlisle had been in a pre-Germs band with Darby Crash called Sophistifuck and the Revlon Spam. By 1980, when Jenny Lens photographed guitarist Caffey, vocalist Carlisle, bassist Margot Olaverra, drummer Gina Schock, and guitarist Jane Wiedlin (from left) at the Starwood, the Go-Go's were about to embark on their first tour of Great Britain While there, they recorded a single for Stiff, the bouncy "We Got the Beat." The Go-Go's were on their way.

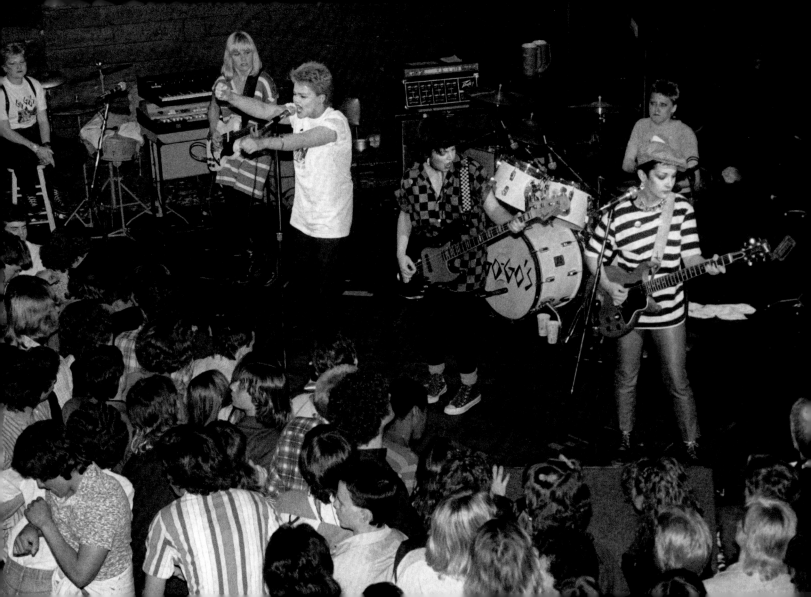

The Dickies, 1979 photograph by Janette Beckman

In 1979, the Dickies scored a record contract with the L.A.-based label A&M, owned by Herb Alpert and Jerry Moss. That year, A&M released the albums *The Incredible Shrinking Dickies* and *Dawn of the Dickies,* and the band toured England. The label hired Janette Beckman to shoot publicity and album-sleeve photos of the band (including this one) while the Dickies were in London. Unfortunately, such Dickies numbers as "(I'm Stuck in a Pagoda) with Tricia Toyota" never caught on with the general public; however, the band did inspire future punk rockers, including the Offspring, who enlisted the Dickies to tour with them in 1999.

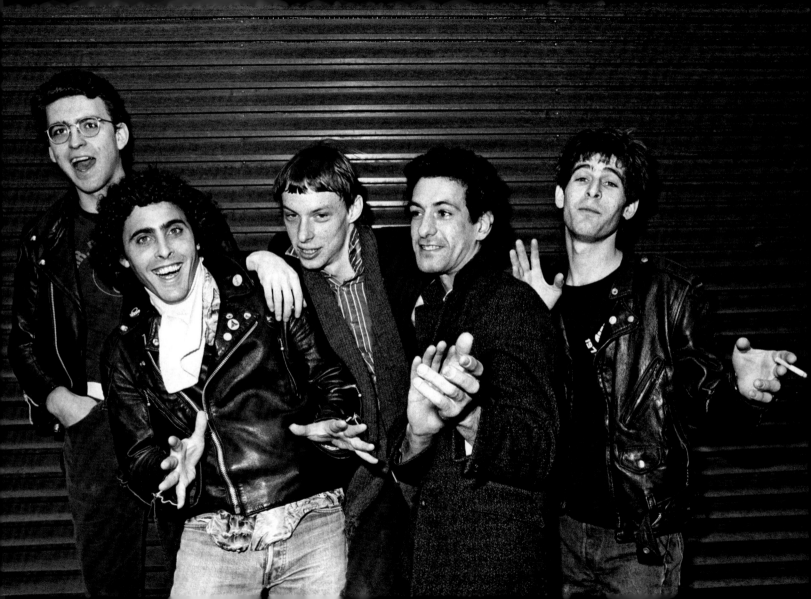

Darby Crash, 1980 photograph by Gary Leonard

During the summer of 1980, following the release of the Germs' album *G.I.* (produced by Joan Jett in 1979), Darby Crash spent time in England. Unfortunately, his growing heroin addiction and predisposition toward depression fueled his self-destructive tendencies. With the Germs heading toward disintegration, Crash began planning a new combo, the Darby Crash Band. But on December 7, 1980, he instead decided to follow in his idol Sid Vicious' footsteps to the grave. He injected himself and his friend Casey Cola with an overdose of powerful China White heroin. She survived their suicide pact but he died. The next day, John Lennon was shot down by Mark David Chapman, and Darby's posthumous glory was cut short.

233

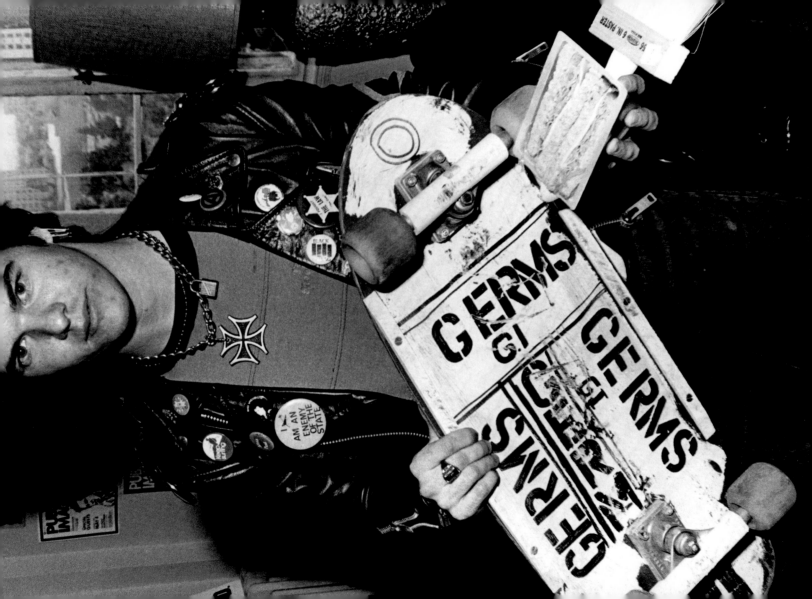

Bryan Gregory, 1980 photograph by David Arnoff

Not long after the Cramps relocated to Los Angeles, guitarist Bryan Gregory vanished after a gig—along with the van full of band equipment and his occultist paramour. He apparently had given up music to seek a career in the horror-movie industry. Though he posed naked with a boa constrictor wrapped around his torso, his dream of becoming the next Boris Karloff never materialized. He formed the band Beast, which did not last, and reportedly worked as a sex-shop operator, tattoo artist, and warlock. He never reunited with the Cramps, who replaced him with Kid Congo Powers; the latter met the band in 1977 when he took a Greyhound to the Big Apple to check out the punk scene. Gregory died on January 10, 2001, of heart failure.

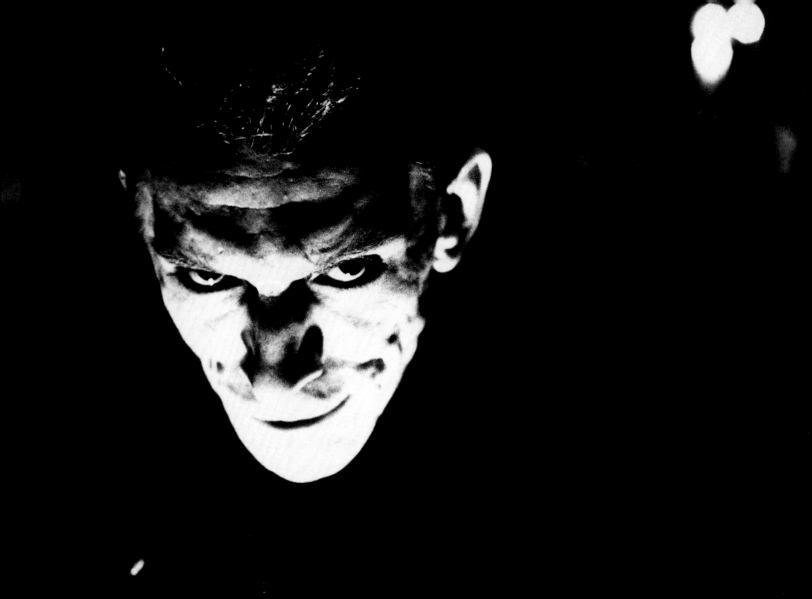

Fear's Lee Ving, 1980 photograph by Gary Leonard

Part of the Germs' legacy was an ever-increasing horde of skate punks emerging from beach towns outside L.A. Another of the various early punk bands to attract aggressive young fans who would soon constitute the hardcore scene was Fear. Loved by some (like doomed actor John Belushi), reviled by others (including rival bands from the Valley), Fear's lead singer Lee Ving frequently acted in a variety of TV and film productions as—what else?—a punk rocker. Fear's brutal sound and punk parodies like "I Love Livin' in the City" attracted L.A.'s version of London's Oi movement. "Ving would bait the audience like a wrestler," said David Anderle, who produced Fear's 1981 release *The Record*. "If anyone jumped onstage, he'd beat them up." Here, Fear terrorizes the Whisky on January 23, 1980.

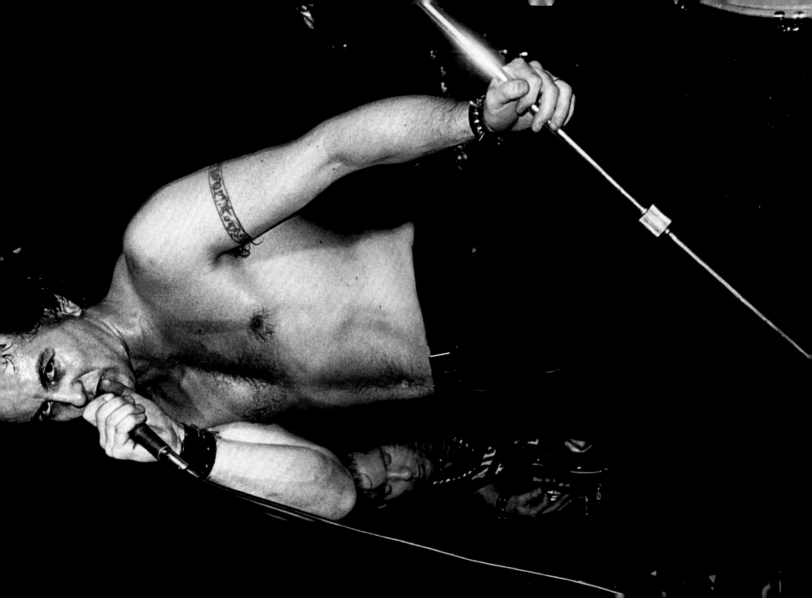

HERE, THERE, AND EVERYWHERE

Patti Smith and her Fender Duo-Sonic, 1979

photograph by Godlis

Back in 1976, Patti Smith had bought herself a guitar for $110 ("on time") at Manny's on West Forty-eighth Street in New York City. "I wasn't interested in learning chords," she later wrote in her 1998 volume *Complete*. "I was interested in expressing ideas, however abstract, within the realm of sound." Something else happened in 1976: "It was at this time, while attempting to mount a tide of feedback, that I met Fred Sonic Smith," she recalled in *Complete,* "who with few words showed me the way to draw from my instrument another language, or as he put it, to be sonically speaking." By 1980, the Smiths had retreated together to Fred's hometown of Detroit. The previous year, the Patti Smith Group gave its last New York performance (documented here) at the Palladium on Fourteenth Street. Among the songs performed were those from that year's album, the final recording by the original PSG. Its title: *Wave.*

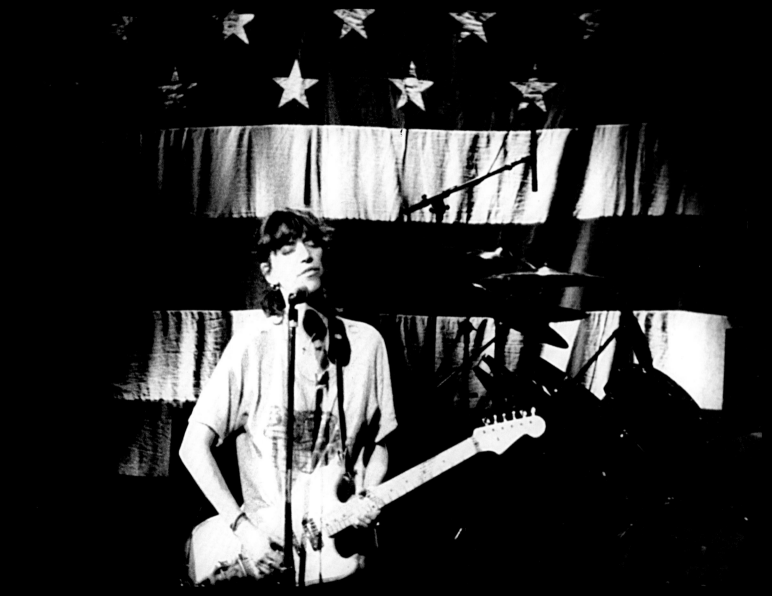

The Ramones, 1981 photograph by Godlis

In a rare moment back in New York, the Ramones stomp down St. Mark's Place. By decade's end, Dee Dee would quit the increasingly fractious band. Joey, Dee Dee, and Johnny all died not long after the dawn of the twenty-first century.

"The Ramones were the true meaning and balls of New York."

—Marky Ramone

237

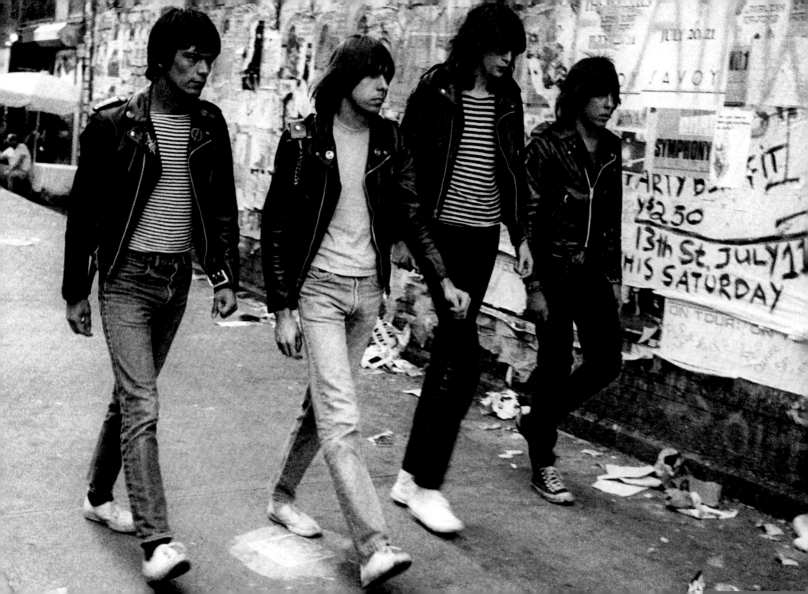

Talking Heads, 1981 photograph by Godlis

Jerry Harrison, Tina Weymouth, Chris Frantz, and David Byrne (clockwise from top left) made a stir with "Psycho Killer" off their debut album in 1977, but hit the Top Ten with their cover of Al Green's "Take Me to the River" on 1978's *More Songs about Buildings and Food.* "The Talking Heads were very lucky," David Byrne later said. "I expected it to take about five years for people to find out about us and it took around two.

I've spoken to other people who took much longer, like twenty years, before their audience increased to beyond fifty people. There's a good way and a bad way of looking at that. Obviously, you shouldn't persist at something if no one's interested. But part of the object of doing something is to get your ideas across to other people, so you got to make some effort." The Talking Heads recorded their final album, *Naked,* in 1988.

Stiv Bators, 1981 photograph by Robert Matheu

Just as the Patti Smith Group disintegrated with Smith's departure to Detroit, other CB's bands broke up under the strain of "too much too soon." The Dead Boys died for good after making their second album, *We Have Come for Your Children*, in 1978. Stiv Bators moved to L.A., began working as a solo artist, and recorded some power-pop singles for Greg Shaw's Bomp label. Here Bators relaxes in a bubble bath at his Tropicana bungalow.

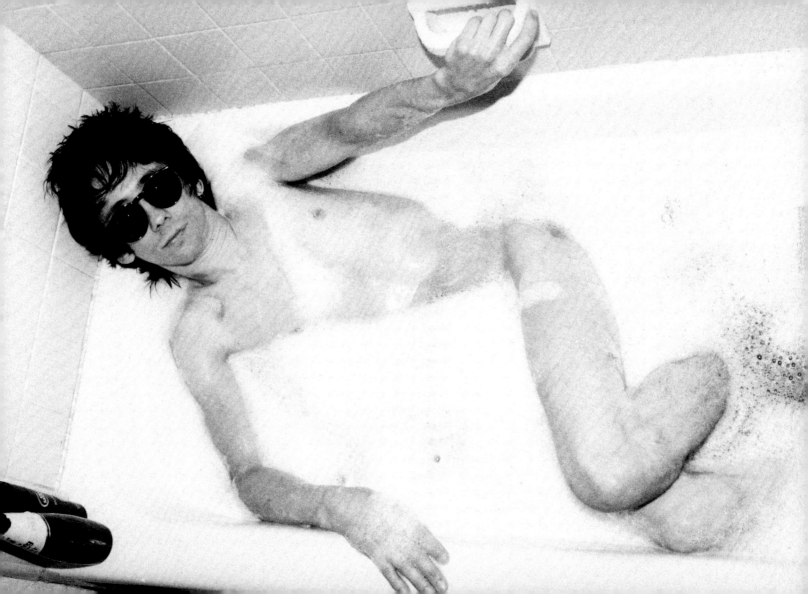

John Lydon, 1980 photograph by Jenny Lens

John Lydon continued to perform with PiL, whose membership changed frequently. At this May 4 gig at Olympic Auditorium, his obvious boredom was relieved when he spotted an enthusiastic child in the audience. "That little boy was having fun so John enlisted him to sing," recalls Jenny Lens.

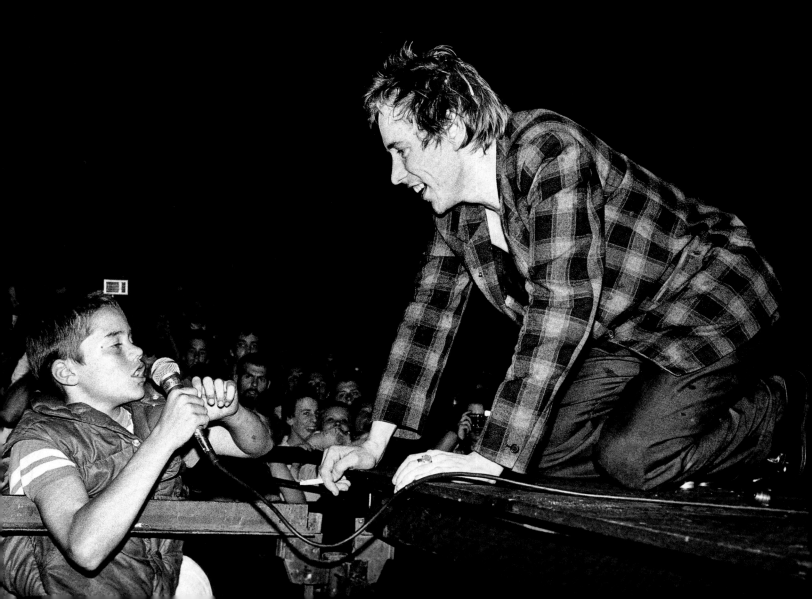

The Blitz, 1981 photograph by Janette Beckman

As the '70s turned into the '80s, some of London's old-school punks became adherents of a synth-pop style termed New Romantic. One-time It Girl Jordan and other former Pistols fans traded safety pins and bondage gear for ornate and fanciful get-ups for a night out listening to such New Romantic bands as Duran Duran and Spandau Ballet. A hot London club called the Blitz, where trendsetting doorman Steve Strange ruled the roost, found party people discoing the night away.

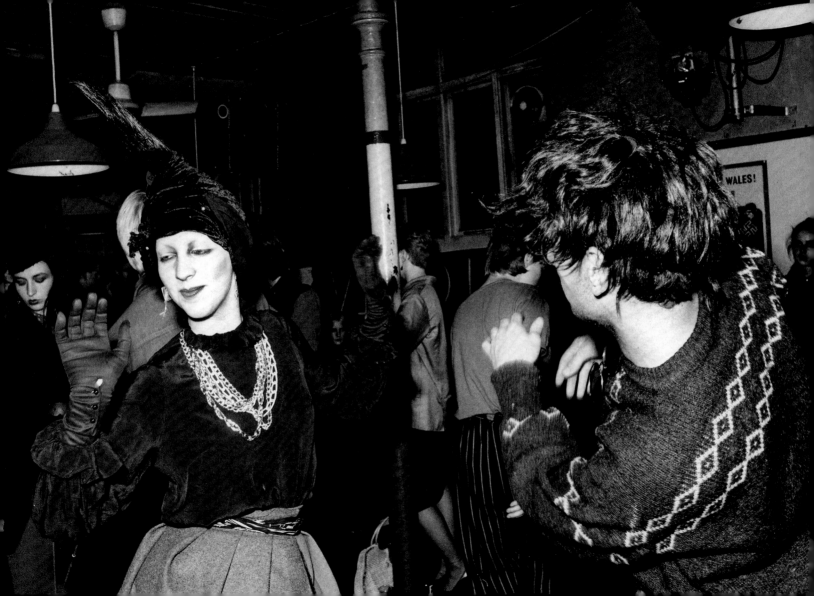

Gang of Four, 1980 photograph by Ebet Roberts

One of the best of England's political punk bands, Gang of Four—vocalist Jon King, bassist Dave Allen, guitarist Andy Gill, and drummer Hugo Burnham—formed in Leeds in 1977. Though the band named itself after a Maoist group, its sound was influenced by funk and reggae, mixed with spare arrangements and occasional dissonant sonics. The band's EP *Damaged Goods* brought them lots of fans in New York, where they frequently toured. Here, the Gang of Four perform at New York's Irving Plaza. Soon after this photo was taken, Allen quit the tour and was replaced by funk bassist Busta "Cherry" Jones, who had augmented the Talking Heads' bass section for a while.

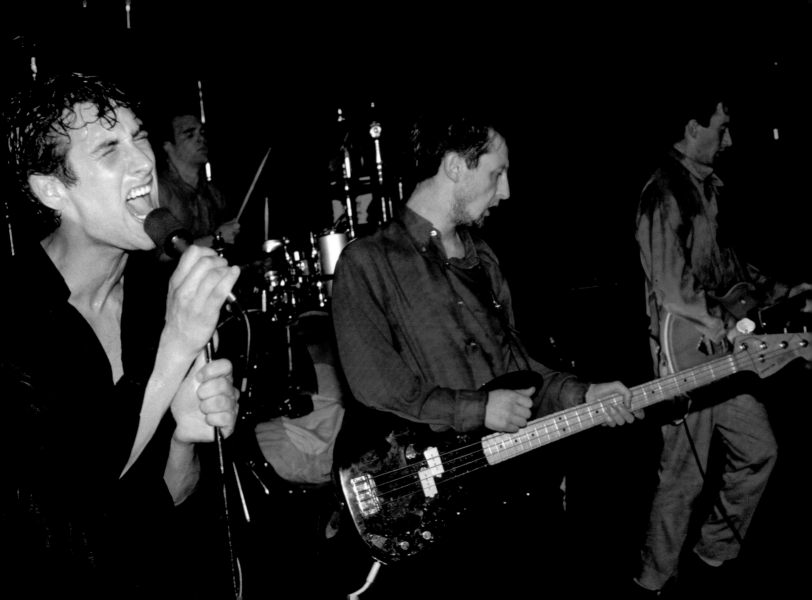

Stiff Little Fingers, 1982 photograph by Ebet Roberts

Reggae-inclined UK band Stiff Little Fingers returned to the States after the release of their 1982 album *Now Then*. In a review of the album, *Sounds* magazine called SLF "a fully realized postpunk hard pop band—smart and with sass." On *Now Then*, the group covered the 1970 reggae tune "Love of the Common People."

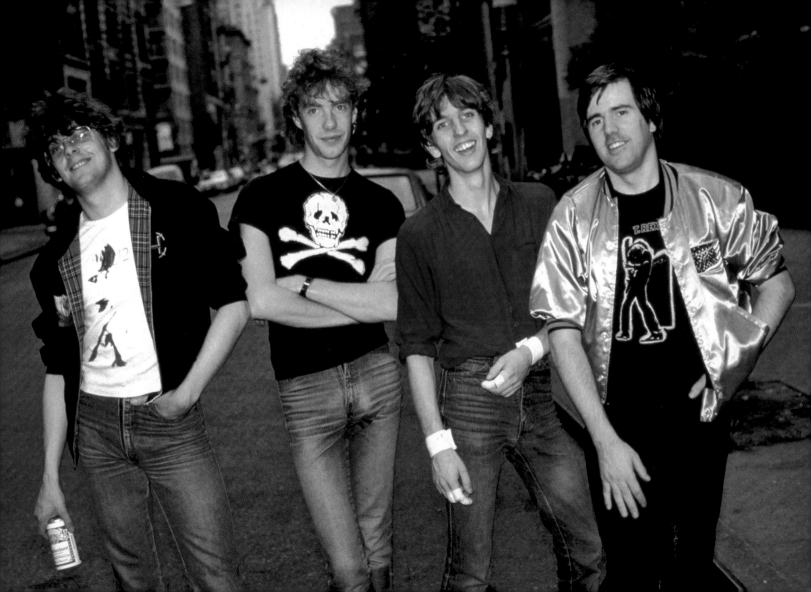

The Clash, 1979 photograph by Robert Matheu

Robert Matheu photographed Mick Jones, Joe Strummer, Topper Headon, and Paul Simonon disposing of their beverages backstage at Detroit's Masonic Auditorium on September 17, 1979. According to Matheu, whose shot ran in *Creem* magazine in 1980, "the band rarely let their guard down."

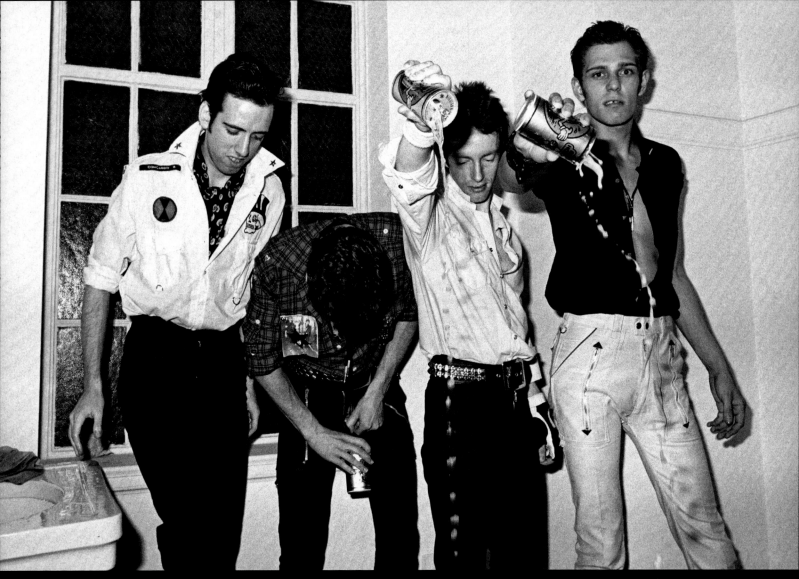

Joe Strummer, 1980 photograph by Roberta Bayley

The Clash spent much of the early '80s touring or in the studio. Here, Roberta Bayley catches Joe Strummer in Manhattan near Times Square. The wear and tear caused by the band's success would eventually take its toll on Strummer. He would vanish for a while prior to the Clash's massive 1982 tour and re-emerge with a Mohawk just in time to hit the road after the release of *Combat Rock.*

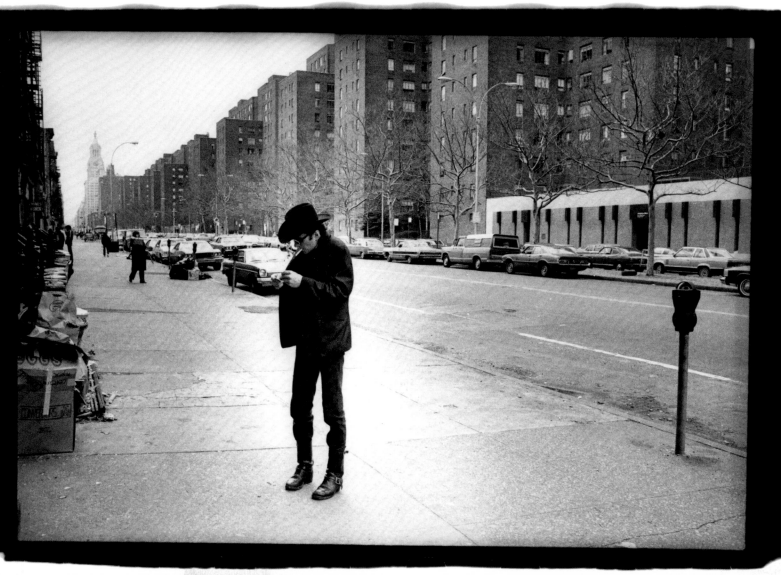

The Pretenders, 1980 photograph by Robert Matheu

In 1980, Chrissie Hynde brought her boys—bassist Pete Farndon, guitarist James Honeyman-Scott, and drummer Martin Chambers (from left)—back to her old stomping grounds for a successful tour. "I've been asked endlessly about being a female in a man's field, blah, blah, blah," Hynde once said, "and it's tedious to be asked those questions because I didn't think it was a man's field. *I* was in it, for a start. I never felt discriminated against. I never felt that I had to work harder than a man. I never thought I had anything to prove."

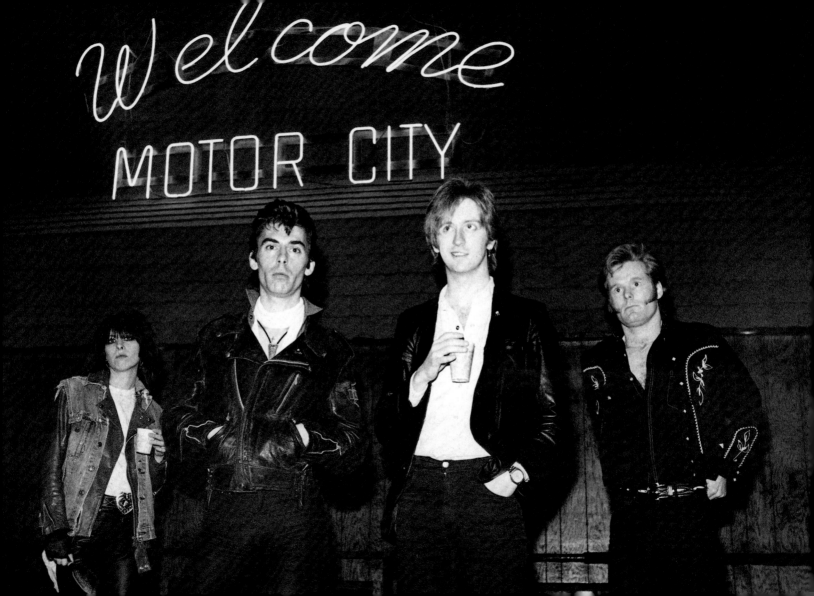

Lydia Lunch, 1982 photograph by David Arnoff

After recording her solo album *Queen of Siam,* Lydia Lunch began working in films with New York underground filmmaker Richard Kern and writing prose and poetry.

She started her own label, Widowspeak, to release spoken-word material. "I'm not a fan of habit," she once said. "Ritual, yes, habit no."

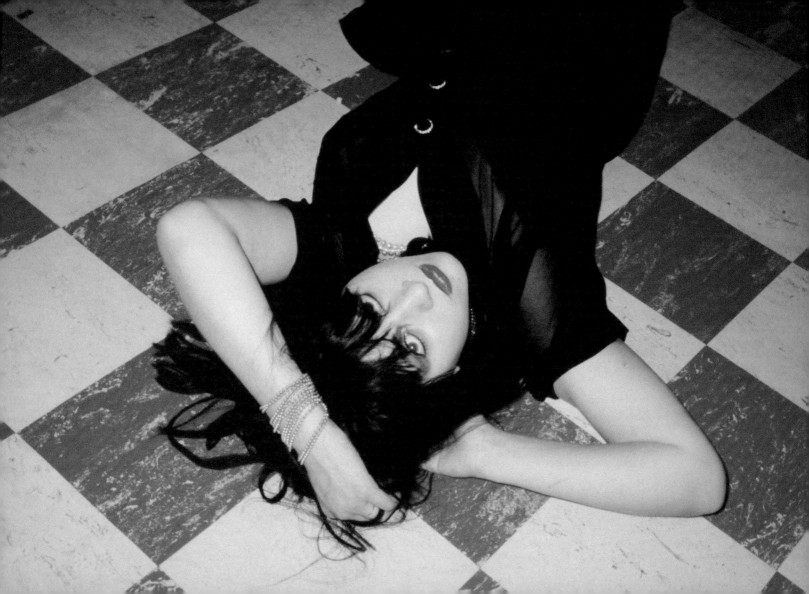

Andy Warhol and William Burroughs, 1980 photograph by Bobby Grossman

Two of the spiritual godfathers of punk, artist Andy Warhol and writer William Burroughs, occasionally made the scene. Warhol supported the work of downtown graffiti artists such as Keith Haring and Jean-Michel Basquiat. Burroughs had befriended Patti Smith as early as the mid-1970s, and lived in a Bowery loft called the Bunker, close to CBGB. "William Burroughs lived nearby as did [Allen] Ginsberg [who lived in the same building as Richard Hell]," David Byrne once pointed out. "And though neither of these figures could be classified as 'romantics' they, and their attitude toward life and art, were part of the mystique of the era. Though not musicians per se, they were as much an inspiration as the music that had come before us."

248

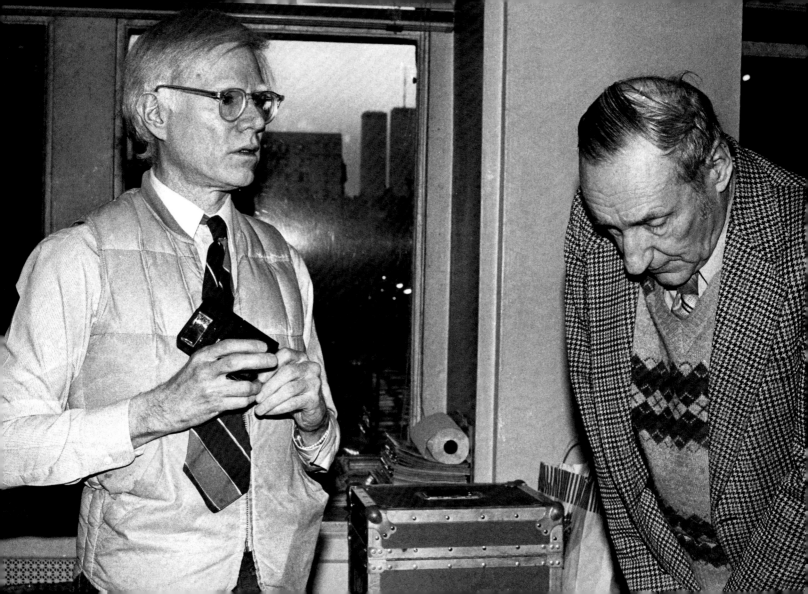

The Clash, 1981 photograph by Bob Gruen

Backed by the stunning New York City skyline—including the Empire State Building and the Twin Towers—Joe Strummer, Mick Jones, and Paul Simonon (from left) pose atop the RCA Building, on the balcony above the famous Rainbow Room. Unfortunately, the beautiful view did not mirror the group's future. Topper Headon, missing on this day, would be dismissed due to his drug addiction, and the relationship between Jones and Strummer was beginning to disintegrate just as theirs was becoming the biggest band in the world. Jones eventually would be ousted from the band, and the group would hobble along before breaking up. Jones found some success with his new outfit, Big Audio Dynamite, and Strummer would participate in the Pogues, make a solo album, and finally form a group called the Mescaleros. Tragically, after playing a couple of songs with Jones at a benefit for firemen, in 2002, Strummer died suddenly from heart failure caused by a congenital heart defect.

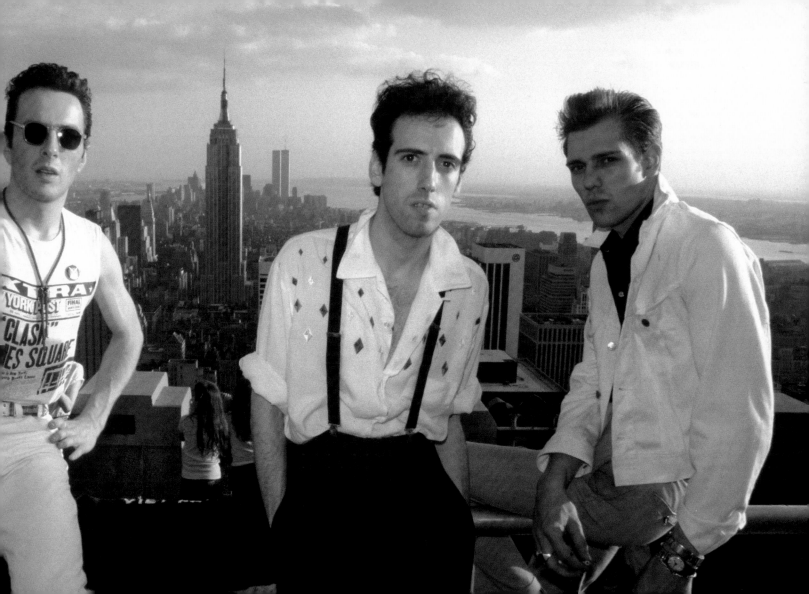

Tom Verlaine, 1981 photograph by Janette Beckman

After Television's two critically acclaimed albums *Marquee Moon* and *Adventure* flopped, the group fizzled in 1978. Tom Verlaine began recording as a solo artist, and when Janette Beckman caught up with him on tour in Philadelphia, he had just released his sophomore effort, *Dreamtime.* "We shot the photo in a very rundown neighborhood in Philly," says Beckman. "He was really quiet and seemed very soulful, with a kind of melancholy about him." Verlaine would continue to make solo albums, and in the 1990s he reunited with Television for some performances and recordings and played guitar on Patti Smith's 1996 comeback album, *Gone Again.*

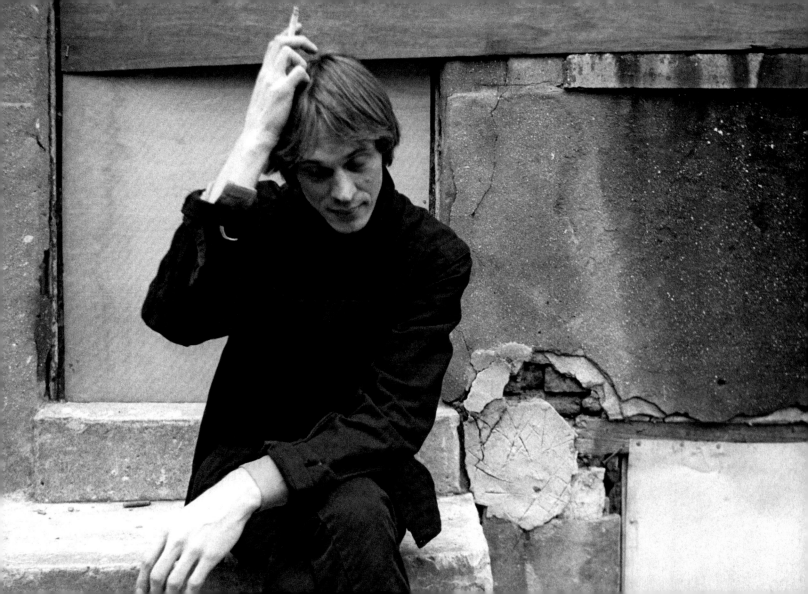

The Psychedelic Furs, 1982 photograph by Marcia Resnick

In the early 1980s a host of British bands began making an impact in the States. Many came from punk roots but had smoothed out their rough edges to gain commercial success. Formed by the Butler brothers—Richard (far right) on vocals and Tim (at left) on bass—the Psychedelic Furs scored success in England with their first single, "We Love You," in 1979.

Richard's slightly John Lydon–esque vocals gave the Furs a compelling, mood sound, and their first three albums were well received. They garnered U.S. hits with "Love My Way" (from their third LP) and "Pretty in Pink" (originally on *Talk Talk,* their sophomore effort), which inspired a John Hughes film by the same name—in turn making the song a hit.

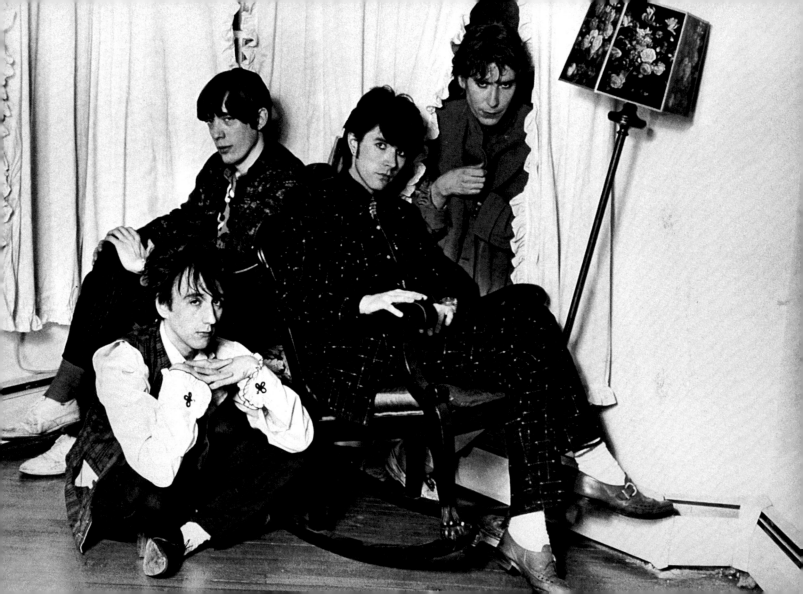

The Slits, 1981 photograph by Fran Pelzman

One legacy of the punk movement that would continue to reverberate into the 1990s and beyond was the inclusion of women in what had previously been male-dominated rock & roll. The pioneering Slits refused to compromise their vision or sweeten their sound, despite the fact that a poppier style helped some female-led groups make it into the mainstream. Their U.S. tours encouraged more young women to pick up guitars and plug in. "When I first saw them, I was in the Beastie Boys," said drummer Kate Schellenbach, who later formed the all-female Luscious Jackson. "We were all really into them, but it was extra-special for girls. They brought out the dub bass and scratchy guitar, which was originally Luscious Jackson's approach. For me, Jill [Cuniff] and Gabby [Glazer] [her LJ bandmates], they were seriously heroes. When some girls would be playing Barbie we would play dress-up like the Slits."

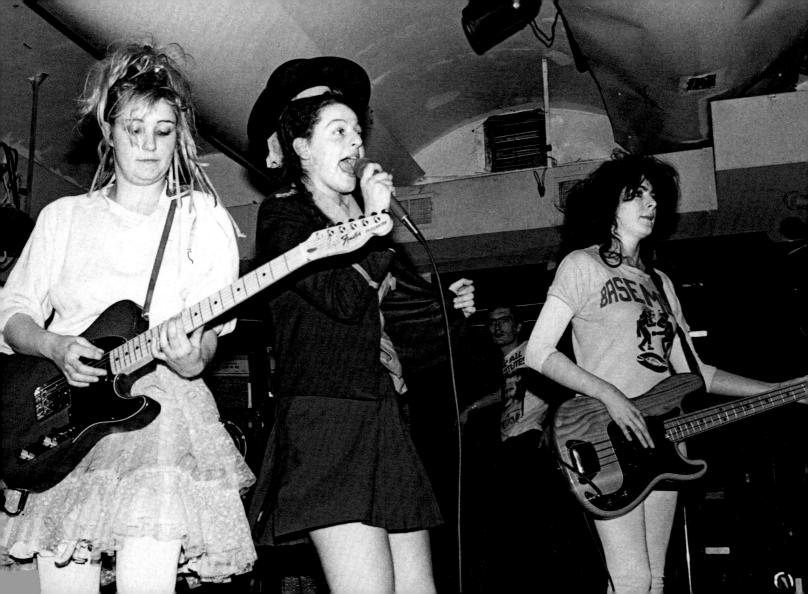

Iggy Pop, 1981 photograph by Bob Leafe

Some protopunk originators continued to make inroads in the 1980s. Through many ups and downs, the relentless, hard-driving Iggy Pop would still make waves with his incendiary live performances, winning over yet another generation of fans. David Bowie would score a hit with Iggy's composition "China Girl" in '83. The Igster's confrontational interaction with his audience—perhaps his greatest bequest—would hugely influence the burgeoning hardcore scene, with its stag dives and mosh pits. Here, Iggy greets h fans at a New York City show.

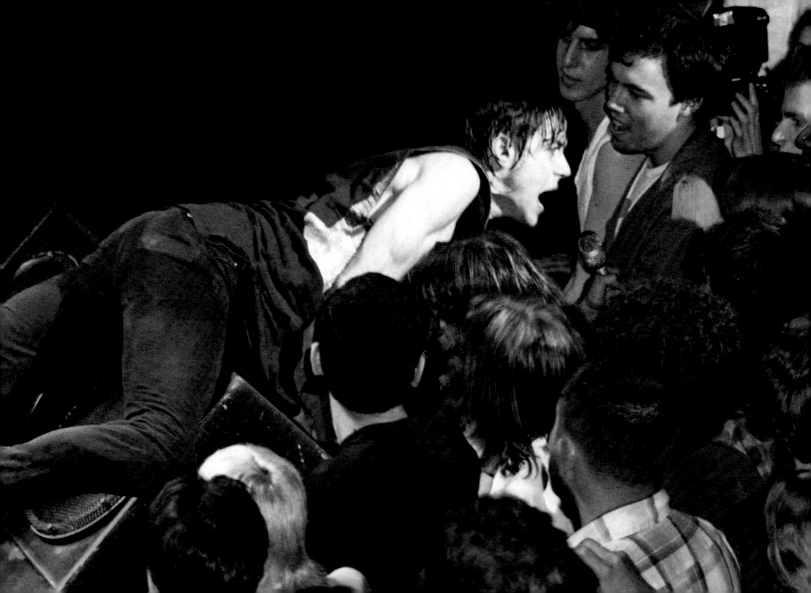

Exene and Lydia Lunch, 1982 photograph by David Arnoff

Two outspoken queens of punk united in the early 1980s for the first of several collaborations. Their first creative joint venture, a book of verse entitled *Adulterers Anonymous*, was published in '82. Here, Exene and Lydia (from left) pose for a Valentine's Day card. The two would also work together in the '90s on a spoken-word recording.

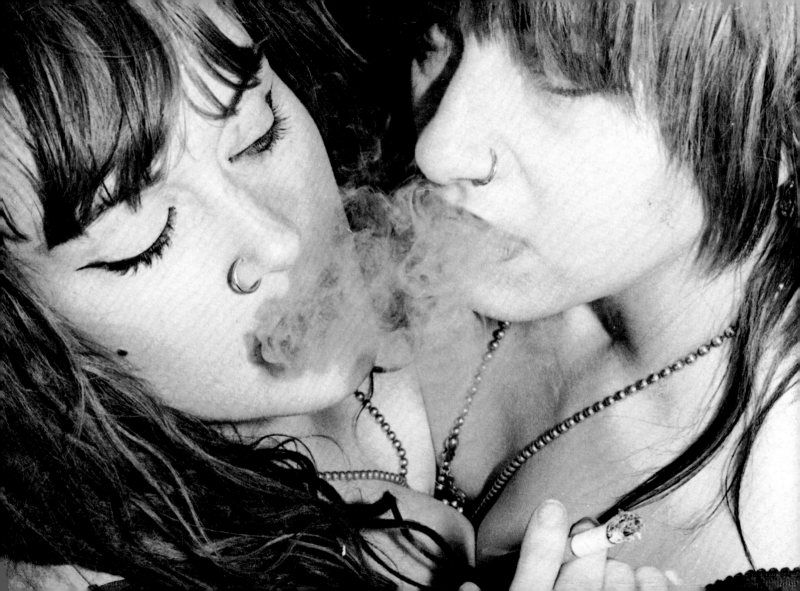

Chrissie Hynde, 1984 photograph by Robert Matheu

With her tough stance, crystalline vocals, masterful songwriting, and notable guitar slinging, Chrissie Hynde of the Pretenders inspired many inexperienced female musicians to join bands. She remembers those early days of punk when she formed the Pretenders: "I started playing with some of the guys that went on to become the Damned, I played with some of the guys who went on to become the Clash. I knew some of the girls in the Slits. I thought Ari Up was amazing. There was Siouxsie, and Gaye Advert, who was in the Adverts. That was the beauty of the punk thing. The so-called punk scene in my mind only lasted for six months. No one would have been considered 'good for a girl.' That kind of discrimination didn't exist in that scene. You were *in* the band—and did whatever your contribution was. That was when saw the pinhole of light I headed toward I saw I could slip through the net. It wouldn't be a gimmick, I could get in there." Here, Hynde goes for a ride on former Sex Pistols guitarist Steve Jones Harley in Los Angeles' Griffith Park.

255

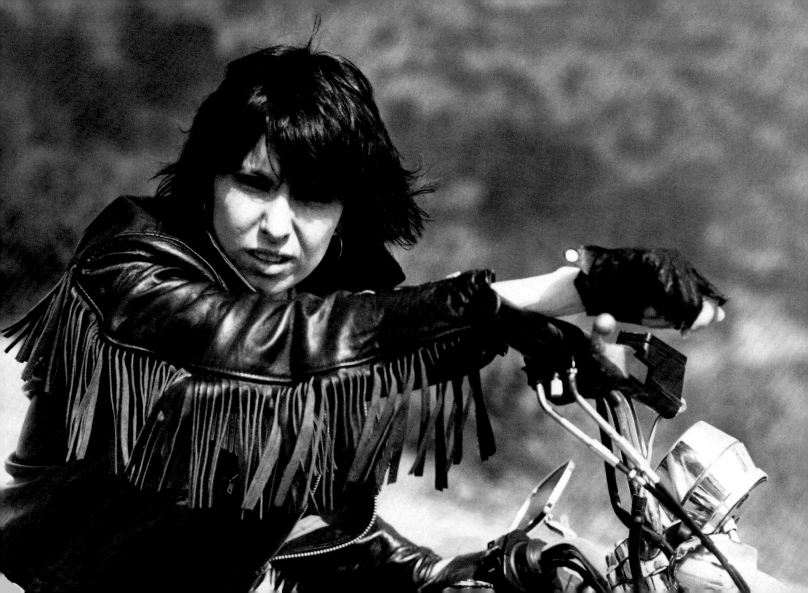

Siouxsie Sioux, 1980 photograph by Ebet Roberts

With her mournful but powerful vocals and black clothes and hair, Siouxsie Sioux created a lasting image for punk women. She spawned the goth look, and as Siouxsie and the Banshees' sound moved in that dramatic direction in the 1980s—presaged by their 1981 single "Spellbound"—it affected the sonics of future bands in the States, England, and Australia. Here, Siouxsie hypnotizes a New York City audience.

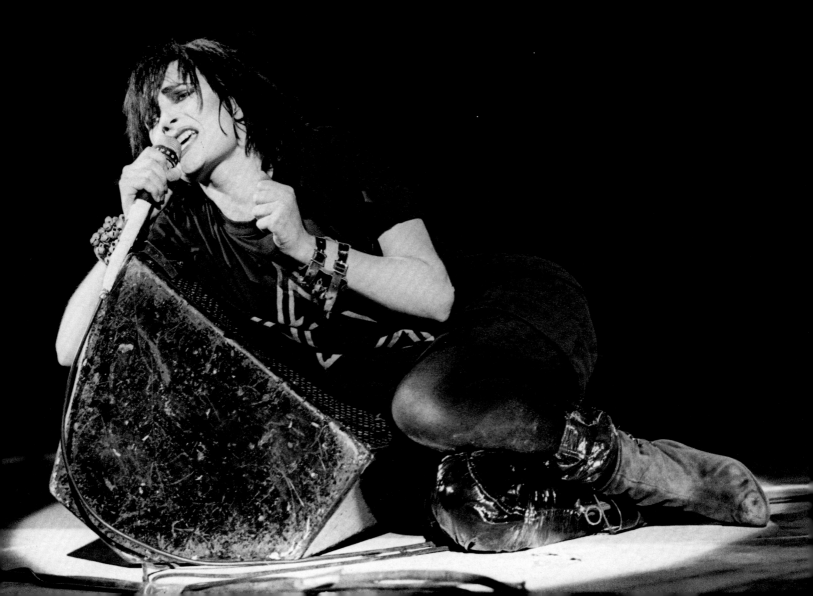

Exene, 1981 photograph by Bob Leafe

"We'd drink in the alleys because it was a ritual that united us ... It was so important to bring a six-pack, or smuggle in a bottle to the show, or be the one over twenty-one who could buy booze for the rest ... I loved drinking. I loved getting drunk and being wild in the parking lot; running and dancing and fighting and watching the bands play ... Once in about '81, the Whisky gave me a tab, for some strange reason. I'd drink martini after martini and buy drinks for whoever happened by my booth next to the front door ... This all ended after two weeks of nonstop taking advantage of the only free thing I'd probably ever gotten."

—Exene Cervenka

photograph by Ebet Roberts

Soon to be one of pop music's most eccentric superstars, Cyndi Lauper started the 1980s as the "chick singer" for the New Wave outfit Blue Angel. Her impressive five-octave voice and gutsy stage presence were much in evidence, though she didn't yet have the repertoire of catchy songs—like "Girls Just Want to Have Fun"—or the zany wardrobe and Krazy Kolor hair that would evolve in time. Blue Angel released one album, in 1980, over the course of a four-year career.

Robert Gordon with Link Wray and band, 1978 photograph by Gary Green

Along with an embrace of the primal garage rock of the '60s, punk gave the nod to an earlier, simple but emotive, form of music—'50s rockabilly. The Cramps first covered the more obscure nuggets—the weirder, the better—in their sets. Vocalist Robert Gordon quit the punkish Tuff Darts to focus entirely on the rockabilly sound. He recorded a 1977 album with distinctive guitarist Link Wray, whose 1958 instrumental "Rumble" featured a menacing riff that evoked the sound of a gang fight. With Gordon's crowd-pleasing take on "Red Hot," originally cut for Sun Records in the '50s by Billy Lee Riley, the album caused a stir. Here, opening for Blondie at New York's Academy of Music, are Link Wray, bassist Rob Stoner, drummer Anton Fig (now part of the band on *Late Night with David Letterman*), and Robert Gordon (from left).

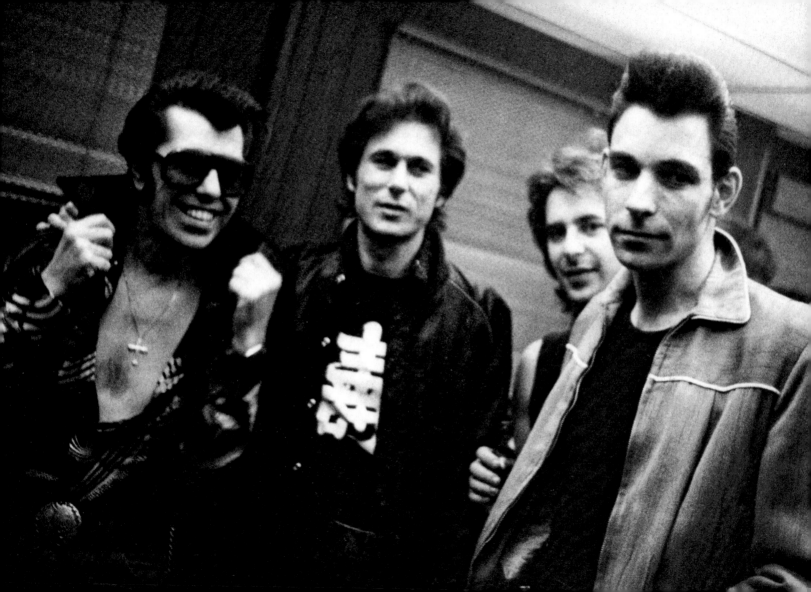

Buzz and the Flyers, 1980 photograph by Gary Green

One of the earlier adherents of rockabilly was a New York–based band, Buzz and the Flyers, who tried to look, dress, and live in a manner authentic to that 1950s musical style. Here, in the Brooklyn apartment they shared, are lead singer Buzz Wayne (front and center, in leopard-skin chair) and lead guitarist Michael Gene (as in Gene Vincent; far right). The other members are Pete Morgan (on stand-up bass) and Rock Roll (snapping his fingers), who usually played the snare drum while standing up, rockabilly style. This photograph was used for the back cover of the group's debut 45, a heavy cardboard (old-style) record sleeve. The three-song single was produced by New York Doll Sylvain Sylvain for his own Sing Sing Records. It was the second and final record produced for that label, and included Buzz songs "Little Pig," "You Crazy Gal You," and "Let's Bop."

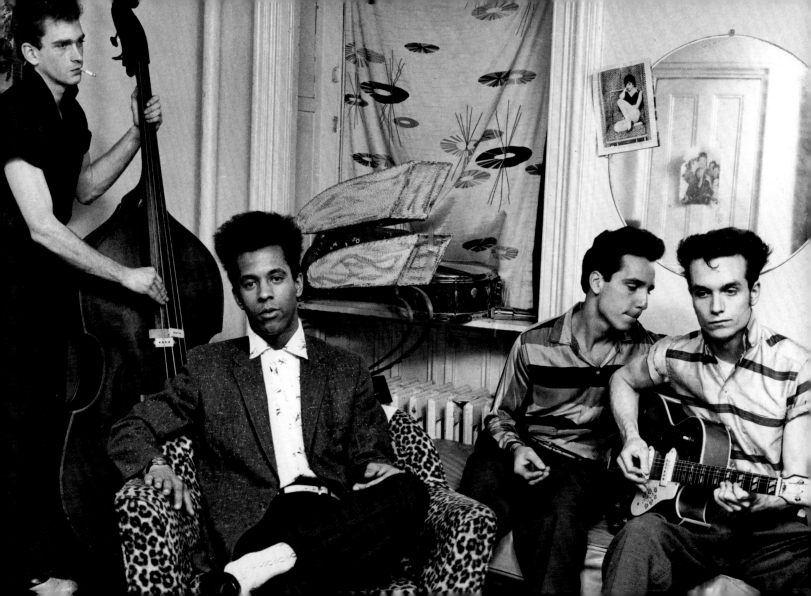

Pleasant and Levi, 1981 photograph by Gary Leonard

In London, the Teddy Boys were part fashion trendies living a retro lifestyle, part 1950s rock & roll followers. From that scene came punk adherents, as well as a rockabilly craze that predated by several years America's infatuation with the style. Decades after the deaths of such American rock & roll pioneers as Eddie Cochran and Gene Vincent, those artists continued to be revered in England—though forgotten by their own compatriots. The London-based Levi and the Rockats, composed of rockabilly fans became popular there in the late '70s, before relocating to L.A. In Hollywood, lead singer Levi Dexter and scenester Pleasant Gehman began stepping out together and eventually tied the knot—though the union ended in divorce. On this May evening at the down 'n' dirty Zero Zero Club, the soon-to-be-unhappy couple hoisted their beers.

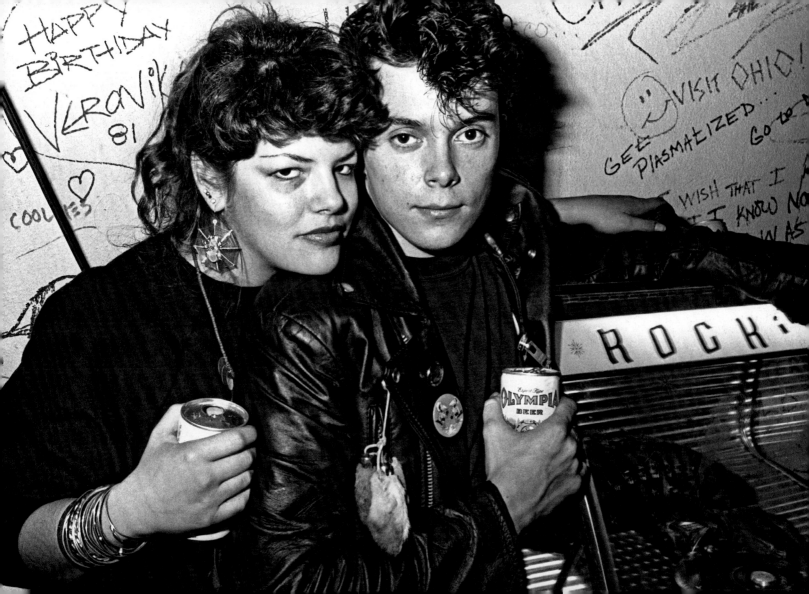

Brian Setzer, 1982 photograph by Gary Green

Vocalist/guitarist Brian Setzer had played in such punkish bands as the Bloodless Pharaohs at CBGB since the late 1970s. Relocating to London, however, proved a smart career move, since it provided him with the audience for his music that had eluded him in New York; after forming the Stray Cats, Setzer, upright bassist Lee Rocker, and drummer Slim Jim Phantom shipped out to London the summer of 1980. There they inked a British record deal, with their debut produced by Dave Edmunds. It spawned the British hit singles "Rock This Town" and "Stray Cat Strut," and once they were chosen to open the Rolling Stones' U.S. tour in 1982, they attained massive success in their home country. The location of their hugely popular first video: New York City's St. Mark's Place.

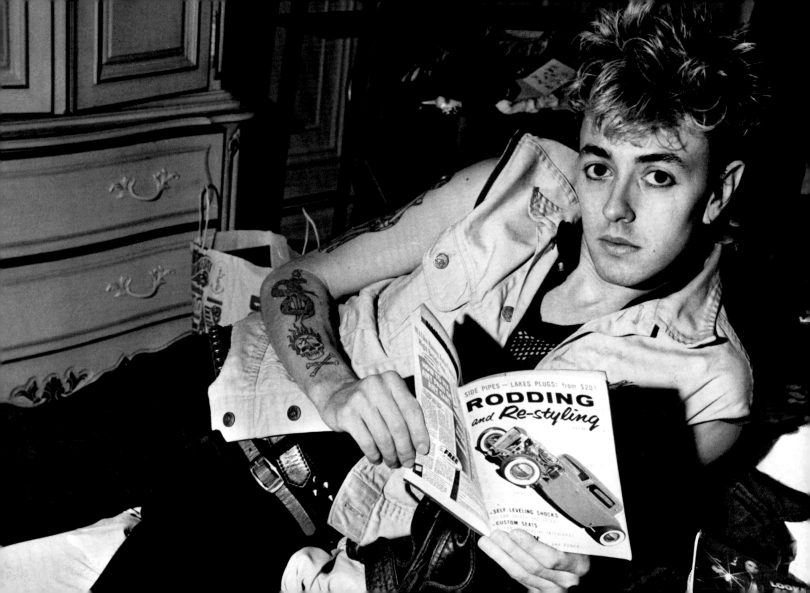

SIDE PIPES — LAKES PLUGS: from $20!

RODDING
and Re-styling

• SELF-LEVELING SHOCKS
• CUSTOM SEATS

Panther Burns, 1980 photograph by Ebet Roberts

Joining forces with Tav Falco's somewhat twisted West Memphis rockabilly-tinged brew, Alex Chilton played guitar and produced the debut album for Panther Burns. Named for an Arkansan crossroads town near West Memphis, Panther Burns played a steamy blues that found kindred spirits in the Cramps, whom Falco, himself a dramatic front man, first met when they were recording in Memphis. "They were an inspiration to me," said Falco (b. Gus Nelson). "There was this sense that anyone could burn. I'm really grateful to the Cramps for showing us the way." Here, Tav Falco and Alex Chilton chill out before a September 21 gig at the New York City club SNAFU

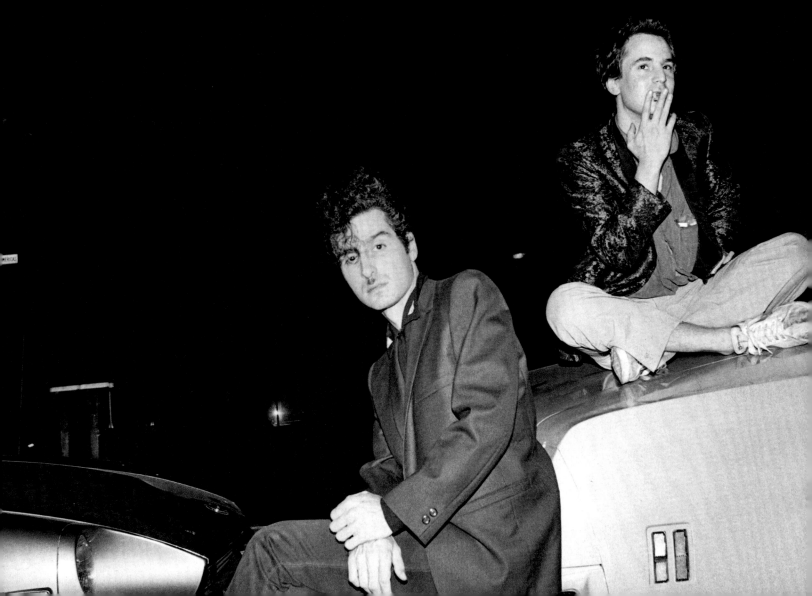

Magazine, 1980 photograph by Ebet Roberts

An original member, with Pete Shelley, of the Manchester band the Buzzcocks, vocalist Howard Devoto (center) left that group after six months to form Magazine in 1977. Magazine's debut single, in January '78, "Shot by Both Sides," boded well for Devoto's dark vision. His band had the chops too—John McGeoch on guitar and sax, Dave Formula on keyboards, Barry Adamson on bass, and Martin Jackson on drums. But after releasing four superb albums, the group broke up in '81, about year after this portrait was taken outside th New York City nightclub Hurrah.

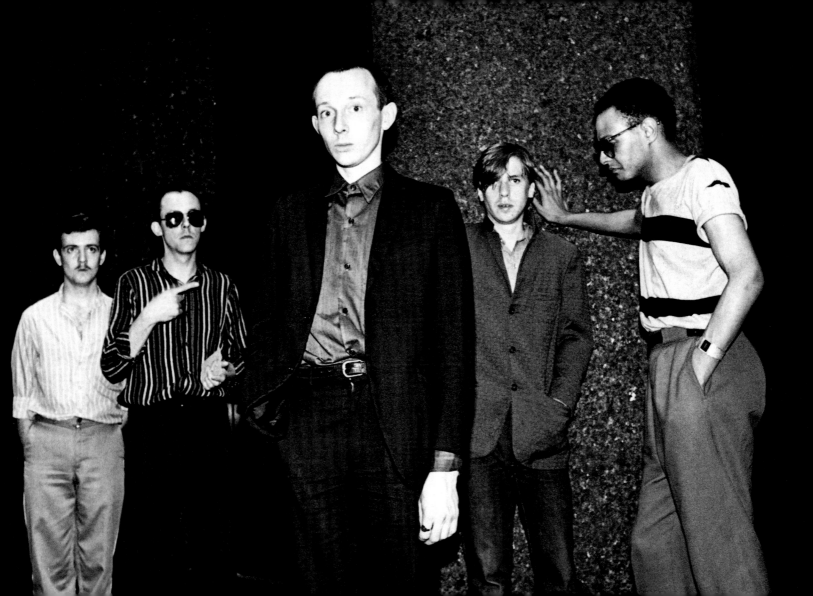

The Cure, 1980 photograph by Ebet Roberts

It's hard to believe the affable-looking lads that constituted the Cure during their first U.S. tour would become the big-haired painted faces behind the goth movement a few years later. Led by vocalist/guitarist Robert Smith (far right), the band played literate, melodic material, performing controversial songs like "Killing an Arab" (inspired by Albert Camus' *The Stranger*) and "Boys Don't Cry" (used subsequently as the title for a U.S. movie). Smith had been among those lucky few to witness the early Sex Pistols shows at the 100 Club and, inspired, had started the Cure in 1976. Here, at Hurrah, the Cure play their first New York show.

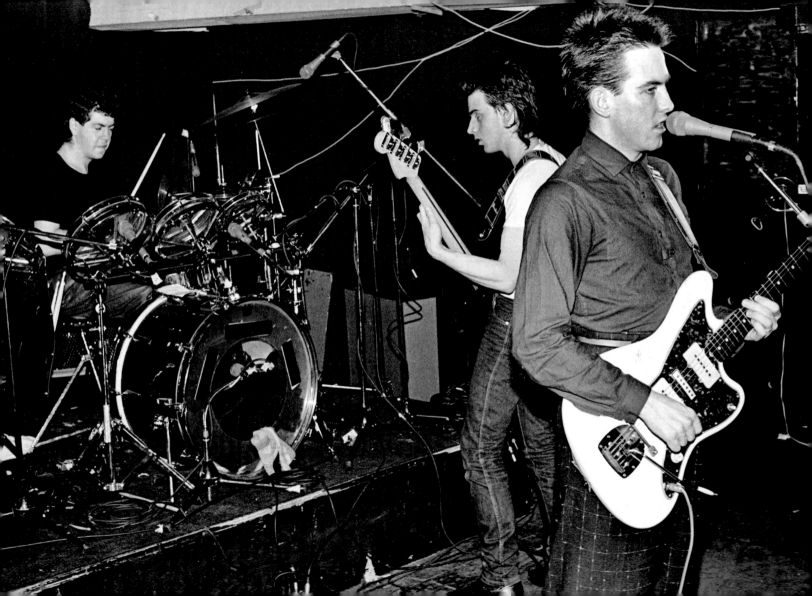

The Cure, 1980 photograph by Ebet Roberts

On their first trip to New York from London, the Cure stroll along Broadway, approaching Columbus Circle near Hurrah, located on the Upper West Side. The next few years would find auteur Robert Smith (second from left) dividing his time between the Cure and Siouxsie and the Banshees (for whom he filled in on guitar after their guitarist quit mid-tour). As he participated in the Banshees' recordings and performances, he gradually evolved into the "messiah of melancholy," as he was later dubbed.

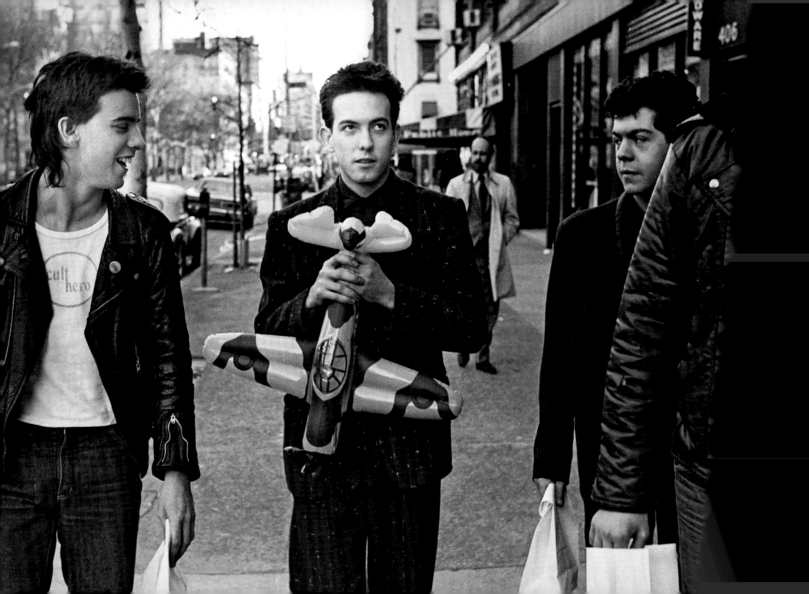

The Modettes, 1980 photograph by Ebet Roberts

The uptown Manhattan club Hurrah, sometimes referred to as a New Wave disco, catered to the onslaught of English bands coming to New York in 1980. Located in a roomy space with a dance floor, the upstairs club, booked by Anglophile Ruth Polsky (later tragically run down by a taxi while about to enter the Limelight nightclub) and avant-gardist Jim Fouratt, had a "moderne" feel to it. One flight up, a DJ spun records, while bands played on the floor below. The Modettes, who performed at Hurrah on September 10, 1980, were formed in '79 by U.S.-born guitarist Kate Korus (left), after she quit the Slits. Bassist Jane Crockford (right) had briefly been a flatmate of Sid Vicious', and vocalist Ramona Carlier (center) hailed from Geneva, Switzerland. Korus met drummer June Miles-Kingston on the set of the Sex Pistols film *The Great Rock 'n' Roll Swindle.* The Modettes scored a UK hit with their catchy debut single "White Mice," and did a feisty take on the Stones' "Paint It Black."

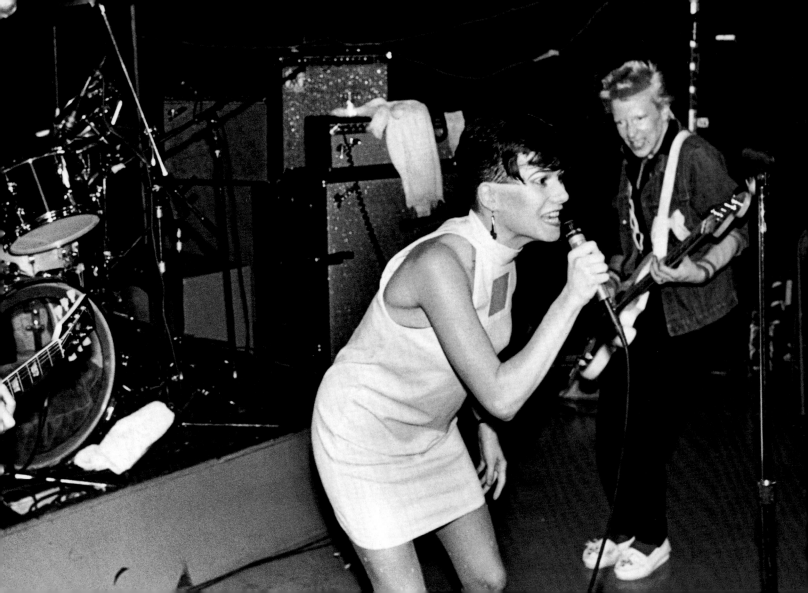

The Bush Tetras, 1980 photograph by Charlyn Zlotnik

The East Village three-women, one-man outfit the Bush Tetras made an impact with their sassy first single "Too Many Creeps." Guitarist Pat Place (a veteran of the Contortions), drummer Dee Pop, vocalist Cynthia Sley, and bassist Laura Kennedy (from left) constituted "a pioneering rhythm and paranoia band," according to *Village Voice* critic Robert Christgau—"I just can't go out on the street anymore / too many creeps!"

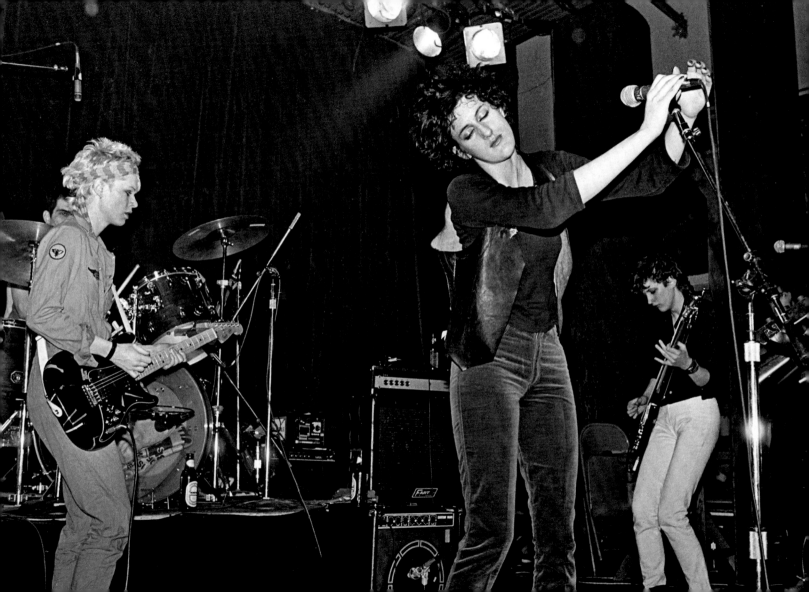

Jean–Michel Basquiat, 1980 photograph by Bobby Grossman

Intertwined with the East Village postpunk music scene was a breed of street-wise, punk-inspired, hit-and-run artists, many of whom first became known via graffiti. Basquiat, whose tag was SAMO, made exquisite expressionistic paintings, and became a protégé of Andy Warhol and the darling of the SoHo gallery world. He hung out wherever the latest underground music was played, as did such artists as Kenny Scharf and Keith Haring. Tragically, Basquiat overdosed on heroin in 1988 at age twenty-seven.

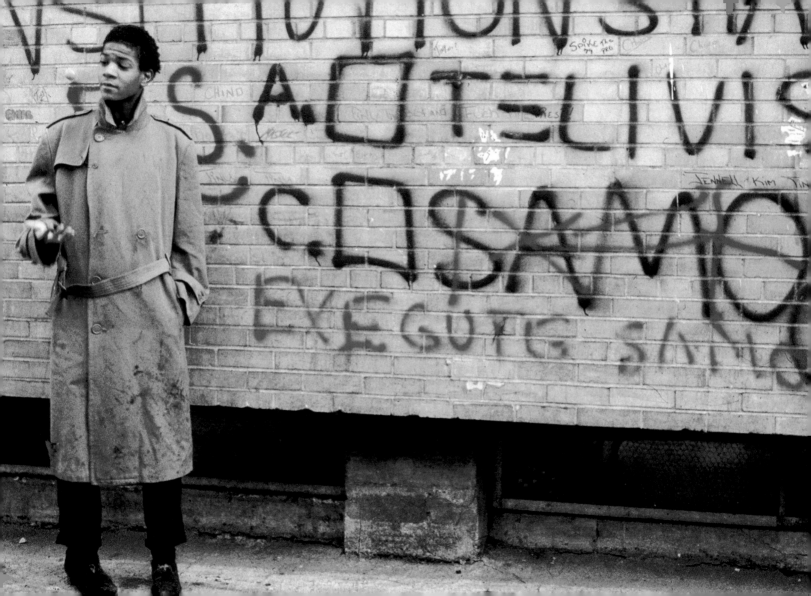

Fab Five Freddy, Debbie Harry, and Lee Quinones, 1980

photograph by Bobby Grossman

The rap and hip-hop that spilled out of street parties and parks in the South Bronx—as much a music revolution in the early '80s as the sounds that had emerged in Lower Manhattan, London, and L.A. in the '70s—would blend with New York punk as reggae had with UK punk. Blondie was the first of the CB's bands to embrace the sound, toasting Fab Five Freddy and Grandmaster Flash in the 1980 hit "Rapture." Here, Harry (center) hangs with graffiti artists Fab Five Freddy (left) and Lee Quinones. Freddy would become friendly with members of the Clash, who also began to incorporate rap into their music.

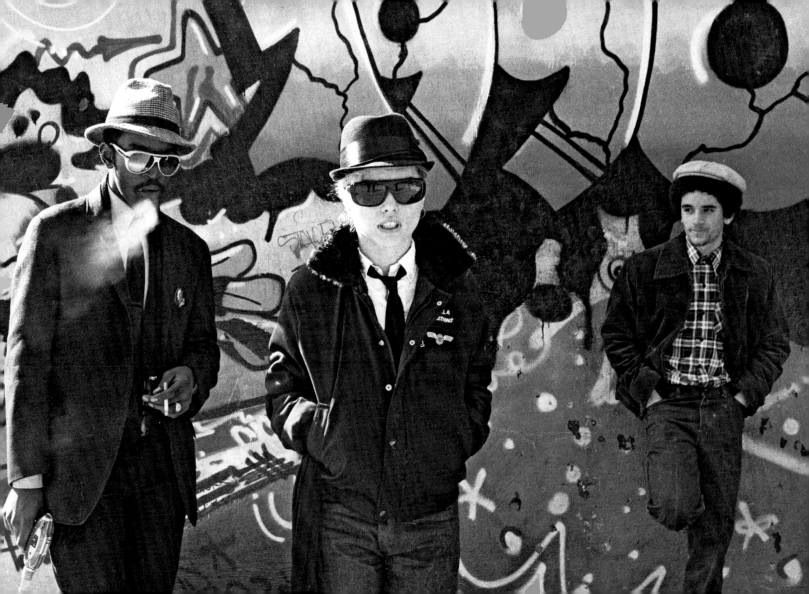

Chrissie Hynde, 1984

photograph by Robert Matheu

"If I'd been a good enough guitar player, I would have been happy to just be the guitar player. But I was frustrated by the fact that I could sing and I could write songs, so that sorta took over. I think at the end of the day, whatever's your strongest point, that's got to be what you go with. I was good at being the front person and the band leader—that was always my strong point. Because I'm very much a purist with the way I see how things should be done. And to me, though rock is all about breaking rules—and you're allowed to do whatever you want to—I have my own rules that I stick to. For example, I think the singer's job onstage is to make the guitar player look great. That's what a whole band is all about. Everyone is in a position to set someone up—like a soccer match. Everything is setting up the next move for the next person."

—Chrissie Hynde

Walter Steding, 1979 photograph by Bobby Grossman

After being credited as "producer" on the Velvet Underground's debut album in 1966, Andy Warhol waited until 1980 before wearing that hat again. This time his artist, Walter Steding, played a strange electronic violin. Here, Steding is photographed at Hurrah. Warhol died suddenly following gallbladder surgery in 1987.

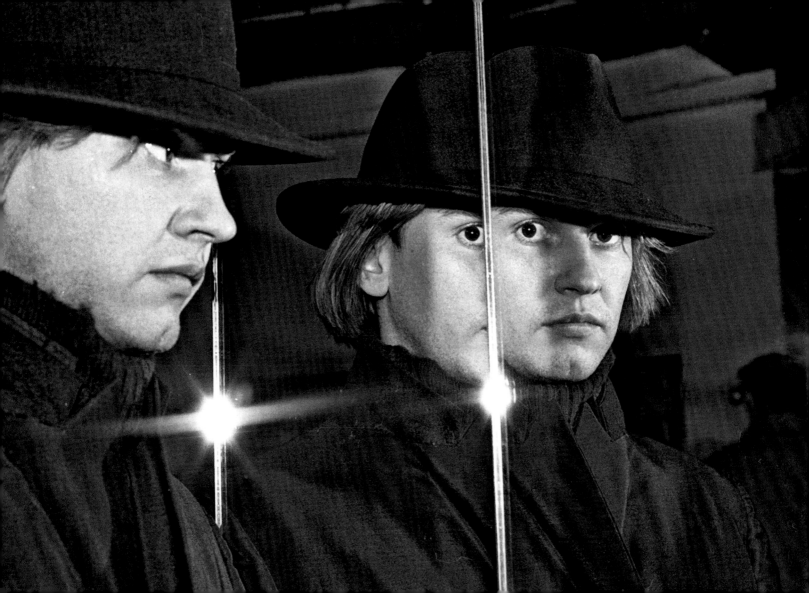

David Johansen, 1978 photograph by Roberta Bayley

Following the breakup of the New York Dolls, vocalist David Johansen worked as a solo artist for a while. He continued to make the downtown scene and was among the first of the CBGB regulars to hear the Ramones and Television in the mid-'70s. His solo material was more crooned pop than punk rock. Eventually, Johansen would reinvent himself as Buster Poindexter, a tuxedoed, louche singer who scored a hit with "Hot Hot Hot," a remake of a Caribbean soca song. His next outfit would be the Harry Smiths, who specialized in bluesy murder ballads.

273

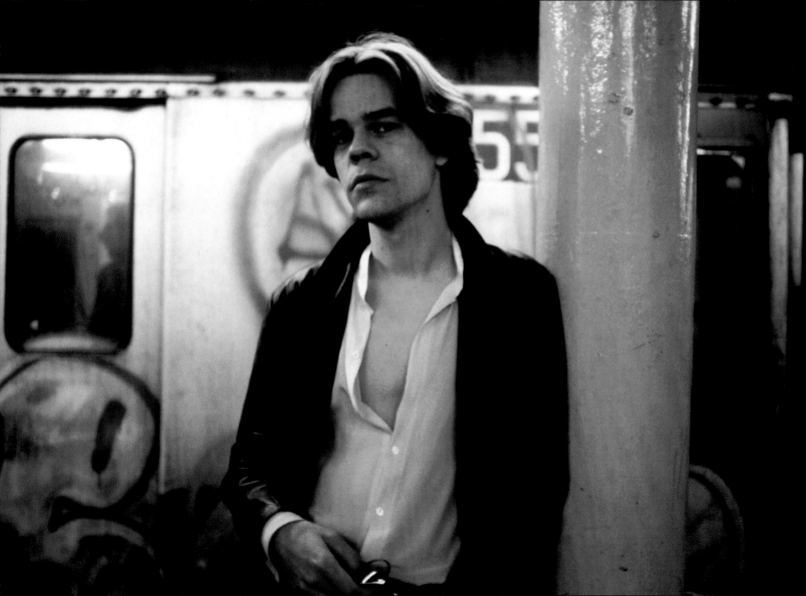

Billy Idol, 1983

photograph by Raeanne Rubenstein

After Generation X broke up and Billy Idol became a solo artist, his photogenic sneer, platinum spikes, and bulging biceps became perfect raw material for the brand-new MTV. One of the first (and only) punks to become a video star, Idol appeared in his "White Wedding" and other babe-populated videos in the mid-'80s, propelling himself to megastardom.

Even after he went Hollywood, though, Idol used to wax nostalgic: "The best concert I ever saw was the Sex Pistols at the 100 Club, Oxford Street, London, in February 1976 . . . My friends and I were from Bromley, and we loved it, not having seen anything as stripped down and to the point . . . I was about seventeen years old. Soon we started groups of our own."

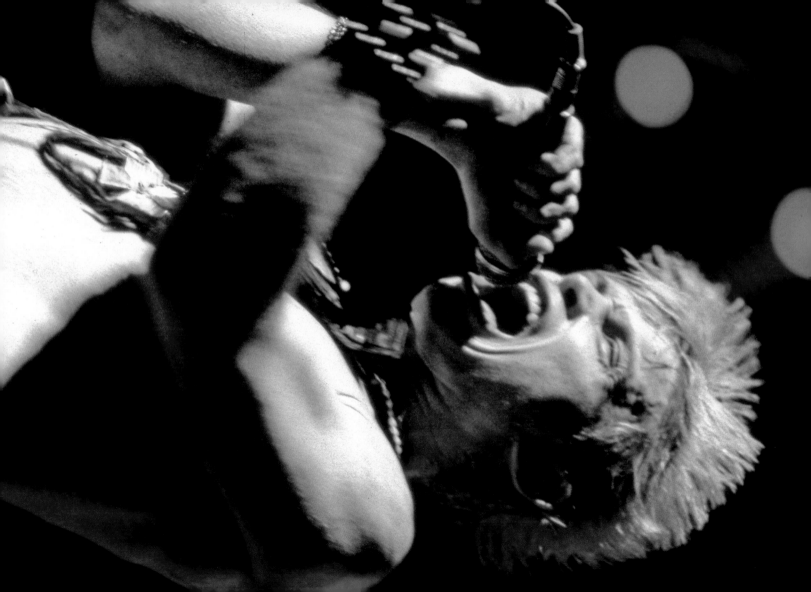

The Undertones' Feargal Sharkey, 1980 photograph by Ebet Roberts

The skinniest man in punk rock, Feargal Sharkey was renowned for his frenetic stage presence as leader of Derry's finest, the Undertones. The band's albums *Hypnotized* (1980) and *Positive Touch* (1981) won raves from none other than the *Voice*'s picky Bob Christgau: "The good-kids-of-the-year are as honest as power pop (remember power pop) ever gets. They're also as powerful, which I bet has something to do with why they're so honest."

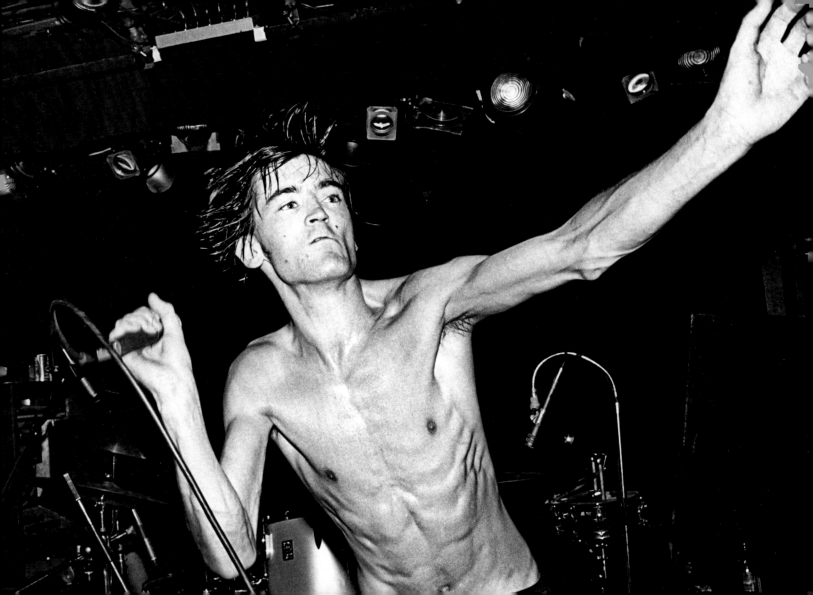

The Specials, 1980 photograph by Jill Furmanovsky

The Slits' and PiL's experimentation with dub 'n' bass set the stage for a whole new ska movement, 2-Tone, named after the record label, with its black-and-white logo, that released records by the Specials, then other ska-influenced bands. Rather than feature rappers as in hip-hop, these bands engaged toasters, who talked their talk into the mic, and walked their walk while the musicians played. These biracial bands were fun, dancing was a must, and everyone dressed in the retro '60s Caribbean-meets-mod style—porkpie hats for the guys, black-and-white houndstooth minis for the gals. The seven-piece Specials formed in '77 in Coventry, England, and included keyboardist Jerry Dammers (who wrote many of the songs), bassist Sir Horace Gentleman, guitarist Lynval Godling, guitarist Roddy Radiation, vocalist Terry Hall, vocalist/percussionist Neville Staples, and drummer John Bradbury. Their successful early singles like "Gangsters" and "A Message to You Rudy" led to a debut album, which was produced by Elvis Costello.

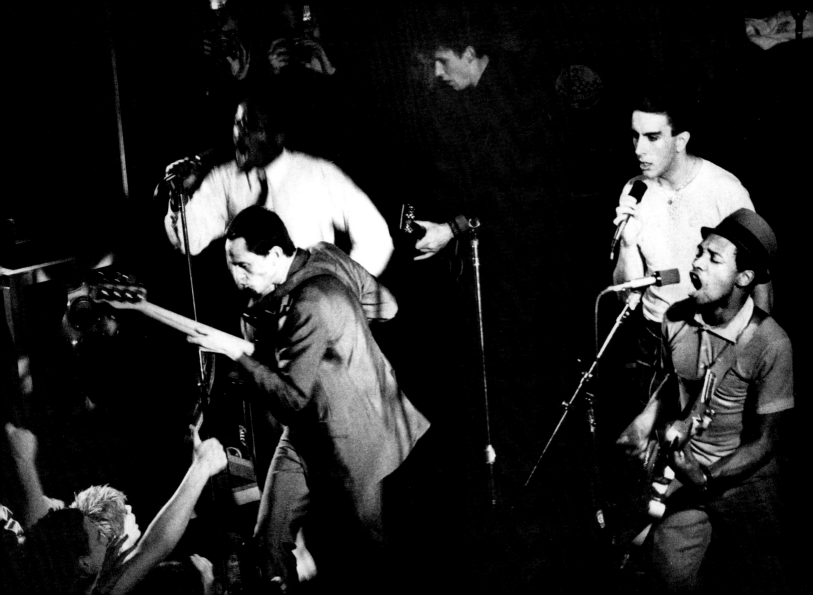

Madness' Mark "Bedders" Bedford, 1981 photograph by Janette Beckman

On the heels of the Specials, the seven-piece band Madness—whose bassist Mark "Bedders" Bedford here plays with spray paint—had the biggest hit of all the ska groups with "Our House" in 1983. That was the year the band toured America with David Bowie and the Go-Go's and made a lasting impression on fifteen-year-old Gwen Stefani, who would one day form the multiplatinum ska-tinged surf punk band No Doubt. "I'll never forget the David Bowie, Go-Go's and Madness concert at Anaheim Stadium in 1983," Stefani says. "It was the summer before ninth grade. I cried the whole time during the concert because it was so intense. I couldn't believe I was seeing Madness, even though I was really far away and it was a really big place. It was awesome. I was mesmerized by Madness."

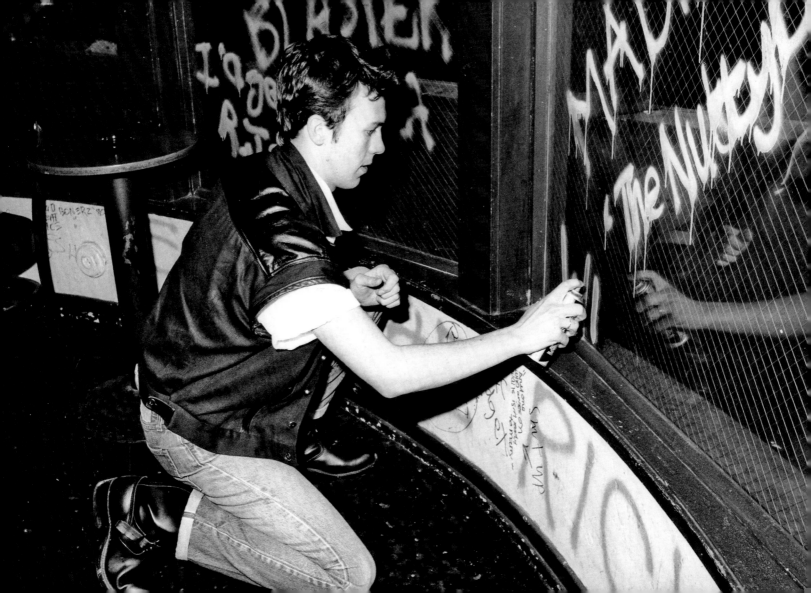

The English Beat, 1980 photograph by Janette Beckman

Formed in 1978 in Birmingham, England, ska band the English Beat comprised Andy Cox, Everett Morton, David Steel, Dave Wakeling, and Ranking Roger. Although they originated as the Beat, the band added *English* to their name when they performed in the States, to differentiate themselves from an L.A. power-pop band of the same name.

Mentored by the Specials, the band released a ska version of Smokey Robinson's "Tears of a Clown" on 2-Tone in 1979, and had a breakthrough hit with "Mirror in the Bathroom" in '80. Here, they are photographed in their hometown of Birmingham right before recording the LP *I Just Can't Stop It.*

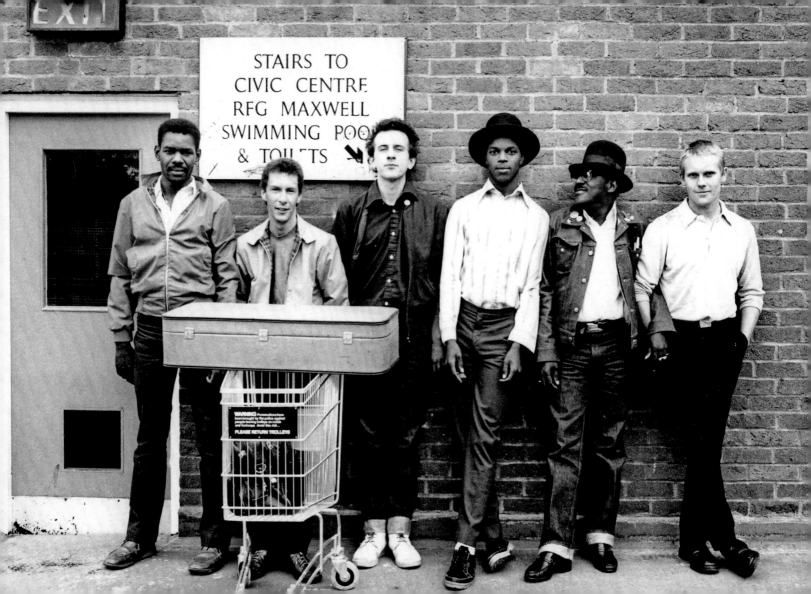

Musical Youth, 1983 photograph by Charlyn Zlotnik

With ears opened up to reggae and ska, the London-based group of youngsters Musical Youth had an out-of-left-field hit in 1982 with "Pass the Dutchie." Slang for a chalice pipe, the term *koochie,* in the original version by the Mighty Diamonds, was disguised in this clean-cut take (*dutchie* means "cook pot"). The five members, who hailed from Birmingham, ranged in age from eleven to sixteen and included two sets of brothers, plus a friend. The song crossed the Atlantic and stayed on the pop charts for eighteen weeks, cresting at number ten.

Joe "King" Carrasco and the Crowns, 1982 photograph by Charlyn Zlotnik

With reggae and ska coming to the States from the Caribbean by way of the UK, it was only natural that our south-of-the-border-inspired cousins the Tejanos would make sonic encroachments into postpunk music. Taking their cue from such '60s Tex-Mex greats as the Sir Douglas Quintet and out-there garage band ? and the Mysterians, Joe "King" Carrasco and his band the Crowns brought from Austin a hyperactive crown-topped showmanship and Farfisa organ to win the hearts of New York's postpunksters.

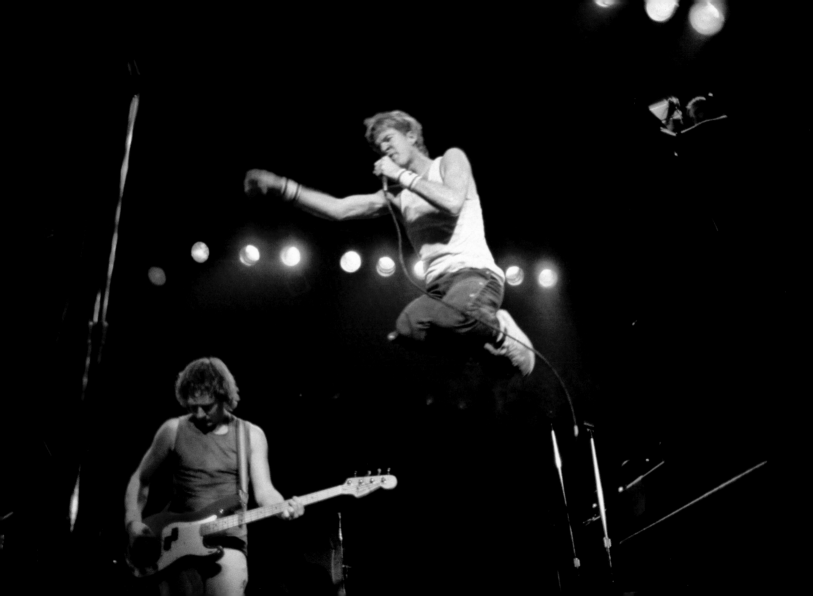

The Lounge Lizards, 1980

photograph by Charlyn Zlotnik

Sax man John Lurie (center) punked up bebop to create the Lounge Lizards with former No Waver guitarist Arto Lindsey (right), from DNA. Lurie had already starred in the downtown punk noir classic *Stranger Than Paradise,* directed by fellow CBGB alumnus Jim Jarmusch, who'd done time in the downtown outfit called the Del Byzantines. Also playing "fake jazz" for the Lizards were Lurie's brother Evan (on keyboards), former member of the Feelies Anton Fier (on drums), and Steve Piccolo (on bass).

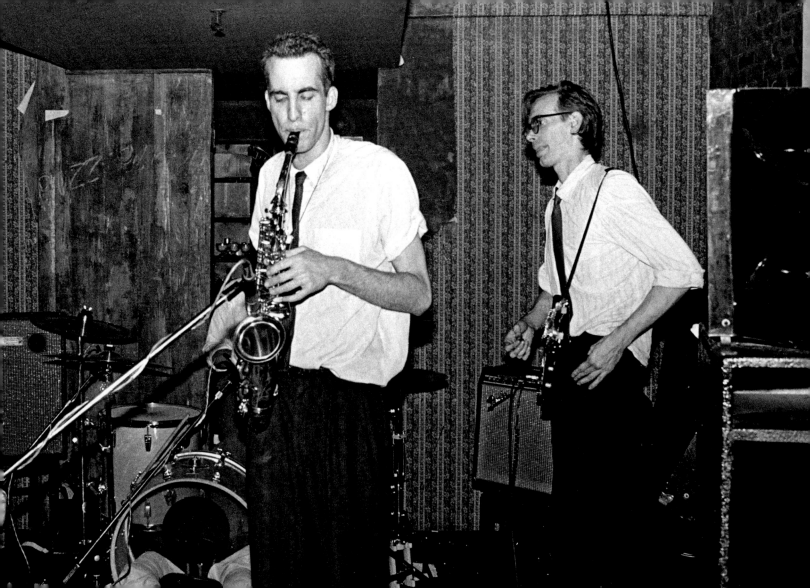

The Necessaries, 1980 photograph by Charlyn Zlotnik

The guitar-crunchy Necessaries found a fervent following, but they only released a couple of singles in the States. Propelled by the songwriting of vocalist/guitarist Ed Tomney (right), the band originally included UK guitar slinger Chris Spedding, who was replaced by local hotshot Randy Gunn. Former Modern Lovers bassist Ernie Brooks and drumme Jesse Chamberlain made this one rockin' combo, and for a couple of years they were favorites on the downtown circuit.

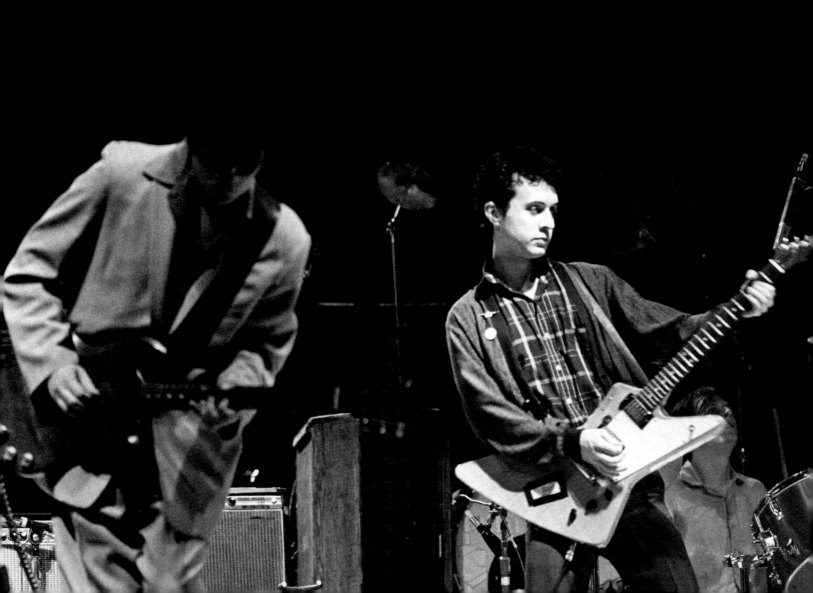

Mission of Burma, 1982 photograph by B. C. Kagan

One of the few East Coast bands to carry on the political messages of the Clash, the Boston-based postpunk combo Mission of Burma influenced the hardcore scene thanks to their LOUD guitars. The band made the landmark *Signals, Calls, and Marches* EP in 1981, but guitarist Roger Miller, tape manipulator Martin Swope, and drummer Peter Prescott split up in the mid-'80s, after Miller began experiencing hearing loss. The individual members continued to play in various outfits, and Moby covered the group's signature song, "That's When I Reach for My Revolver," in 1997. Finally, Mission of Burma reunited in the twenty-first century.

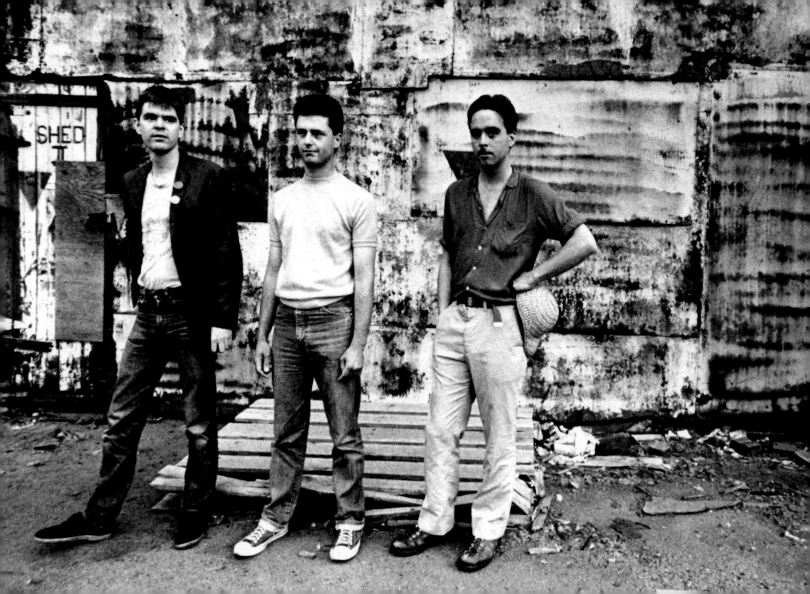

Nervus Rex, 1980 photograph by Charlyn Zlotnik

A power-pop combo that made catchy singles, Nervus Rex featured Lauren Agnelli on guitar and vocals. She would go on to form the faux-Beatnik group the Washington Squares. Here, the band perform at the UK Club, one of the dingy downtown clubs that featured postpunk bands on a regular basis.

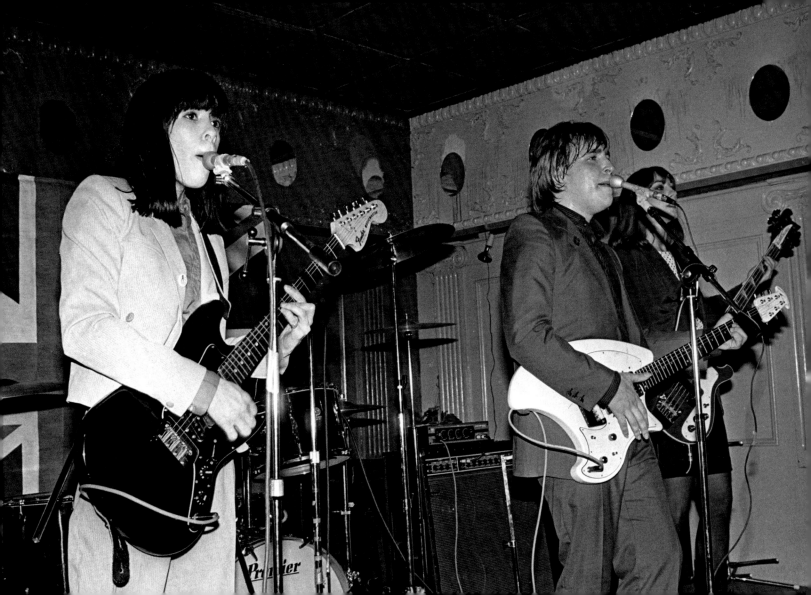

U2, 1981 photograph by Ebet Roberts

U2 had just played their first New York City gig at the Ritz, on East Eleventh Street, when Ebet Roberts shot the band upstairs in the club's balcony. Drummer Larry Mullen, guitarist the Edge, vocalist Bono, and bassist Paul Clayton (from left) were in a rush; a taxi awaited them on the street, Roberts remembers. "They said that they didn't like to be photographed all together, and wanted to be shot in pairs," she says. "But since we only had five minutes, they stood as a group. I had recently met their manager Paul McGuinness in England and he had told me that I had to check out this little band he was bringing to the States. He said they were going to be huge." When Roberts photographed them on this St. Patrick's Day, U2 had only released one album, *Boy*. It wasn't long, though, before McGuiness' prediction would come true.

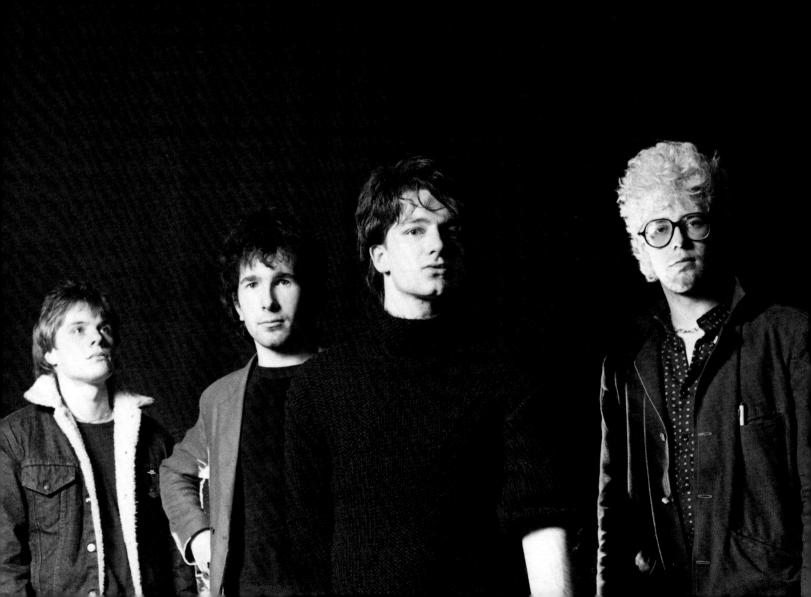

The Clash, 1981 photograph by Bob Leafe

Despite the cries of "sell out" that were haunting them, the Clash still made a stop at Tom Snyder's television program in '81. Joe Strummer, Topper Headon, Paul Simonon, and Mick Jones (from left) seem fascinated by Snyder's teddy-bear mascot.

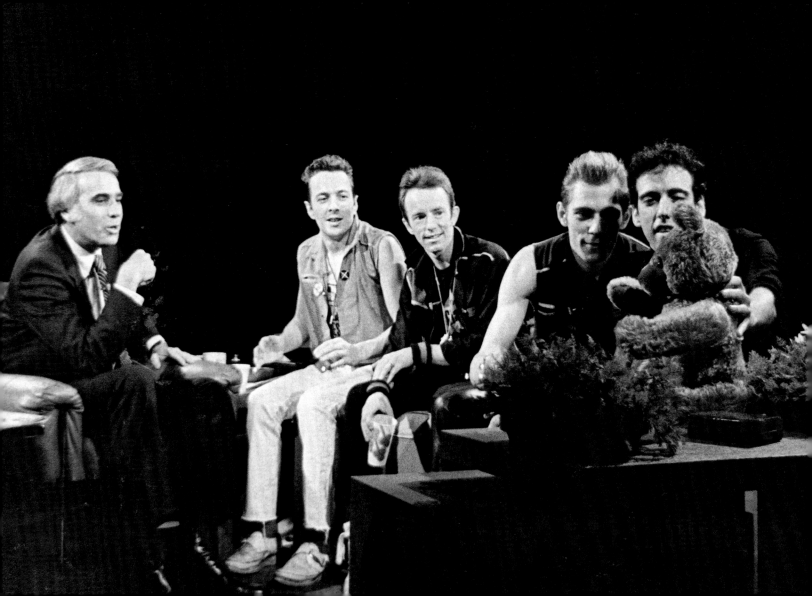

The Clash, 1982 photograph by Bob Gruen

With the Clash's 1982 album *Combat Rock,* the vegetarian Joe Strummer decided to go whole hog, dressing in battle-fatigue trousers and shearing his do into a Mohawk. Bob Gruen shot the band at RFK Stadium, where they would open for the Who. Joe Strummer and Mick Jones were communicating less and less, and by the next year the band had splintered, with Jones forming Big Audio Dynamite. Strummer and Simonon enlisted new members to tour and record but the final Clash album, *Cut the Crap,* was poorly received. The band officially announced its demise in November 1985

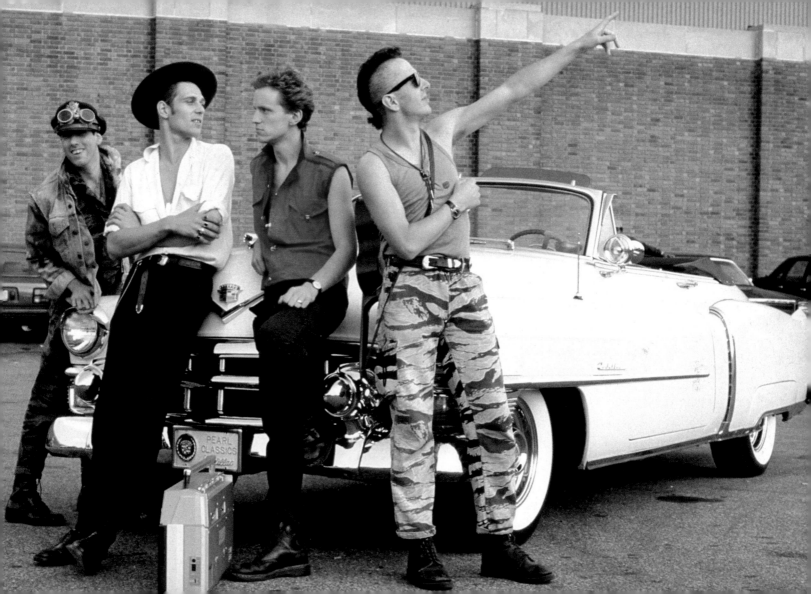

The Birthday Party, 1983 photograph by David Arnoff

The dark, noisy, aggressive Birthday Party formed in Melbourne, Australia, and the cacophonous lot made up for lost time once they got to America. Here, multi-instrumentalist Mick Harvey, guitarist Rowland S. Howard, vocalist / songwriter Nick Cave, and bassist Tracey Pew (from left) hang out at the Tropicana in L.A. "I have a certain way with words when it comes to violence," Nick Cave once admitted. "I just enjoy ruminating over the details."

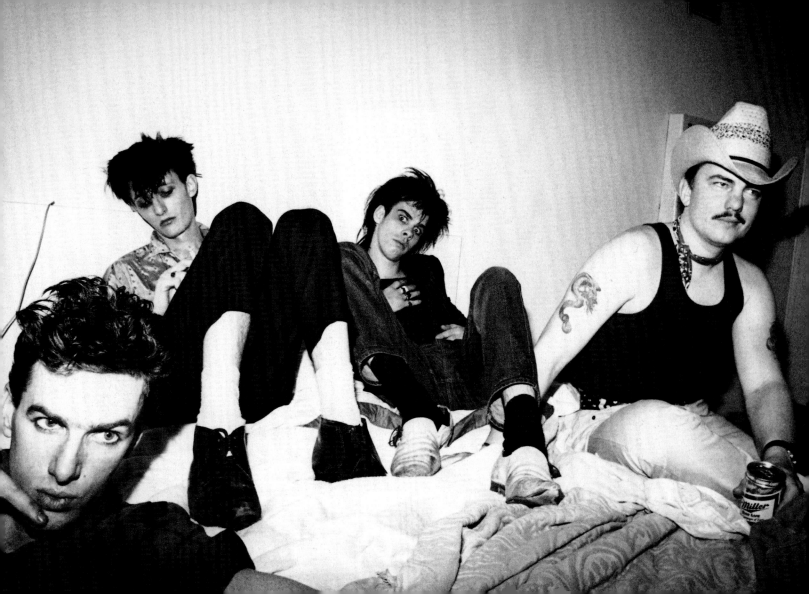

Nick Cave, 1984 photograph by David Arnoff

"What makes E. N. [Einstürzende Neubauten, whose guitarist/founder Blixa Bargeld would soon play with Cave in the Bad Seeds] great in my eyes is the same thing that makes Johnny Cash or the Velvet Underground, John Lee Hooker, Suicide, Elvis, Dylan, Lead Belly, the Stooges great. They are all innovators and what sets Hank Williams apart from the bulk of his contemporaries is the same thing that sets E. N. apart for the huge, faceless morass that modern New Wave music has become. Through their own hard work, by steadfast lack of compromise, through the pain of true self-expression, through a genuine love of their medium, they have attained a sound which is first authentic, and which is utterly their own. But not for the sole purpose of being different. They are a group which has developed its own special language for one reason—to give voice to their souls."
—Nick Cave

289

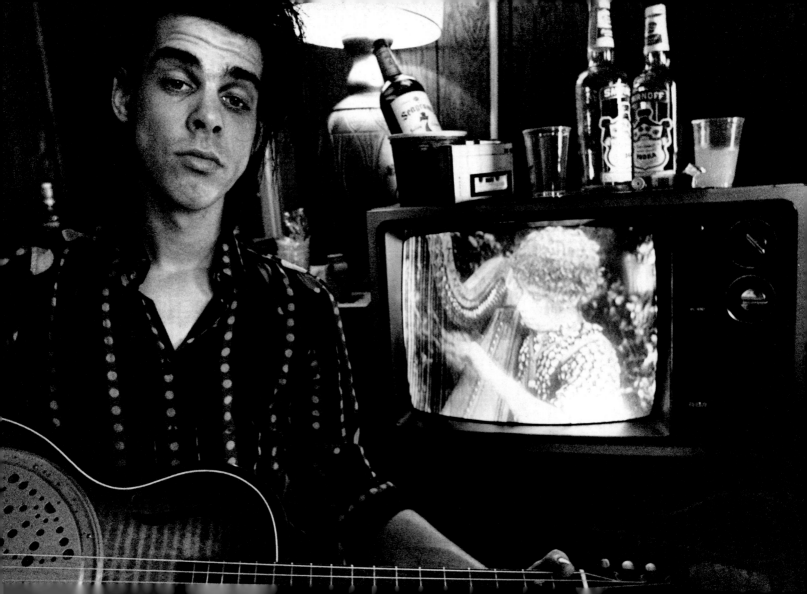

Henry Rollins and Lydia Lunch, 1983 photograph by David Arnoff

Before he totally transformed himself into the testosterone beast of Black Flag, Henry Rollins was still in touch with his inner girly-boy and spent time with Lydia Lunch working on spoken-word projects and costarring in the underground film *The Right Side of My Brain*, directed by Richard Kern. Lunch also collaborated with the Birthday Party.

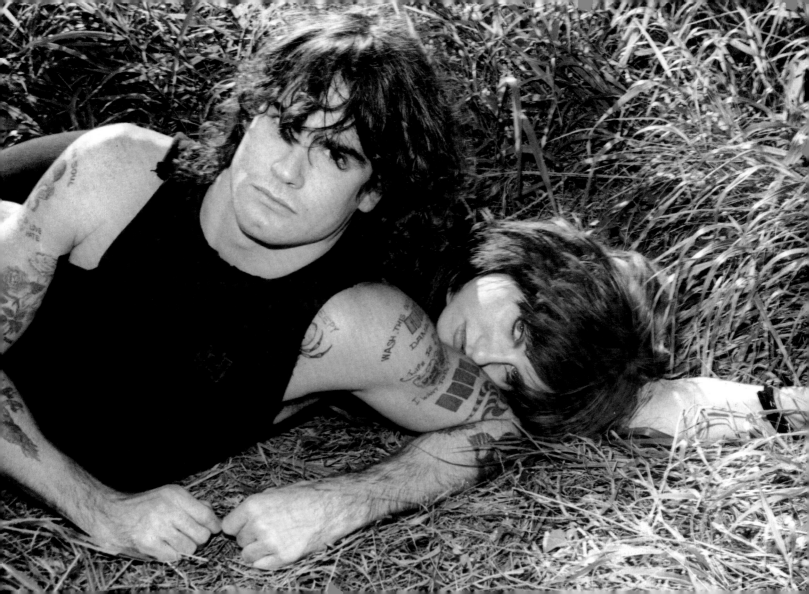

Pulsallama, 1982 photograph by Disk O'Dell

Pulsallama was an offshoot of the wacky Lower East Side Ladies' Auxiliary, a kind of depraved social club whose members hung out at the tiny Club 57 on St. Mark's Place in the East Village. The seven-piece vocal-and-percussion ensemble originally included fashion designer Katy K and Ann Magnuson, later a well-known actor and performance artist in L.A. The band made a splash with the single "The Devil Lives in My Husband's Body" and toured England with the Clash, inspiring the formation of UK group Bananarama. One UK tabloid quipped, "Pulsallama eats Bananarama for breakfast." Photographed in London: April Palmieri, Min Thometz, Wendy Wild, Kim Davis, Judy Monteleone, Stacey Joy Elkin, and Jean Caffeine (from left).

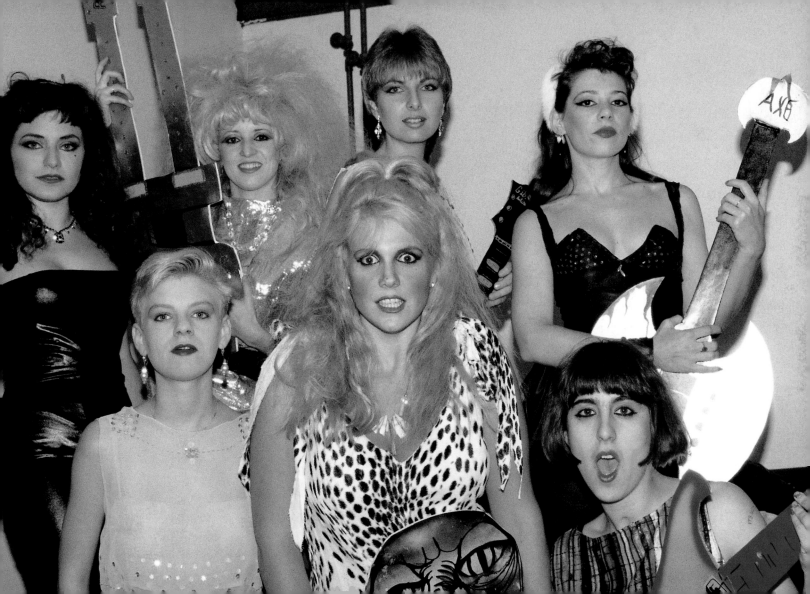

The Go-Go's, 1981 photograph by Robert Matheu

After the Go-Go's triumphal tour of
England and the success of their British
single, the group returned to L.A., where
Margot Olaverra was replaced with
Kathy Valentine. They signed a contract
with Miles Copeland's I.R.S. Records
and were teamed with producer Richard
Gottehrer, who produced Blondie's first
album. The result, 1981's *Beauty and the
Beat,* went double platinum, making the
Go-Go's the first all-gal band in history to
hit number one (where their album stayed
for six weeks). When he photographed
Charlotte Caffey, Jane Wiedlin, Belinda
Carlisle, Gina Schock, and Kathy Valentine
on July 15, 1981, Robert Matheu recalls,
the gals could not believe superstardom
was within their reach.

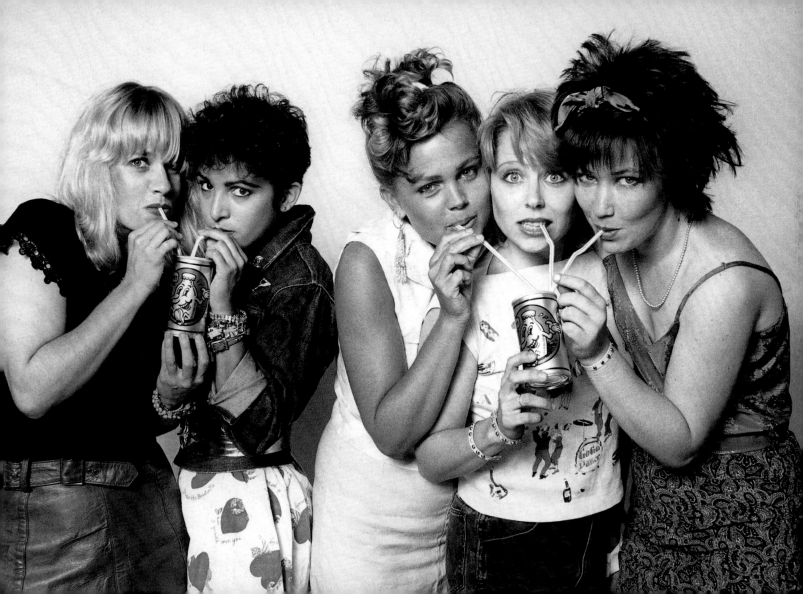

Kathy Valentine and Jane Wiedlin of the Go-Go's, 1982

photograph by Charlyn Zlotnik

Performing here at Madison Square Garden on January 22, 1982, the Go-Go's were the first all-woman band to headline New York's big-time concert venue. Eventually, the group's massive success would tear them apart. After the Go-Go's broke up in 1984, the members continued to pursue music projects. Since 1990, the band has sporadically reunited to tour and record.

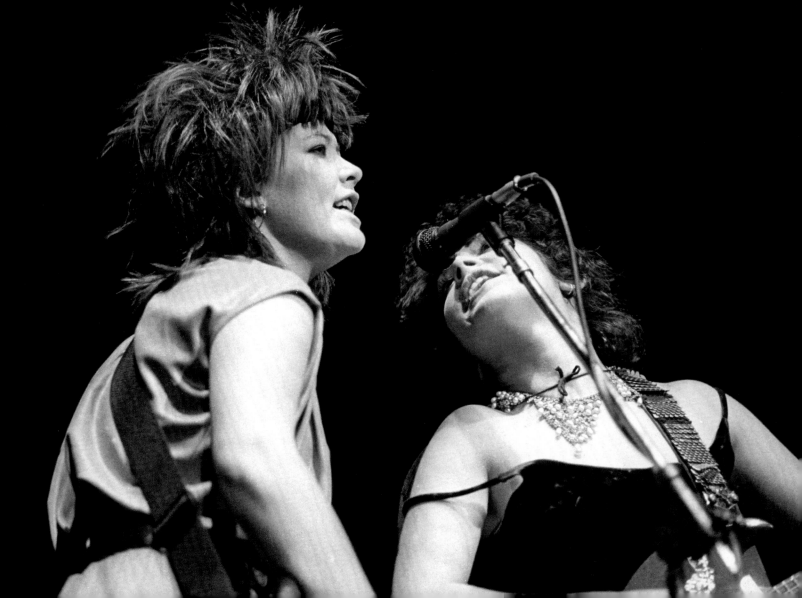

Steve Severin and Siouxsie Sioux, ca. 1984 photograph by Janette Beckman

"I took this photo on the Bowery in New York," Janette Beckman recalls of her session with Siouxsie and the Banshees founders Steve Severin (guitarist) and Siouxsie Sioux (vocalist). "They were doing an in-store at Tower Records around the corner on Broadway, and the lines were the longest I had ever seen. All the best New York goths had turned out for the occasion in all their finery. Siouxsie was definitely their punky queen."

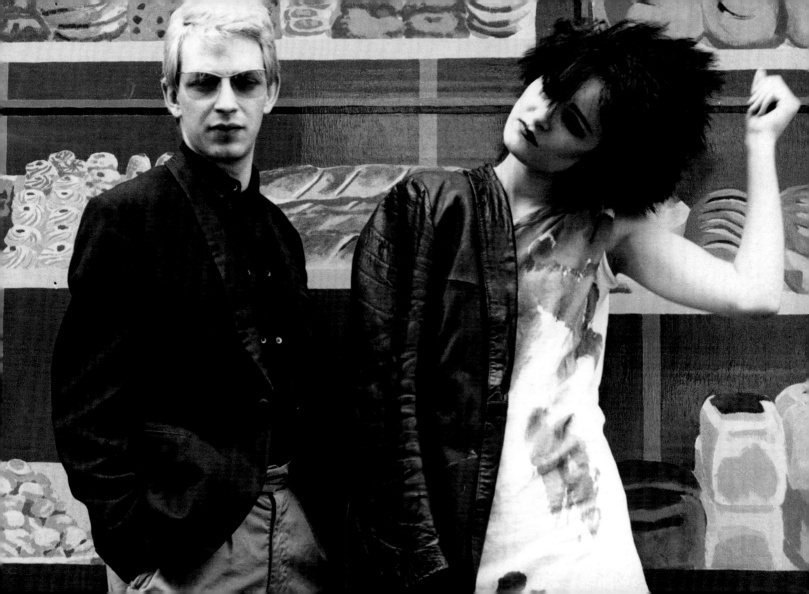

John Sex, 1984 photograph by April Palmieri

A little bit Brian Setzer, a little bit Liberace, John Sex was a postpunk überperformer who became a favorite at Club 57 on St. Mark's Place. Backed by the Bodacious Ta-Ta's, Sex did campy send-ups of characters ranging from James Bond to a New Romantic to a disco king. With the stated goal of "seducing the world," Sex toured America and Asia, and sometimes performed with his snake, Delilah. Here he struts his stuff at New York's Pyramid Club on Avenue A.

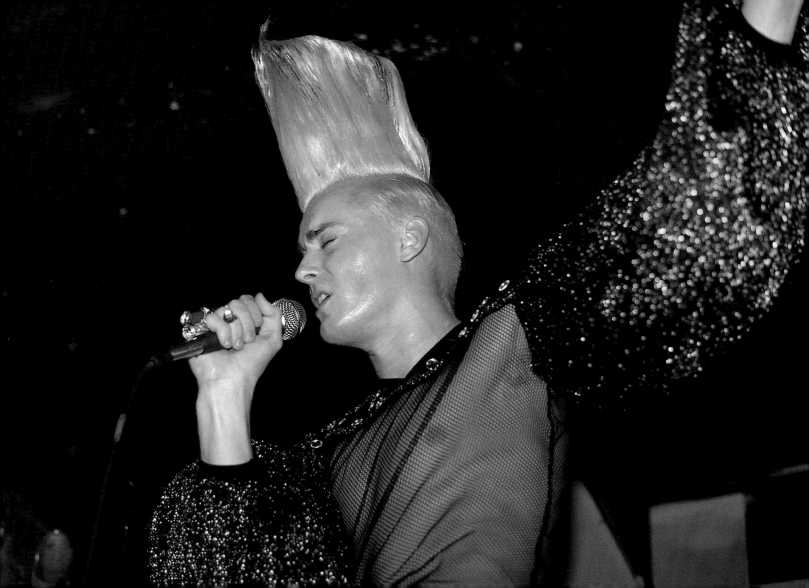

Dave Edmunds, 1982 photograph by Charlyn Zlotnik

Longtime producer and journeyman rocker Dave Edmunds (right) began performing in the '60s in such bands as Love Sculpture. In 1971 he scored a hit with "I Hear You Knockin'," then cast his lot with Rockpile, a pub-rock "supergroup" that included Nick Lowe. As a solo artist, he had minor hits with Elvis Costello's "Girls Talk" and Graham Parker's "Crawling from the Wreckage." In 1987, the Welshman produced k.d. lang's major-label debut, *Angel with a Lariat.* Here Edmunds performs with his band at the Capitol Theatre in Passaic, New Jersey, on May 15, 1982.

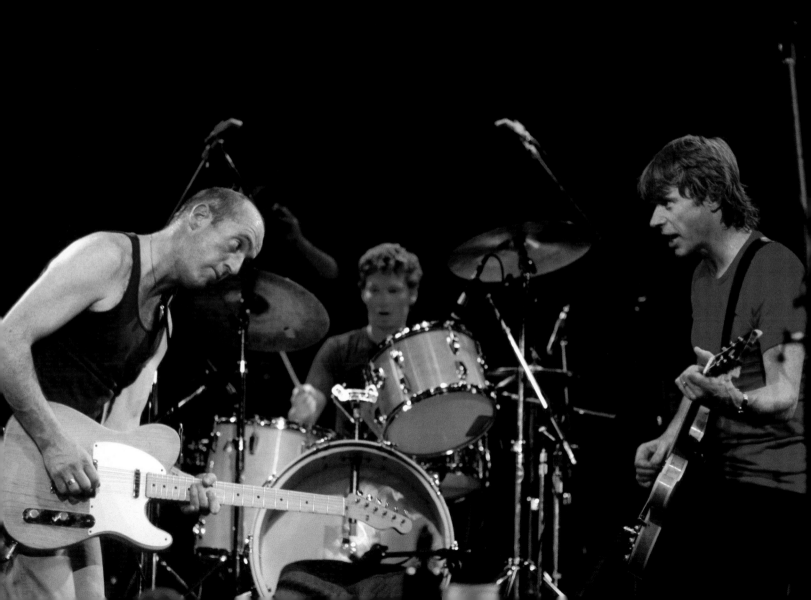

Joe Jackson, 1981 photograph by Gary Green

The pale piano prodigy Joe Jackson got lumped in with the punk movement, as his angry demeanor and eclectic style made him no Billy Joel. His Top Twenty hit "Is She Really Going Out with Him?" was a punky paean to a wretched romance. Gary Green photographed Jackson several times for the artist's album portraits and publicity pictures. On this occasion, the two had stopped into the P&G Pub on New York's Upper West Side after a session. "I remember the Ronald and Nancy Reagan photograph in the background being of importance at the time in providing a point of irony to how we both felt about the political landscape then," says Green. "I have a great deal of respect for Joe Jackson and how he's pursued the music that's interested him regardless of fashion or trends."

Sonic Youth, 1985 photograph by David Arnoff

Named after Fred Sonic Smith's Sonic Rendezvous Band, noisy combo Sonic Youth was formed in New York by guitarist/vocalist Thurston Moore, guitarist Lee Ranaldo, and bassist/vocalist Kim Gordon in 1981 (the lineup solidified when drummer Steve Shelley joined in 1985). Originally part of the post–No Wave aesthetic, the band became a kind of role model for future grunge architects like Kurt Cobain, who appreciated feedback and pop hooks. Here, Moore and Gordon, who later married, deliver their confrontational sound at Club Lingerie in Hollywood on August 22, 1985. Inspired by their West Coast sojourn, the band went on to record "Death Valley 69."

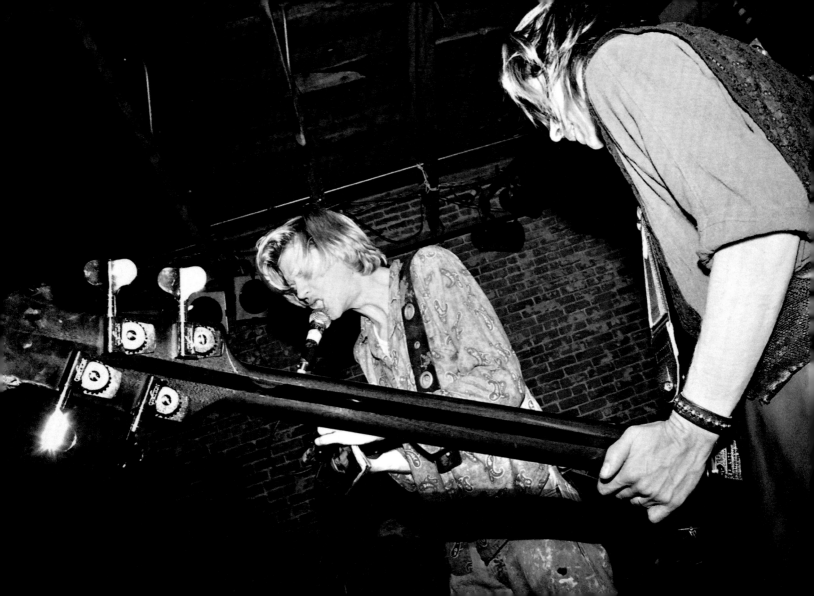

Sonic Youth, 1986 photograph by Ebet Roberts

Kim Gordon, as bassist and provocateur of Sonic Youth, became another highly influential figure on the postpunk scene. A kind of spiritual godmother to the riot grrrl scene of the 1990s, Gordon collaborated on side projects like Ciccone Youth and produced the first album by Courtney Love's band Hole. Here she rocks CBGB with Lee Ranaldo on June 13, 1986. Sonic Youth has continued to record and tour into the twenty-first century.

The dBs, 1981 photograph by Stephanie Chernikowski

North Carolinians the dBs formed in the late 1970s in New York, where singer / songwriter Chris Stamey had been playing bass with Alex Chilton. Stamey and the dBs' other masterful songwriter, Peter Holsapple—both Big Star adherents—composed wry, off-kilter pop nuggets that influenced an array of bands from R.E.M. to the Replacements but failed to bring them a wider audience. Here on the streets of New York are bassist Gene Holder, drummer Will Rigby, guitarist/vocalist Peter Holsapple, and guitarist/vocalist Chris Stamey (from left). The band reunited in 2006 and began performing and recording together again.

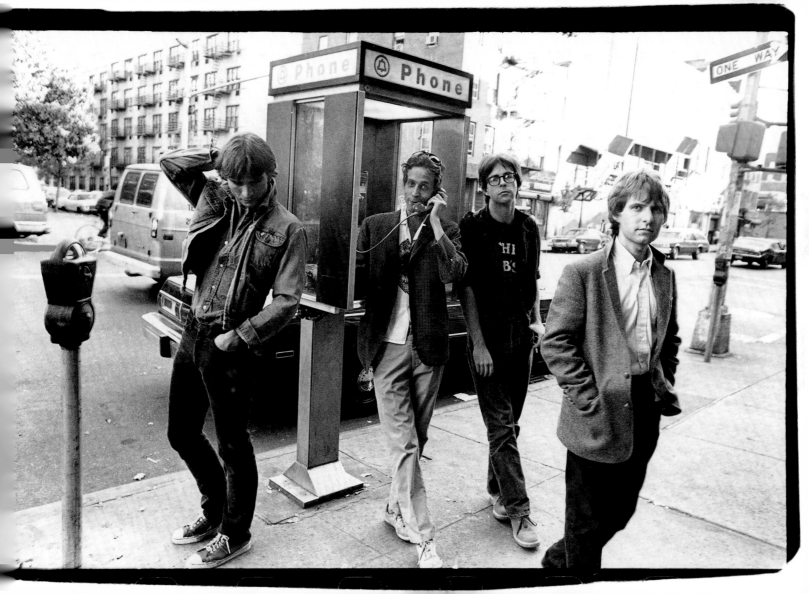

Crime and the City Solution, 1985 photograph by David Arnoff

Another outfit hailing from Melbourne, Australia, the group Crime and the City Solution was a sort of little brother band to the Birthday Party. After moving to England, singer/songwriter Simon Bonney enlisted former Magazine guitarist Mick Harvey, along with former Swell Maps drummer Epic Soundtracks. The Birthday Party's Rowland S. Howard and his brother Harry Howard rounded out the group. Here Bonney, Soundtracks, Harry Howard, Rowland S. Howard, and Mick Harvey (from left) loiter about on London's Portobello Road.

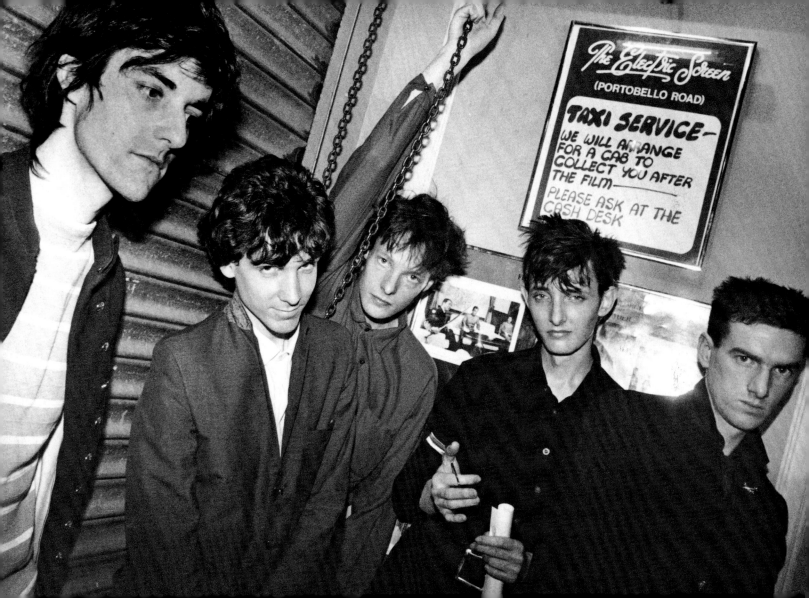

Jeffrey Lee Pierce, 1981 photograph by David Arnoff

A fan of both the blues and Blondie, Angeleno Jeffrey Lee Pierce worked behind the scenes as president of the Blondie Fan Club in the 1970s and penned articles for *Slash* magazine before forming the Creeping Ritual, with best buddy Kid Congo Powers, in 1980. Steeped in voodoo and overamped blues, the band transmogrified into the Gun Club, named by another Pierce pal, Keith Morris, then lead singer of Black Flag. A talented and tormented writer, Pierce was a riveting front man who always seemed on the verge of collapse as he wailed and moaned songs like "She's Like Heroin to Me" and "Sex Beat."

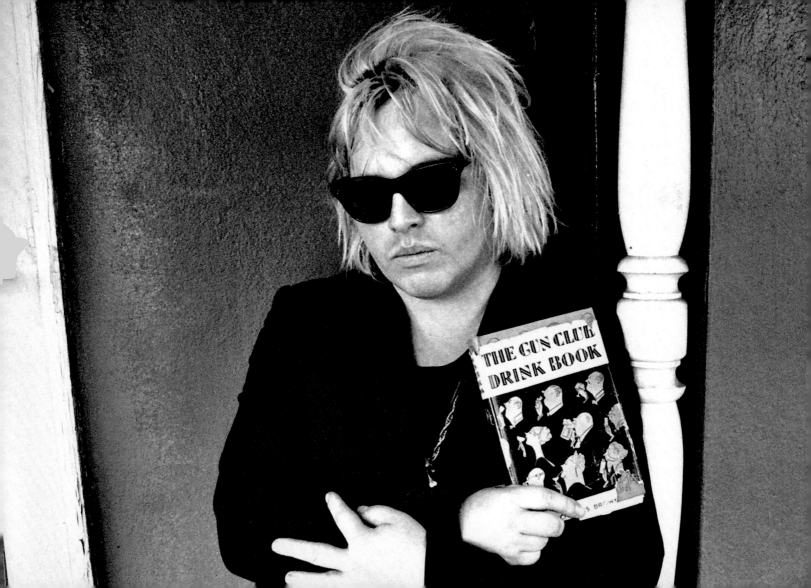

Stiv Bators, 1982 photograph by Bob Leafe

"One of the things about Stiv that people didn't realize was that he was just a nice boy from the Midwest who wanted to be Iggy Pop."

—Bebe Buell, one-time paramour

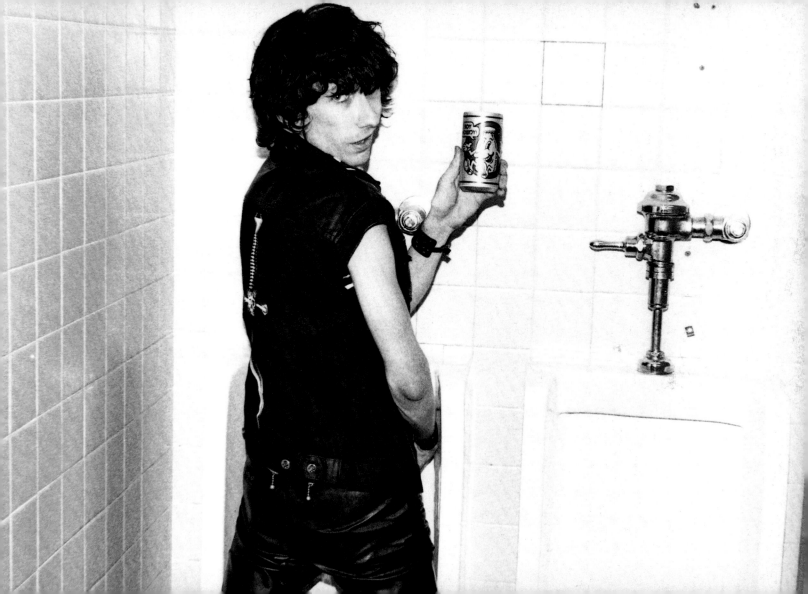

Gang of Four, 1983 photograph by Bob Leafe

Having lost two bass players, Gang of Four enlisted fellow Brit Sara Lee (center), who soon became yet another rhythmic role model, along with Tina Weymouth and Kim Gordon; it soon seemed a woman bass player was a requisite for 1980s bands. With their leftist lyrics and propulsive beats, Gang of Four had become critics' darlings;

Robert Christgau himself awarded the band's five releases between 1980 and 1982 with his hard-to-get A or A- ratings, writing, "By propelling punk's amateur ethos into uncharted musical territory, [Gang of Four] pull the kind of trick that's eluded avant-garde primitives since the dawn of romanticism . . . Don't let's boogie—let's flop like fish escaping a line

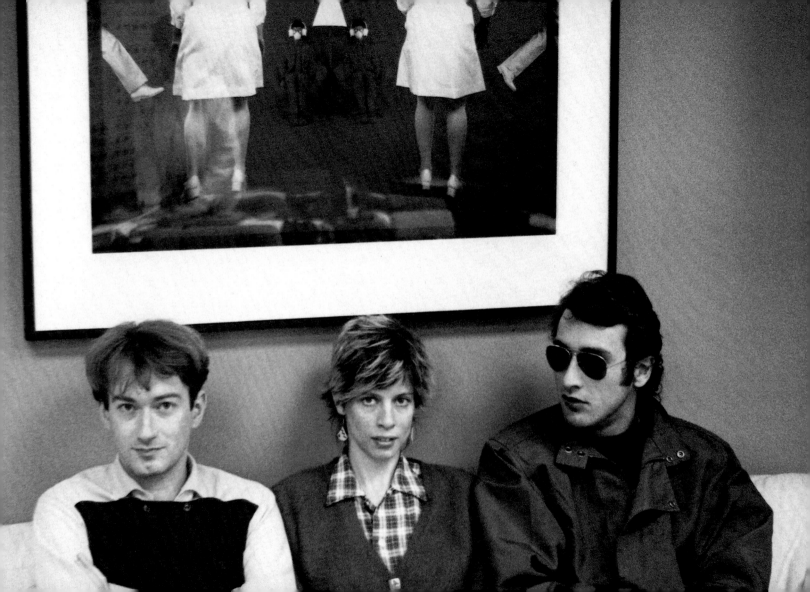

Echo and the Bunnymen, 1980 photograph by David Arnoff

Featuring Ian McCulloch as a compelling Jim-Morrison-meets-Lord-Byron front man and Will Sergeant with his swirling guitars, Echo and the Bunnymen—McCulloch, Sergeant, Les Pattinson, and Pete de Freitas (from left)—brought a Liverpudlian flavor to America in 1980. McCulloch's distinctive high-rise noir do and penchant for long dark trench coats ushered in a new fashion trend. Plus, the Bunnymen had attitude galore: "I think if we had come out in 1990 we could have been a lot bigger," McCulloch remarked in 1996. "Instead we were fighting the whole decade [the '80s]. You know, there was so much crap there. We did have a reputation for being awkward and particularly coming over here the first few times, just telling everybody they were idiots—but a lot of them were. We did try and kind of do things differently and not be like all of them other people that wanted to be stadium bands. So, I think our timing didn't help. The positive side of it is that we were burning light[s] . . . Beacons. For me there are two meanings. That we have shone so very very brightly and that we continue to emit."

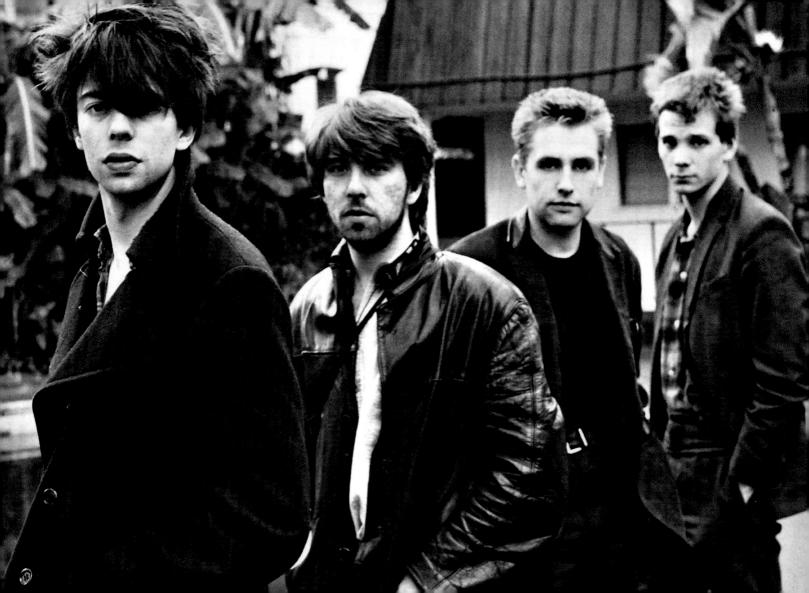

Teardrop Explodes, 1981 photograph by Ebet Roberts

Led by the surreally poetic Welshman Julian Cope (center), the Teardrop Explodes, in their music, philosophies, and drugs of choice, predated the '90s rave culture. With a sort of psychedelic swoon-pop sound and flying-saucer-believer-type lyrics, Cope gradually went more and more out on a limb after the band's debut *Kilimanjaro*. He left the Liverpool-based group in the midst of recording their third album and began pursuing his own circuitous path. Cope did have some solo success with a more traditional pop-style song "World Shut Your Mouth" in 1987, and was last known to be writing a treatise on Neolithic archeology and playing in a "glambient" combo in rural England.

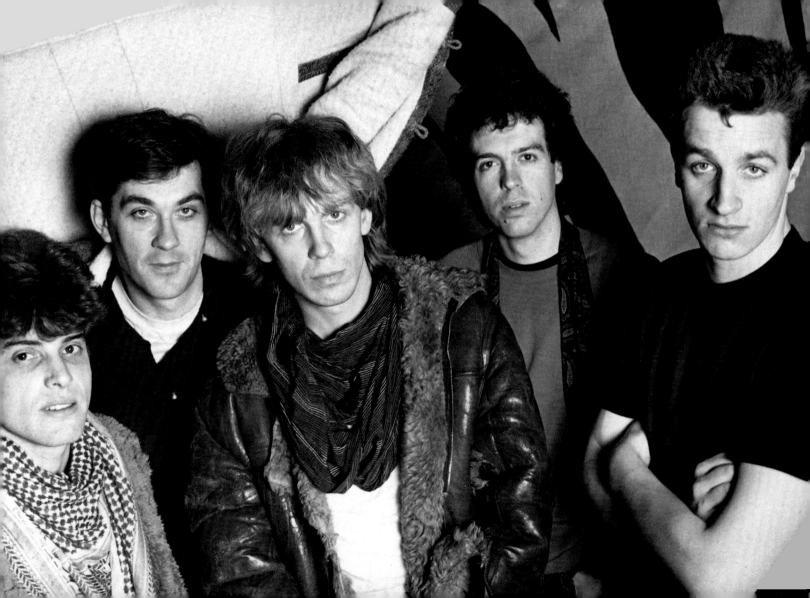

The Pogues, 1984 photograph by Bob Gruen

It was hard to believe a street punk like Shane MacGowan could put together an eight-piece ensemble like the Pogues. And eventually the band did kick him out for his bad behavior. But while it lasted, between MacGowan's brilliant songwriting and his undeniable charisma as a front man, the Pogues were awe-inspiring in all their decadent glory. Originally formed in October 1982 as Pogue Mahone, the Pogues included James Fearnley (who had been in the Nips with MacGowan), Cait O'Riordan (who would later marry and divorce Elvis Costello), Jem Finer, and Andrew Ranken. Additional members joined over the years, including Joe Strummer, who produced the band's 1990 album, *Hell's Ditch,* and replaced MacGowan on lead vocals from 1991 to 1992. MacGowan eventually reunited with the Pogues.

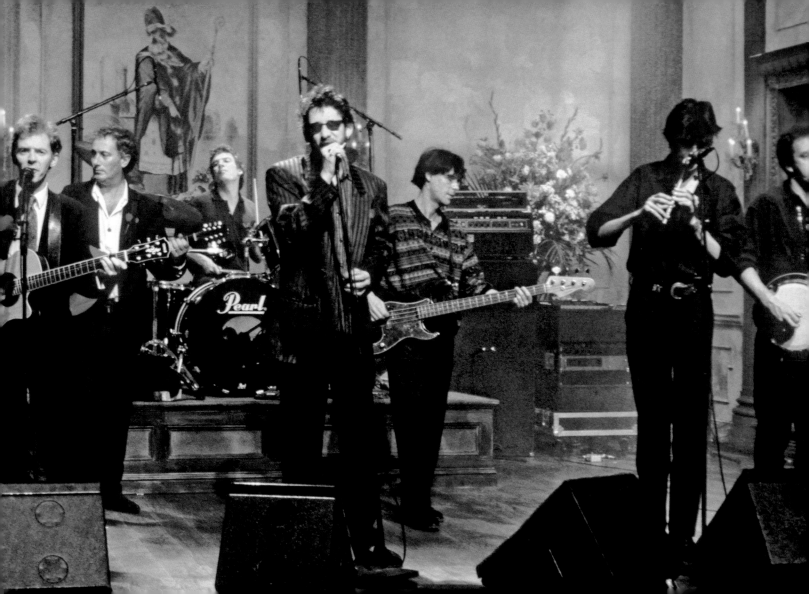

The Jesus & Mary Chain, 1985 photograph by Tony Mottram

With a barrage of feedback, dark and muffled vocals, and an illusive mystique, the Jesus & Mary Chain exhibited influences ranging from the Velvet Underground to Joy Division to the Ramones. A pair of Glaswegian brothers on guitars and vocals—William and Jim Reid (front and right)—formed the band in 1984, and have since employed a revolving door of rhythm sections, including such drummers as future Primal Scream front man Bobby Gillespie. Early on, the band relocated to London, but they frequently toured the States. Robert Christgau said of the band's debut album *Psychocandy,* "When the feedback wells up over the chords in perfect pseudomelodic formation, I feel as if I've been waiting to hear this music all my life.

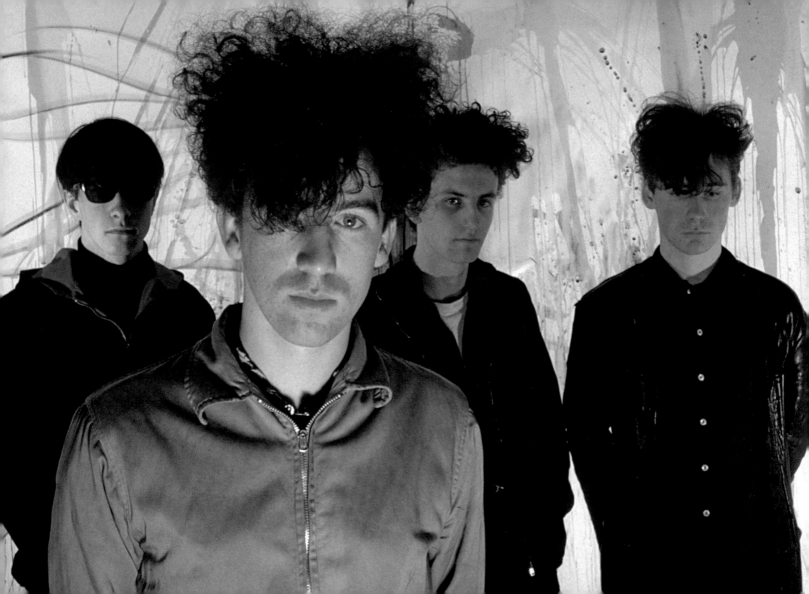

The Smiths, 1986 photograph by Stephen Wright

Formed in 1982 by New York Dolls fan Morrissey and guitarist extraordinaire Johnny Marr, the Smiths originated in Manchester. The vocalist and guitarist, both veterans of local bands with names like the Nosebleeds and Sister Ray, met at a Patti Smith concert during the PSG's last tour of 1979. With Mike Joyce on drums and Andy Rourke on bass, the Smiths quickly found a following. The *NME* wrote of one of their early gigs, "Their sound—a fine, fierce combination of tight drums, hidden walls of guitar and deepest of bass lines—proved to be a suitably refined, aggressive setting for the searing wail and majestic poetry of their enigmatic vocalist." In the late '80s, Morrissey became a solo artist, and on June 18, 2004, he reunited the New York Dolls by asking the three surviving members to play an arts festival he curated in London. "Music is a calling," Morrissey once said. "I don't exist anywhere else."

309

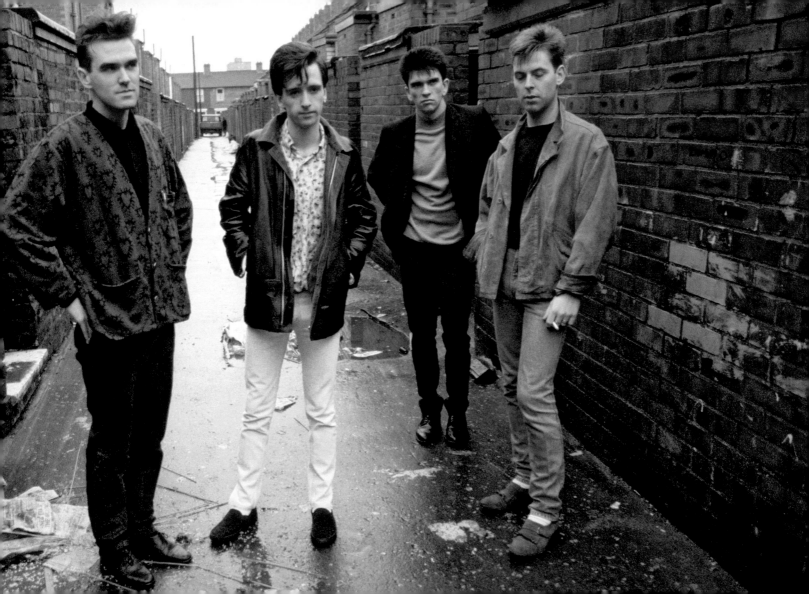

Lene Lovich, 1983 photograph by Ebet Roberts

With a remarkable multi-octave vocal range and a flair for dramatic stage presentations, Lene Lovich brought a theatrical approach to music. Born Lili Marlene Premilovich in Detroit, she worked in experimental theater and as a sculptor in London before getting signed to Stiff Records. Her songs "New Toy" and "Lucky Number" became popular in New York dance clubs like Hurrah. For this photo session, Ebet Roberts remembers, "She was wonderful—she knew exactly what to do to get great shots. I didn't have to direct her very much."

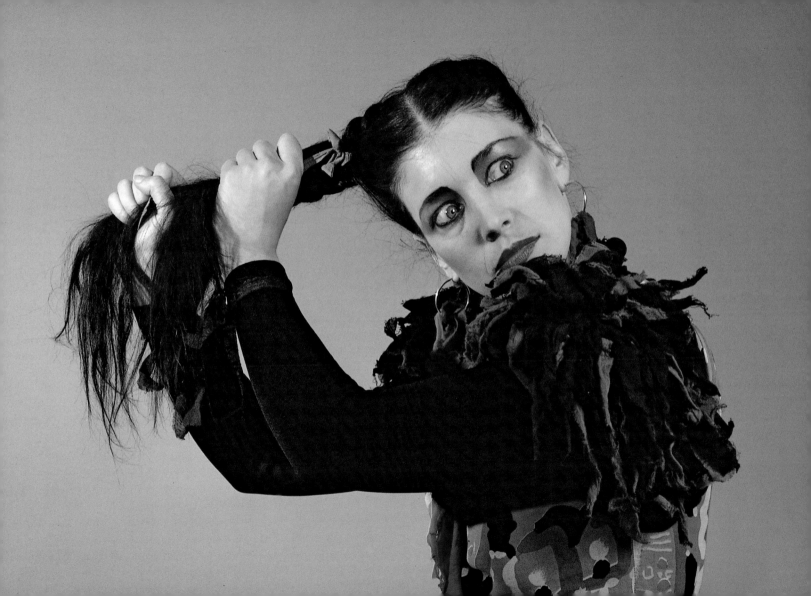

Nina Hagen, 1984 photograph by Mellon Tytell

Hailing from East Berlin, Nina Hagen appeared in outrageous getups, in which she'd sing in her operatic voice about UFOs. Her style has been described as the missing link between Yoko Ono and Diamanda Galás. Hagen's 1982 album *Nunsexmonkrock* featured David Letterman sidekick Paul Shaffer on keyboards, guitarist Chris Spedding, and the baby Red Hot Chili Peppers rapping on one track. In 1987, Hagen released an EP called *Punk Wedding,* inspired by her recent marriage to a teenage fan.

311

Girls' night out, 1981 photograph by Ebet Roberts

A bevy of eccentric gals happened to gather together one night at the Mudd Club, New York's trendy downtown nightspot, and photographer Ebet Roberts was there to capture it: German banshee Nina Hagen; arty chanteuse Lene Lovich; scenester Colette; Karla DeVito, Meat Loaf's touring duet partner on "Paradise by the Dashboard Light"; and vocalist of the Hurricane Jones Band Melinda Jones (from left).

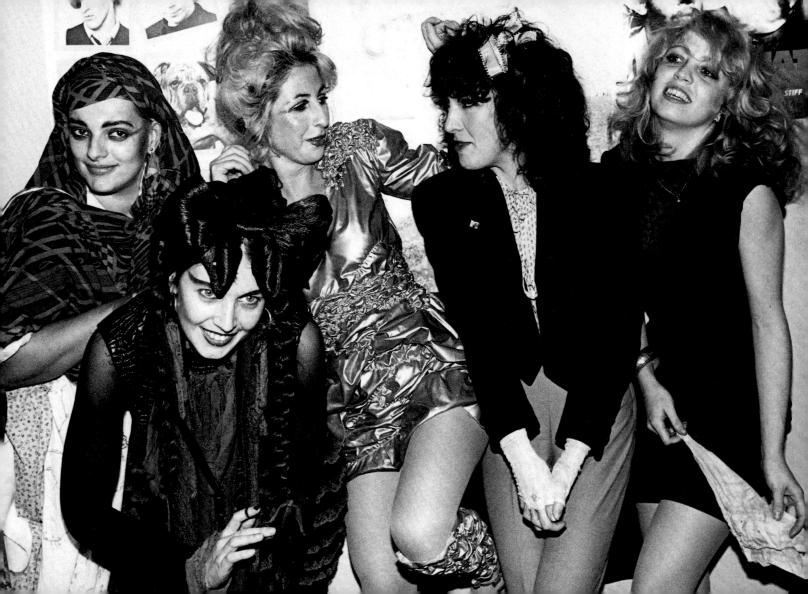

Adam Ant, 1984 photograph by Robert Matheu

Adam Ant first began performing his "ant music" in London, aided and abetted by Malcolm McLaren and guitarist Marco Pirroni. His pirate look briefly became the rage, but soon gave way to England's New Romantic style, which made some inroads in L.A. and New York. Adam and the Ants broke up in 1982, and Adam Ant carried on as a solo artist. In the 1990s, he acted in films and television shows and made occasional guest appearances onstage with Nine Inch Nails.

313

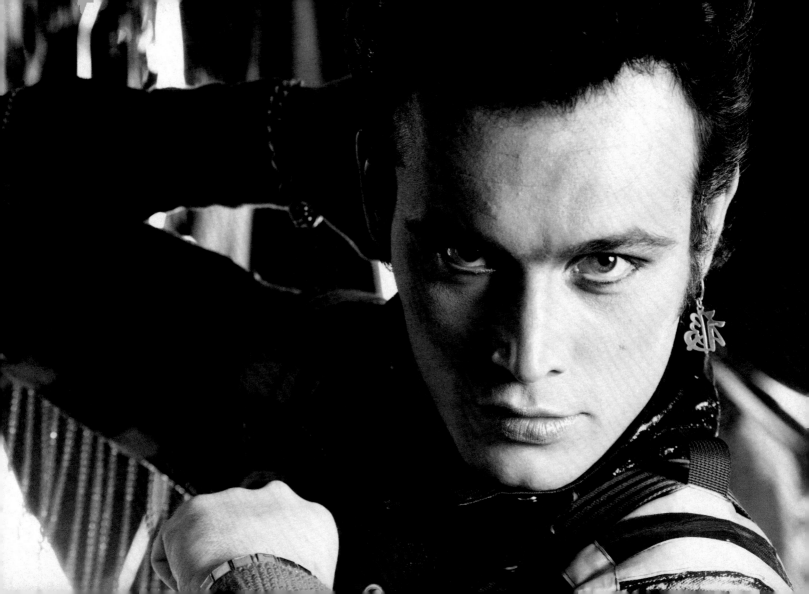

Bow Wow Wow, 1983 photograph by Bob Leafe

Another Malcolm McLaren discovery, thirteen-year-old Annabella Lwin was working at a cleaners, where she sang along with the radio, when she was chatted up by a redheaded stranger one day. "He asked if I'd like to go audition for a band," she later recalled. "At first I thought he was trying to pick me up but after he explained that I could bring a friend and it would be during the day, I decided to go. After the audition, I worked in the dry cleaners until the man who asked me to audition—Malcolm McLaren—got me fired. He said the band I'd been auditioned for—Bow Wow Wow—had been booked to go out on tour." With the fetching teen on lead vocals, Bow Wow Wow quickly scored a hit with a cover of "I Want Candy." Richard Gottehrer, producer for Blondie and the Go-Go's, had originally written and performed the song in the 1960s with his group the Strangeloves. Here Bow Wow Wow appear on the New York City TV show *We're Dancin'*.

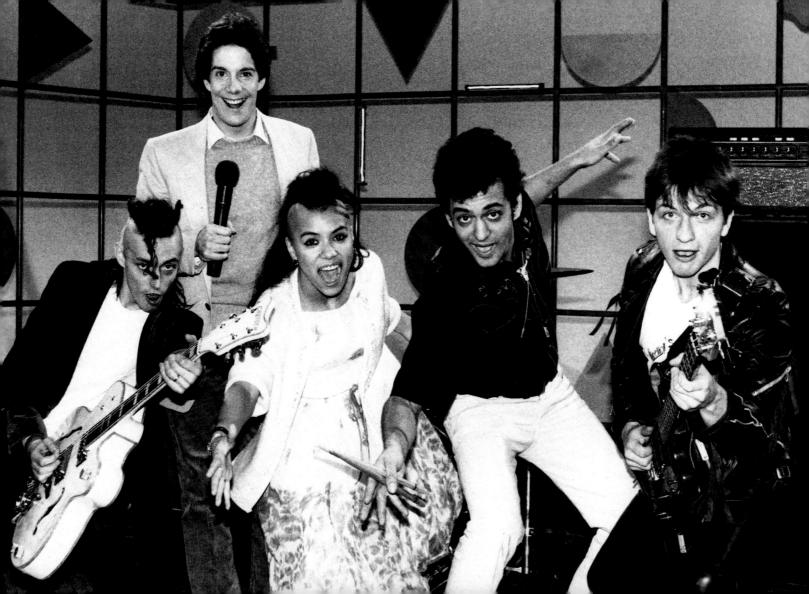

R.E.M., 1985 photograph by Stephanie Chernikowski

The college town of Athens, Georgia, the birthplace of the B-52's, also yielded R.E.M., who played their first gig in 1980. Drummer Bill Berry, vocalist Michael Stipe, guitarist Peter Buck, and bassist Mike Mills (from left) toured constantly up and down the East Coast and caught on in New York after playing the Mudd Club in 1981. Their popularity in college towns was partially due to an explosion of college radio stations that preferred to spin DIY discs, like R.E.M.'s first single, "Radio Free Europe."

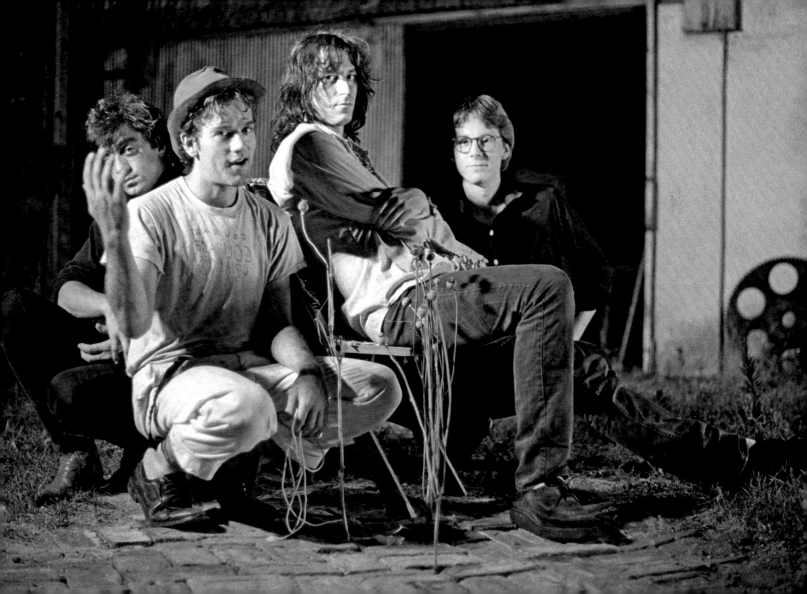

R.E.M.'s Michael Stipe, 1985 photograph by Stephanie Chernikowski

During the early days of R.E.M., charismatic front man Michael Stipe, with his long curly locks hanging in his eyes, would whirl and twirl while singing the songs' indecipherable lyrics. In 1982, Stipe told *Rolling Stone,* "We're not a party band from Athens. We don't play New Wave music, and musically, we don't have shit to do with the B-52's or any other band from this town. We just happen to live here." A major influence on Stipe, he later said, was Patti Smith: "[Her] *Horses* was really visceral. It grabbed me like nothing else I'd ever heard before."

316

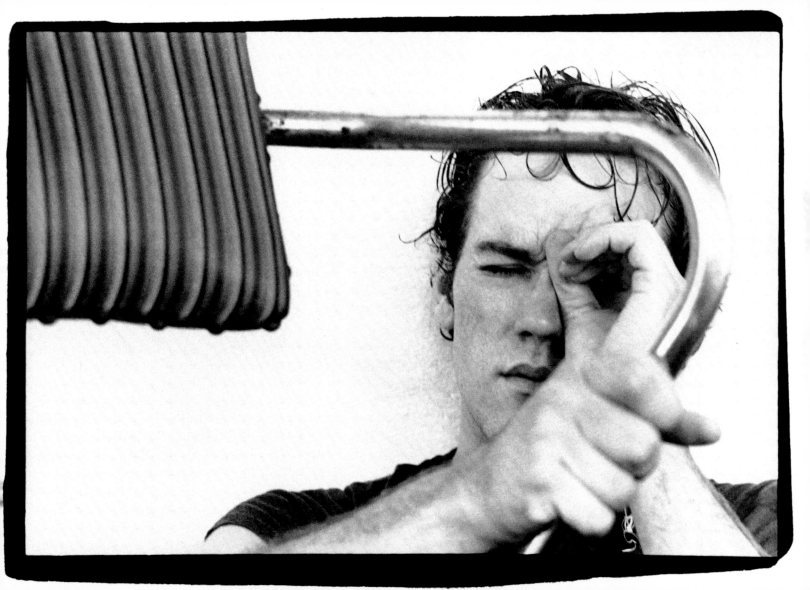

Pylon's Vanessa Ellison, 1980 photograph by Charlyn Zlotnik

The spare sonics and uninhibited vocals of Pylon—another band from Athens, Georgia—endeared them early on to scenesters in New York. Ellison would seem to lose herself onstage, channeling her songs like a possessed Bible-thumper on salvation day. The band frequently traveled to Manhattan for gigs, opening for Gang of Four and eventually headlining.

"When we started, we thought it was just going to last long enough to play around some," said Pylon's bassist Michael Lachowski. "But once we were playing clubs and making money, it was like 'Hell yeah!' And then when the first single came out and got publicity in New York, it was like 'Whoa!' Most of what happened to us was just offered and we just went along."

The Members at the Urgh! Festival, 1981 photograph by David Arnoff

As punk and New Wave started to make some inroads into the scene, labels like I.R.S. (operated by Miles Copeland) and booking agencies like Frontier Booking International (FBI; operated by his brother Ian Copeland) began to specialize in the "new music" coming from England, college towns, and punk clubs. R.E.M. signed to I.R.S. as were popular garage-rockers the Fleshtones. Miles Copeland promoted the Urgh! Festival at Santa Monica Auditorium, which presented numerous punk bands, including London, the Members.

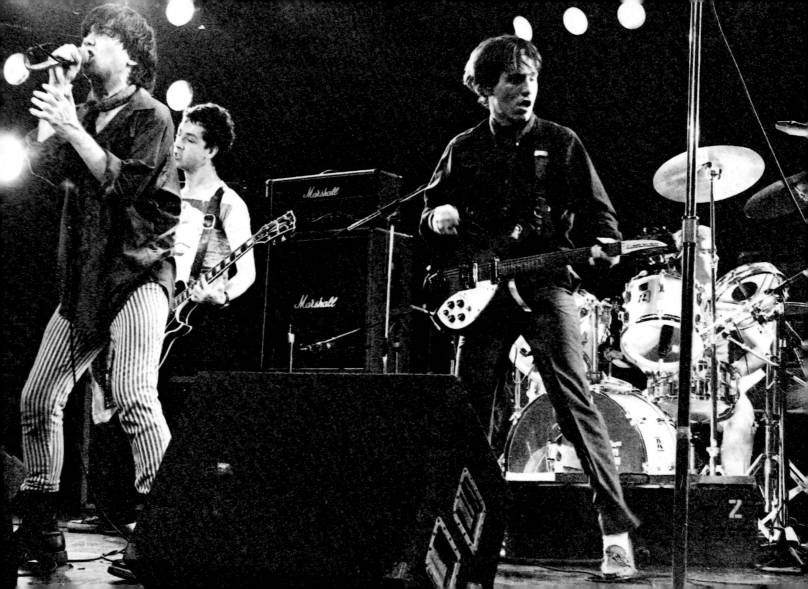

The Gun Club, 1981 photograph by David Arnoff

Though founding guitarist Kid Congo Powers moved from the Gun Club to the Cramps, Jeffrey Lee Pierce found Ward Dotson to take Powers' spot. With Terry Graham and Rob Ritter holding down the rhythm section, the band made the extraordinary *Fire of Love* for Slash Records. A two-month tour in the requisite van ensued, which did not sit well with Pierce. "Doing that tour was almost like volunteering for Vietnam," he later wrote. "I remember just driving through Texas thinking, I'm just too far gone … like going up the river in *Apocalypse Now* … and it had completely ruined my life. Completely ruined my senses, affections, and so forth. I'd become completely jaded and soulless, and meaningless."

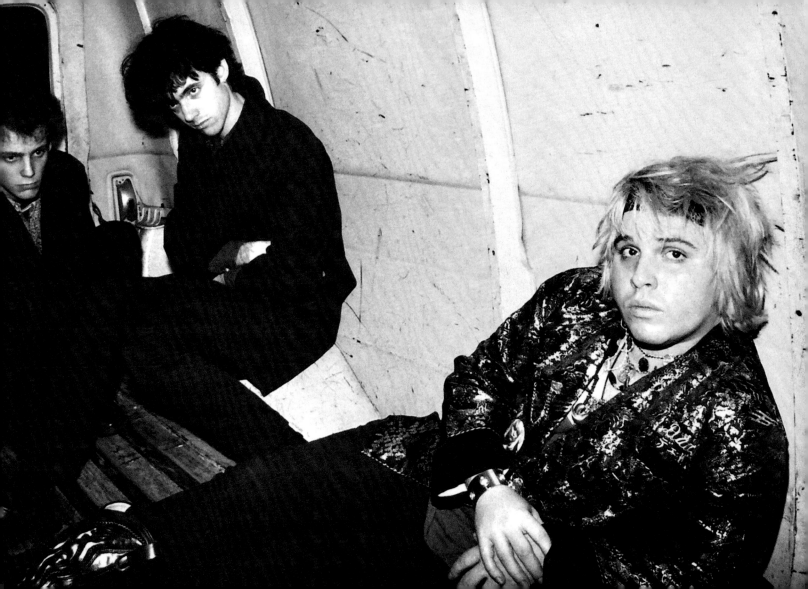

The Blasters, 1982 photograph by Ebet Roberts

Brothers Dave and Phil Alvin (from left) grew up in Downey, California, listening to obscure R&B and rockabilly 45s they found at mom-and-pop record stores. Fueled by the ferocity of the punk scene in late '70s L.A., they formed the Blasters to play the roots music they loved. Their dreams came true when they got to perform alongside some of their heroes, like sax man Lee Allen, and to back up th great Big Joe Turner. Here they play som of their "American music" at New York's Mudd Club.

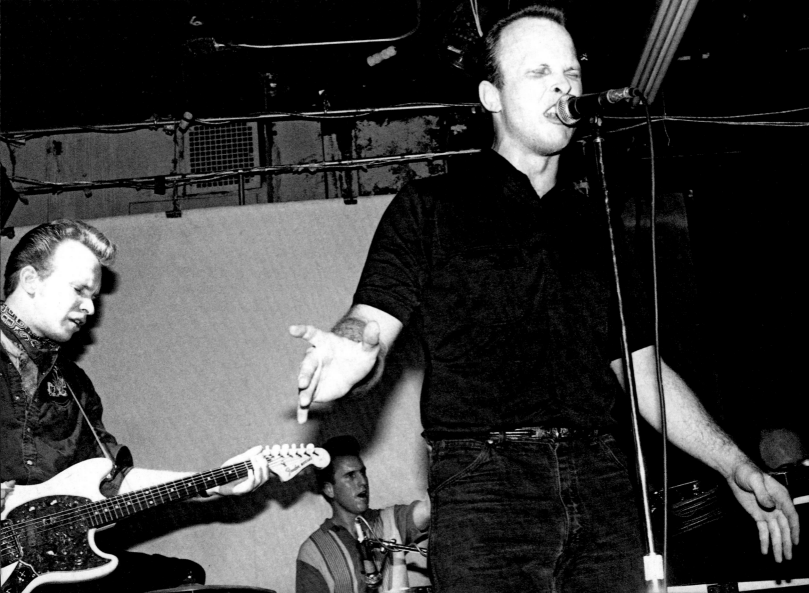

The Replacements, 1984 photograph by Stephanie Chernikowski

"Vocalist Paul Westerberg sings from the heart and he knows how to break it," Bruce Pavitt of Seattle's *The Rocket* wrote about the Minneapolis combo the Replacements. Beloved for their raucous, unpredictable shows, the Replacements toured America in the mid-1980s, wreaking havoc everywhere they went. Masterful songwriter/vocalist Paul Westerberg (left) found the perfect foil in whacked-out guitarist Bob Stinson (second from right) his brother Tommy Stinson (holding a beer)—who started playing bass for the band at age twelve—and drummer Chris Mars (right). They shoulda been contenders, but never had a hit. Their "I Will Dare," "Alex Chilton," and "Unsatisfied" belong in a time capsule as some of the best songs of the '80s.

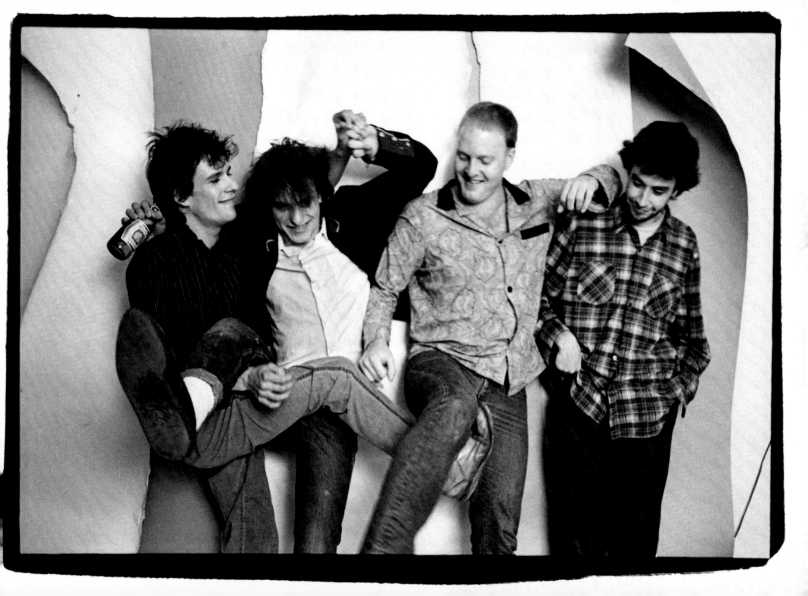

Red Hot Chili Peppers, 1985 photograph by Ebet Roberts

Young punks from the streets of Los Angeles who became famous for performing in nothing but tube socks, adorning an appendage not usually covered by a sock—the Red Hot Chili Peppers, circa 1985. They had squatted with punks in the late '70s, and by 1983 the group had formed, playing a kind of surf punk meets hip-hop meets funk. The band had just released its George Clinton–produced sophomore album, *Freaky Styley,* when Ebet Roberts photographed the rambunctious boys: drummer Jack Irons, bassist Flea (b. Michael Balzary), guitarist Hillel Slovak, and vocalist Anthony Kiedis (from left). Tragically, three years later, Slovak died, overdosing on heroin, which had also taken its toll on Kiedis. The vocalist managed to kick the drug and eventually wrote the Chili Peppers' breakthrough ballad, 1991's "Under the Bridge"—an emotive eulogy for Slovak. Irons, who quit the band, later played with Joe Strummer before joining Pearl Jam.

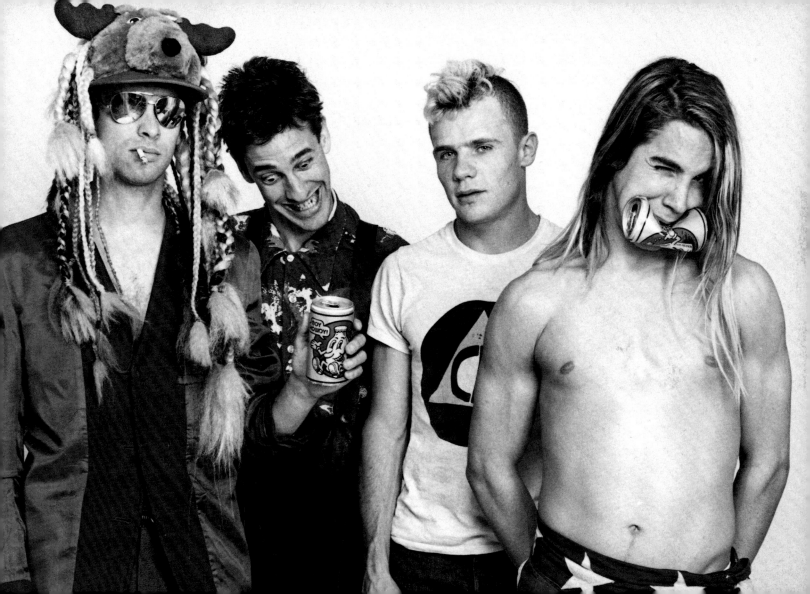

The Cure, 1985 photograph by Ebet Roberts

A lot of hairspray, kohl eyeliner, and lip rouge transformed mild-mannered Robert Smith (center) into a goth cover boy.

And once the band took on the majestic moping of the goth sound they became megastars in the States.

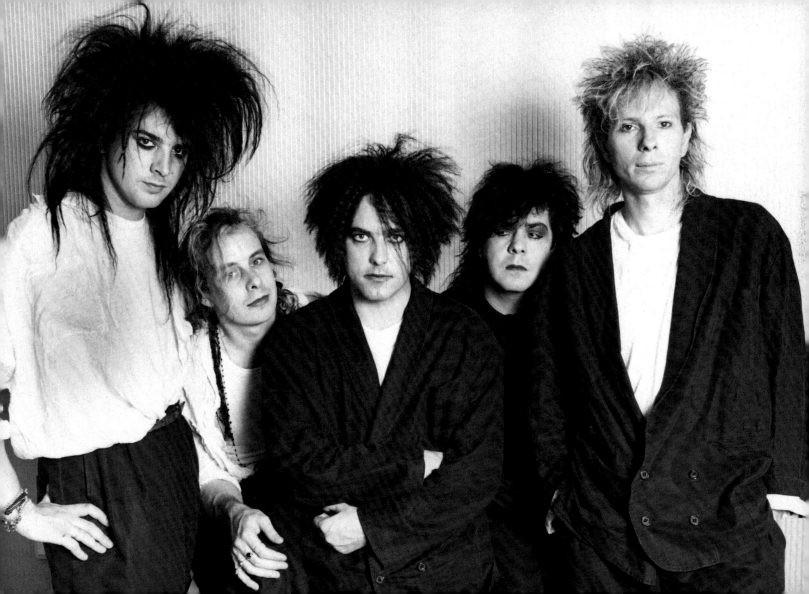

Jeffrey Lee Pierce and Texacala Jones, 1982

photograph by Ebet Roberts

The king and queen of doomy blues, Jeffrey Lee Pierce and his girlfriend Texacala Jones formed Tex and the Horseheads for some riveting performances—both on- and offstage. But, alas, once the relationship ended so did Tex and the Horseheads. The Gun Club eventually imploded, and the haunted, hard-living Pierce recorded some solo albums, wandered the Far East, and eventually settled in London. Tragically, he suffered a stroke in 1996 and died a week later. He was thirty-six.

324

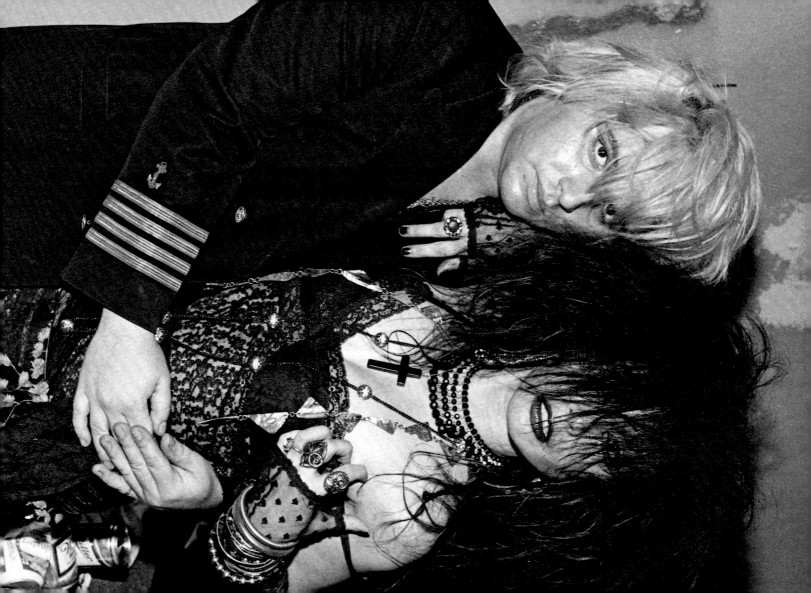

Siouxsie Sioux, 1980 photograph by David Arnoff

The high priestess of goth gets her ebony locks in shape at L.A.'s Tropicana.

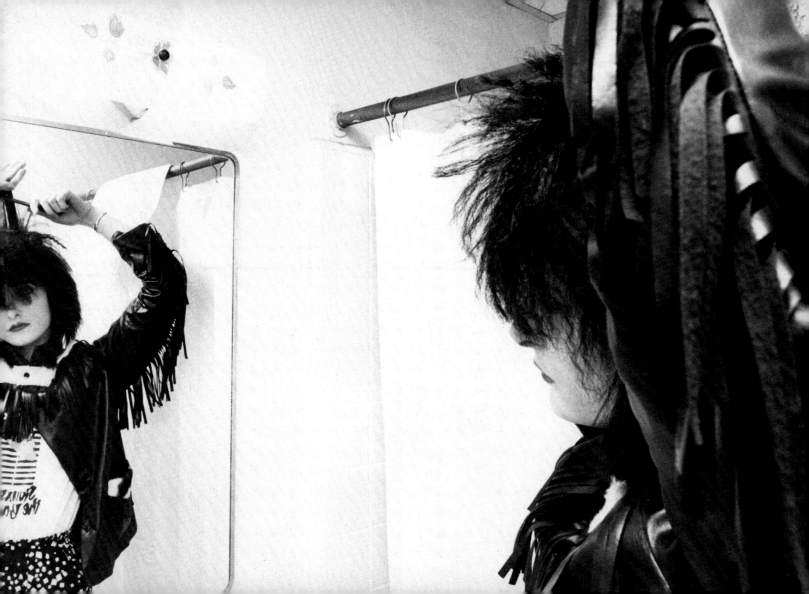

Untold Tales, 1986 photograph by Charlyn Zlotnik

You, too, can look like a punk rocker, thanks to a plethora of East Village hair salons, n[o]
to mention Manic Panic's cavalcade of colorful hair dye right down the street.

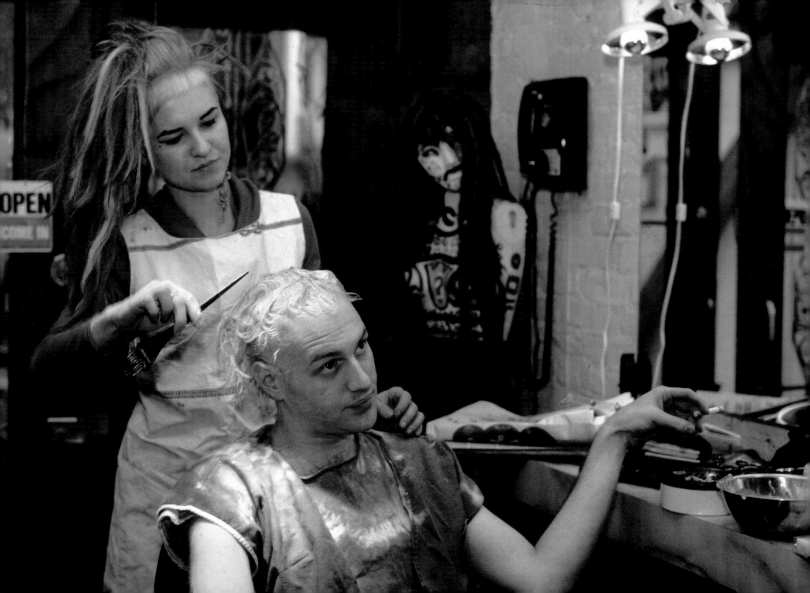

Wendy Wild, 1985 photograph by April Palmieri

Once gracing the cover of *High Times* magazine, which dubbed her "Mushroom Queen," Wendy Wild always said she wanted to be the white Tina Turner. She could belt out songs and she could dance on bars, which she did for nearly two decades in a number of East Village bands, beginning with Pulsallama and ending with Das Furlines, a wacky all-gal punk-rock polka band. Her verve, style, and aplomb took her around the world—until an eight-year bout with brea cancer eventually took her out of it. April Palmieri took this photo of her former Pulsallama band mate backstage at a Ka K fashion show, in which the two modele

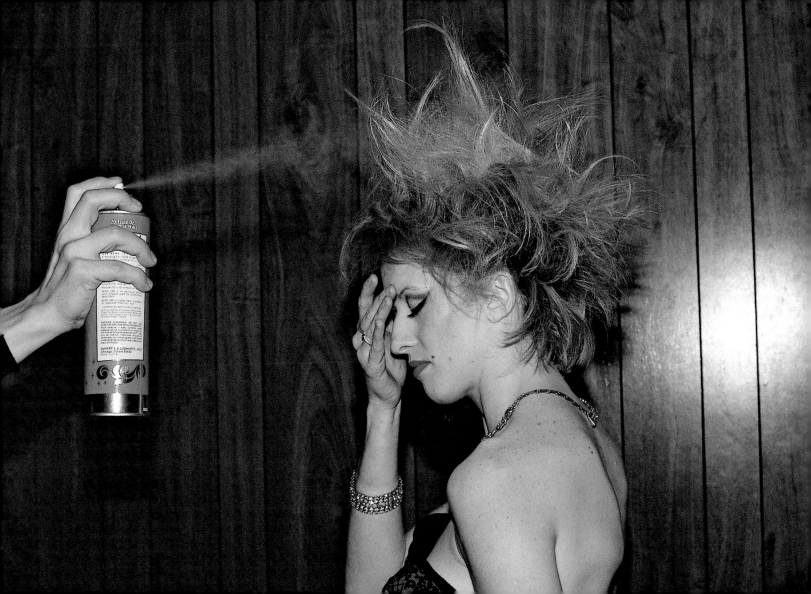

Chrissie Hynde, 1984 photograph by Robert Matheu

Chrissie Hynde's signature makeup style, which she claimed hadn't changed since she was fourteen years old, probably sold more kohl eyeliner than had been purchased since the heyday of the Ronettes.

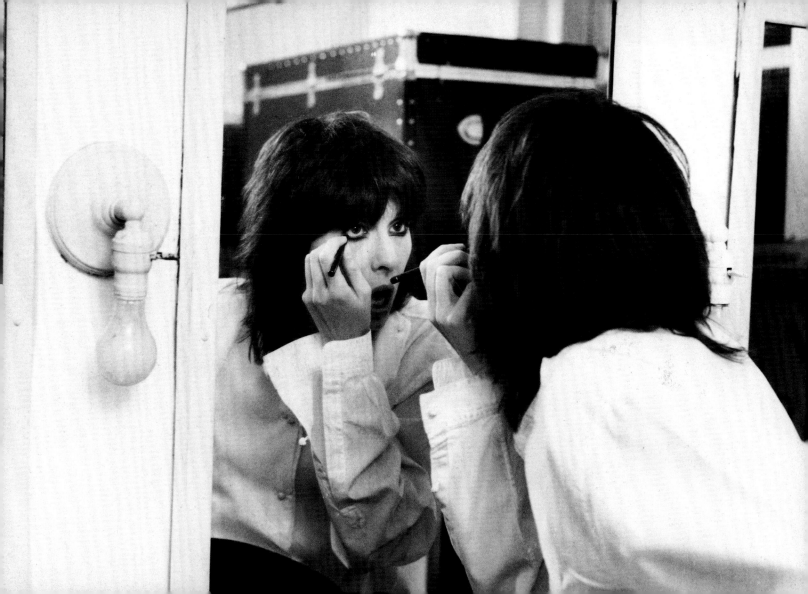

The Bangles, 1984 photograph by Raeanne Rubenstein

In the early 1980s, the garage-band style, with a tinge of psychedelia, took over among many L.A. bands. Dubbed the Paisley Underground, the little scene of like-minded souls included such groups as the Velvet Underground–influenced Dream Syndicate; the Rain Parade; Green on Red; and the only all-woman outfit of its kind, the Bangs. With their name expanded to the Bangles, the band specialized in harmony singing by members Michael Steele (original bassist of the Runaways), guitarist Vicki Peterson, guitarist Susanna Hoffs, and drummer Debbi Peterson (from left). In the mid-'80s, the Bangles scored massive hits, including "Walk Like an Egyptian" and "Manic Monday." "It was irritating in the early days that people, the world, some journalists, whatever, viewed us as a novelty because we were four women playing music together," Susanna Hoffs later related. "We always thought it was kinda funny that we were always compared to the Go-Go's. Even though we loved the Go-Go's it was just that the comparison was to another all-girl band. They all think, like, 'they play pretty good for chicks.' We got a lot of that in the early days. But we always thought of ourselves as a garage band, so we were determined to just do our thing and nothing was going to stop us."

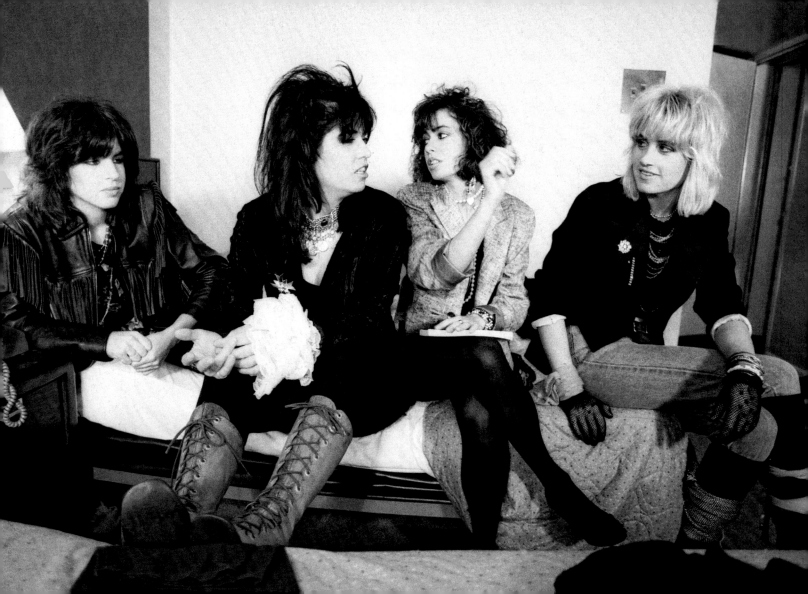

Cyndi Lauper, 1984 photograph by Raeanne Rubenstein

"I always wanted to make world music, to say something that's worth saying and really touch humanity. That's why I'm here. There's a wonderful place that you go when you sing, there's a really good feeling. And it's wonderful to reach out and touch someone with it, because they touch you back. And sometimes that's worth the price of beans."
—Cyndi Lauper

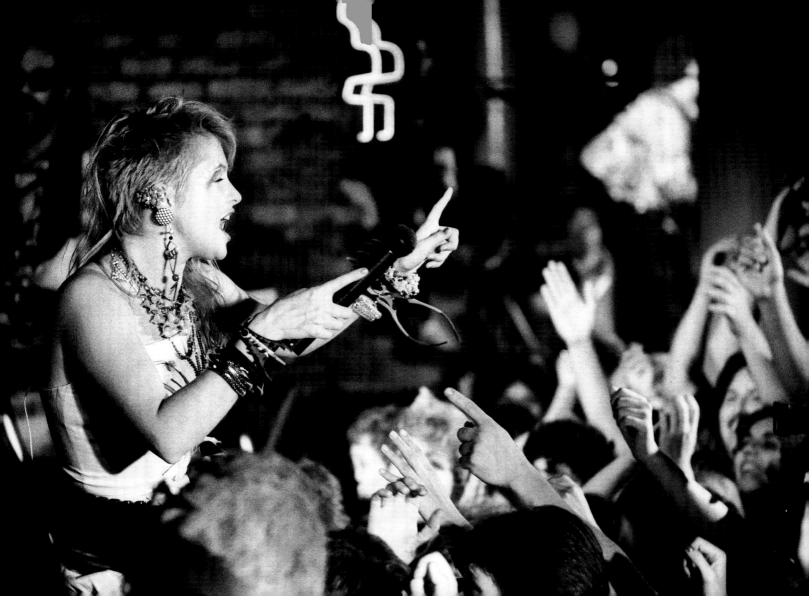

Madonna, 1985 photograph by Ebet Roberts

When dance-music diva Madonna originally moved to New York from Bay City, Michigan, she first threw in her lot with the downtown postpunk scene. She crashed near Port Authority Bus Terminal at the skanky "Music Building," a multistory establishment filled with low-rent rehearsal studios for struggling bands of all stripes. Eventually, Mark Kamins, a boyfriend who deejayed at Hurrah, helped her with some demo recordings, which found their way to Sire's Seymour Stein. He first inked a deal with the future superstar while recovering from a heart ailment in a Manhattan hospital. "There have been lots of versions out there of my fateful meeting with Seymour when I visited him in the hospital," Madonna has confessed. "It's true I was so broke that I had been eating on a dollar-a-day budget—so when he promised me a recording deal for two singles and 'we'll see how it goes,' plus lots of Italian dinners, needless to say I jumped at the prospect. I was thrilled to be on the same label as the Pretenders and Talking Heads. Who knows, if I didn't meet Seymour Stein, I might still be a broke dancer living in Hell's Kitchen."

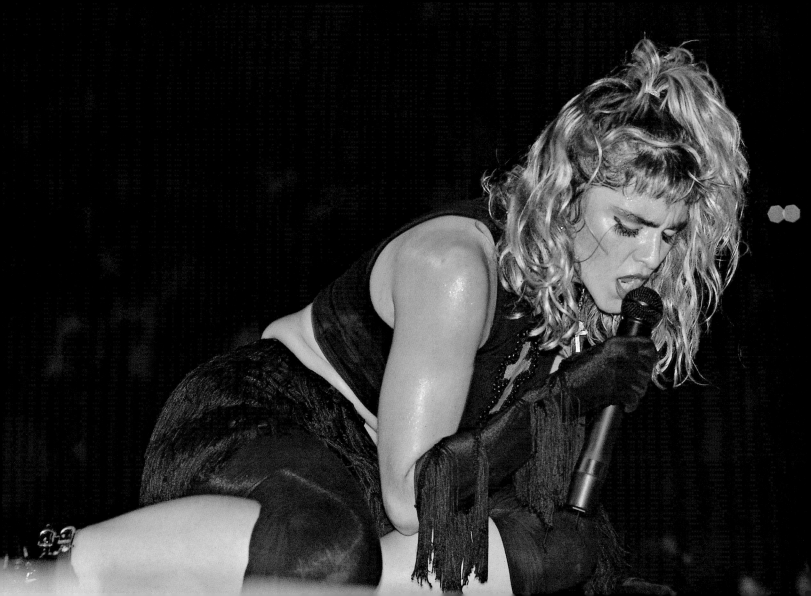

The Mad Violets, 1986 photograph by April Palmieri

Just as Los Angeles had its Paisley Underground, New York had its share of postpunk psychedelic combos, who dressed and played in a manner faithful to their '60s counterparts. Vocalist Wendy Wild, guitarist Keith Streng, keyboardist Deb O'Nair, and bassist Chas Leland (from left) constituted the Mad Violets, a sort of garage-band supergroup. Wild hailed from Pulsallama, Streng played lead guitar in garage-band stalwarts the Fleshtones, O'Nair tickled the keys of her Vox organ in the Fuzztones, and Leland had played in '70s CBGB band Susan.

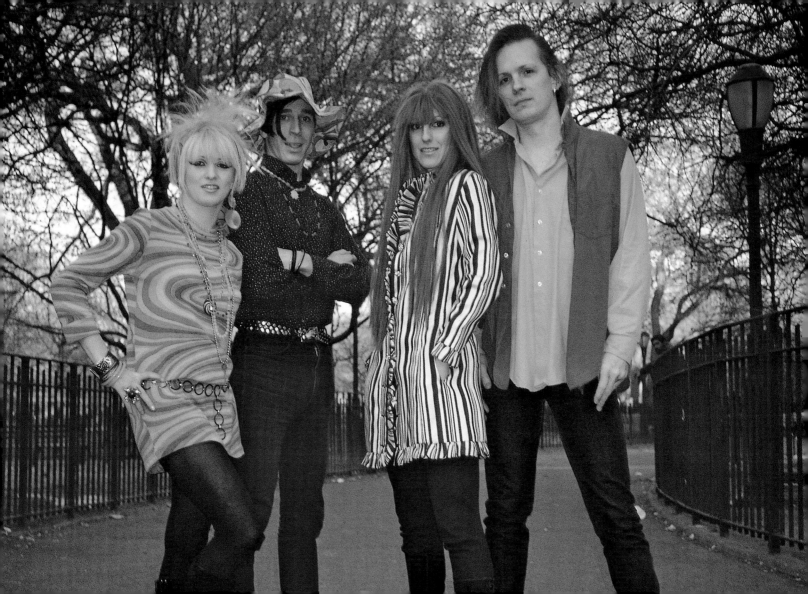

Das Furlines, 1987 photograph by April Palmieri

Shrouded in mystery, Das Furlines claimed to hail from the Black Forest of Germany. Yet with New Yorkers Wendy Wild and Deb O'Nair, along with filmmaker Rachel Amodeo, among the band's members, the group's origins were more likely the Lower East Side of New York. Creating a seminal hybrid of punk and polka, the fetching fivesome began as a self-described "all-girl Monks cover band." Unsung pioneers of punk, the Monks formed in Germany in the mid-'60s and played a feedback-drenched, organ-driven, garage-meets-Beatnik-meets-oompah-pah style of music. Once Das Furlines began duplicating the Monk instrumentation—guitar, bass, organ, drums, and banjo (!)—and repertoire, the won over an audience of cynics who did the chicken polka rather than the pogo. Seen here, Das Furlines enigmatic guitaris Holly Hemlock and media-shy bassist Liz Luv dish out "Nix Nein Frankenstein" at New York's Pyramid Club.

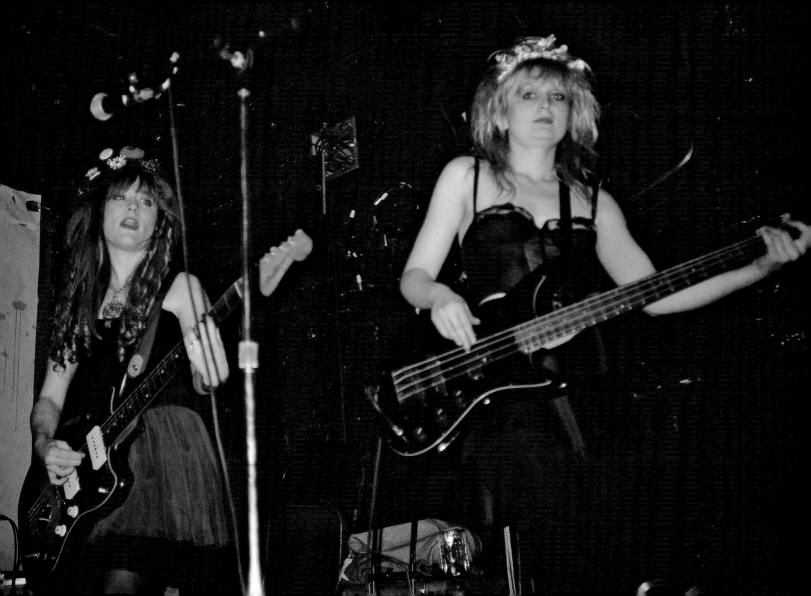

Lou Reed, 1985 photograph by Bob Leafe

Punks turned altruistic in the 1980s. The Boomtown Rats' Bob Geldof started the trend by organizing Live Aid in '85. Soon after, inspired by a comment Bob Dylan made onstage about helping American farmers, Willie Nelson, Neil Young, and John Mellencamp founded Farm Aid. At the first Farm Aid concert, in Champaign, Illinois, none other than Lou Reed volunteered to perform gratis (as seen here), as did X. By the mid-'80s, Reed had settled down and gotten married, spending part of his time in bucolic Pennsylvania. Some of his solo albums, such as *New Sensations* ('84), showed Reed's mellow side. He still wrote gritty urban narratives, however, as evidenced by the masterful album *New York* ('89).

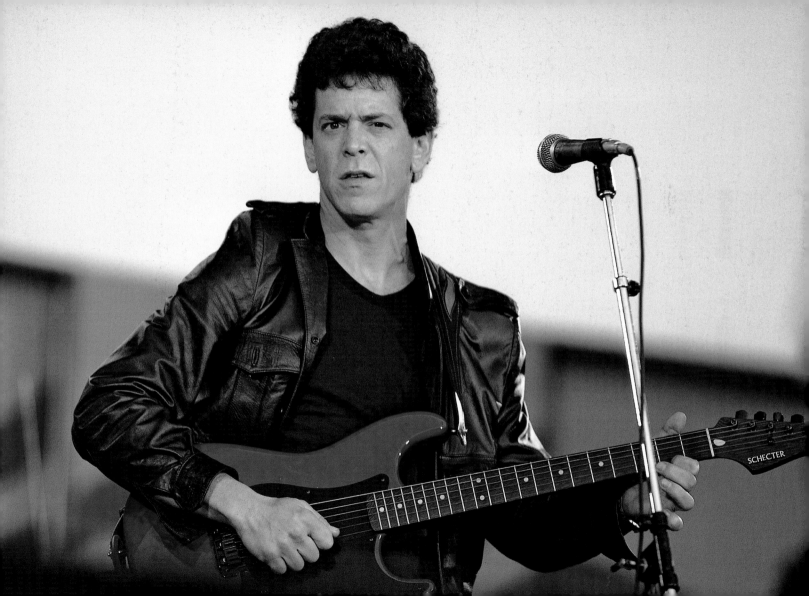

Beastie Boys, 1986 photograph by Janette Beckman

Originally forming—then with drummer Kate Schellenbach—as a bunch of skateboarding teenage punks, the Beastie Boys transformed into hip-hop B-boys and scored a massive hit with "(You Gotta) Fight for Your Right (to Party)." Ad-Roc (b. Adam Horovitz), Mike D (b. Michael Diamond), and MCA (b. Adam Yauch) (from left) exchanged guitar and bass for microphones, and made the first rap album to hit number one, *Licensed to Ill*, in 1986. "We're doing what we want to do, and that's why the kids respect us," said Mike D of the trio's success. "We're not listening to older people. We're going to do it—if for nothing else, just because they told us we can't. We are exercising our constitutional rights to be fresh."

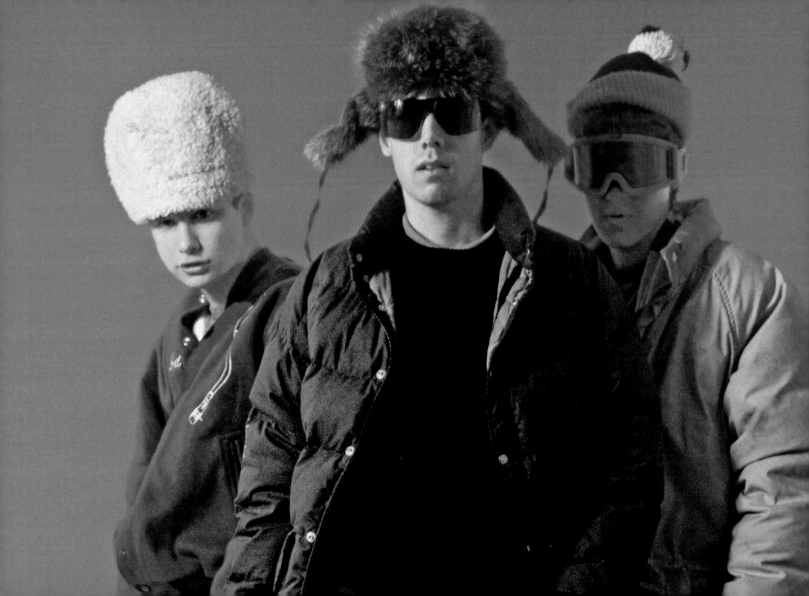

Living Colour, 1989 photograph by Charlyn Zlotnik

Among New York's postpunk bands who played CBGB in the early '80s, Living Colour closed out the decade performing at Madison Square Garden, as photographed here in September '89. Guitarist Vernon Reid (right) had played in avant-funkster ensembles Ronald Shannon Jackson's Decoding Society and Defunkt before forming Living Colour in '83. Bassist Muzz Skillings (left), vocalist Corey Glover, drummer William Calhoun, and Reid were spotted at CBGB by Mick Jagger, who financed a demo. This led to a record deal, resulting in Living Colour's first album, *Vivid,* in 1988. It yielded the politically charged megahit "Cult of Personality." According to Reid, "You have to own the moment you're in."

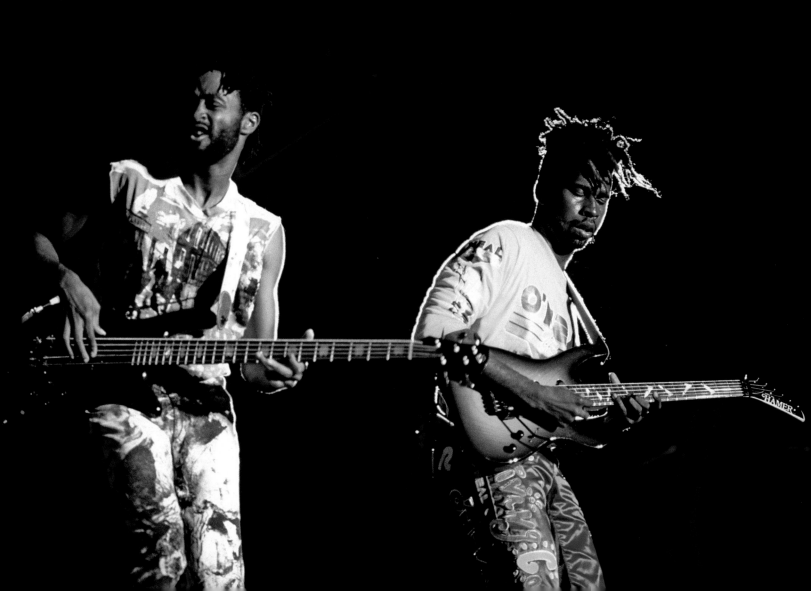

Forming in 1986 in Boston, the Pixies—guitarist Joey Santiago, bassist/vocalist Kim Deal, guitarist/vocalist Black Francis (aka Frank Black), and drummer David Lovering (from left)—found the same college-radio support as R.E.M. did. "With seductive pop melodies, distorted surf riffs, extraterrestrial lyrics, a mysterious Latin flavor, and leader Black Francis' deranged shrieks, the Pixies came off like Beach Boys on acid," wrote one commentator. After the band broke up, Kim Deal formed the Breeders. Years later, Chrissie Hynde recalled, "I saw Kim Deal in some band, it wasn't the Breeders. I went there by myself on my birthday. It was in some little college venue. I met her in the elevator and I thought that was really neat. I got all excited, and to tell you the truth she seemed pretty excited to meet me. I saw the show and thought it was great. Then I left—that was my birthday treat to myself."

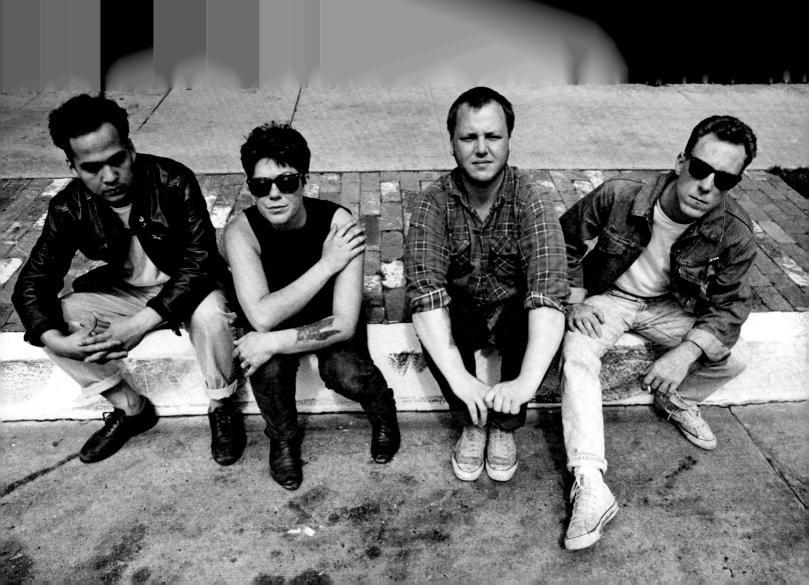

The Mekons, 1987 photograph by Ebet Roberts

Formed in 1977 by erstwhile art students in Leeds, England, the Mekons (named for a comic-book character) have since proved to be one of punk's longest-running groups. Although they originated with a stripped-down sound, the band has traipsed the sonic rainbow over the past thirty years, their outspoken socialist politics the one constant. "Every day is a battle / How we still love the war," they sang in the twenty-first century. By the time of this 1987 gig at CBGB, the group, most of whom had relocated to the States, had embraced a sort of loud-fast-honky-tonk approach. The lilting vocals of then-newcomer Sally Timms (left) added a lushness to duets with original member Jon Langford (second from right). The he/she harmonies would take on a twang in the raucous Waco Brothers, an alternative-country outfit the two went on to form.

HARDCORE

Black Flag, 1980 photograph by Gary Leonard

Giving birth to the loud-fast-rules hardcore scene, Black Flag formed just outside Los Angeles in Hermosa Beach in 1977. Original lead singer Keith Morris later recalled, "Our dedication to our cause was ceaseless. We were going to make as large a racket, piss as many people off, go apeshit as we could, and we had no choice but to play to please ourselves and a handful of friends." After singing on the pivotal 1978 single "Wasted," Morris would depart Black Flag to start the Circle Jerks, another hardcore pioneer. Black Flag's membership would be in constant flux until the band's demise in 1986. Here, in one of the band's lineups, Greg Ginn, Dez Cadena, Robo, and Chuck Dukowski (from left) play the Starwood, in L.A., on November 18, 1980.

The Circle Jerks, 1981 photograph by Gary Leonard

Here leaping through the air, front man Keith Morris (left) was a riveting vocalist and, with the Circle Jerks, picked up where he left off in Black Flag. "You can cuss, spit, throw bottles / Broken bottles, but it ends with the handcuffs on your hand," he sang in "Back Against the Wall." At the Starwood this particular evening—March 10, 1981—fortunately, no bottles were being tossed.

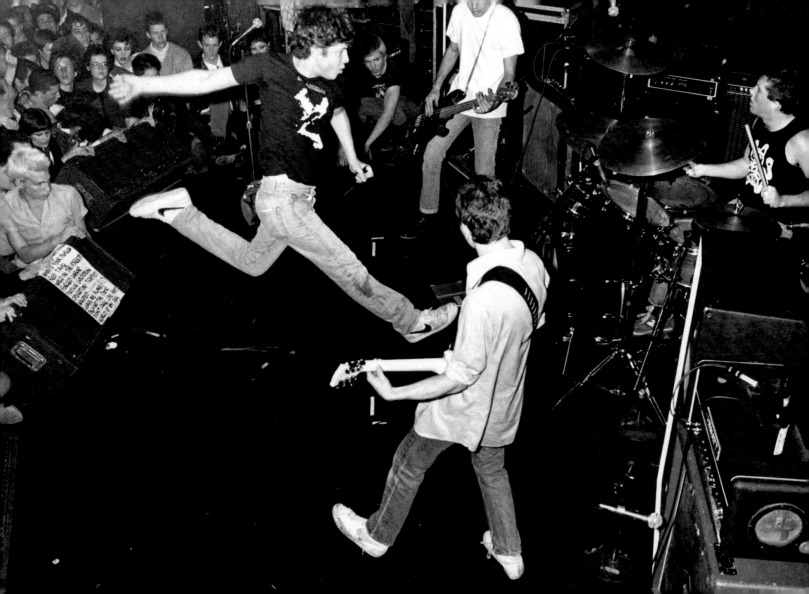

The Dead Kennedys, 1981 photograph by Bob Leafe

Hurtling out of San Francisco, the Dead Kennedys became America's most overtly political punk band. With lead singer / anarchist Jello Biafra's confrontational lyrics—not to mention the band's name—there could be no doubt as to the group's sentiments. As Ronald Reagan was elected president and the Me Decade ensued, the Dead Kennedys sang "California Über Alles" and, on their Alternative Tentacles label, released the hardcore compilation *Let Them Eat Jellybeans* (Reagan's favorite candy). Here, the Dead Kennedys perform at Bond's in Times Square, where London's politico punks the Clash had recently staged a seventeen-night stand.

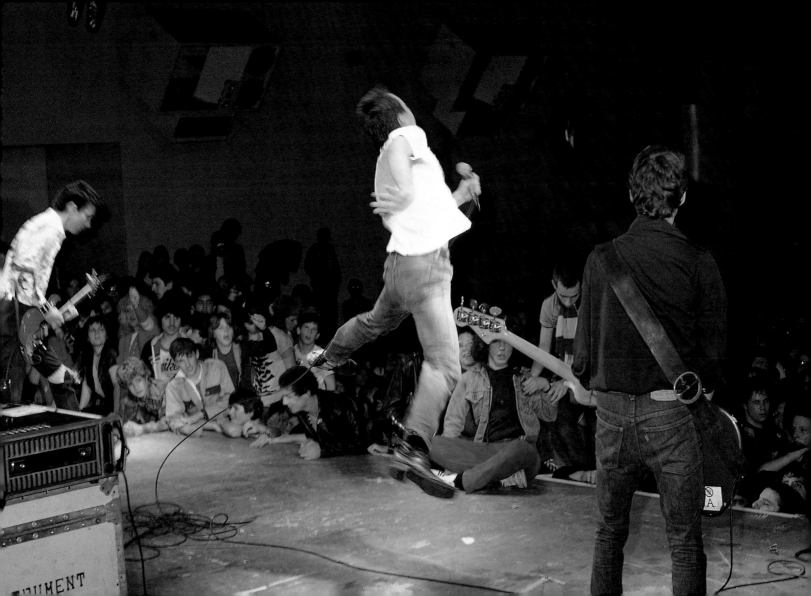

Jello Biafra, 1981 photograph by Bob Leafe

The author of "Too Drunk to Fuck," Dead Kennedys mastermind Jello Biafra was never afraid of controversy. In 1979, he ran (unsuccessfully) for mayor of San Francisco, and seven years later his home was raided in response to an H. R. Giger painting gracing the cover of the Dead Kennedys LP *Frankenchrist*. Charged wit obscenity, Biafra and company stood tria the case ended in a hung jury and was later dismissed. After the band's breakup the singer was sued by his bandmates fo refusing permission to license "Holiday in Cambodia" for use in a Levi's commercia

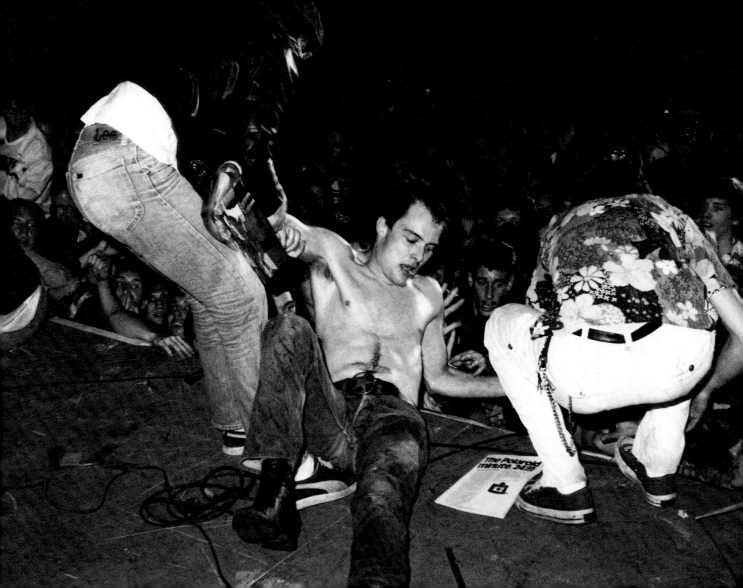

Hardcore at the Starwood, 1981

photograph by Gary Leonard

Stage diving became a common practice at hardcore shows, and at the Starwood, balcony diving, too, took place on occasion. "We thought the hardcore people were sorta like dumb kids," complained L.A. punk vixen Pleasant Gehman. "Some of the bands were great, but it was hell trying to go see them because there'd be a bunch of football jocks with Mohicans there."

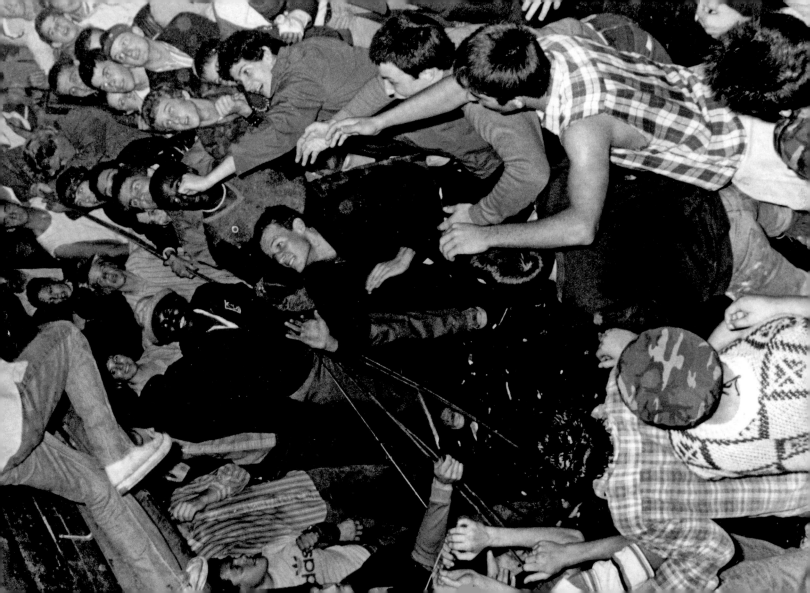

The Circle Jerks, 1980 photograph by Gary Leonard

Bassist Roger Rogerson flies, while Keith Morris keeps his feet on the ground at this Starwood gig on November 11, 1980. Remembers veteran scribe Don Waller, "Once the South Bay / Orange County hardcore movement—'we'll show you Hollywood pussies how to really get crazy'—stormtrooped in off the sands, the surf punks wrecked every place that allowed 'em to play."

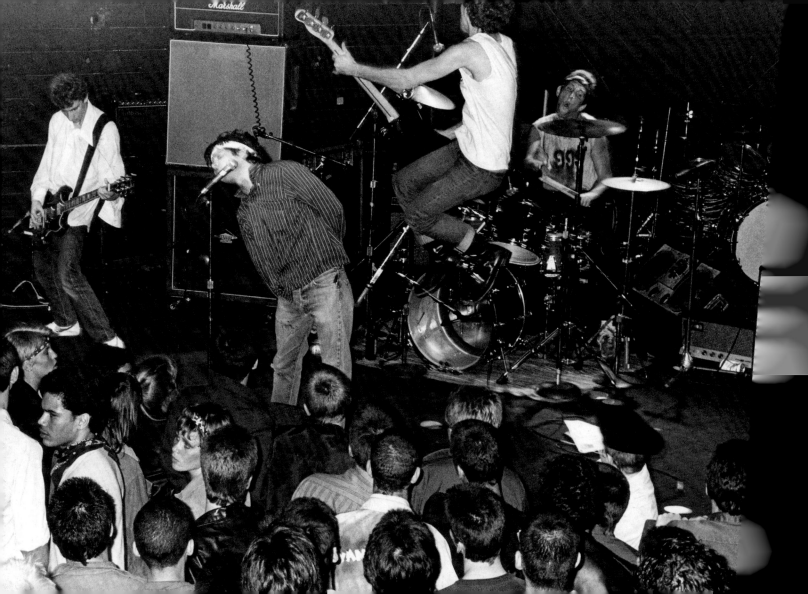

The Minutemen, 1980 photograph by Gary Leonard

A powerhouse trio, the Minutemen formed in 1979 in blue-collar San Pedro, California. The band got its name in part from the brevity of its numbers. Vocalist / guitarist D. Boon, bassist / vocalist Mike Watt, and drummer George Hurley played lightning-speed hardcore that would eventually incorporate elements of free jazz, folk, and funk. The Minutemen became the second band after Black Flag to release a record on the South Bay indie label SST, operated by Black Flag guitarist Greg Ginn and bassist Chuck Dukowski. The Minutemen, seen here performing at the Starwood, became one of hardcore's most popular bands and were constantly on the road. Following a 1985 gig, Boon was killed when the band's van was involved in a horrific accident. Watt and Hurley carried on as fIREHOSE for a while, and in the twenty-first century, Watt played bass in the re-formed Stooges, with Iggy and the Asheton brothers.

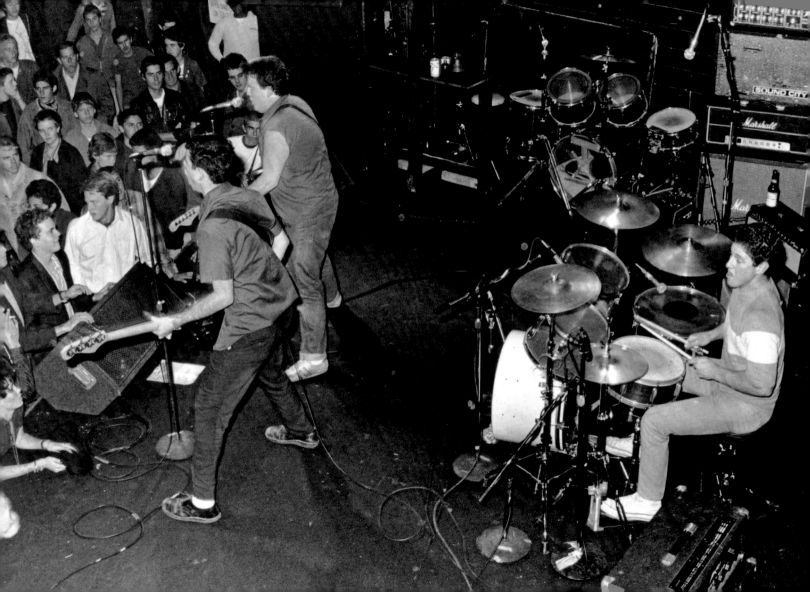

The Flesheaters, ca. 1979 photograph by Sumishta Brahm

Formed by Chris D. (b. Desjardins) in Los Angeles, the Flesheaters became a favorite of veteran critic Richard Meltzer, who called the band's auteur "a goddamn genius." Chris D. had also been a scribe at *Slash,* and he enlisted pals from the Blasters and X to back him up in the Flesheaters. On the band's 1981 album *A Minute to Pray, a Second to Die,* Chris D. "sang of feverish visions, satanic possession, boneyards, and bloodletting," reported UK music journalist Barney Hoskyns.

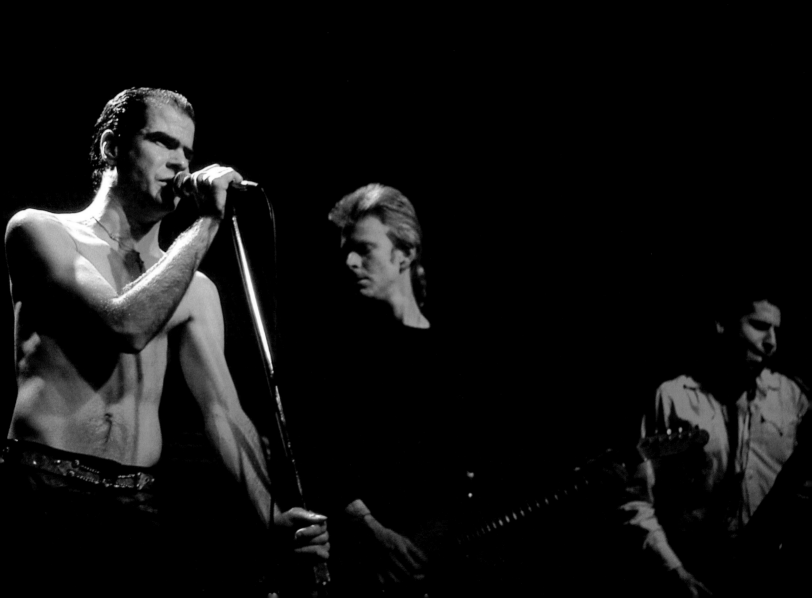

Mosh pit, 1980 photograph by Gary Leonard

Hardcore polarized L.A.'s punk scene; though there was the occasional mixed bill featuring Black Flag, the Blasters, and Fear, fans eventually split into three camps: hardcore, roots rock, and Paisley Underground. The latter two's audiences would overlap, but the former began attracting mainly the (very) young and (very) restless. The mosh pit at hardcore shows was not for those who did not want to risk a jackboot to the nose. "Punk was urban, hardcore was suburban," espouse Greg Shaw, whose Bomp record store, label, and fanzine had veered gradually toward power pop over the years. "Punk had been arty and conceptual, but then came the kids from the beach, boneheads who'd heard that punk was violence, but didn't realize it was metaphorical violence." The Starwood, the site of this Gary Leonard photo, became a foundation of the mosh pit.

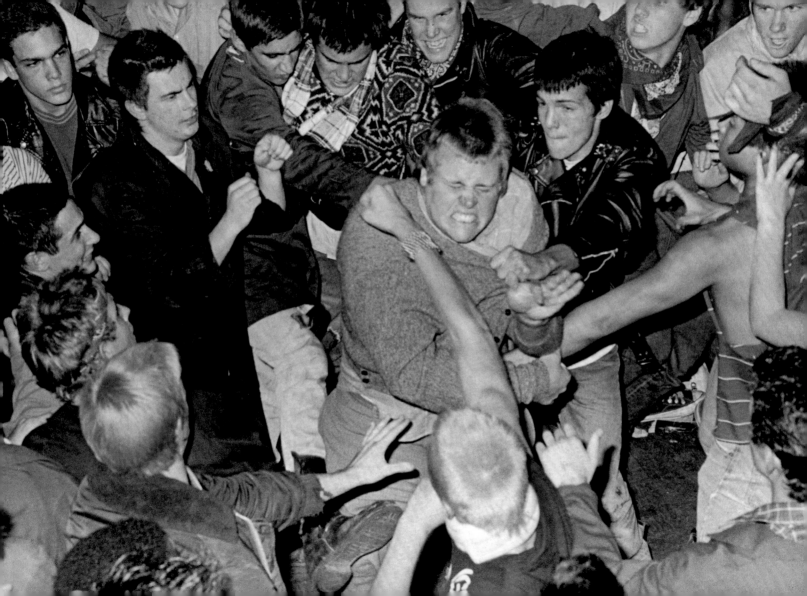

Chuck Biscuits, 1983 photograph by Sumishta Brahm

Drummer Chuck Biscuits, like vocalist Keith Morris, spent time in Black Flag before drumming for the Circle Jerks. Photographer Sumishta Brahm documented the drummer's first-ever gig with the Circle Jerks. The guitarist for the Jerks, Greg Hetson, was an alumnus of surf-punk band Red Cross (who, after being sued by their namesake, changed their name to Redd Kross). Lasting into the 1990s, the Circle Jerks inspired such retro-punk stars as Green Day. The Circle Jerks have reunited sporadically in the twenty-first century.

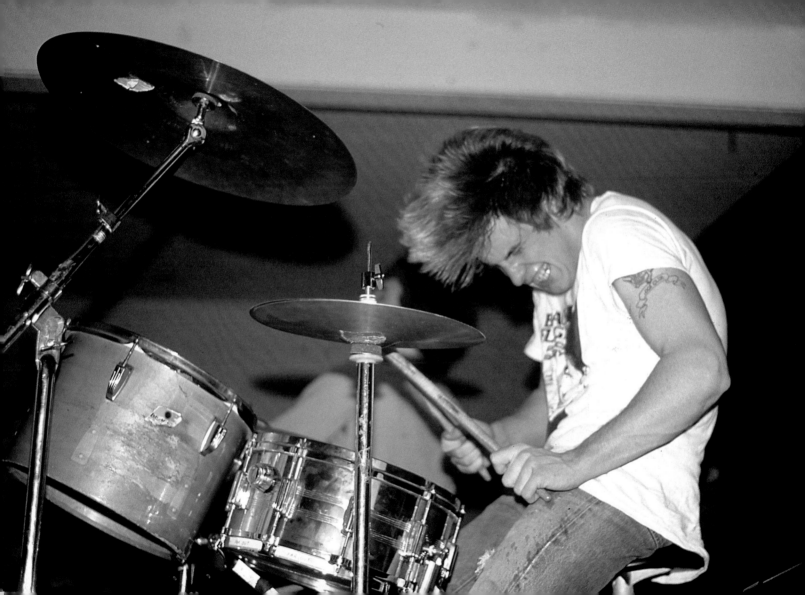

Social Distortion's Mike Ness, 1983

photograph by Sumishta Brahm

Vocalist/guitarist Mike Ness and guitarist
Dennis Danell formed Social Distortion in
1979. Four years later, the band released
their first album, *Mommy's Little Monster.*
Social Distortion's sound was rootsier than
that of their fellow surf punks; they even
did a cover of the June Carter Cash/Merle
Kilgore song "Ring of Fire," which had
been a 1968 hit for Johnny Cash.

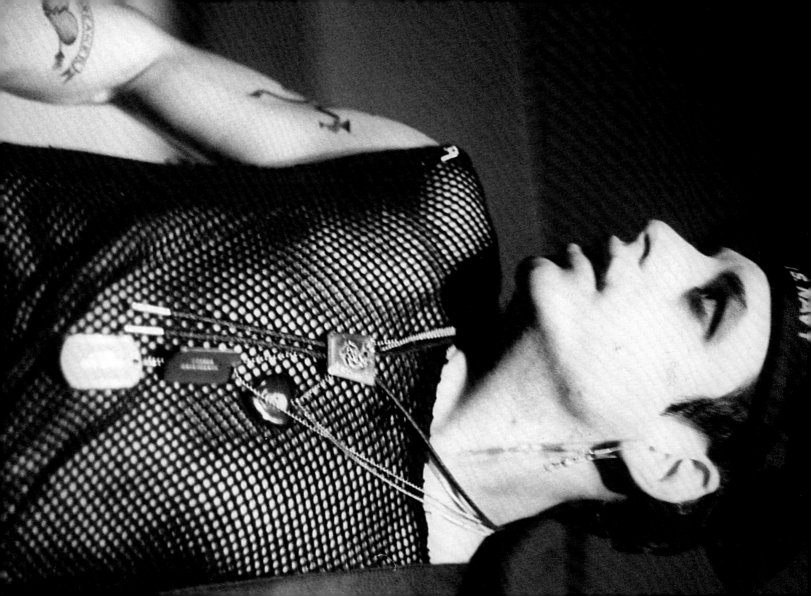

Minor Threat's Ian MacKaye, 1982 photograph by Nancy Breslow

A veteran of the Washington, DC, hardcore scene, Ian MacKaye first played in the Teen Idles, who made their way to California to play gigs in L.A. (for fifteen dollars) and San Francisco (for eleven). Back in DC, MacKaye became determined to return integrity to music and refused to "sell out" to major labels. He formed the band Minor Threat and started Dischord Records to release the work of various hardcore bands, including Scream (with future Nirvana/Foo Fighters member Dav Grohl). With the song "Straight Edge" ("Always gonna keep in touch / Never want to use a crutch"), Minor Threat espoused the clean-living philosophy adhered to by some East Coast hardcore punks. Breslow took this photo at a packed club "in a bad neighborhood" in Washington, DC.

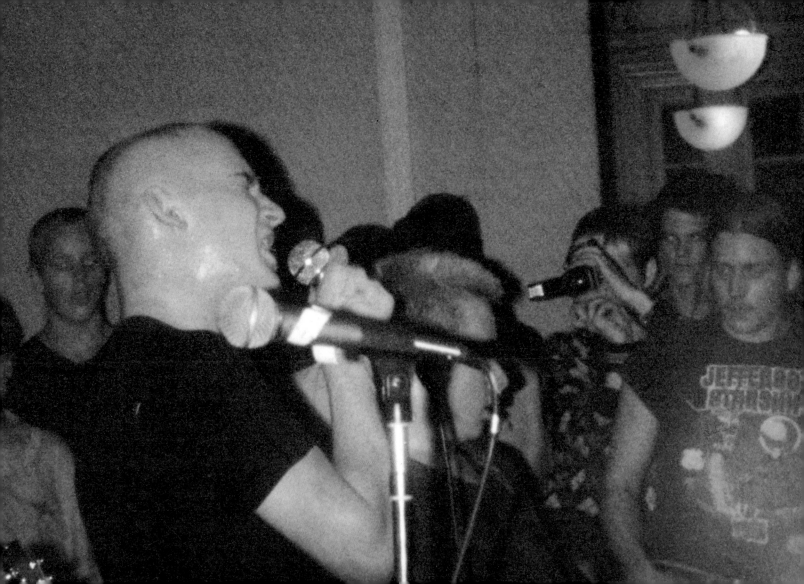

Dave Parsons at Rat Cage Records, ca. 1982 photograph by Nancy Breslow

The New York City hardcore scene originally centered around a decrepit building on Avenue A between Tenth and Eleventh Streets, which housed Rat Cage Records, in the basement, with a recording studio and illegal club upstairs. Known as 171, the studio and club were operated by former members of Th' Cigaretz, Jerry Williams and Scott Jarvis, who became friendly with fellow Southern transplant Dave Parsons, an erstwhile vinyl merchant. Black Flag and Bad Brains played gigs at 171 early on, and the Beastie Boys hung out at the Rat Cage while they were still a hardcore unit; the Beasties and Bad Brains made seminal recordings at the studio upstairs. Rat Cage proprietor Dave Parsons had moved to New York from Florida and opened his tiny shop specializing in hardcore records and fanzines. After 171 was closed down by city officials, the Rat Cage relocated to a storefront on East Ninth Street, where Nancy Breslow snapped this picture.

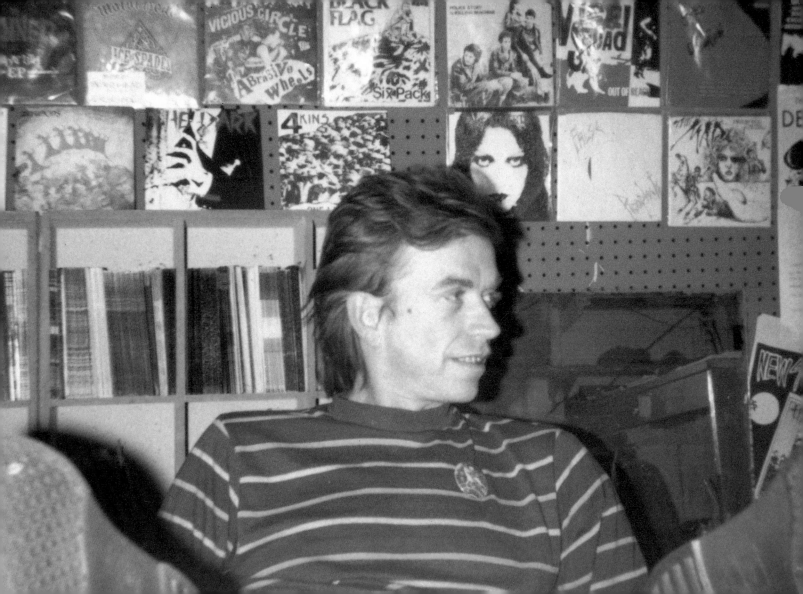

Henry Rollins, 1982 photograph by Bob Leafe

Black Flag's fourth vocalist, Henry Rollins (b. Garfield), met the band when the constantly touring hardcore outfit played his native Washington, DC. Rollins had performed briefly in a local hardcore group, but after joining Black Flag onstage for an impromptu number in 1981, he was shocked when they asked him to join as their lead singer. "It was my favorite band, and all of a sudden I'm the singer," Rollins later recounted. "It was like winning the lottery ... What I was doing kind of matched the vibe of the music. The music was intense, and, well, I was as intense as you needed." He moved to Los Angeles, got the Black Flag–logo tattoo, and changed his last name from Garfield to Rollins. Here, Rollins performs with Black Flag in New Jersey.

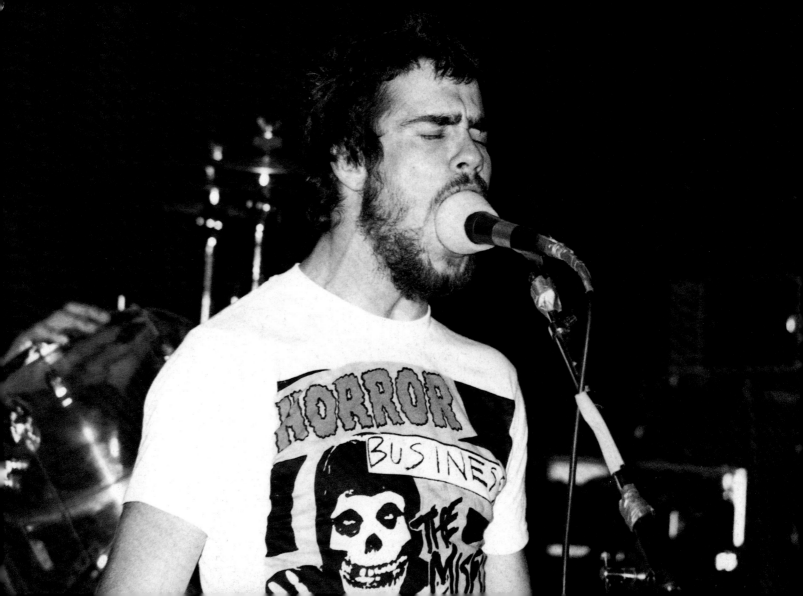

The Cro-Mags' Harley Flanagan, 1984 photograph by Nancy Breslow

Just as Black Flag and the Dead Kennedys emerged from the California punk scene, a few East Coast punk rockers led that locale's hardcore charge. Vocalist Harley Flanagan had been the twelve-year-old drummer for the late '70s punk band the Stimulators, playing alongside guitarist Denise Mercedes, a niece of Allen Ginsberg. Flanagan formed the Cro-Mags in the early '80s. Nancy Breslow snapped this portrait while Flanagan enjoyed an Agnostic Front gig at CBGB.

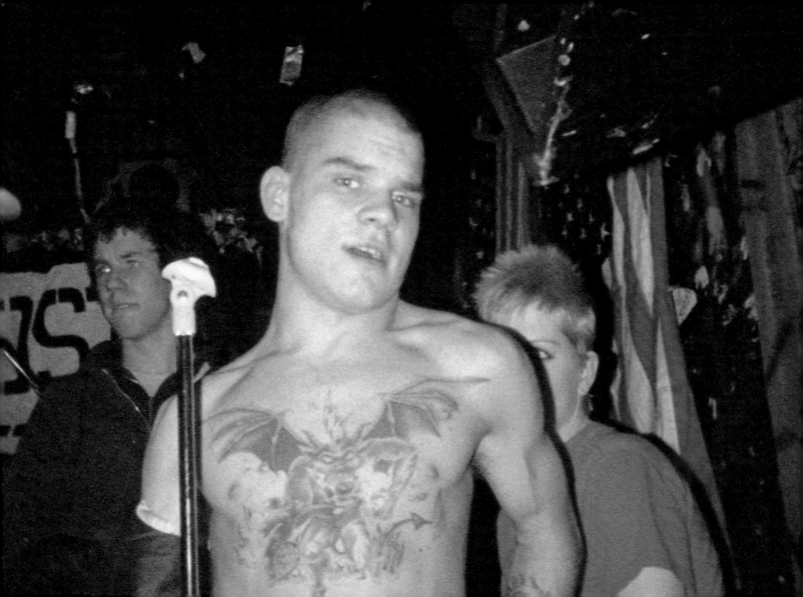

Agnostic Front, 1984 photograph by Nancy Breslow

Agnostic Front was one of numerous young hardcore bands to spring up in New York in the early 1980s. Many of the bands played at the illegal after-hours club A7, on the corner of Avenue A and Seventh Street (the bar later became King Tut's Wah Wah Hut, and two decades hence, Jesse Malin of the hardcore band Heart Attack bought the joint and named it Niagara). Fanzines like New York's *Short Newz,* San Francisco's *Maximum Rock 'n Roll,* and L.A.'s *Flipside* covered the hardcore scene. Nancy Breslow, who photographed many of the hardcore bands, edited *Short Newz* (under the pen name Jim Short); she once got her nose broken at a Circle Jerks gig, then rebroken at a Dictators show, but she continued to make the scene.

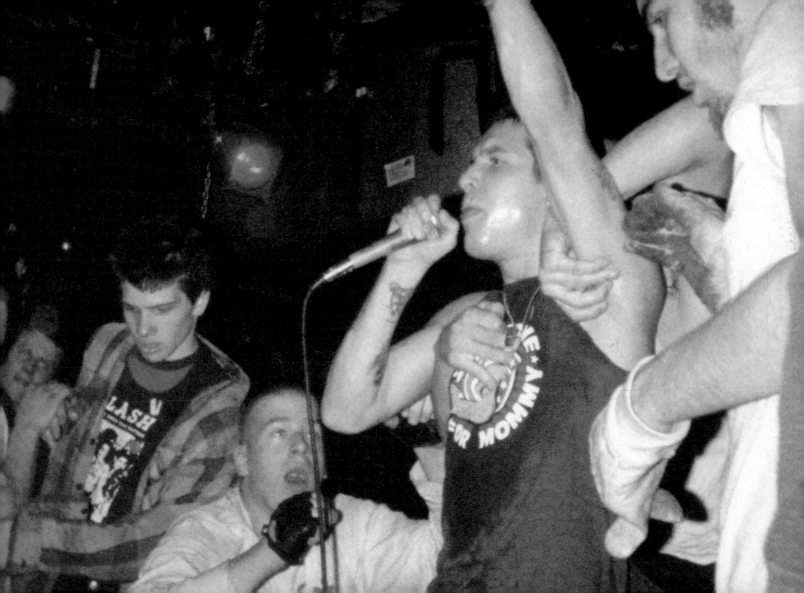

Hardcore fans at CBGB, 1989 photograph by Frank White

In 1982, CBGB began hosting weekend all-ages, hardcore matinees featuring local bands like Crucial Truth, Heart Attack, Reagan Youth, the Young and Useless, and Urban Waste and touring bands from DC and L.A. who were in town to play evening shows at larger venues. "It was very strange to wake up, eat breakfast and go over to CB's while it was light out and in fact in mid-day," *Short Newz* reported of a June 1982 matinee featuring L.A. band Agent Orange. Many of the young New York skinheads espoused the straight-edge philosophy of no drugs, no alcohol, and no sex; the Hare Krishna movement eventually recruited members of the Cro-Mags and Crucial Truth and other hardcore devotees.

355

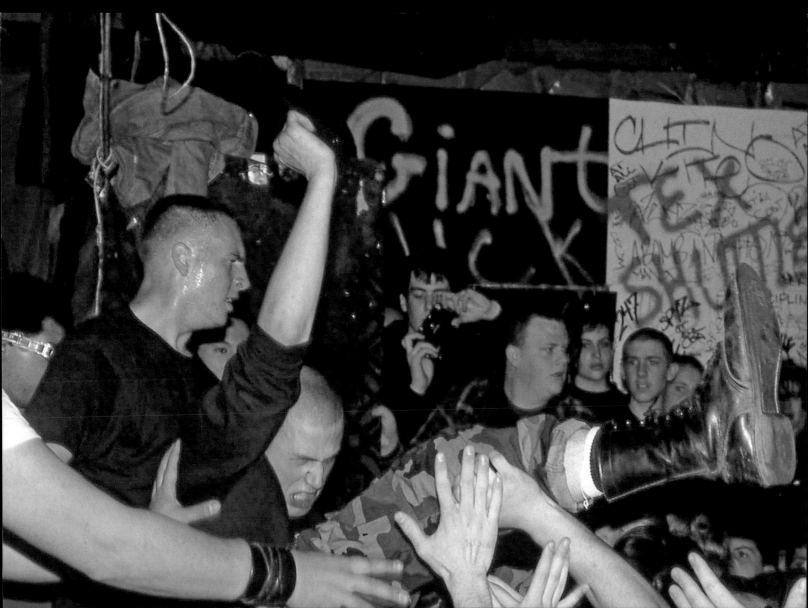

Black Flag, 1982 photograph by Bob Leafe

"People can get real nasty if you don't do what they think you should do. And the nastier segments of Black Flag's audience focused their wrath on Rollins. People were not content merely to spit on Rollins—they would put out cigarettes on him, douse him with cups of urine, punch him in the mouth, stab him with pens, heave beer mugs at him, scratch him with their nails, hit him in the groin with water balloons. On tour, his chest often looked like a disaster area."

—Greg Ginn, Black Flag guitarist

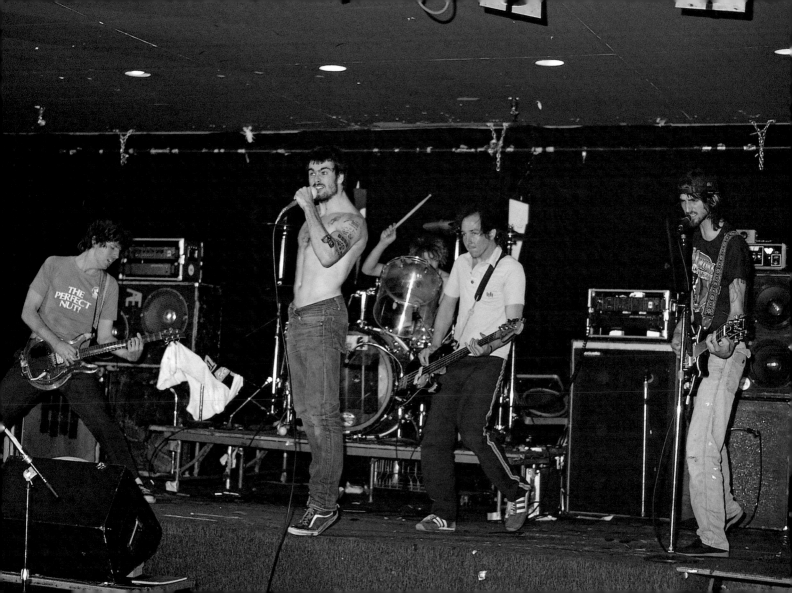

The Bad Brains' Dr. Know, ca. 1982 photograph by John Kelly

Moving from Washington, DC's go-go movement into punk, the Bad Brains became one of that city's most influential hardcore bands. In 1977, as the jazz-funk-fusion band Mind Power, guitarist Dr. Know (b. Gary Miller), bassist Darryl Jenifer, drummer Earl Hudson, and vocalist H.R. (b. Paul Hudson)—Earl's brother—got turned on to the punk-reggae sound coming from the Clash. They became the Bad Brains and began playing New York regularly as a hardcore band in 1980, embracing Rastafarianism and thereby influencing the hardcore scene's straight-edge ideals. Writer Peter Aaron, vocalist for downtown New York band the Chrome Cranks, described one 1982 Bad Brains show at CBGB: "A wave of frenetic, mountain-plowing locomotion engulfed me. Bodies were immediately flying everywhere, careening off walls and one another as the monolithic roar dominated everything. And, in the middle of it all, the tornado in the eye of the hurricane, was the whirling, possessed vocalist, snarling, shrieking, and moaning with the fiery eyes of a preacher."

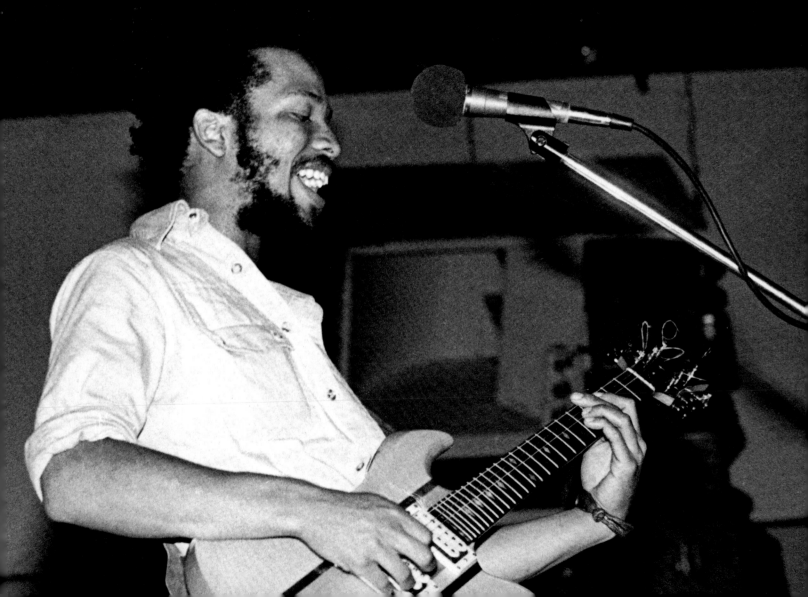

The Bad Brains' H.R. and Dr. Know, 1989 photograph by Frank White

"My goal has always been to be as powerful as the Bad Brains."

—Dave Grohl, the Foo Fighters

"The Bad Brains influenced me more than any other band in the world."

—Adam Yauch, the Beastie Boys

358

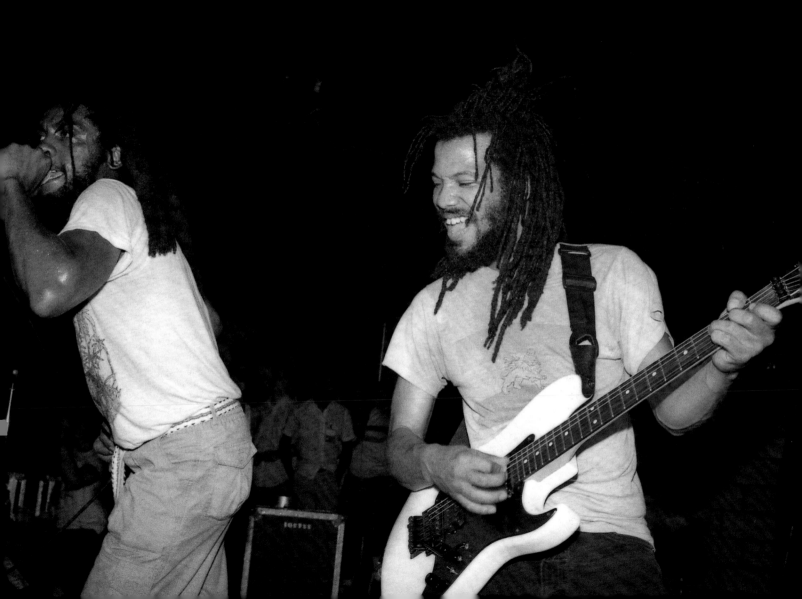

D.O.A., 1984 photograph by Nancy Breslow

The hardcore scene was also popular in the United Kingdom and Europe in the early 1980s. Here, the Canadian hardcore band D.O.A. plays for Dutch punks at the Paradiso in Amsterdam. That city boasted a thriving hardcore scene including such bands as the politically charged BGK, led by vocalist Tony Slug. In the mid-1980s, the band made its way to New York to play punk mecca CBGB.

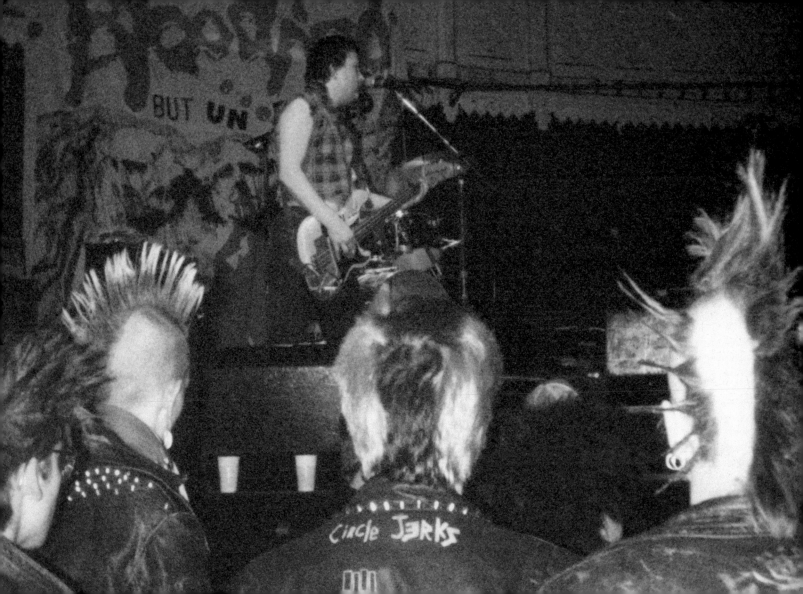

Mosh pit at the Ritz, 1987 photograph by Frank White

After the hardcore scene splintered in Los Angeles following the 1986 breakup of Black Flag, it continued unabated throughout the decade in New York.

Larger halls like the Ritz began promotin hardcore shows, where decibels—and testosterone—sometimes got out of control.

360

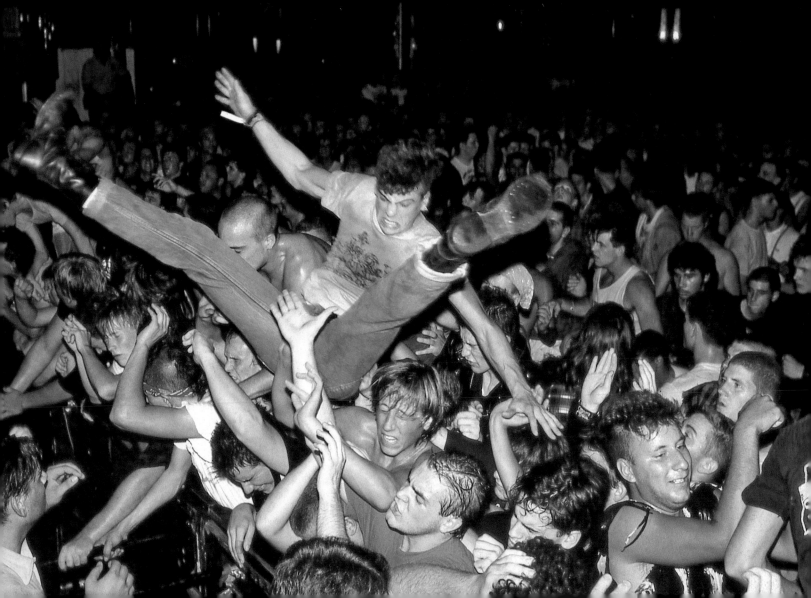

Hardcore matinee, CBGB, 1989 photograph by Frank White

Long after the Voidoids and the Dead Boys had laid down their axes, punk rock
continued to thrive at CBGB, thanks to the hardcore scene.

361

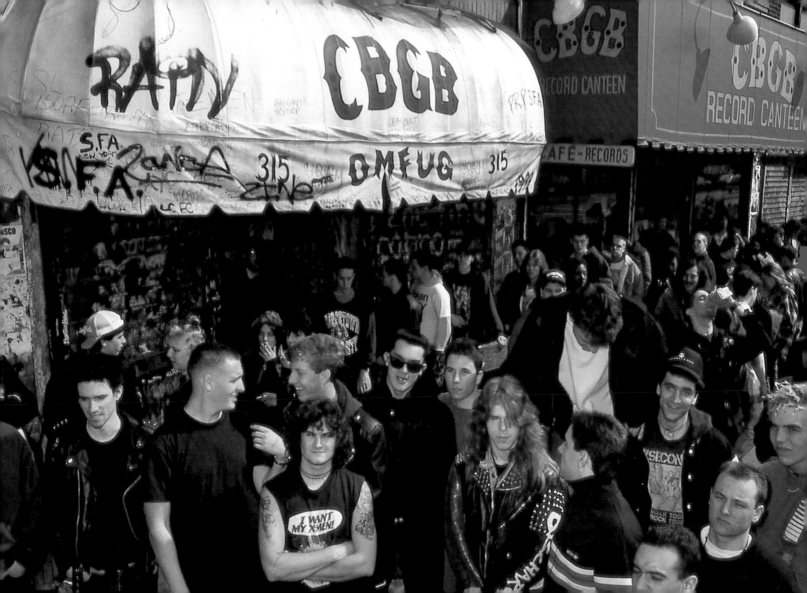

GBH, 1987 photograph by Frank White

Short for Grievous Bodily Harm (the legal term for assault in England), GBH was one of London's first hardcore bands. The group formed in 1980 and soon opened shows for the re-formed Damned and the UK Subs. Members went by first names only: vocalist Colin, guitarist Jock, bassis Ross, and drummer Wilf. Here, GBH, who frequently crossed the Atlantic to play the States, perform at Irving Plaza in November 1987.

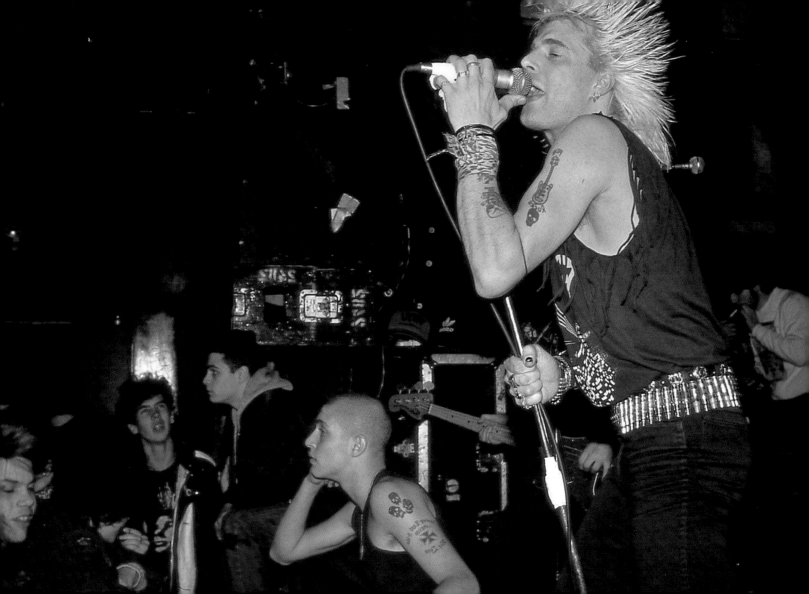

East Village punks, ca. 1989
photograph by Maria Del Greco

On the cusp of a new decade, the outré look of punk had spread to a new generation. From John Lydon's multicolored dreads to GBH's Mohawks, punk dos flourished, creeping gradually into the mainstream.

363

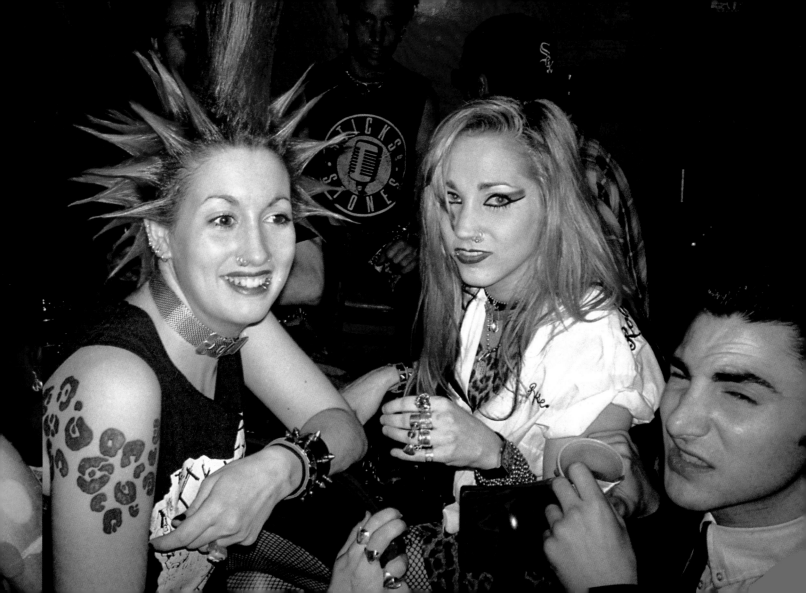

Fugazi, 1993 photograph by Ebet Roberts

A handful of veterans of the hardcore scene made powerful music in the late 1980s and into the '90s. These sounds would strongly influence commercially successful punk, from the grunge of Nirvana and Pearl Jam to the pop-punk of Green Day, the punk metal of the Offspring, and the ska-punk of No Doubt. Thanks to these groups, a whole new flowering of punk would take hold. One of the most influential of the original hardcore musicians was former Teen Idles and Minor Threat main man Ian MacKaye (far left). He formed Fugazi in 1987 with guitarist Guy Picciotto, bassist Joe Lally, and drummer Brendan Canty. As did MacKaye's previous bands, Fugazi—philosophically opposed to the mainstream record conglomerates attempting to sign them—released their albums on indie label Dischord, which MacKaye founded in 1980. A major adherent of punk's DIY ethic, MacKaye has continued to remain true to his youthful ideals.

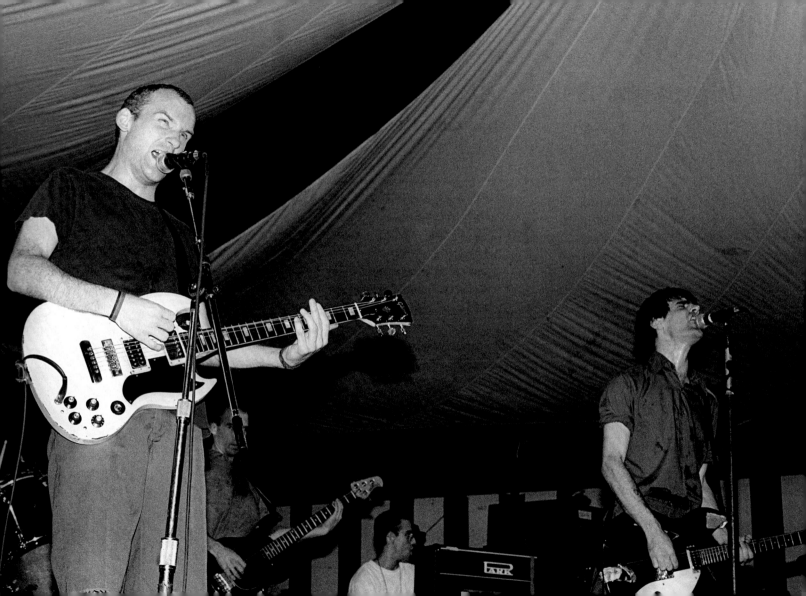

DGeneration, 1992 photograph by Bob Gruen

While children and grandchildren of punk—including Nirvana and Green Day—were percolating on the West Coast, a homegrown scene was at work spawning DGeneration in New York. Guitarist Howie Pyro (second from right) had been a teenaged member of punk band the Blessed in the late '70s, known for gobbing the audience at Max's and CBGB, where their graffiti graced the bathroom walls. Vocalist Jesse Malin (center) said he had a "Ramones ADD appetite" and cut his teeth as a teen playing in hardcore band Heart Attack and made pocket change by driving New York bands to gigs and serving as a roadie. As DGeneration, they unfurled the Dolls-meet-Stooges sonic flag, and played to enthusiastic audiences, eventually touring with Green Day. Since the band's implosion (as it seems most true punk bands do implode), the members have gone on to different musical endeavors. Harkening back to his teenage roots, Malin's 2007 solo album was aptly titled *Glitter in the Gutter.*

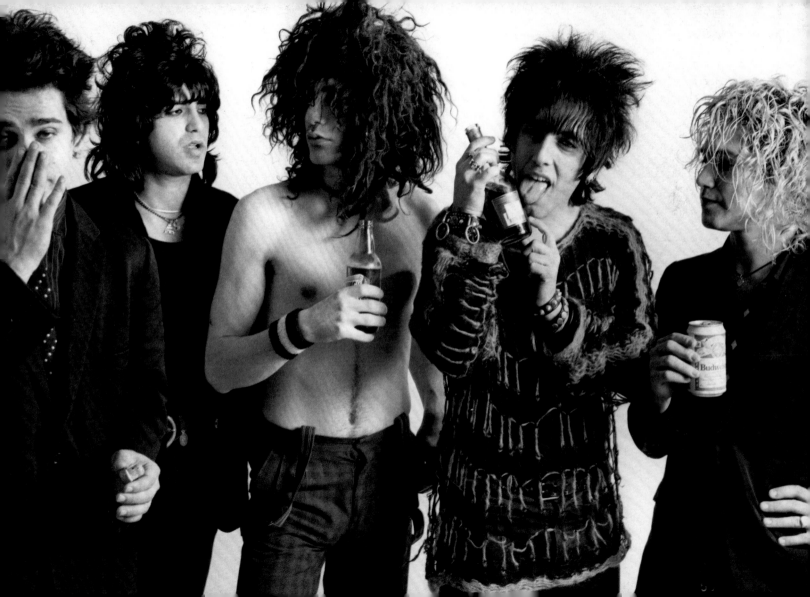

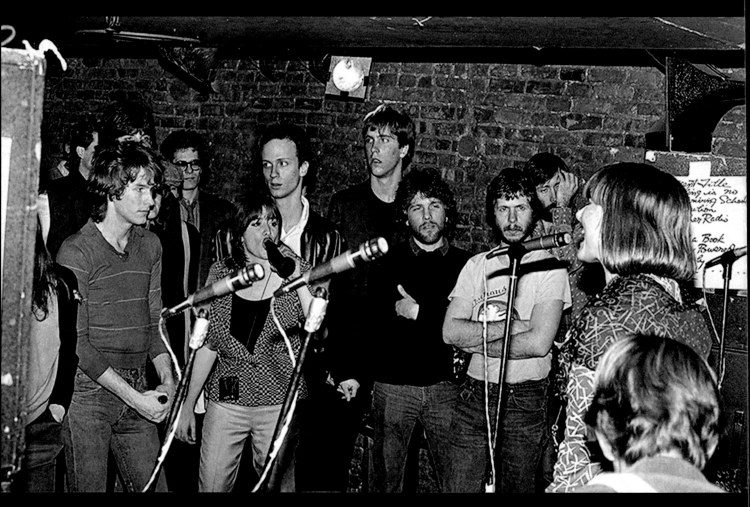

I am extremely grateful to Deborah Aaronson, executive editor at Harry N. Abrams, for enlisting me to participate in such a fantastic project. Her expertise and savoir faire were indispensable. We were very fortunate to have on board our punk train the talented and hardworking designer Neil Egan, as well as savvy editorial assistant Laura Tam and expert copy editor Carrie Hornbeck. Many thanks, as well, to Abrams' Steve Tager and Eric Himmel. My gratitude also goes to my industrious and supportive agent Sarah Lazin and her assistant Shawn Mitchell. I am most appreciative of Richard Hell's involvement in the book—I would never have dreamed when I first fell for the Voidoids in 1977 that I'd get to do a book on punk rock with him as our guiding light. Thanks to Charlyn Zlotnik for discovering among her archives the photo of a would-be music scribe at a 1980 Pylon show at TR3. Several others lent a helping hand in various ways, including Fred Patterson, Nancy Breslow, Lindsay Hutton, Nancy Heidel, Scott Jarvis, Peter Zaremba, Lenny Kaye, Jenny Lens, Vivien Goldman, Tony Fletcher, Philip Andelman, Elda Stilletto, Mike Watt, Ed Keupper, Bob Gruen, Janette Beckman, Stephanie Chernikowski, Jon Espinoza, Kim Apley, Deb O'Nair, Jimmy Cohrssen, Melissa Koval, and Gary Stewart. The unflagging support given by my Ramones-loving son Jack and my husband Robert Warren, who played his own fair share of punk-rock venues over the years, was invaluable, as always. And if not for the music that changed my life—much of it created by those pictured in these pages—I could not have written this book. Special thanks to the Buzzcocks, who rock as hard in 2007 as they did in the 1970s. Finally, my deepest appreciation goes to the brilliant photographers who so artfully captured the essence of punk—and who were so generous and collaborative throughout the course of this project.

—H. G.-W.

HOLLY GEORGE-WARREN is an award-winning writer, editor, producer, and music consultant. She has contributed to more than forty books about music, and has written for such publications as *The New York Times, Rolling Stone, Village Voice, Entertainment Weekly,* and *MOJO.* Her most recent book is *Public Cowboy No. 1: The Life and Times of Gene Autry.* In her wild youth, she played electric guitar in various bands on the stages of such legendary NYC clubs as CBGB, Max's Kansas City, the Peppermint Lounge, and the Pyramid.

SOURCES

Much of the information included in the captions came from interviews I conducted over the years. Articles in back issues of fanzines; the late great *New York Rocker* and *Trouser Press*, and *MOJO* also proved essential. The following is a list of other crucial sources, from which information was gathered and quotes were drawn:

Books

Azerrad, Michael. *Our Band Could Be Your Life.* New York: Little, Brown & Co., 2001.

Bessman, Jim. *Ramones: An American Band.* New York: St. Martin's Press, 1993.

Bockris, Victor, and Roberta Bayley. *Patti Smith: An Unauthorized Biography.* New York: Simon & Schuster, 1999.

Bockris, Victor, and Gerard Malanga. *Up-Tight: The Velvet Underground Story.* New York: Omnibus Press, 1983.

Bozza, Anthony, and Shawn Dahl, eds. *Rolling Stone Raves: What Your Rock & Roll Favorites Favor.* New York: William Morrow, 1999.

Brown, Rodger Lyle. *Party Out of Bounds.* Atlanta: EvertheMore Books, 2003.

Christgau, Robert. *Christgau's Record Guide: The '80s.* New York: Pantheon, 1990.

Cohen, Scott. *Yakety Yak.* New York: Fireside, 1994.

Connolly, Cynthia, Leslie Clague, and Sharon Cheslow, comps. *Banned in DC.* Washington, DC: Sun Dog Propaganda, 2005.

Coupe, Stuart, and Glenn A. Baker. *The New Rock 'n' Roll.* London: Omnibus, 1983.

Curtis, Deborah. *Touching from a Distance: Ian Curtis and Joy Division.* London: Faber & Faber, 1995.

Dalton, David. *El Sid.* New York: St. Martin's Press, 1997.

Echenberg, Erica, and Mark P. *And God Created Punk.* London: Virgin, 1996.

George, B., and Martha DeFoe, eds. *Volume: International Discography of the New Wave.* New York: One-Ten Records, 1980.

George-Warren, Holly, and Patricia Romanowski, eds. *The Rolling Stone Encyclopedia of Rock & Roll.* New York: Fireside, 2001.

Gilbert, Pat. *Passion Is a Fashion: The Real Story of the Clash.* New York: DaCapo, 2004.

Gimarc, George. *Post Punk Diary 1980–1982.* New York: St. Martin's Press, 1997.

———. *Punk Diary 1970–1979.* New York: St. Martin's Press, 1994.

Gray, Marcus. *Last Gang in Town: The Story and Myth of the Clash.* New York: Henry Holt & Co., 1995.

Heylin, Clinton. *From the Velvets to the Voidoids.* New York: Penguin, 1993.

Hoskyns, Barney. *Waiting for the Sun.* New York: St. Martin's Press, 1996.

Johnston, Ian. *The Wild Wild World of the Cramps.* London: Omnibus, 1990.

Juno, Andrea. *Angry Women in Rock.* Vol. 1. San Francisco: Juno Books, 1996.

Juno, Andrea, and V. Vale, eds. *Incredibly Strange Music.* San Francisco: Re/Search, 1998.

Kaye, Lenny. Introduction to *Blank Generation Revisited.* New York: Schirmer, 1997.

Kent, Nick. *The Dark Stuff.* New York: Penguin, 1994.

Kristal, Hilly. *CBGB & OMFUG: Thirty Years from the Home of Underground Rock.* New York: Harry N. Abrams, 2005.

Lazell, Barry. *Punk! An A–Z.* London: Hamlyn, 1995.

Leonard, Gary, and Don Snowden. *Make the Music Go Bang!* New York: St. Martin's Press, 1997.

Lunch, Lydia. *Paradoxia: A Predator's Diary.* N.p.: Creation Books, 1997.

Lydon, John, with Keith and Kent Zimmerman. *Rotten: No Irish—No Blacks—No Dogs.* New York: St. Martin's Press, 1994.

McDonnell, Evelyn, and Ann Powers, eds. *Rock She Wrote: Women Write about Rock, Pop, and Rap.* New York: Delta, 1995.

McNeil, Legs, and Gillian McCain. *Please Kill Me.* New York: Grove Press, 1996.

Meltzer, Richard. *A Whore Just Like the Rest.* New York: Da Capo, 2000.

Monk, Noel E., and Jimmy Guterman. *12 Days on the Road: The Sex Pistols and America.* New York: Quill, 1990.

O'Brien, Glenn. Foreword to *Bande a Parte.* Paris: Editions du Collectionneur, 2005.

O'Dair, Barbara, ed. *Trouble Girls: The Rolling Stone Book of Women in Rock.* New York: Random House, 1997.

Pierce, Jeffrey Lee. *Go Tell the Mountain.* Los Angeles: 2.13.61, 1998.

Ramone, Dee Dee, with Veronica Kaufmann. *Lobotomy: Surviving the Ramones.* New York: Thunder's Mouth, 2000.

Robbins, Ira A., ed. *Trouser Press Record Guide.* 4th ed. New York: Collier, 1991.

Salewicz, Chris. *Redemption Song: The Ballad of Joe Strummer.* New York: Faber & Faber, 2007.

Sarig, Roni. *The Secret History of Rock.* New York: Billboard, 1998.

Savage, Jon. *England's Dreaming.* New York: St. Martin's Press, 1992.

Schinder, Scott, and the editors of Rolling Stone Press. *Alt-Rock-a-Rama.* New York: Delta, 1996.

Smith, Patti. *Complete.* New York: Doubleday, 1998.

Sullivan, Denise. *Rip It Up! Rock & Roll Rulebreakers.* San Francisco: Backbeat Books, 2001.

Unterberger, Richie. *Unknown Legends of Rock 'n' Roll.* San Francisco: Miller Freeman Books, 1998.

Liner notes (and recommended listening!)

A Life Less Lived: The Gothic Box, Rhino
Clash on Broadway, Sony/Legacy
Left of the Dial: Dispatches from the '80s Underground, Rhino
No Thanks! The '70s Punk Rebellion, Rhino
Just Say Sire: The Sire Records Story, Rhino
Live Seeds: Nick Cave & the Bad Seeds, Mute/Elektra
Spurts: The Richard Hell Story, Rhino

PHOTOGRAPH CREDITS

N.B. Unless otherwise noted, credits are keyed to "365" numbers

© David Arnoff (www.tnbt.co.uk): 156, 172, 174, 175, 177, 210, 217, 220, 224, 225, 227, 234, 247, 254, 288, 289, 290, 298, 301, 302, 305, 318, 319, 325

© Roberta Bayley (www.robertabayley.com): 29, 31, 34, 36, 38, 39, 56, 59, 75, 119, 132, 135, 245, 273

© Janette Beckman (www.janettebeckman.com/jb.rocks): 96, 99, 117, 125, 128, 130, 138, 146, 150, 152, 157, 158, 160, 166, 167, 168, 176, 232, 241, 250, 277, 278, 294, 335

© Sumishta Brahm (www.sumishta.com): 230, 346, 348, 349

© Nancy Breslow (www.myspace.com/brezlo): 350, 351, 353, 354, 359

© Stephanie Chernikowski (www.stepcherphoto.com): 37, 41, 52, 57, 68, 73, 74, 79, 81, 82, 120, 300, 315, 316, 321

Corbis: © Gary Leonard/Corbis: 233, 235, 261, 339, 340, 343, 344, 345, 347

© Maria Del Greco (www.mariadelgreco.com): 363 (left and right), page 744

© Danny Fields: 16, 17, 18, 19, 20, 21, 22, 94

© Jill Furmanovsky (www.rockarchive.com): 10, 93, 102, 103, 106, 107, 109, 110, 111, 112, 113, 114, 116, 121, 124, 126, 129, 131, 139, 140, 143, 144, 148, 153, 159, 161, 162, 164, 165, 170, 179, 276

© GODLIS (www.GODLIS.com): 33, 40, 43, 44, 45, 47, 51, 54, 67, 71, 72, 76, 77, 78, 147, 173, 236, 237, 238

© Gary Green (www.garygreenphotographs.com): 60, 84, 259, 260, 262, 297

© Bobby Grossman (www.bobbygrossman.com): 248, 269, 270, 272

© Bob Gruen (www.bobgruen.com): 11, 12, 13, 14, 15, 23, 24, 25, 26, 28, 30, 32, 35, 46, 50, 53, 55, 58, 63, 64, 65, 66, 69, 85, 89, 91, 92, 95, 97, 98, 100, 101, 105, 108, 122, 127, 133, 134, 136, 137, 141, 151, 163, 169, 182, 183, 184, 186, 249, 287, 307, 365

© Scott Jarvis Collection; photo by Russell Boone: 61

© Theresa Kereakes (www.punkturns3 com): 208, 215, 218

© Chuck Krall: 8, 9, 115, 181, 185, 188, 189, 191, 192, 193, 194, 195, 203, 221, 222

© Bob Leafe (www.bobleafe.com): 87, 180, 253, 257, 286, 303, 304, 314, 334, 341, 342, 352, 356

© Jenny Lens (www.jennylens.com): 123, 155, 190, 196, 197, 198, 199, 200, 201, 202, 204, 205, 206, 207, 211, 212, 213, 214, 216, 223, 226, 228, 231, 240

© Robert Matheu: 1, 7, 48, 83, 86, 90, 118, 239, 244, 246, 255, 271, 292, 313, 328

© 1974, 2007 Richard Meyers; Richard Hell Papers, Fales Library: photo by Jay Craven: 27

© Dennis Morris (www.dennismorris.com): Front cover

© April Palmieri (http://aprilnyc.vox.com): 291 photo by Disk O'Dell; 295, 327, 332, 333

© Retna Ltd. (www.retna.com): 3, 4, 5 © Nat Finkelstein/Retna Ltd.: 104 © Veuige/Dalle/Retna Ltd.: 309 © Stephen Wright/Redferns: 308 © Tony Mottram/Retna UK; 337 © Steve Double/Retna Ltd./Retna UK: 251 © Marcia Resnick/Retna Ltd.: 283 © B.C. Kagan/Retna Ltd.

© Ebet Roberts (www.ebetroberts.com): 42, 49, 62, 70, 80, 88, 142, 145, 14 154, 171, 178, 229, 242, 243, 256, 258, 263, 264, 265, 266, 267, 275, 285, 299, 306, 310, 312, 320, 322, 323, 324, 331, 338, 364, back cove Ebet Roberts Studio: 357 © John Kelly 252 © Fran Pelzman

© Raeanne Rubenstein: 6, 274, 329, 330

© Bob Simmons (www.picasaweb.google.com/telebob): 2

© Mellon Tytell (www.mellontytell.com): 311

© Frank White: 355, 358, 360, 361, 362

© Dawn Wirth: 209, 219

© Charlyn Zlotnik (www.czfiles.com): 268, 279, 280, 281, 282, 284, 293, 296, 317, 326, 336, page 736

For Wendy and Luis, and all the
others who left us too soon.

Editor: Deborah Aaronson
Designer: Neil Egan
Production Manager: Alison Gervais

Library of Congress Cataloging-in-Publication Data

George-Warren, Holly.
 Punk 365 / Holly George-Warren ; foreword by Richard Hell.
 p. cm.
 ISBN 13: 978-0-8109-9404-1
 ISBN 10: 0-8109-9404-6
 1. Portrait photography. 2. Punk culture—Pictorial works. 3. Punk rock musicians—Portraits.
 I. Title. II. Title: Punk three hundred sixty five.
 TR681.P84G46 2007
 779.092—dc22
 2007011913

Foreword copyright © 2007 Richard Meyers
Copyright © 2007 Holly George-Warren

Front cover: The Sex Pistols, May 23, 1977, by Dennis Morris
Back cover: The Dead Boys' Stiv Bators, April 24, 1977, by Ebet Roberts

Published in 2007 by Abrams, an imprint of Harry N. Abrams, Inc.

Printed and bound in China
10 9 8 7 6 5 4 3 2 1

harry n. abrams, inc.
a subsidiary of La Martinière Groupe

Harry N. Abrams, Inc.
115 West 18th Street
New York, NY 10011
www.hnabooks.com